2006

To my favorite
MIA companion
and fellow
Impressionist
painting
enthusiast.
Not to mention
supportive friend
Merry Christmas
Ann

With
love,
Judy

# THE
# PRIVATE LIVES
# OF THE
# IMPRESSIONISTS

# THE
# PRIVATE LIVES
# OF THE
# IMPRESSIONISTS

Sue Roe

HarperCollins*Publishers*

HarperCollins books may be purchased for educational, business, or sales promotional use. For information, please write: Special Markets Department, HarperCollins Publishers, 10 East 53rd Street, New York, NY 10022.

First published in 2006 in Great Britain by Chatto & Windus.

FIRST U.S. EDITION

Library of Congress Cataloging-in-Publication Data is available upon request.

ISBN 10: 0-06-054558-5
ISBN 13: 978-0-06-054558-1

06 07 08 09 10 RRD 10 9 8 7 6 5 4 3 2 1

# CONTENTS

# LIST OF ILLUSTRATIONS

*Part-title illustrations*

All images have been supplied by the Bridgeman Art Library, with the exceptions of nos. 7 and VII, reproduced by kind permission of the Bibliotheque Nationale, Paris.

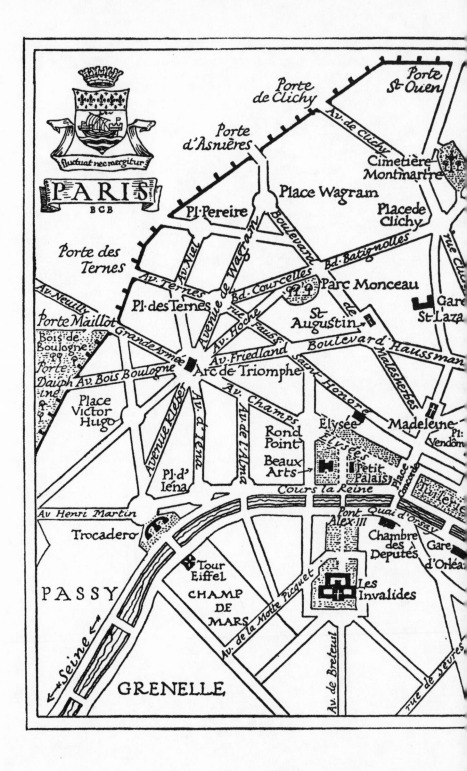

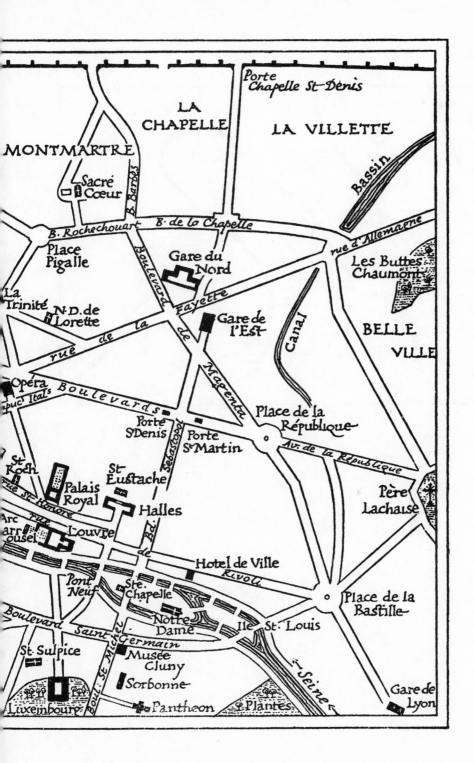

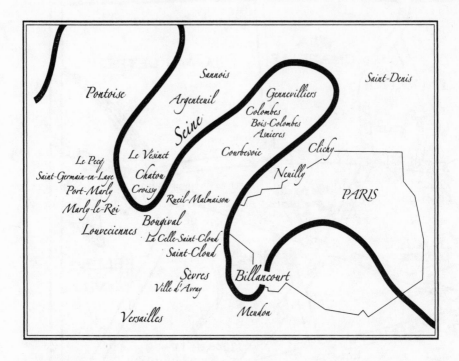

Les Banlieues

# PROLOGUE

NEW YORK, 1886. A SHORT, dapper Frenchman in black frock-coat, starched collar and top hat arrived at the American Art Association in Madison Square, in preparation for an exhibition of 'Works in Oil and Pastel by the Impressionists of Paris'. He had sent ahead of him a cargo of 300 French paintings.

The visitor was Paul Durand-Ruel, an art dealer who dealt from two galleries in the artists' quarter of Pigalle, Paris, and another in London's New Bond Street. He had been invited to show the works of a group of artists who had been exhibiting in Paris for more than ten years, and who had attracted the attention of the Parisian press for their radical painting style. Their works were painted with none of the traditional framing devices, pictorial perspectives or conventional subject matter favoured by the viewers and collectors who patronised the Salon des Beaux-Arts. Durand-Ruel's artists were unconcerned with elevating subjects: the moral tales, dramatic scenes from history or mythology, or biblical parables preferred by the upper middle classes of Paris. They simply painted life as they saw it: in the city streets, the country lanes, the riverside cafés in and around Paris.

One of Durand-Ruel's painters, Claude Monet, had invented an ingenious way of painting water, in coloured rivulets and flurries which seemed to move and sparkle on the canvas. Another, Auguste Renoir, painted glorious society portraits of the *haute bourgeoisie* and specialised in sumptuous nudes. Years later, Renoir told his son a (possibly apocryphal) story about Durand-Ruel's arrival in America. He had apparently been a little concerned about getting Renoir's nudes through customs, so he had arranged a meeting with the Chief Customs Official of New York, an ardent Catholic. The Sunday following his arrival, Durand-Ruel accompanied him to Mass, where he placed a large donation in the collection box. His cargo of paintings went through without a hitch.

Durand-Ruel's French painters included a woman, Berthe Morisot, who with a unique, light palette painted enchanting scenes of everyday life. His cargo also included Edgar Degas's pastels and oil paintings of

prehensile-looking crouching women, performing their ablutions in tubs or combing one another's hair, and his exquisite ballet scenes from the Paris Opéra. There were soft, gentle landscapes by Camille Pissarro and Alfred Sisley, who painted the country lanes in the *banlieues* – suburbs – of Paris – winding paths beneath snow and hillsides sparkling with blossom. In addition, the cargo included works by one anomaly: the man who had for two decades inspired and magnetised these artists but had never actually exhibited with them. Edouard Manet's work – louche, lush snapshots of city life, and portraits charged with psychological insight – was notorious in Paris. He had become a celebrity in 1863, with *Le Déjeuner sur l'herbe*, a landscape scene featuring a nude woman and two clothed men, which had shocked the French public, and again in 1865 with *Olympia*, a portrait of a courtesan, which had shocked them even more.

In Paris, for more than a decade, the group had collectively – and pejoratively – been known as the Impressionists. For the whole of that time, they had been struggling to make their reputations as painters, unable to get their work past the prejudiced, snobbish and retrograde juries of the Salon des Beaux-Arts. For most of this time, the Impressionists had barely been able to support their families. When Durand-Ruel stepped into the American Art Association that day in 1886, he was making history. He needed to. He was in massive debt, partly because his two decades of support for these artists had brought him very little revenue. He had chosen the American Art Association because it was a non-profit-making educational institution and exhibiting there would exempt him from payment of duty on his cargo. Because of his foresight in bringing their work to New York, the Impressionists would soon be known the world over. In our time, a work by any one Impressionist can command a price of several million dollars, but Durand-Ruel was taking a huge gamble. His timing was right; the American market was ready, and the gamble paid off. But who were these painters? Where and how had they met? How had they formed a group, and remained together? How had they survived?

This book tells the story of how the Impressionists came together, and of their lives, loves, personalities and the themes and development of their art, concentrating on the twenty-six years between their first meeting and the climactic moment in 1886 when Durand-Ruel introduced their work to New York. From that point on the individual members of the group went their separate ways, following different artistic paths, and though some of them remained friends they each developed separate careers. The years from 1860 to 1886 were the essential years in which they shared their lives as a group, and the story that follows details the true years of Impressionism.

# THE BIRTH OF IMPRESSIONISM

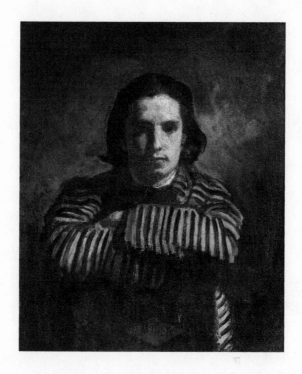

Gilbert Alexandre de Severac, *Portrait of Claude Monet*, 1865

# NAPOLEON III'S PARIS

*'The Seine. I have painted it all my life, at all hours of the day, at all times of the year, from Paris to the sea . . . Argenteuil, Poissy, Vétheuil, Giverny, Rouen, Le Havre.'*

— Claude Monet

THE SEINE FLOWED THROUGH its narrow bed, meandering from Paris to the Normandy coast, drawing all the countryside between into one region. 'Le Havre, Rouen and Paris are a single city, in which the Seine is a winding road,' Napoleon III, Emperor of France, was fond of saying. In Paris, along its banks, rows of irregular-shaped houses made a low, untidy skyline. On the Île Saint-Louis, large, old houses with balconies and balustrades lined the narrow road skirting the river. On the Left Bank, the horizon was wide open as far as the blue slate gables of the *hôtel de ville*; on the right bank you could see as far as the lead-covered dome of Saint Paul's. The Seine was a working river, its surface a clutter of colour, alive with cargo. Emile Zola later described it, in his novel *L'Œuvre:* 'a dormant flotilla of skiffs and dinghies, . . . barges loaded with coal lighters . . . flat river barges were moored four deep along the Mail. Piled high with yellow apples, they made a blaze of gold.'

Early in 1860, Claude Monet — twenty, clean-shaven and handsome, with brown, appraising eyes and floppy dark hair — made his way along the Right Bank, to a ramshackle building next to the Palais de Justice, at the angle of the Boulevard de Paris and the quai des Orfèvres. Outside, suspended from the upper floors of the building, swung a huge, rusty sign: *SABRA, Dentiste du Peuple.* The building where the dentist pulled teeth at one franc apiece also housed the studio of 'Père' Suisse, a former artist's model of uncertain origins who twice daily opened his doors so that students could, for a fee of ten francs a month, sketch from his model. By February 1860, Monet had begun life as an art student in Paris, attending Suisse's studio every day.

In 1860, Paris was still a medieval city, with dark, mouldering, rat-infested streets, and no efficient sewage system. The jumble of crumbling buildings, and the absence of air and sunlight, trapped all the smells of decay and detritus that people still lived among. Household waste ran in indentations down the middle of the grimy cobbled streets. The poor lived in filthy, broken shacks and shanties clustered around Clichy, Mouffetard and the Louvre. Balzac had called all these the Louvre's 'leprous façades'. Napoleon III himself, who in 1830 had thrown out the republicans and restored the Empire, called Paris 'nothing but a vast ruin, with plenty to suit the rats'. But in 1853, Baron Haussmann had been elected Prefect of the Seine. He immediately began making plans to transform the city. On 1 January 1859, Napoleon signed a decree approving the Baron's plans to tear down the inner city wall. Former suburbs of Paris – including Auteuil, Belleville and Montmartre – now became part of the city. But the suburbs were still comparatively rural, especially Montmartre, which in 1859 was a muddle of houses with gardens, broken-down shacks, and cheap little run-down bars and *crémeries*. The country lanes of Montmartre housed the poor workers employed by the seamstresses, florists and laundresses who worked at the foot of the hillside in Pigalle. This was also the district – lively with cafés, brasseries and café-concerts (*cabarets*) – where the artists congregated. They gathered in the Café de Bade, Tortini's or the Moulin Rouge, where among chilled pitchers brimming with pink champagne, grimy young men were surrounded by women in brash, red lipstick and cheap crinolines.

The rich were ferried in horse-drawn carriages down the newly created Boulevard Haussmann to the Opéra in Pigalle's rue le Peletier, the women decked out in silk-embroidered crinolines, feathers and pearls. But not just the rich: everyone was on the move. In 1855, the Universal Exhibition – a vast, commercial fair, designed to demonstrate to the world Paris's prosperity, and to show off its decorative arts and material culture – had introduced new fashions and set new precedents in taste. The Emperor's musical soirées, held in the gardens of the Château of the Tuileries, set the sartorial tone. The audiences comprised a mingling of the *haute bourgeoisie* with newly affluent members of the upwardly mobile merchant and industrial classes who were moving into Haussmann's new apartments and buying chic, new mass-produced ornaments and furniture. Since 1857, 300 newly acquired horse-drawn omnibuses had been circulating among neighbouring boulevards (not simply, as they once had, servicing the more profitable routes). For the first time, Parisians could move easily through the city for shopping and entertain-

ment, although the top deck was barred to women, for fear of their showing their ankles as they mounted the stairs. Haussmann was laying down new streets, pulling down whole districts, and creating new squares. Some said Haussmann's Paris was designed for the easy surveillance of approaching armies; others, that it was really contrived to drive the poor of Paris away from the central *arrondissements*, out to the suburbs. As the construction took place, and the industrial and commercial classes began to purchase smart new apartments, there was increased potential for extravagance, commerce and the pursuit of pleasure, and an obsession with clothes and decoration. The city was in a state of flux. There was a new sense of bustle and movement, and, for the first time, a mix of people of all classes in the streets, which smelled unmistakably of Paris: a mingling of leeks and lilacs. When the bulldozers arrived and began their clearing-up operation to remove the workers' shacks and create the rue de Rivoli, the rag-pickers came in: tramps and absinthe drinkers, poking about among the debris for the coins and jewellery rumoured to be buried there.

The newly affluent middle classes also joined the crowd who flocked every year to the Salon des Beaux-Arts. The Salon, held annually in the Palais de l'Industrie, a huge exhibition centre in the Champs-Elysées, was the social event of the year. During the first two weeks of May, some 3,000 visitors crowded into the Champs-Elysées and queued to see the show – Zola described it as a seething tide of humanity. People spilled out into the gardens, wedged in between sculptures; at lunchtime, Le Doyen's, Tortini's and other nearby restaurants, particularly those with a café-concert, did a roaring trade. On the eve of the show, privileged artists, critics and patrons gathered for the *vernissage* (varnishing day), or private viewing. Up until the last minute, horses and carts arrived, bearing vast canvases and colossal sculptures; the top decks of the omnibuses were crowded with artists and weighed down by pictures. Celebrated artists sent canvases measuring ten or twelve by twenty feet: the larger the canvas, the greater the opportunity for attention from critics and patrons. 'In sumptuous studios, in wretched garrets, amid affluence, amid scenes of squalor and hunger, artists of all kinds and degrees had been squeezing thousands of tubes and daubing thousands of canvases in preparation for the great day.' The vast exhibition filled more than two dozen rooms, and the exhibits took up the equivalent of some eight miles of space. The walls were crammed four deep with paintings, hung by the jury in spaces selected according to perceived importance; to be 'skyed' (hung near the ceiling) was regarded as the ultimate slight, since a work hung there could barely be seen.

For the artists, the Salon exhibition was crucial, since in the days before dealers and small galleries it was the only real way of exhibiting their work, establishing a reputation as an artist, and attracting the attention of aristocratic patrons and collectors and museum purchasers. Those eligible for submission to the Salon jury included only members of the Académie des Beaux-Arts; students of the Académie's educational establishment, the Ecole des Beaux-Arts; and students of the Ecole's affiliated studios. Predictably, the jury tended to favour established artists (who were invariably Académie members), so competition among the lesser known was fierce.

The Académie des Beaux-Arts was a subsidiary (responsible for painting and sculpture) of the Institut de France, the central governing body of all French cultural life. The Ecole des Beaux-Arts was an imposing institution on the rue Bonaparte, in the heart of Saint-Germain-des-Prés. Professors were appointed, and prizes (including the Prix de Rome) awarded, by the Salon jury. A throwback to the Italian Renaissance, the Ecole, originally founded in 1684, consisted (as it does today, though in a somewhat dilapidated state) of vast studios built round a series of leafy courtyards and cloisters. Its long corridors were littered with classical statues on plinths, the walls decorated with friezes. Around the ceilings of the vast inner hall, elaborately decorated in brown, cream, terracotta and gold, an upper cloister ran on all four sides beneath a huge, octagonal glass roof. Inscribed around the ceiling in gold were the names of all the great masters: Holbein, Dürer, Rembrandt, Van Dyck, Velásquez. A central part of the curriculum was the study of the works of the Old Masters, and an essential part of any student's education was the copying of the Old Masters in the galleries of the Louvre. Students at the Ecole des Beaux-Arts received strictly academic, classical training, which consisted of copying from the antique, learning anatomy by sketching from corpses (generously lent by the Medical School) and learning to paint elevating religious and mythological subjects. On Monday mornings, the rue Bonaparte was crowded with models, already in costume (soldiers, shepherdesses), hoping to be picked for work. The teaching at the Ecole perpetuated the taste exemplified by the annual Salon exhibitions, and the goal of an academic education was to exhibit there.

The values of the Institut de France, therefore, permeated every level, even determining acceptable subjects for painting. Prime positions at the Salon were occupied by paintings of historical, mythological or biblical subjects depicting edifying moral lessons, or celebrating *la gloire de la France*. Narrative scenes from the literature of Goethe, Shakespeare, Byron or Sir Walter Scott were also acceptable. Among the most popular subjects

were shipwrecks, which elevated a seascape into an instructive human tragedy. In 1859 (the year Monet arrived in Paris), a copy of Gericault's gigantic seascape, *The Raft of the* Medusa, painted in 1819, was being exhibited—the story of fifteen shipwrecked sailors who had resorted to cannibalism. They had been found 'lying on boards, hands and mouths still dripping with the blood of their victims, shreds of flesh hanging from the raft's mast.' This was a great subject, gory and gasp-making. The most popular artists included Gérôme, Meissonnier, Moreau, Delacroix and Ingres.

The values of the Académie also determined techniques for painting. Works were expected to be microscopically accurate, properly 'finished' and formally framed, with proper perspective and all the familiar artistic conventions. Light denoted high drama, darkness suggested gravitas. In narrative painting, the scene should not only be 'accurate', but should also set a morally acceptable tone. An afternoon at the Salon was like a night at the Paris Opéra: audiences expected to be uplifted and entertained. For the most part, they knew what they liked and expected to see what they knew. The rising middle classes – particularly industrialists and merchants – liked to see paintings they could understand, and to learn from what they saw. This sector of the audience had helped the success of the Barbizon landscape artists – Millet, Rousseau, Troyon, Diaz and Daubigny – since their rural scenes were ones that the middle classes could envisage adorning their own walls. But even their paintings, begun in the open air, were 'finished' in the studio. Anything out of the ordinary, in subject matter or execution, was viewed with suspicion. Even Delacroix (among artists, the Byronic hero of the day), whose biblical and mythological paintings seem, to the twenty-first-century eye, to fit the bill, was seen as something of a dangerous radical. His work had vitality and movement, his brush strokes were indirect, sensual and suggestive, and his colours, especially his reds, were thought radical to the point of recklessness. The Old Masters were still the gods of painting. The old values prevailed, and new ideas were strictly discouraged. Those who studied at the Ecole des Beaux-Arts thus received an extremely rigorous, disciplined, classical education, and the Ecole admitted only unmarried (thus, it was assumed, truly dedicated) students – those prepared to sacrifice everything for their art.

But Paris was overrun with art students. Thousands attended studios, which proliferated throughout the city in garrets, alleys and tiny upstairs rooms from Montparnasse to Montmartre. These were normally run by present or former members of the Académie, most of whose reputations had seen better days, who opened their studios to students for a monthly fee in order to make a living. (These *académies libres* were free only in the

sense that they were liberated from the strict educational rubric of the Académie.) Most students regarded this experience as preparatory: after doing their time in a studio, they would expect to apply for a place at the Ecole. In the studios, they worked from plaster casts and a life model, with – theoretically, at least – regular visits from the tutor, who was expected to offer advice and criticism, though practices varied widely. The students tended to be rowdy and undisciplined, with initiation rites for newcomers (posing in the nude, or picking up unpleasant bits of litter). In ground floor studios, the main purpose was to attract attention to the tutors, who exhibited their own work there with the door open to the street in the hope of attracting passing purchasers. In attic studios throughout Clichy, Pigalle or Montmartre, students worked with almost no facilities, in rooms of varying size, often completely empty but for a clatter of easels, an antique statue or two, and a nude model. Suisse's establishment in the rue des Orfèvres, on a kind of mezzanine level on the third floor (which also housed his living quarters) was one such studio – a far cry from the splendour of the Ecole des Beaux-Arts, but nevertheless loosely affiliated to the Académie. Suisse, by now elderly, had a reasonable reputation. In his youth he had exhibited at the Salon, and Courbet, Corot, Delacroix and Bonington had all studied under him. Former students of the Ecole often dropped in at his evening sessions as a way of continuing their studies.

★

No one knows why Claude Monet chose Suisse's, but by February 1860, a year and a half after arriving in Paris, he was studying there every day. Confident and ambitious, he had come to the metropolis from Le Havre in Normandy, where his father and aunt were successful business people. Le Havre was a busy port, and an increasingly prosperous resort. Monet's father was a ship's chandler, and the Monets were affluent, sociable and popular people who knew how to enjoy life. They gave parties and concerts, and Monet's mother loved to sing; there was always music in the household. They had moved to Le Havre from Paris when Monet was five, to join his Aunt Marie-Jeanne Lecadre, who was already established there in a prosperous chandler's business. She lived in a large villa with a terrace overlooking the sea, in Saint-Adresse, then a suburb of Le Havre. Monet's father settled his young family in Igouville, the business district next to the harbour, and soon he was making a good living. Since the coming of the railways, Le Havre had been rapidly expanding, flanked with huge hotels and lively with regattas. In the summer, Parisian visitors flocked to the casino and the beach, where they paraded their finery on

the promenade in the daytime, and gambled their money at night. Local cartoonists depicted them, elaborately decked out, with minuscule waists and frilly parasols, asking hopelessly metropolitan questions of the local fisherwomen ('Is the sea salty all the year round?' – 'No, we tip it in just before you arrive').

By the time he was fifteen, Monet was charging commercial rates for his caricatures of local dignitaries. He was a skilled draughtsman, with a keen, satirical eye, and his drawings were popular. He took them to Gravier's, a stationer, framer and ironmonger in the busy, commercial rue de Paris, where the shops advertised '10,000 novelties' and placed outside their doors mannequins wearing the latest Paris fashions. The landscape painter Eugène Boudin, a native of Honfleur, just across the estuary, sometimes exhibited work at Gravier's: moody paintings of the sea and of Normandy's vast, windy skies (like grey crystal, the poet Rimbaud said), vivid sunsets and low horizons. At Gravier's, Monet's caricatures were soon selling for 15 or 20 francs a head. 'Had I carried on,' he later remarked, 'I would have been a millionaire.' In the shop, he met Boudin, who admired his drawings and encouraged him to paint and sketch his own environment: the harbour, chalk cliffs of the pays de Caux, its gossamer-like cloud formations, and the verdant hillsides of Honfleur. Monet had spent his childhood playing beneath the cliffs and along the bustling quayside among the noise of cargo being unloaded, the clutter of market stalls, and crowds massed to watch the boat races. With Boudin, he spent hours doing what he loved best: roaming the countryside, making sketches in the open air and watching the sunset, a bright, orange disc which threw haphazard streaks of orange into the fading blue water.

But in 1857, Monet's mother died. The Monet household was suddenly silent; the concerts, dinners and soirées abruptly stopped. 'Aunt Lecadre' took over the care of seventeen-year-old Claude, encouraging him to continue his drawing and painting. Increasingly, he bunked off school to paint out of doors. Claude hated school. He resented being trapped inside a building and told what to do, even for a few hours a day. He left before his final examinations (the exact date, between 1855 and 1857, is unknown), infuriating his father, and began to dream of life as an artist in Paris. Aunt Lecadre, an amateur painter herself, had connections there. She knew one or two painters who exhibited at the Salon des Beaux-Arts, and she and Claude persuaded his father to let him try his luck in Paris, on condition that he took proper lessons at one of the studios affiliated with the Académie. Aunt Lecadre wrote letters of introduction to her painter friends, including Troyon, the Barbizon landscape painter, and Monsieur Monet applied to Le Havre municipal authorities for a

grant. He was refused twice, but by the second refusal the young Monet had already left for Paris.

He booked into a hotel and made straight for the Salon, where he introduced himself to Aunt Lecadre's friends. When Troyon saw his work, he recommended a couple of months' study in Paris, followed by a return to Le Havre to study landscape in the summer, then a definitive return to Paris in the autumn. Monsieur Monet and Aunt Lecadre endorsed this plan by agreeing to provide Monet with a regular allowance, so long as he worked in a proper studio. Aunt Lecadre wanted him to go to the renowned academician painter Thomas Couture, who had a good reputation for preparing students to enter the Ecole. But by the time Monet met him, Couture was old and crabby. He told Monet he had 'completely given up' painting, and Monet found him bad-tempered and off-putting. By June, Monet had taken rooms in Montmartre, at 5, rue Rodier, and begun painting and drawing on his own. By February 1860, when he moved again, renting a sixth-floor attic room at 18, rue Pigalle, he was a regular student at Suisse's.

He attended Suisse's from six in the morning, when it opened, and again in the evening from seven until ten. Suisse gave no formal supervision or instruction; there was no compulsory attendance, and no examinations – all of which suited Monet perfectly. The studio was large, bare, well lit, with two windows, one overlooking the courtyard, the other looking out across the river. The walls were grimy with smoke, and completely empty except for the easels and the model's metal crossbar, with its ropes and nooses used for the most difficult poses. The students shouted across to one another, teased the model, and puffed on their pipes, sending smoke up to the ceiling. Monet, though outgoing and popular, studied conscientiously, working with great concentration.

★

At Suisse's Monet met Camille Pissarro, who regularly dropped in at the studio to sketch from the model in the evenings. (In the daytime he painted in the countryside, or copied dutifully from the Old Masters in the Louvre.) A Portuguese Jew with dark, gentle eyes, aquiline nose and a huge white beard, Pissarro was only thirty-one, ten years older than Monet, but he already had all the appearance of a venerable, wise old man. Like Monet's, Pissarro's family were merchants, but his background could hardly have been more different. He was born in the Danish West Indies, in the Caribbean island of St Thomas, where the Pissarros' shop, at 14, Dronningens Gade, the main commercial street, sold haberdashery, hardware and ships' stores. He therefore passed his early years in a burning

climate, where the colours were vivid and hot, in the heart of the sugar, molasses and rum-producing areas. The Pissarros were active figures in the Jewish community which comprised almost a quarter of the population. His father, Frédéric, a French Jew, had sailed to the West Indies in 1824, aged twenty-two, to take over the business from his Uncle Isaac, who had died that year. Frédéric caused a scandal by marrying Isaac's widow Rachel, a strong, domineering woman with two daughters, and they had four sons before their marriage was formally recognised by the synagogue. Camille, the third son, was born in 1830.

As a child, Pissarro lived with his family above the shop until, aged eleven, he was sent to a French boarding-school, the 'Pension Savaray' in Passy, then still a leafy hillside suburb near the Bois de Boulogne, overlooking the Seine. In his drawing lessons, Monsieur Savaray told him, 'Draw from nature during your holidays – as many coconut trees as you can!' (Pissarro did, making careful pencil sketches.) On their days off from school, the boys were taken to the galleries of the Louvre, where they watched students copying from the Old Masters. When, in 1847, Pissarro completed his studies, Paris was in a state of political turmoil that would lead to revolution in February 1848.

He returned to the Caribbean dreaming of an artist's life in Paris, equated in his mind with anarchist ideals and ambitions to épater la bourgeoisie. Unable to settle back in St Thomas, he sailed with a young Danish painter to Venezuela, where they enjoyed the vivacious life of the streets and painted the landscape and the carnival. In 1855, when his younger brother died, he returned to St Thomas. But he was unable to settle and was soon on his way back to Europe. He headed for London, but the news that his stepsister Delphine was critically ill in Paris diverted him there instead.

When Pissarro arrived, he found the city changing before his eyes; Haussmann's renovations were already under way. He met Jean-Baptiste Corot, the portrait and landscape painter, who praised his work and advised him to get out of the city and paint the countryside, for 'the muse is in the woods'. Pissarro was fascinated by the cool, pale landscapes surrounding Paris, and began to explore the locations around the River Seine, painting the fields and suburbs, inspired by the soft changing light. In the evenings, he returned to the family home at the foot of the hillside of Montmartre, at 49, rue Notre Dame de Lorette. It was a full house: he lived there with his mother Rachel, his surviving stepsister Emma Isaacson and her five children, a cook, a maid, and the freed black slave Rachel had brought with her from St Thomas.

In 1858 the Pissarro family moved into a more fashionable suburb, but

Camille wanted to stay in Montmartre, where he found lodgings for himself and continued to mingle with artists and writers in the cafés. The following year (the year Monet arrived in Paris), Pissarro's first painting was accepted by the Salon. Following this auspicious start, he was determined to follow his course as an artist, living independently, with the freedom to spend his evenings with other artists in the cafés of Pigalle and Montmartre. In 1859, the talk in the cafés was revolutionary. With the changes taking place in Paris, the rise of the new middle class and increased mobility for the workers, the values of Empire were gradually being put to the challenge. Pierre Joseph Proudhon, the social theorist, was the talk of the day. His book, *Justice in the Revolution and the Church*, had just been seized by the police, and his socialist supporters were incensed. Pissarro, who believed deeply in social justice for all, was fired by Proudhon's theories, though (unlike Proudhon) he also had a strong sense of family, maintaining a close connection with his own. In 1860, his mother hired a new maid, a country girl from Burgundy, the daughter of an unskilled farm worker who grew vines on his own bit of land. Julie Vellay was a proud, principled girl with blonde hair and dazzling blue eyes. Pissarro, fascinated by her peasant origins as well as by her beauty, was captivated.

Julie was outspoken and loyal, with a fiery, volatile temperament, and she was proud of her origins. (When, later, she had maids of her own, she fiercely defended their rights, writing a storming letter to the abusive previous employer of one of her serving girls: 'You are surrounded by people who will meet your needs, so stop interfering with one who isn't interested in you.' Since the girl had no mother, she was 'looking after her interests a bit'. Julie wrote without grammar or punctuation, in her own vernacular rhythms, but there was no doubting her meaning.) Both she and Pissarro had a fierce sense of natural human justice, and Pissarro was deeply devoted to her. For several months they succeeded in keeping their affair a secret, but soon Julie became pregnant. When he asked his parents for their permission to marry her they were aghast, but Pissarro ignored them, and set up home with her. Soon afterwards she suffered a miscarriage, and took a job working for a florist, while Pissarro, still largely dependent on his parents' financial support (and, despite their attitude, still devoted to his family), continued to paint.

At the end of the day, Suisse's students often crossed the river and spent the evening on the Left Bank, in the Closerie des Lilas, the café with an enclosed garden terrace, at the junction of the boulevard Saint-Michel and the boulevard du Montparnasse. In the café, women of the night mingled with students, the dancers sang along with the band, and a mouse ran

around under everyone's feet. It was a popular venue, always alive with laughter and hubbub, but Monet preferred the more bohemian Brasserie des Martyrs, which was on the rue des Martyrs in Montmartre, near Pissarro's lodgings in Notre Dame de Lorette. Here, writers, reviewers, fledgling poets and artists *manqués* mingled with penniless philosophers, great painters, obscure painters, off-duty government officials, and the writer Firmin Maillard, who wrote a colourful description of it all. Nobody had any money. Courbet would turn up in an old white shirt that looked as if it had been run up out of his grandmother's old apron. Baudelaire would be there in his famous white face powder, articulately defending his reputation as a subversive (he had just published the infamous *Les Fleurs du mal*). As the night wore on, there was loud singing, bouquets of violets wobbling in button-holes; someone would sprint across the room and start hammering on the piano. All the while, circulating and hovering, the women would be leaning in. There was not one man in the place who didn't have a special favourite: Noisette, who sang in the café-theatre; Clotilde, Hermance and Titine; Cigarette; Moonlight; Montonnet-Glass-Eye; and Œuf à la Plat. Monet sat around making caricatures of them all.

<div align="center">★</div>

In April 1861 Monet was temporarily drafted into the army, where for a while he served in Algeria. He thus just missed the arrival at Suisse's, that autumn, of Paul Cézanne, a new, strange, brooding student from Aix-en-Provence, with the distinctive, singsong accent of the Midi. Tall, round shouldered, with short, black hair, swarthy dark skin and a black, drooping moustache, he aroused great curiosity. His life drawings were so bizarre that the other students were beginning to ridicule them. Cézanne only came to Suisse's in the mornings, so Pissarro, tipped off by Suisse's Cuban student, Oller, made a special daytime visit to get a glimpse of 'the strange Provençal'.

At twenty-two, Cézanne was intense, clumsy and paranoid; he seemed suspicious of everyone. He drew with great care and passion but the results were baffling. He worked the forms of his figures outwards from their inner structure, and thus seemed oblivious to contour. His lines were wobbly and his figures looked like bits of mauled Plasticine. Nevertheless, he seemed to like it at Suisse's, where nobody tried to instruct him. Pissarro, intrigued, was curious to know what was beneath his defensive exterior.

Cézanne had spent his childhood at 14, rue Mertheron in Aix, a sleepy town at the foot of the great Mont Sainte-Victoire, where the misty light

around the mountain seems to change as you look, turning the olive trees blue. His father, originally a dealer in hats, had been so successful that he had purchased Aix's only bank. Two years before Paul left for Paris, Monsieur Cézanne bought an enormous, almost derelict Louis XIV mansion, the Jas de Bouffan, former residence of the governor of Provence. This vast, neglected property of thirty-seven acres, with an avenue of chestnuts at the rear, lay about half a mile to the west of Aix in the heart of the Provençal countryside. The family spent weekends and summers there, bathing in the large pool, surrounded by stone dolphins and limes. They occupied only part of the house; the rest lay closed up and disused. Paul's bedroom (and later his study) was high up in the eaves, away from the rest of the family. If for Monsieur Cézanne this property was a sign of prosperity, for his son it was somewhere to escape to and dream in. He never got on with his father, who was stern, irrational and controlling. His apparent refusal to let his son grow up was a self-fulfilling prophecy; for many years Cézanne was to remain furiously dependent on him. Paul was much closer to his mother, his sister Marie and his close childhood friend, Emile Zola.

Even as children, Zola and Cézanne, both gifted at drawing (Zola more so than Cézanne) had seen themselves as misfits, bohemians and intellectual geniuses. They studied Latin and read Victor Hugo, and spent long, lazy summers together in the countryside, reciting poetry, making up their own pretentious doggerel and setting each other clever quizzes and tests of intellectual ingenuity. As a child, Cézanne had an eight-page booklet laid out with printed questions and spaces where one could fill in the answers. 'What do you consider to be your most estimable virtue?' 'Friendship.' 'What do you think would be your worst fate?' 'Destitution.' 'Where would you like to live?' 'Provence and Paris'. The stage was set. (He also named Rubens as the painter he most admired, which may to some degree explain the strange bulkiness of his early figure drawing.)

In 1858 Zola and his mother suddenly left Aix for Paris, where Zola found a job at the Librairie Hachette. Cézanne, already prone to depression, found himself intolerably lonely. Zola wrote regularly, trying to persuade his friend to join him in Paris. Cézanne, still struggling to pass his *baccalauréat*, resisted. He enrolled at the University of Aix, to study law, and took classes at Aix's Municipal School, where he did some life drawing and oil painting. He hated the law, which threatened, he told Zola, to destroy his muse. 'Find out about the entrance exam for the Académie,' he eventually asked Zola. 'I'm still determined to compete with you at any price – provided, of course, it doesn't cost anything.'

In April 1861, accompanied by his father and sister Marie, Cézanne arrived in Paris and enrolled (perhaps on Zola's advice) at Suisse's, with a view to gaining admission to the Ecole. After finding him suitably respectable lodgings in the rue Coquillère near the Bourse, Monsieur Cézanne and Marie returned to Aix, leaving Paul to begin his life in Paris. He worked hard at Suisse's every day and spent most of his evenings in Zola's lodgings.

But the bouts of depression and self-loathing continued. He was soon complaining that the move to Paris had not made him happy. Yes, he was an art student in Paris, but all that meant was that he studied at Suisse's every morning from six until eleven, lunched in a café for a few sous and . . . so? Was that all there was to being an artist? How was that supposed to be an inspiring life? 'I thought when I left Aix I would leave behind the depression I can't shake off,' he complained to Zola. 'But all I've really done is change places. I'm still depressed. I've just left my parents, my friends and some of my routines, that's all.' He did, however, take himself off to the galleries of the Louvre, the Musée du Luxembourg and Versailles, and was bowled over by what he saw. Such variety, such profusion, he had never seen works of art like these, he told Zola . . . but 'don't think that means I'm turning into a Parisian'. He also went to the 1861 Salon, where he looked carefully at everything and was deeply impressed – 'I could give you some beautiful descriptions . . .' As a Provençal, he had none of the cynicism of young bohemian Parisians, who were used to seeing walls covered in canvases and were bored by the preponderance of historical and mythological scenes. For Cézanne, the Salon was spellbinding: 'all tastes, all styles meet – and clash – there'.

Gradually, at Suisse's, he got to know Pissarro, who encouraged him in his work. Cézanne was trying, he told Zola, to 'solve the problem of volumes'. This was nonsense, said Zola, he should concentrate on expression, none of his figures seemed to express anything. But his figure drawing was fraught with problems, not least because he was convinced the models were all trying to flirt with him (perhaps they were): 'the sluts are always watching you, waiting to catch you off your guard. You've got to be on the defensive all the time, and then the motif vanishes.' In general, he was suspicious of women, but he liked Julie.

Cézanne was chronically disillusioned, slashing his canvas to pieces when he was dissatisfied with a painting. He failed to gain a place at the Ecole, and was always threatening to leave Paris; Zola and Pissarro were continually persuading him to stay. In September, depressed and disenchanted, he did go back to Aix, where he took a job in his father's bank. But he was soon bored, and scrawling rhymes on his bank ledger –

'The banker Cézanne does not see without fear / Behind his desk a painter appear.' He stayed in Aix for just over a year. By November 1862, he was back in Suisse's studio.

# THE CIRCLE WIDENS

*'I only sleep with duchesses or maids. Preferably duchesses' maids.'*
—Claude Monet

THE FOLLOWING SUMMER, IN 1862, Monet was in Le Havre, preparing to return to Paris. He had been drafted out of the army on grounds of sickness and had spent the summer convalescing and running around with Johan Barthold Jongkind, a Dutch landscape painter more than twenty years his senior who had come to Le Havre to paint the landscapes of Normandy. He was a brilliantly subtle painter of water and a wild card, living openly with his mistress and ravaged by alcohol. Monet found him endlessly entertaining. Jongkind seems to have been a major factor in Monsieur Monet and Aunt Lecadre's decision to allow the young Monet to go back to Paris and take up his studies again. Since he seemed to have no particular desire to return to Suisse, Aunt Lecadre contacted her cousin, the landscape painter Auguste Toulmouche, who agreed to take him on as a pupil. So in 1862 Monet arrived once more in Paris, this time bringing a bundle of Le Havre landscapes. Seeing these, Toulmouche praised his work, but told him he would be much better suited to another, more broadly academic painter, Charles Gleyre.

★

Gleyre was a formal painter of Swiss origin. (Suisse may have taken the name he did to trade surreptitiously on Gleyre's reputation.) A member of the Académie des Beaux-Arts, Gleyre's paintings were conventional and anecdotal. He had been highly acclaimed at the 1843 Salon, but he thought of himself as a staunch republican. Since Napoleon's overthrow of the Second Republic, Gleyre's reputation had diminished, but he was a respected teacher. His studio, despite its informal atmosphere, was more academic than Suisse's. He emphasised the importance of drawing

and composition and told Monet, 'just remember this, young man: when you do a figure study, always have the antique in mind'. He set the students occasional exercises, and sometimes made encouraging comments on their work. Somewhat ironically, given his Republican convictions, he took particular pride in his more socially illustrious pupils.

His studio was at 70bis, rue Notre Dame des Champs, a long, sinuous road running between the boulevard Montparnasse and the boulevard Raspail. It was lively and popular, always crowded with thirty or forty students, including (unusually) three women, all working at their easels in the greyish northern light of a large bay window. For three weeks of the month they drew from a male model in drawers, and for the fourth, from a nude female model (they came in various shapes and sizes). One of the women students, a buxom, freckled English girl, complained about the drawers. 'But I don't want to lose my students from the faubourg Saint-Germain' (where the families of Gleyre's wealthiest students lived), explained Gleyre.

When Monet arrived in November 1862, he cut a dash in well-tailored clothes with fashionable lace cuffs. He responded immediately to the more socially propitious ambience of Gleyre's studio, where there was greater opportunity for showing off than at Suisse's. One of the women students, fancying her chances with the new 'dandy', began to try her luck. 'Sorry,' said Monet, 'I only sleep with duchesses or maids. Preferably duchesses' maids. Anything in between turns me right off.' Gleyre himself came in, to find Monet already on the podium with the model, instructing the students from on high: 'only getting a better look at the texture of the skin . . .'

Gleyre's less rowdy students included Pierre-Auguste Renoir, aged twenty, who had started at the studio that April. He was from a working family and had spent his childhood in housing that bordered on the Louvre, where the artisans lived. His father was a tailor from Limoges. (Renoir later remembered him sitting cross-legged, like a yogi, 'surrounded by rolls of cloth and samples, scissors and little red velvet cushions . . . fastened on his forearm, to stick his needles and pins into'.) He had brought his young family to Paris when Pierre-Auguste and his brother and sister were small children. When Haussmann's demolition began and they were forced out of the rue de Rivoli, they moved to the Marais – the Jewish quarter – and later to Montmartre, where Renoir now lived, renting a series of cheap apartments (at that time, apartments in Montmartre could be rented for next to nothing). He was quite happy to move around Montmartre, believing that 'you always have to be ready

to start out in search of a subject. No baggage. A toothbrush and a piece of soap.'

As a child, Renoir demonstrated his talent by drawing on the floor with tailor's chalk. As soon as he was old enough (thirteen), he started work as a porcelain painter, rendering flowers and profiles of Marie-Antoinette by hand on teacups and vases. He was paid by the amount of crockery he completed and since he was a very quick worker he made good money. By the time he was fifteen he had been able to help his parents buy a small artisan's cottage in Louveciennes, a village in the crux of the Seine's meander, a few miles west of Paris. But with the introduction of new machinery and advances in the mass production of porcelain, the money he had saved began to melt away. He got a job decorating blinds, and by painting lots of clouds was able to turn out sizeable quantities at speed. But he could see that his days as an artisan were numbered. With the support of his brother (a journalist in Paris, and, like all the Renoirs, quick-witted) he decided he wanted to become a professional painter. The family called in a local artist to give his opinion on the boy's work. When he was lavish with his praise, the whole family burst into tears and lamentation, but all agreed they would have to let him go.

Renoir's mother Marguerite was a strong and sometimes stern woman, but she was also very hospitable. Every weekend she made a large casserole and anyone who turned up was invited to her table. Among her regular visitors were the amateur painters Oulleve and Laporte and her daughter Lisa's husband Leray, all of whom advised her that the Atelier Gleyre, affiliated (like Suisse's) to the Académie des Beaux-Arts, was one of the most talked-about studios in Paris. At Gleyre's there would be a regular life model, and since Renoir particularly wanted to practise figure drawing Gleyre's seemed the inevitable choice. Leray helped Renoir buy his first box of paints and an easel, and the boy was on his way. By some accounts, Renoir even briefly attended evening classes at the Ecole itself, where he studied drawing and anatomy, but he disliked the formality of it all and preferred Gleyre's. He always said that 'it was with Gleyre that I really learned to paint'.

Gleyre was cautious when he saw Renoir's work. 'Young man,' he said, 'you are very skilful, very gifted, but it looks as if you took up painting just to amuse yourself.' 'Well, yes,' replied Renoir, 'if I didn't enjoy it, I wouldn't be doing it.' His colour schemes worried Gleyre, particularly his use of a dingy-looking red. 'You don't want to turn into another Delacroix,' he warned. So Renoir painted a nude especially for him, following all the teacher's rules: 'caramel-coloured flesh set off by bitumen as black as night, back lighting on the shoulder, and a tortured

expression on the subject's face, apparently due to a pain in the stomach.' Gleyre was thrilled. But then he thought about it. 'You are making fun of people,' he said.

★

Also at Gleyre's was Alfred Sisley, aged twenty-three in 1862, son of an English merchant and a Frenchwoman. He had been sent to London for four years, to work in the family firm ('Thomas Sisley, Importer of French Goods' – silks, shawls, gloves and paper flowers). There he had been to the National Gallery and seen paintings by Constable and Turner. But he had no head for business, and by the time he returned to the family home in the rue Hauteville, he was determined to become an artist. He lived as a kind of *amateur* (a painter with private means, of which there were many in Paris), and spent his evenings at the Café Mazin, or the Crémerie Jacob in Montmartre.

While he was studying at Gleyre's, Sisley met a young woman living in the Cité des Fleurs – a beautiful, secluded street in the Batignolles, lined with silver birch trees. Marie-Louise Adelaide Eugénie Lescouezec, five years his senior, was sensitive and refined, with a lovely face; Renoir later remembered that Sisley's new friend seemed 'exceedingly well bred'. Her background was uncertain: in some versions, the family's financial ruin had forced her to become a model; in others, her father, a military officer, had been killed in a duel when she was a child. Whatever her background, Sisley fell in love with her, and remained devoted to her from the moment they met. When he moved into her apartment, his allowance from his father was abruptly severed. Marie-Eugénie, like Julie Vellay, took a job working for a florist to help support her penniless artist lover (though evidence suggests that the Sisleys' poverty was probably not so much abject as genteel).

Renoir, Sisley and Monet immediately became friends. There was another student at Gleyre's whom no one could fail to notice (he stood head and shoulders above the rest), and who caught the attention, particularly, of Renoir. Frédéric Bazille was serious and distinguished – 'the sort,' Renoir thought, 'who'd have a valet to break in his new shoes for him.' Bazille (twenty-one in 1862) was the son of a wealthy Montpellier wine-grower, a prominent citizen who owned and managed vineyards, dairies and orchards. Bazille's mother was from a family of prosperous bankers and her brother, Commandant Lejosne, was a military commander, based in Paris. Bazille's parents lived at Méric, an estate on the outskirts of Montpellier belonging to Frédéric's mother and her sister. Frédéric was slow to make friends. As well as being shy and diffident he

was still very close to, and entirely dependent on, his family, who provided him with an allowance to pursue his medical studies at the Ecole de Médecin, which he did reluctantly while also studying at Gleyre's.

Renoir soon ran out of money, and had to take up decorating porcelain again. But both his brother Edmond and Claude Monet encouraged him to go on painting. Renoir and Monet pooled their resources by sharing lodgings, where, between classes, they eked out a living by doing portraits of tradespeople. Monet, always the cute businessman, arranged the commissions. They were paid 50 francs per portrait (though sometimes months would pass between commissions). All their money went to pay for their lodgings, a model, and coal for the stove, which both heated their food and kept the model from freezing. To save fuel, they cooked their beans while the model posed. One of their sitters was a grocer, who provided them with the beans. A sack lasted a month, then they switched to lentils. From time to time, Monet used his charm on the local restaurateur, and they dined out on truffles and Chambertin. Monet still wore the best cloth and lace, and never paid his tailor, who eventually confronted his young student client with his bills. 'Monsieur,' protested Monet, 'if you persist in badgering me like this, I shall have to take my custom elsewhere.' The poor man decided it was worth it, to go on dressing a gentleman. 'A born lord,' said Renoir.

Cézanne was still at Suisse's, where he remained in touch with Pissarro, who introduced him to Monet, Renoir and Bazille the following year, in 1863. In summer 1862 Cézanne sat the entrance exams for the Ecole des Beaux-Arts and failed them, shattering his dreams of academic success and the prospect of finding a patron. But he was still determined to make his way as an artist in Paris and would occasionally turn up at their lodgings, where he was welcomed as a friend. Renoir was fascinated by him: he observed that everything about Cézanne – his personality, his movements, his voice – seemed 'encased in an invisible shell'. One morning Cézanne rushed in with the news that he had found a purchaser, whom he had come across in the rue de la Rochefoucauld, quite by chance. He was walking back from the Gare Saint-Lazare with a landscape under his arm after a day's painting in the country when a young man stopped him in the street and asked to see his work. Cézanne bent down and propped his canvas against a wall, making sure it was in the shade to avoid the light reflecting, and the stranger was delighted, especially by the green of the trees: he could almost smell the freshness, he said. Monet and Renoir listened. 'I said, "If you like it, you can have it",' said Cézanne. Monet and Renoir waited. 'Well, he can't afford to pay me, but he's taken the painting, I insisted.'

★

Meanwhile Bazille had gradually made friends and begun to adjust to the demands of bohemian living. He was soon writing home that there was 'a great difference between the kind of life I lead now and the one I led last year with my old friends in Montpellier'. His mother appeared to have underestimated the amount he would need to live on. With his paints and canvases, medical books and laundry (where his shirts were being shredded and all his buttons had disappeared) he needed more money. He also needed a studio. One of his friends, a student called Villa, had found one on the rue Vaugirard (skirting the Jardins du Luxembourg), but at 600 francs he could not afford it by himself. Bazille wanted to join him. It was impossible to make progress simply by studying at Gleyre's, he told his parents: he needed to be able to draw at home as well, and it was impossible in his cramped lodgings. His other friends were Renoir, Monet and the Vicomte Lepic, son of the Emperor's aide-de-camp, who had entered Gleyre's to 'improve' himself and was one of his illustrious students from the Faubourg Saint-Germain. Lepic also had his own studio. Bazille was a conscientious student, with some good ideas. He earned one of Gleyre's rare compliments when he came up with the idea of making a sketch of the model in actual size.

The winter of 1862–3 was mild, often cloudless, and by spring everyone was in good spirits, working hard preparing for the Salon. This was optimistic; the students were inexperienced and, except by association with Gleyre, completely unknown. But they were all extremely ambitious, and this year a new restriction had been introduced: artists were invited to submit three works only, which seemed to mean an increased chance of a newcomer's work getting through. The sun was already shining, and on sunny afternoons Bazille and Renoir wandered together through the Luxembourg Gardens, admiring the colours of the spring flowers against the grey stone rims of the borders. This was the kind of thing he wanted to paint, Bazille told Renoir, as they passed a baby crying crossly in its pram, while its nurse, behind a tree, flirted with a soldier: glimpses of ordinary life. 'The big classic compositions are finished,' he said; 'an ordinary view of daily life would be much more interesting.' As they walked, they came up with a plan: why not form a group of artists, to band together people with similar ideas? Monet agreed. He had begun to find Gleyre frustrating: he was essentially traditional, with no real interest in the natural world. One morning at Gleyre's Monet declared that he had finally seen the light: 'truth, life, nature – everything that moved him – clearly did not exist for Gleyre'. As Easter approached,

the studio began to seem stifling. 'Let's get out of here!' he said, one afternoon. They all thudded downstairs and made for the Gare Saint-Lazare.

Cézanne and Zola were already in the habit of escaping to the countryside at weekends, leaving on the first train every Sunday morning, weighed down with easel, paints and stools. They got off at Fontenay-aux-Roses and cut across country to the Loups Valley as far as the Chalot or 'Green' pond, slimy with rushes, where they spent long, lazy days reading and painting *en plein air* (in the open air). Monet, Renoir, Bazille and Sisley began to follow suit.

They took the train as far as Melun, to the north of the forest of Fontainebleau. From Melun they walked to the neighbouring villages of Chailly and Barbizon (thirty-four miles from Paris), on the north-west side of the forest. This was not new territory for artists. The preceding generation of French landscape artists – Millet, Rousseau, Diaz, Corot – had congregated around Barbizon (Millet and Rousseau had both lived there), painting the softly lit landscapes, farm tracks and the peasants at work in the fields. Pissarro was already in the habit of painting out of doors, although like the Barbizon painters, he finished his works in the studio. The following summer, in 1863, he met Monet again (whom he had not seen since Monet left Suisse's) and joined the emerging group.

Arriving in the village of Barbizon at Easter 1863, Gleyre's students decided to have lunch in a place they found in the Grand Rue, the Restaurant des Artistes – we might have known, commented Renoir. They were fed rotten eggs by an old peasant granny, an incident which drove them onwards to the next village, Chailly, a mile and a half away, which looked out over the same stretch of forest, Bas-Bréau, with its ancient oaks and beeches. 'Certain parts of the forest are truly wonderful,' Bazille wrote home to his mother, 'we can't even imagine such oak trees in Montpellier.' They put up at the two local inns – the Lion d'Or and the Cheval Blanc, across the street – then made their way into the forest. A week later they were still there, Bazille writing home that 'Monet from Le Havre', who was quite good at landscapes, was giving him very helpful advice.

The vast forest of Fontainebleau, covering 62,000 acres of crags and woodland, was a popular destination for shopkeepers, apprentices and dressmakers on their Sunday afternoons off. In the early 1840s, when the Barbizon painters first began working there, it was a wild, mysterious place with vast, craggy rocks. They occasionally saw stags, hinds and wildcats. But since the coming of the railway in 1849 it had become a favourite place for outings and picnics. Workers on holiday flocked from

Melun now that the journey was easy: it was an hour and a half by train from Paris, and only three francs, sixty-five. On Sundays, the painters were surrounded by courting couples, crowds of picnickers and other revellers. One day, oblivious to his surroundings, Renoir suddenly found himself the butt of a mocking group of milliners and their beaux. The girls tried to poke his eye out with their parasols, and one of the men kicked his palette off his thumb, to a roar of mocking laughter. All at once, as in a dream, the bushes parted and a huge man with a wooden leg limped to the rescue. He waved his stick at them until they all ran off. As Renoir thanked him, the stranger stopped to look at the canvas. 'Good, good,' he nodded. 'But why do you paint so black?' It never hurt Courbet to use black, said Renoir. The man pointed to the shadows of the leaves and the trunk of a tree. Even these caught the light, he said. 'Bitumen is finished! Lighten up your palette!' Realising he was talking to a painter, Renoir asked the man's name, and the Barbizon painter Diaz introduced himself. It was a defining moment for Renoir, who decided that from now on he would take the risks with colour which Gleyre had always tried to discourage.

After they had explored Chailly, the painters moved on to the next village, Marlotte, where at 37, rue Murger, Mère Anthony kept her famous inn, Le Cabaret; here her daughter Nana waited at tables and flirted with the guests. At weekends, the place could be rowdy: there were noisy parties with guitar music, plate-smashing, and sometimes even a knife fight. But on weekdays the painters went there to eat and talk. Renoir painted the scene, Monet and Sisley standing grouped round the table, with Toto the lame dog at their feet and a newspaper doubling up as a tablecloth. With them was a local painter, Jules LeCœur, whose companion, Clemence Trehot, had a younger sister, a dark, sultry, exotic seventeen-year-old, called Lise,[*] whose charms Renoir succumbed to. It was not just him, said Renoir, Sisley was just as bad, he could never resist a pretty girl. He and Renoir would be walking along the street, talking about the weather when suddenly – no more Sisley: 'I would find him charming a young lady.'

In April 1863 the jury's decisions were announced. Of the group of friends at Gleyre's, only Renoir had been successful. He had exhibited *La Esmeralda*, a sentimental depiction of a peasant girl and her goat; he now destroyed it in disgust. But Monet, Sisley and Bazille were not the only disappointed painters around. That year, 2,800 pictures were rejected. The jury accepted 5,600 paintings, but these represented the work of just

---

[*] Not to be confused with Lisa, Renoir's sister.

988 painters (compared with 1,289 painters in 1861). The works accepted comprised only the most popular artists and same old, perennial subjects. Since exhibiting work at the Salon was the only way to bring it to the attention of prospective purchasers, the rejected artists were furious. Painters everywhere were up in arms; the Café de Bade buzzed with indignation.

But it was an election year and the Emperor did not want to run the risk of jeopardising votes. The roar of dissent at the Académie had political implications: the perpetuation of the same old standards and prioritising of existing members meant that the art world was favouring its tried and tested artists at the expense of new talent. Jury members voted for their friends, and established painters went on making money, creating no new opportunities for new painters to find patrons or purchasers. Thousands of aspiring young artists were effectively blocked from making a living.

Napoleon III, though he claimed an interest in the arts, could see that he ran the risk of being perceived as repressively conservative and dangerously undemocratic. Seeing the scale of the discontent, he decided to take steps. On 22 April the Emperor himself, accompanied by his equerry, appeared at the Palais de l'Industrie, demanding to be shown everything that had been submitted, whether accepted or rejected. He sent for the 'too-handsome Nieuwerkerke', the Minister of Fine Arts (rarely seen without the Emperor's niece, Princesse Mathilde, on his arm). The Minister was nowhere to be found, so Napoleon made his own announcement. At first, he called for all the pictures to be re-judged, but he was hastily advised that if this happened, the entire hanging committee would resign. He therefore published a notice in the *Moniteur*, announcing an unprecedented democratic gesture: he would allow the public to be the judge of the nation's art. An exhibition of all the rejected works would open, a fortnight after the Salon itself, on 17 May. This Salon des Refusés was nicknamed 'The Emperor's Salon'. When the *Moniteur* arrived on the news-stands, there was a huge wave of excitement.

The Salon des Refusés was held at the Palais de l'Industrie, in rooms adjoining the official Salon, separated from it only by a turnstile. The public approached with gleeful, macabre fascination, like – so it was said – a crowd waiting to enter the Chamber of Horrors. Top hats and crinolines, parasols and gold-tipped canes were jostled and pushed around as everyone pressed forward to get a view of the large numbers of exhibits. The catalogue listed only 781, though there were many more. The artists included Cézanne, Pissarro and Whistler, whose *White Girl* was among the successes of the show. The *Refusés* promised 'spice, inspiration, amazement', and no one was disappointed. The crowd was ready for it.

The new audience was commercially prosperous, had ready money, and was eager to spend it. They expected tasteful art from the Salon, and though the word on the Emperor's Salon was that the rejected work had shock value, nothing could have prepared them for some of the things they saw.

On the first day alone, the Salon des Refusés attracted more than 70,000 visitors. The crowd exploded in indignation, hooting with laughter and jeering at the paintings. They saw pictures of disproportionately large trees, apparently unfinished forest scenes, and paintings with no proper framing devices. Images reared up, with no proper foregrounds or backgrounds. There were figure paintings of people who looked like pigs, and crowd scenes with no story. Shock waves spread through the rooms. In the newspapers, cartoonists had a field day representing spluttering fat men pointing with their canes, and pregnant women having to be removed bodily from the scene. Napoleon had surely been right to suppress these horrors. But one painting completely stole the show. In the farthest room hung a work that seemed, the critics said, to explode from the wall: 'the sharp and irritating colours attack the eye like a steel saw,' wrote Jules Claretie in his review. Beside its vivid colours, all the surrounding paintings simply looked like pale imitations of Old Masters. This was something else. All those who saw it were stopped in their tracks.

Edouard Manet, who had exhibited at the Salon before, was this year exhibiting a monstrosity. Everyone stared in horror at Le Déjeuner sur l'herbe, an outrageous depiction of a naked woman, brazen and unashamed, staring straight out at the viewer and seated on a riverbank between two clothed men. Behind her, a second, lightly draped woman, up to her ankles in water, stoops in the distance. This bold display was shocking enough in itself, but what really astonished the public was the modernity of the scene. The men were grouped casually, in modern dress: the painting seemed to be about the present day. Though Manet's painting was based on an engraving by Raphael, and took its subject matter from Giorgioni's Pastoral Symphony, these references passed completely over everyone's heads. That was the problem: the painting looked so real. The crowd was shocked to the root. It might have been even more scandalised to know that the nude, one of Manet's regular models, was Victorine Meurent, a working-class woman from Montmartre, and that the men were modelled by Manet's younger brothers. The painting was seen as an obscene, provocative taunt, doubly shocking by virtue of its ordinariness. In fact, Manet's intentions were artistically honourable. He had simply substituted a modern group for an idea he had taken from classical painting. All he wanted, moreover, was success and public

approbation. But this painting was certainly not going to earn him the accolade he craved. The critics who could bear to look criticised the work not only for its immorality but for the 'brusque and sharp contrasts' of the colours, complaining that Manet appeared to have no sense of harmony, light or shadow. Not content to dispense with half-tones, he contrasted tones with double or treble intervals: the colours were brash and harsh, the effect – especially to the untrained eye – garish and jarring.

Gleyre's students all gathered at the Salon des Refusés to look at *Le Déjeuner sur l'herbe*. Bazille already knew of Manet, through his uncle and aunt, Commander and Madame Lejosne, who moved in Manet's social circles, while Claude Monet had met Gustave Manet. Monet now realised that Gustave must be the brother of the notorious painter. Nevertheless it would be another two years before their paths crossed with his. Although Manet already had something of a following, for the jeering crowd at the *Salon des Refusés*, the man who had painted *Le Déjeuner sur l'herbe* could barely be imagined. There was plenty of speculation: he was presumably a dissolute, greasy-haired bohemian who lived in a sordid attic, a man of no taste and no *standing*. In fact, this could not have been farther from the truth.

Manet was a complex character. Totally at home in the cafés, and a familiar *flâneur* in the streets, he was a true Parisian. His father was a *Chevalier de l'Ordre de la Légion d'honneur*, Judge of the First Instance of the Seine (he held court at the Palais de Justice, adjacent to the building where Suisse kept his studio), and Manet's mother was the god-daughter of the King of Sweden. Manet spent his childhood in the heart of Saint-Germain-des-Prés, at 5, rue Bonaparte, in the first floor apartment of a large building with an imposing gated courtyard, with the Ecole des Beaux-Arts on the other side of the road. (In 1855, when he was twenty-three, the family had moved to 69, rue de Clichy.) The Manets were wealthy and influential; they owned large areas of land in Gennevilliers, an increasingly wealthy suburb of Paris near Argenteuil, where as children, the little Manet brothers spent their summers in the countryside.

At school Manet did not excel. When he left, Judge Manet persuaded him to enter the Ecole Navale. Aged seventeen, as a sailor on the crew of *Le Havre et Guadeloupe*, he sailed to Rio. On board ship, he lay on deck and watched the extraordinary skies, great, changing swathes of vivid colour. The ship docked in time for the Rio carnival, with wild music and dancing in the streets, irresistible African slave women and gorgeous Brazilian prostitutes, one of whose charms he succumbed to. By the time he returned to Paris, he had decided that the sailor's life (despite its off-duty advantages) was not for him; he wanted to be a painter. Judge Manet

wanted him to enter the Ecole des Beaux-Arts, but this was too
conservative a route for Manet. He went instead to the allegedly more
radical studio of Thomas Couture, the historical and genre painter, and
grew frustrated and bored. He disliked Couture (as Monet had), and
showed it. While the other students dutifully copied from the antique,
Manet sketched the statue upside-down. He hated the claustrophobic
atmosphere of the studio. He couldn't imagine why he was there, he
complained to his childhood friend, Antonin Proust. He found everything
absurd; the light and the shadows false. It felt like a tomb. He realised that
they couldn't undress a model in the street, but after all, he told Proust,
there were fields, and surely in the summer they could make studies from
the nude in the countryside, if the nude was the be-all and end-all in art.
For a while, he went to Suisse's, but he soon tired of that too, and spent
most afternoons in the Louvre, studying the Old Masters. When Judge
Manet saw that his son was serious he helped to set him up in his own
studio in the rue Guyot, on the western side of the Batignolles, near the
parc Monceau. (When the Judge died, in 1862, each of the Manet
brothers inherited a substantial fortune.)

In 1863 Manet, at thirty-one, was elegant and seductive, with golden
hair (receding since he was seventeen), a fashionable silky beard,
penetrating, deep-set eyes and an alert, nervous step. Broad-shouldered
with a slim waist, impeccably dressed in the latest tight-fitting trousers,
lemon suede gloves, top hat and chic, slip-on shoes, he walked with a light
cane and a suggestive swagger. Urbane and charming, he was the talk of
his circle, which included established Salon artists such as the engraver
Félix Bracquemond and painters Zacharie Astruc, Alfred Stevens and
Fantin-Latour, to all of whom he was a valued friend. Though he was
witty and mischievous, he had never been known to be ungenerous or
unkind. Women adored him; even men swooned in admiration when
Manet entered a room. Antonin Proust willingly admitted that 'few men
have been so attractive'. In his studio, he painted surrounded by admirers,
talking all the time, making broad, scintillating brush strokes, flinging back
his long, curly hair. When he entered a café, heads turned. Manet loved
the life of the streets and adored café society. Pigalle, noisy with cafés, bars
and restaurants, was where he loved to be. He lunched every day at
Tortini's on the boulevard des Italiens, and at five o'clock appeared again
in the Café de Bade. This district, at the foot of the *Butte* – hillside – of
Montmartre, was where for half a century writers and artists, diplomats
and financiers had gathered. Towards six o'clock, the women would
appear in a rustle of silk and a cloud of musk or patchouli, gleaming with
jet and brocade, their hair in magnificent chignons beneath feathered hats.

In the Café de Bade, Manet held court with his distinctive, cracked voice, which the Goncourt brothers, waspish journalists and brilliant chroniclers of their age, found unbearable, but which women clearly adored. He was popular, loyal and endlessly sociable, though in private he could sometimes fly off the handle. One friend called him 'the spitfire'.

The previous year, in 1862, he had painted the crowd at one of Napoleon III's twice-weekly musical concerts, in the court gardens of the Château of the Tuileries. Men in tight, striped trousers and women in gigantic hats and elaborate parasols gathered on wrought-iron chairs, or circulated from group to group discussing the latest news – the new shops in the boulevard des Capucines; Wagner's latest performance at the Salle des Italiens. In the foreground of *Music in the Tuileries Gardens* sits Madame Lejosne, wife of Commander Lejosne, her staggeringly plain features barely softened by the veil of her hat. In his work, Manet exhibited his harsher side: his vision was unflinching, and his taste for stark colour contrasts meant that many found his work abrasive to the eye. He exhibited *Music in the Tuileries Gardens* at Martinet's shop, where all who saw it observed that it had no conventional framing devices, the colours seemed to clash, and it had no proper subject: where was the battle, the tragedy, the shipwreck, the parable, the sentimental child? Also in this painting, the poet Baudelaire appears. Manet met him at one of Madame Lejosne's soirées, and they discovered an instant, mutual affinity.

Both Manet and Baudelaire were compelled by the changing streets of Paris, and fascinated by the people whom Haussmann had not quite succeeded in squeezing out: the tramps and rag-pickers who poked about in the remains of the fast-disappearing medieval city. These people were Paris's history. They roamed the dimly lit alleys of Pigalle and the shanties which still bordered the district of Clichy. The rag-pickers intrigued both artist and poet; Manet's paintings of them were inspired by Velázquez's portraits of the 'low life' of seventeenth-century Spain. Manet adored the Spanish artists, and used Velázquez's colour schemes – black, white and pink. Though he did not visit Spain until 1865, he had seen the Spanish Old Masters in the Louvre, and his fascination with them had already earned him the nickname 'Don Manet y Courbetos y Zurbaran de las Batignolas'. In his best work, he painted dazzling surfaces with shining, vivid brush strokes, and hinted – in a facial expression, the turn of a head or foot – at the complexity of human psychology. His portraits of *The Old Musician* and *The Absinthe Drinker* – a man in a battered top hat slumped against a wall, his empty bottle rolling away from him – had both been inspired by Velázquez. But Manet's public was slow to appreciate these depictions of modern life. He was at home with Baudelaire when news

came that *The Absinthe Drinker* had been rejected by the Salon. Never mind the Salon, 'you've just got to be true to yourself', said Baudelaire. He *was* being true to himself in *The Absinthe Drinker*, he protested.

Manet met Victorine Meurent, the twenty-year-old model for *Le Déjeuner sur l'herbe*, in the corridors of the Law Courts, possibly as she was on her way to or from a hearing before the Judge. Attracted by her bold stare and coarse beauty, he painted her a number of times. *The Guitar Player*, in which she posed eating cherries from a brown paper bag, her guitar under her arm, had won him an honourable mention at the Salon. In 1862, when the Spanish National Ballet appeared at the Paris Hippodrome, Manet found another inspiring model. Principal dancer, Lola de Valence, dark, exotic and androgynous, stamped her foot, raised her arms and rattled her castanets with unmistakable eroticism. Manet borrowed his friend Alfred Stevens's enormous, lavish studio to paint her portrait. Paintings of Lola were acceptable to the Salon since the realism of the Spanish National Ballet was undeniable, but the jury's reaction to *The Absinthe Drinker* still rankled. In the summer of 1862, the year his father died, Manet was lazing on the riverbank with Antonin Proust one Sunday afternoon, watching a group of bathing women emerge from the water. 'So,' he drawled, 'they'd prefer me to do a nude, would they? Fine, I'll do them a nude.' In Couture's studio, he had already copied Giorgione's *Women with Musicians*. 'I'll re-do it, with a transparent atmosphere, like those women over there. Then I suppose they'll really tear me to pieces. They'll tell me I'm just copying the Italians now, rather than the Spanish. Ah well, they can say what they like.' The result was *Le Déjeuner sur l'herbe*, now hanging in the Salon des Refusés, the butt of a mocking crowd.

# CAFÉ LIFE

*A conversation with Degas would see Manet sweeping out dramatically . . .*

STUDYING IN THE LOUVRE ONE day in 1863, Manet met Edgar Degas, a twenty-eight-year-old painter who also frequented the cafés and bars of Pigalle. They were soon meeting regularly in the Café de Bade. By spring 1863, Degas had also become disillusioned with the Salon. He had exhibited for several years, but this year the Salon had accepted only one of his works, a small historical scene, which they had mistakenly described as a pastel and hung in a dark corner where it could barely be seen. When he met Manet, Degas was still working very much in the classical tradition, making academic studies of Spartan boys at their exercises. In 1855, aged twenty, he entered the Ecole des Beaux-Arts, but like Manet, he quickly became disillusioned and now worked on his own. Unlike Manet, however, his approach to painting continued to be rigorous and academic. He worked long hours in the *Cabinet d'Estampes* (the Print Room), copying from the Old Masters. Essentially, however, he was an original, primarily a colourist. In the notebooks he kept daily, he jotted down ideas for compositions, always highlighting his thoughts about colour: for *The Daughter of Jeptha*, 'pinkish and bluish draperies on neutral grey grounds and black cypresses . . . The red of Jeptha's dress . . . some reddish brown, some slightly pinkish . . . Graduated blue sky . . . the ground at the front a grey-violet shadow . . . Look for some turquoise in the blue . . .' He was fascinated by the tension between art and artifice: 'draw a straight line askew, as long as it gives the impression of being straight'. He was impatient with conventional poses, and drawn to the real: 'do portraits of people in their familiar, typical poses . . . So if the smile is typical of the person, make them smile.'

Degas was dark and aquiline, with soulful, hooded eyes. Italian by birth, he was the son of a prosperous Neapolitan banker, Auguste de Gas, and a

Creole girl, the beautiful Celestine. She was nineteen when Degas was born, and had seven more children, five of whom survived, before she died, aged thirty-two. She was gorgeous, impulsive and exotic, a real Creole belle, with melting eyes, ruffled skirts and a rose in her belt. (All his life, Degas distrusted the scent of women's perfume and hated flowers.) Though Celestine had also managed to fit into her short life a long, serious affair with Auguste's younger brother, her husband was devastated by her death. He spent long hours by himself, listening to Italian music and listlessly playing the piano. Degas was thirteen when his mother died, and still at school at the Lycée Louis-Le-Grand, on the rue Saint-Jacques. Though his teachers sometimes found him lacklustre and withdrawn, he made friends he would keep all his life. They included Henri Rouart, Ludovic Halévy and Paul Valpinçon, whose father Edouard was a collector and friend of Ingres. Degas spent his summers at their country estates – the Valpinçons' estate, Menil-Hubert, was close to the provincial racecourse at Argentan in Normandy. When Degas left school at nineteen, on 27 March 1853, he began to study for the law but his passion was painting, and by 7 April he already had permission to copy at the Louvre. When he announced that he wanted to become a painter, his father made no comment. In 1854 he abandoned his legal studies and enrolled in the studio of Louis Lamothe, a pupil of Ingres, where he learned the importance of drawing and his lifelong respect for the Old Masters.

Though Degas was a great talker and *boulevardier*, completely at home in the streets, bars and café-concerts, his mannerisms were more studied, his delivery more archly, exaggeratedly Parisian than Manet's easy style. Degas saw talk as a kind of commerce – through verbal sparring, you scored social points – and Manet indulged his thirst for endless repartee. Degas developed a reputation as a great wit, and his sayings were remembered and repeated. But though he loved the life of the streets, he was shy and essentially a loner. His studio was sacrosanct and he worked entirely in private. No one was allowed to enter, let alone to watch him as he worked. Social gossip was fine, even *de rigueur*, but he hated empty, uninformed gossip about art – 'anyone would think paintings were made like speculations on the stock market, out of the frictions of ambitious young people'. That kind of talk was merely a form of trading; it 'sharpens the mind, but clouds your judgement'. He worked in his studio from morning until night; his life, someone said, was as regular as a musical score. 'I assure you,' he said, when asked about his technique, 'no art is less spontaneous than mine. What I do is the result of reflection and study of the Old Masters. I know nothing about inspiration, spontaneity,

temperament.' His models were subjected to the same degree of rigour: he would never have thought of flattering and wooing them as Manet did. When he looked at a girl he saw flesh, bone, braced muscle, ligaments in tension. 'Is that supposed to be my nose, Monsieur Degas?' asked one. 'I've never had a nose like that.' She was pushed out into the street, her clothes thrown after her. But when he told another model that she had a backside like a pear, she went around boastfully repeating the compliment.

Degas never seemed quite at ease with women. (Manet, fascinated by this, once mischievously started a rumour that Degas must be sleeping with Clotilde, his young, attractive housemaid. When questioned, she reported that she had once entered his bedroom while he was changing his shirt. He had shouted, 'Get out, you miserable creature!') He always said he had no desire to marry. 'What would I want a wife for? Imagine having someone around who at the end of a gruelling day in the studio said, "that's a nice painting, dear."' The glamorous, bejewelled women with bare shoulders and plunging necklines, hauled by their husbands from salon to opera box then on to some glittering dinner party, dismayed him. He felt a particular horror for the necks and shoulders of women past their prime. Seated next to one such lady at dinner one evening, he told his friends she had been practically naked, he could not take his eyes off her. Suddenly turning towards him, she had asked, 'Are you staring at me?' 'Good Lord, Madame,' he replied, 'I wish I had the choice.' In his studio, he hid himself away, reluctant to be interrupted, completely unsociable until the end of the afternoon. 'The artist must live apart,' he believed; 'his private life should be unknown.' If the work was going well, he could sometimes be heard singing a little song to himself, his voice drifting out on to the staircase. One of his favourites went, 'I'd rather keep a hundred sheep / than one outspoken girl.'

<p style="text-align:center">★</p>

With *Le Déjeuner sur l'herbe*, Manet made a far greater impact at the Salon than if he had won the prizes he craved. From now on he was known throughout Paris, a glamorous and risqué addition to every hostess's dinner party. He gave Commander Lejosne the first version of *Le Déjeuner sur l'herbe*, and the Commander hung it in his drawing room, where it could be seen by all the artistic, literary and political figures of the day. For Gleyre's students, Manet's reputation was something to aspire to: for the time being they were aware of him only as a kind of artistic celebrity; a remote, inspiring rebel. But he was central to the feeling that new, radical standards were being set. In the autumn, Monet, Sisley, Renoir and

Bazille returned to Gleyre's for the new term. Bazille and his friend Villa had found the perfect studio, due to become vacant in the New Year. It even had a patch of garden, with a peach tree and lilacs. Bazille told his father he could already see himself out there, painting from the model in the sunlight. 'It always hurts me, I assure you, to be a drain on you . . .' He promised to be frugal, made time for a social call to Commander and Madame Lejosne, and Monsieur Bazille paid the deposit.

Manet was out of town that October. He had rushed off, mentioning to only a few close friends that he was leaving for Holland. 'When he comes back,' Baudelaire told a mutual friend in astonishment, 'he'll be bringing his *wife*.' Though less than ten years older than Renoir, Monet, Sisley, Bazille and Cézanne, Manet already had a complex past. Twelve years previously, in 1851, while he was still studying at Couture's, he had fallen in love with the Dutch girl who came to the Manets' house to teach the boys to play the piano. Suzanne Leenhoff was beautiful and serene, a blue-eyed blonde with a fair complexion, delicate fingers and a Rubenesque figure. Antonin Proust remembered noticing at the time that Manet suddenly seemed to be more good-looking than ever, but even Proust knew nothing of Manet's secret. Manet was secretly visiting Suzanne in her lodgings in the rue de la Fontaine-au-Roi; by April 1851, she was pregnant. Unsure what to do, Manet was certain of one thing: Judge Manet must never find out. Illegitimacy was all very well in Montmartre, where it was an everyday occurrence. But an illegitimate child would have been far from socially acceptable for a judge's son.

Manet confided in his mother, with whom he had a close relationship, and Madame Manet devised a cunning plan. Suzanne's mother was informed. She promptly left Holland for Paris. The child was born on 29 January 1852, and registered 'Koella, Léon Edouard, son of Koella and Suzanne Leenhoff.' Some say Koella was a made-up name; other sources give it as Madame Leenhoff's maiden name. Either way, the child was thus registered, with his father's Christian name, as his mother's son. But he was presented in society as Suzanne's brother, the last-born son of his grandmother, Madame Leenhoff.

Suzanne, her mother and baby Léon settled in the Batignolles, in the rue Saint-Louis (now the rue Nollet), and Manet began a double life, continuing to present himself socially as the eligible son of Judge and Madame Manet, but secretly spending most of his free time with his new family. Paradoxically, the only way for Manet to protect his relationship with his son was to deny his parenthood; it is an indicator of Manet's personality that he apparently pulled this off with complete sang-froid, and kept up the duplicity for ten years, until Judge Manet's death in 1862.

On 6 October there was a small family party. Manet's and Suzanne's brothers all met in the Batignolles, and eleven-year-old Léon was given a few hours' holiday from the Marc-Dastes School, to attend. Then he was taken back to school by Eugène Manet and Ferdinand Leenhoff, while Edouard and Suzanne left for Holland, where they were married in Zalt-Brommel on 28 October. Madame Manet signalled her approval by adding 10,000 francs, 'as an advance on his inheritance', to the 9,000 francs Manet had inherited from his father's estate, to which that summer he had added his share of the sale of some twenty-five acres of the Manets' Gennevilliers property. When they returned to Paris, he and Suzanne set up house with Léon in an apartment at 34, boulevard des Batignolles. Manet was devoted to Léon, who remained close to his 'sister' and 'godfather' all his life. The true story of Léon Koella's identity never came to light. Speculation has raged, especially among art historians and biographers, ever since. If Madame Leenhoff's maiden name was Koella, Madame Manet may have invented an ingenious double-blind, effectively diverting the suspicious from dwelling on other, more scandalous possibilities closer to home. Some have even darkly alluded to a family rumour that the child was actually Judge Manet's. In that case, perhaps the son (unwittingly) seduced the father's mistress. Thanks to Madame Manet's ingenious intervention, no one will ever know.

<center>★</center>

In January 1864, Bazille and Villa moved into their new studio, and Bazille began to look for cheaper lodgings. Though Bazille now had a studio of his own where he could continue his work in the evenings, he was still keen to continue at Gleyre's in the daytime. However, the teacher's studio was under threat. Gleyre was ill, in danger of losing his sight, and short of funds. His students were very sorry, as they were fond of him, and nobody wanted to leave his studio. But there were other places, Bazille assured his parents – 'free' studios, like Suisse's, where there was no tuition, though students paid a small fee to attend the studio and work from the model. He planned to enrol in one of these if Gleyre was forced to close. (The studio was formally closed in July 1864.)

Meanwhile, perhaps to divert themselves from the sad prospect, the students were staging a ballet of *Macbeth*, with Bazille in the role of *danseuse*. 'You may be interested to know,' he wrote home to his father, 'that a *pas de deux* was incorporated into the big banquet scene. I had a costume of pink *lustrine* made, a blouse and a very short skirt, and an undershirt of stiff muslin, the kind used by decorators to back wallpaper.

Someone lent me silk tights, dancer's shoes, and fake necklaces and bracelets, which looked stunning. Needless to say it was a tremendous success. Our posters and invitations are going to be published in a small magazine. I will send you our caricature.' His mother sent him a box of shirts, and encouraged him to visit Madame Lejosne.

He spent Easter at home in Montpellier, preparing to take his medical examinations for the second time. In late March he returned to Paris, where he failed them again. When he finally found the courage to break the news to his parents, he assured them that he was consoled by the great progress he was now making with his painting, working all day either at Gleyre's or on his own. Monet, who had spent Easter at Chailly, now suggested Bazille accompany him for a fortnight's stay in Honfleur.

They left Paris in late May, stopping off first at Rouen to explore the medieval streets and see Delacroix's painting in the museum. They continued by steamboat to Honfleur, where they rented two rooms from a baker, and immediately began to scour the countryside for subjects. 'This country is paradise,' Bazille told his mother. 'Nowhere could you find more lush fields with more beautiful trees. Cows and horses roam freely everywhere.' Honfleur, with its sweep of high, narrow Norman houses with wooden façades, built around the port, was well known to Monet from his childhood. He led Bazille through the narrow, hilly, cobbled streets up into the hillsides, past large villas in verdant gardens and on into the open countryside, where you can look down past cultivated terraces, to the harbour. Here Widow Toutain, *une vaillante femme*, kept a farm with barns and land, the Ferme Saint-Simeon, which had become a kind of *hôtellerie* for penniless artists looking for a bed of straw, a bowl of cider or a plate of fresh shrimps. In the fresh, clear, Normandy air, with a dazzling view of the water below, they painted from five in the morning until eight in the evening.

When in June Bazille returned to Paris to re-take his examinations, Monet remained in Honfleur. In mid-October he visited his family at Saint-Adresse, but a fierce argument broke out over the debts he had run up in Honfleur. For the next two months he sent repeated appeals to Bazille for money. In December Bazille told his parents he had been running up some bills; he would come home for Christmas as soon as they sent funds – if possible, enough to cover his debts. They responded with characteristic generosity and by the end of the month Monet was back in Paris, bringing with him a sizeable collection of new work.

★

Spring 1865 brought days of seemingly endless rain. Monet, having submitted his seascapes to the Salon, was by April back in Chailly, where he stayed at the Cheval Blanc, one of the two village inns. His work in the forest was being hindered by the bad weather, but this time he had a companion, Camille Doncieux, a quiet, pale-skinned, dark-haired girl he met in the Batignolles. She lived there with her parents, until Monet whisked her away to the Cheval Blanc, where the couple sheltered from the incessant rain and ran up bills they had no hope of paying. When the proprietor pressed them, they made a midnight flit across the road to the Lion d'Or, and began running up bills there instead. The rain eventually stopped, and Monet took his painting things into the forest. As soon as he began to work, he was stopped in his tracks by a bizarre accident. Discus throwers used to practise in the forest, and Monet was injured when a flying discus hit him in the leg. Again, Bazille was summoned, this time for his medical expertise. Using a large earthenware pot, which he suspended from Monet's bed with a chain, he improvised a drainage system for the suspended leg. Nursed by Bazille, who painted the scene, Monet was soon back in the forest.

Bazille was still doing his best to pursue his art while attempting to please and placate his anxious parents. In early 1865 he painted a still life with flowers as a gift to Madame Lejosne, and sent it to the Salon to please her, along with two paintings of Méric. To his parents, he sent a clutch of unpaid restaurant bills, and a confession that his finances were not in good shape. He explained that it was only during his first two years in Paris that he had spent more than he should: 'This Lequet restaurant was my only creditor.' He had borrowed money, overspent, and now intended to borrow at 5 per cent interest the amount owing. But this month, of course, he would also have to find the rent for his studio in the rue de Furstenberg, a location in Saint-Germain-des-Prés, near the Deux Magots, facing Delacroix's studio on the opposite side of the square. Furthermore, he did not see the point this year of spending the summer months, as usual, at home in Méric. He was looking for a pretty model – clothed, of course – vital for the progress of his art, and did not want to try to exhibit in Montpellier: 'the appreciation of a few locals doesn't really mean much to me'. His father, furious, asked him to account for every penny he had spent.

Bazille's paintings were accepted. In fact, the Salon jury showed an extraordinary broad-mindedness that year. After the drama of the last exhibition, in 1863, its members seemed to have decided to open their doors to new work. Cézanne, who had sent some 'fine' landscapes, hoping to 'make the Institute blush with rage and despair', was

disappointed, but works by Renoir, Pissarro, Sisley, and one seascape by Monet all got through. Also accepted was a small work on paper by Degas, *War in the Middle Ages*, which again, to his great annoyance, was wrongly described and badly hung. He resolved that this would be his last history painting. The first medal of honour went to Cabanel for – in Bazille's opinion – his 'terrible portrait of the Emperor'. Monet's painting was noticed, and received a fair amount of attention from other painters. But once again, the *succès de scandale* was by Edouard Manet.

The Salon of 1865 went down as a 'triumph of vulgarity' with Manet's infamy making him the star of the show. Though young, groundbreaking painters were well represented that year, everyone lined up to jeer at Manet's latest provocation, *Olympia*. That it got past the jury at all was somewhat surprising, but perhaps this time the members had done their homework and recognised it as a modern variant of Titian's *Venus of Urbino*. This time, Manet's painting seemed flagrantly provocative. It showed a naked courtesan brazenly arranged on a bed, attended by a black female servant bearing a large bouquet of flowers, presumably a gift from a client. The symbolic touch was added by a small black cat (a symbol of lewdness in art), its tail suggestively raised, the significance of which was not lost on the viewers. Olympia was pale, scrawny and – the ultimate outrage – clearly empty-headed. She stared cynically at the viewer, outrageous, awesome, dangling one yellow mule from her left foot, her other shoe abandoned on the bed. This was clearly a professional, she had no need to be alluring, she was simply doing her job.

The crowd, confronted with blatant prostitution, was horrified, perhaps because for many, the scene was shamefully recognisable. There were some 5,000 registered and a further 30,000 unregistered prostitutes in Paris at the time, who serviced a large proportion of the male middle classes in the *maisons closes*. Unlike the miserable, empty rooms where the poor paid a wretched girl for a few minutes, or the private arrangements in which kept women, lavishly attired, serviced the rich, the *maisons clos* were well-trodden territory for the male bourgeoisie. They consisted of rooms, ornately and ostentatiously furnished, where middle-class men went to take tea, read the newspapers and relax. If they wished, they could adjourn to an inner chamber – such as the one Manet here depicted – where their courtesan would be waiting. The shock, for those who stood before *Olympia*, was the shock of the familiar. She outraged the public for exactly the same reason the figure in *Le Déjeuner sur l'herbe* did: she was all too real. She reverberated (as one of Manet's biographers remarked) with 'disquieting significance'.

Manet was subjected to a new barrage of abuse. People were calling the

painting 'a vile Odalisque with a yellow belly'. Manet told Baudelaire he
had never been so insulted. Part of his charm was that, while he loved
being risqué, he was genuinely astonished when his provocations went
unappreciated. He wanted to be rebellious and adored. One of his critics
grumbled that Manet was trying to be Velázquez on the canvas and
Monsieur Bouguerea (a conventional academic painter) in the drawing
room. The reactions to *Olympia* hurt him deeply, and for a while he
stopped going to the cafés, taking long, solitary walks, nursing his wounds.
'Do you think you're the first person to be in this position?' Baudelaire
reprimanded him; 'are you more of a genius than Chateaubriand or
Wagner?' To others, however, he defended Manet, assuring them that far
from being the wild card people imagined, Manet was actually
straightforward and unaffected, despite his indisputable romanticism.

   To add to Manet's problems, there was another, quieter disruption
going on in the Salon rooms. When they were not deploring *Olympia*, the
audience gathered round to admire an arresting view of Normandy, also
apparently by this 'shocking' artist; but on closer inspection, the signature
looked forged. Facts were checked, the signature was scrutinised, and it
emerged that this painter was not Edouard Manet at all, but the similarly
named Claude Monet, an unknown, but clearly talented newcomer.
Manet's nerves were further jangled. He sat fuming in the Café de Bade.
'Who is this Monet whose name sounds just like mine, and who is taking
advantage of my notoriety?' Those hoping to introduce the two artists
tactfully decided to postpone the event.

   Monet seems to have been quite unfazed by the confusion. Back in
Chailly, he was at work on an immense painting (*The Picnic*) based on
Bazille's idea of life-sized figures. The plan was to construct it entirely
from sketches made in the open air. The painting was to be huge –
between five and seven metres wide – containing twelve life-sized figures.
But it posed fundamental problems. Adapting the sketches to the scale of
a life-sized work, and integrating the figures within the landscape, was
fraught with technical problems. The idea – also inspired by Bazille – was
to create the sense of a fleeting glimpse, the feeling of life going by, with
the freshness of something seen happening in the here and now. Monet
had also taken some ideas from Manet's *Le Déjeuner sur l'herbe*. He wanted
a group of figures, informally arranged, some talking, one glancing up,
another seated casually on the ground. Camille was sitting for both
women; Bazille, for most of the men.

   Bazille's family were still expecting him at Méric, but as spring came to
an end and summer approached, he sent word that he had other plans.
Monet was waiting for him in Chailly, 'like the Messiah. I think he will

need me for four or five days.' When he was finished, Bazille would leave for Montpellier. But Monet's large group painting continued to defeat him. The weather was still atrocious and the work was slow. Though his models could not have been more obliging, the picture just did not seem to work. Whatever Monet did, the figures seemed to be flatly super-imposed on the landscape, rather than an intrinsic part of it. For once, relations between him and Bazille became strained, and Bazille soon left for Paris, where he wanted to get on with his own work.

By August, Monet was still in Chailly, where his painting was still not finished. On the 16th he wrote despairingly to Bazille, telling him he could not do without him to model for the tall figure. Bazille returned three days later, and discovered that Monet had had a row with the landlord of the Cheval Blanc. They put up together across the road at the Lion d'Or.

Back in Paris within the month, Bazille visited dealers with Commander Lejosne, showing them Monet's work as well as his own. He sent an urgent message to his mother, pleading with her to intervene with his father. 'I am 300 francs short, which I must pay before I leave. Recently I had to pay the rent for my studio and my enormous model's fee, which has completely ruined me. Without these I would have managed with the 200 francs I received this morning. Papa is going to be very fed up with me. I have spent too much money and I have not passed my medical exams. I am counting on his forgiveness, but most of all on his goodwill.'

In October, Monet and Camille returned to Paris, lugging the rolled-up, unfinished canvas between them. Monet was still determined to continue work on it – it was to be his great Salon masterpiece – but he now needed a studio where he could work up the sketches he had made in the forest. The couple headed for the rue de Furstenberg, where they made themselves at home in Bazille's studio.

Monet quickly realised that 6, rue de Furstenberg was an auspicious and potentially lucrative location. Its proximity to Delacroix's studio meant that Delacoix's visitors had only to cross the small square to look at more paintings, this time by two new and ambitious young artists. Though he was unable to find the rent, as soon as Monet moved in he saw to it that he and Bazille began to receive visitors of their own. Before long, more than twenty painters had been to admire Monet's work.

In December Bazille sent word to his parents, asking them to send his own landscapes of Honfleur and Le Havre, though they seemed reluctant to do so, murmuring something about the cost of transporting them. He then tried his brother Marc, asking him to send them wrapped round a

large pole, picture side in, rolled in a layer of newspaper, then one of oilcloth or tar-lined paper. With these instructions he sent his brother a copy of the lease on the studio: 'and another thing: I quite erroneously thought we had paid two months' rent in advance . . . We had only paid one. I am enclosing the lease, so that Papa doesn't think I'm making it up. So, we'll be out on the street on 15 January.' He had already found another studio, at 22, rue Godot-de-Mauroy, with a little bedroom, at 800 francs' rent, the cheapest place he could find. He added the latest news of Monet: 'hard at work for some time now. His painting has really progressed, I'm sure it will attract a lot of attention. He has sold thousands of francs' worth of paintings in the last few days, and has one or two other small commissions. He's definitely on his way.'

<p style="text-align:center">★</p>

In the New Year of 1866, Bazille moved into his new lodgings in the rue Godot-de-Mauroy, a pleasant studio, full of daylight, the bedroom so tiny he could barely turn round in it. Monet finally found a studio of his own, at 1, rue Pigalle, and moved all his canvases in. Apparently there was not much room left for him as well as his paintings because Bazille, who was now accommodating Renoir, was still putting him up as well: 'it's practically an *infirmerie*,' he wrote home. His efforts to live frugally continued, he assured his parents: 'we are *not* millionaires at the hôtel de Berri even though we do order Madeira. A dozen of us have got together. I'll only be getting four or five bottles myself.'

In April, Monet was running from his creditors. He went to Sèvres, where he rented a little house in the chemin des Closeaux, near the station of Ville d'Avray. Though he had sold a few paintings, he was still far from being able to pay off his accumulating debts. He had begun work on a new painting, *Women in the Garden*, which was to be even more ambitious than *The Picnic*. This time, although the figures would not be life-sized (thereby avoiding one set of problems), the picture was to be painted entirely in the open air, which would at least dispense with the need to transpose and scale up preliminary sketches. He had a special contraption built, to lower the canvas into a trench while he painted the upper portions. But he was still struggling with the relationship between his landscape and his figures, who looked posed no matter what he did with them. For his new picture, Camille again sat, this time for at least three of the four women. Their dresses were scintillating, shining out in white against the darkness of the foliage. But for some reason the figures were difficult to bring to life. This painting too would clearly demand months of work, and Monet was in dire financial straits. In Le Havre, Aunt

Lecadre was threatening to cut off the allowance she still paid, despite the previous October's row. In fact, she relented. Meanwhile, in Montpellier, Bazille's parents continued to respond to letters from their son: 'Dear Mother, . . . I am very sorry, but I was obliged to borrow 250 francs from Madame Lejosne. I couldn't help it, I swear to you . . .' The expenses he itemised for his parents included canvas, frame, model for two weeks, and 'a green dress which I rented', which he had not included in his calculations.

By the time the Salon deadline began to loom, Monet had temporarily abandoned work on *Women in the Garden*. (He sent it the following year, when it was rejected.) Meanwhile, he submitted two works to the 1866 Salon, then returned to Normandy with Camille, where they were spotted gambling in the local casino.

<p style="text-align:center">★</p>

Cézanne had been working right up to the last minute to meet the 1866 Salon deadline. On the last possible day for submitting, a wheelbarrow arrived outside the Palais de l'Industrie, pushed and pulled by Cézanne and Oller, his Cuban friend from Suisse's. Cézanne rushed to unwrap his paintings, eager to show them to anyone who wanted to see. But by now his hopes were not particularly high. When both his paintings were rejected he was hardly surprised. He headed straight back to Aix, complaining to Pissarro about the 'rotten' family he was being forced to rejoin, all of them 'boring beyond measure'. But he was determined to make his views of the Salon jury felt. He wrote to Nieuwerkerke, protesting that the Salon should be open to every serious artist and requesting that the Salon des Refusés be re-established. Though he received no reply, his letter was preserved, with a draft reply scrawled in the corner: 'What he asks is impossible; his submission has already been judged unsuitable for the dignity of art, and [the Salon des Refusés] will not be re-established.'

By contrast, both Monet's submissions were accepted. He had judiciously selected *The Road to Chailly*, a landscape of the village near Fontainebleau painted two years earlier; and a ravishing portrait of Camille in the rented green dress – a sumptuous, green striped satin affair – which he painted in a mere few days. The picture plays up the contrasts between the fabric of her sumptuous gown, her luminously pale skin and her low, dark brows as she turns modestly away from the viewer, looking back coyly over her shoulder. The 'finish' of the textures – silk and fur, skin and hair – and the delicacy of her long, pale fingers made this the epitome of an acceptable work. This was how the bourgeois audience

wanted to see their women in art. But it also had a tactile immediacy, a naturalist authenticity, which Zola picked up on and pinpointed in his review of the painting, calling it 'that window onto nature'.

One of those who came to stand in front of this painting, studying it with admiration, was Edouard Manet. André Gill, cartoonist of the day, had got hold of the confusion of artists' names, and a caricature appeared in the press. 'Monet or Manet?' read the caption. 'Monet. But we owe Monet to Manet. Bravo, Monet! Thanks, Manet!' Manet was not amused. But later that summer, he made a point of investigating the unknown newcomer whose work had been confused with his. He sent an invitation to Monet to meet him at the Café de Bade, and Monet introduced him to Renoir, Bazille and Sisley. For his part, Manet introduced Degas, who went to see Monet's seascapes: 'I said to him, "I'm off, all these *reflets d'eaux* are making my eyes hurt . . . It was full of draughts; a few more and I'd have pulled the collar of my jacket up."' Zola, introduced into the group by Guillemet, brought Cézanne, and Manet went to Guillemet's studio to see Cézanne's still lifes. He was encouraging and polite, saying he thought the subjects were 'powerfully treated', though privately he considered Cézanne 'not much more than an interesting colorist'. In the tiny Café Guerbois, with its cramped tables, friendly fat proprietress in black dress and white apron, lace curtains and line of pegs along the wall, hung with shiny top hats, Manet reserved two tables, and every evening at five o'clock, he held court. Some said these soirées were a substitute for what he really craved: approbation, decorations and public recognition. (More surreptitiously, Monet wanted these, too.)

These disparate and remarkable painters now began to cohere as a group. Their range of circumstances, backgrounds, talents and tastes could hardly have been more different. But they had one thing in common: the determination to succeed. The café discussions in the summer of 1866 were now becoming heated: a conversation with Degas would see Manet sweeping out dramatically, while Degas sat gloating. They argued about the relative merits of Delacroix and Ingres; naturalist fiction and *plein-air* painting; the state control of the arts, police censorship of literature and journalism, and the control exercised over the Salon by outdated and prejudicial juries. Cézanne (who had returned to Paris from Aix in February) joined them occasionally, and sat glowering in a corner, his trousers held up with string. When Zola came along, the discussions were more political; increasingly so when Cézanne brought Pissarro. Manet, despite his background, was an ardent republican; Pissarro's socialism bordered on anarchy. Monet, the conservative grocer's son, kept his thoughts to himself.

Zola had recently become a Salon reviewer, and Manet lost no time courting him as an ally. He invited him to his studio to see the paintings the jury had rejected, and Zola, a great admirer of Manet's work, temporarily became his public champion. He managed to persuade the editors of the popular left-wing newspaper, *L'Evénement*, to run a series of articles on modern art, which he would write himself under the pseudonym Claude. The first two articles criticised the Salon, with its corrupt and retrograde policies, its prejudices and its nepotism. In one, he singled out Pissarro, who made of 'a simple bit of road, then a hillside in the background, and open fields to the horizon' something 'grave and austere'. Pissarro and Julie had moved south of Paris, where the rents were cheaper. They now lived in Pontoise – just beyond Argenteuil, where the Seine joins the River Oise west of Paris – a medieval village with orchards, sloping hillsides and terraces of red rooftops. In springtime, the hillsides descend into a tangle of delicate branches and a haze of pink and white blossom. Pissarro loved the subtle light and complexity of perspectives, and his landscapes were refreshing, vital and new.

Zola now followed up his first two articles with a third, devoted to Manet. This reminder of the notorious artist of *Le Déjeuner sur l'herbe* and *Olympia* was too much for *L'Evénement*'s loyal subscribers. Letters of protest poured in, demanding that the editor spare his readers any further mental torture and threatening to cancel their subscriptions. The series was abruptly curtailed. Manet, however, was sanguine. He realised that Zola had only been trying to do him a favour. He continued to meet him in the Café Guerbois, and offered to paint his portrait. He needed new friends. Baudelaire, suffering from syphilis, had become so ill that Manet could hardly bear to see him. When he was moved to the hydrotherapy clinic, Suzanne Manet visited him, and played Wagner to him as he lay dying (he died in August the following year).

That summer, Zola and his mother went to Bennecourt, where they entertained Cézanne, who was in one of his depressive phases, 'frightening, full of hallucinations, almost bestial in a kind of suffering divinity', his friends said. He blamed his models, hiring and firing them on a weekly basis and suffering agonies of alternating violence and dread. He shut himself up for weeks, not wanting to see anyone. But he found some respite from his troubles with Zola in Bennecourt, where he was able to paint all day. They stayed at Mère Gigoux's inn, near the river, where in the evenings, joined by other writers and painters, they lay on bales of straw smoking their pipes and talking into the small hours. Cézanne, Zola told his friends, was 'treading ever more firmly the road to originality which is his true nature. I expect he'll be rejected for another ten years.'

From Bennecourt, Cézanne went to Aix, staying long enough to persuade his father to increase his allowance before returning to Paris.

Monet, meanwhile, had spent the summer on the Normandy coast with Courbet and Boudin, visiting Aunt Lecadre in Saint-Adresse, where Camille was still not welcomed, then going on to Honfleur, where he set up his easel at the Honfleur Cheval Blanc, and painted the harbour. Unable to return to Sèvres, which he had left to avoid the bailiffs, he returned to Paris in the autumn, laden with pictures but penniless; collected Camille, and made straight for Bazille's studio. Once again, Bazille took them in. But the coming winter brought more turmoil for Monet and Camille, who now discovered she was pregnant.

~

# MODELLING

*. . . called them back for endless sittings until everyone (except him) was
sick and tired of the idea . . .*

THE WINTER OF 1866–7 SEEMED to go on for ever, sleet and snow
lasting well into the spring. All Paris was preparing for a massive,
glittering event. Napoleon had called for another *Exposition
universelle*, intended to promote Paris as the centre of the new commercial
world and celebrate the magnificent success of the Second Empire. In fact,
his regime was politically precarious. Ominous events abroad, including
the recent Prussian victory over Austria at Sadowa, put France in a
vulnerable position. Napoleon also faced economic difficulties, and his
health was not good. But none of this could have been deduced from the
lavish preparations for dazzling exhibitions and festivities. Victor Hugo
wrote a booklet promoting Paris as the capital of Europe, and the opening
day was set for 1 April. Ten days before the opening, torrential rain and a
sea of mud swamped the exhibition ground, but preparations were
completed in time, and the *Exposition universelle* opened.

Dominating the place de l'Alma, Haussmann's magnificent new square,
was the talk of the exhibition, an elliptical glass structure, 482 metres long,
set in a filigree of ironwork, with a vast, domed roof of red arcades.
Ranged around this dazzling construction was a ribbon of kiosks and stalls,
served by pretty girls and tribesmen in national costume. Above the
grounds hovered a double-decker balloon – the height of modern
technology – in which Nadar, the celebrity caricaturist and photographer,
took visitors, a dozen at a time, for flights above the grounds. Along the
Seine ran newly built excursion boats – the first ever appearance of the
*bateaux mouches* – carrying 150 passengers at a time. Inside the huge
pavilion, all the leading countries of the new industrial era presented their
exhibits: gleaming machines, the latest in modern military technology;

exotic Oriental fabrics. The Americans exhibited an amazing new invention: the 'rocking-chair'. France was displaying all the latest goods from its new department stores, together with complete model workers' dwellings, to demonstrate the quality of life for the French worker in the new industrial age. The workers from Belleville, who still lived in shanties and shacks, pressed forward in silence to stare, amazed, at these peculiar fabrications. Napoleon III had sent his own, special exhibit: a sculpture of a sturdy nude reclining on a lion, entitled 'Peace'. Napoleon himself was not the only august presence. King Wilhelm I of Prussia sent an equestrian statue of himself, which he accompanied with tremendous pomp and ceremony.

Beside the 'History of Labour' gallery stood that of the Beaux-Arts, where works by Ingres, Corot and Rousseau were being exhibited. Manet, Monet, Pissarro and Cézanne had all submitted works, but they had been rejected: only the works of Salon medallists were on display. Manet, infuriated by his exclusion, persuaded his mother to advance over 28,000 francs of his inheritance, and erected a gallery at one of the entrances to the exhibition on the place de l'Alma, to display fifty of his own works. He had an article by Zola (from *L'Artiste*) reprinted and distributed, and was expecting to make a big international impact. Among the works displayed were some of his magnificent paintings of the sea (*Steamboat, Temps calme*, and *Combat du Kearsage et de l'Alabama*). He knew and loved the sea, and had painted it directly from nature, celebrating its power, evoking the energy of the wind, using vivid, vigorous tones of blue. But once again, he was disappointed. A small exhibition of paintings by a single artist was not what those who flocked to the glittering exhibition of commercial materialism had come to see. The artist's pavilion attracted little attention, except, for some, as another opportunity to come and jeer at *Le Déjeuner sur l'herbe*.

Bazille's mother attempted to capitalise on all the social celebrations by putting her son in touch with a young lady, up from Montpellier for the *Exposition*. But the introduction was not a success. 'If I were a few years younger, and had a few more hairs on my head . . .' he ruefully explained (he was twenty-seven). He had made a far more diverting discovery: the wings of the Opéra. 'Don't worry,' he assured his mother, 'I bring to it all the necessary objectivity, don't be alarmed.' The Paris Opéra was glamorous, gilded and spectacular, dazzling with opulence in the shimmering gaslight. But backstage was another world: cold, grimy, and inhabited by 'dirty machinists, very dumb musicians, a very old [choreographer] Monsieur Auber, and everyone only thinks about getting her job done as quickly as possible to earn a living'. Bazille was

spellbound, chatting with the dancers about their high rents, their dogs and their cats, and fascinated to discover that none of them had a clue what was happening on stage except when she had to go on, and none had ever really thought about why she danced. His other preoccupation (as usual) was Monet, who was becoming more despondent by the day. He would be fine, he was telling his friends, but for the mess Camille had got them into. 'His family is incredibly stingy with him,' Bazille told his mother. 'He will probably marry his mistress. This woman has rather decent parents, who will agree to see her again and help her, if she marries. All this is not very pleasant, but their child will have to eat somehow.'

Monet's father had discovered that Camille was pregnant. The fact that his own mistress was in the same boat seems only to have increased his intolerance. He cut off Monet's allowance altogether, making it impossible for him to support himself anywhere but at home in Le Havre, despite the fact that Bazille, with his parents' approval, bought *Women in the Garden* for 2,500 francs (to be paid in monthly 50-franc instalments). Monsieur Monet was intractable, even when Bazille wrote to him on Monet's behalf. Camille was left in Paris, under the watchful eye of Renoir and a medical student, while Monet returned to Le Havre for the summer. He began to bombard Bazille with letters, begging for money. The situation was unbearable, he had had to leave Camille to give birth to their son by herself in poverty, in August, in their ground-floor studio in Pigalle.

Bazille responded to Monet's pleas by promising help, but when this was not immediately forthcoming, Monet became desperate. Camille would starve, the baby would starve . . . and it would all be Bazille's fault for not providing an endless flow of money. Clearly, Monet had always depended on his father to support his lifestyle and replenish his finances and was now attempting to transfer that responsibility to his friend. It hardly seems to have occurred to him that Bazille might not have limitless funds. Bazille sent more money. Monet spent it. Why was it gone already? Bazille asked, what had Monet done with it? Monet was unable to produce an explanation. Agonised by his predicament, he painted as many landscapes as he could, of Honfleur and Le Havre.

At Meric, having dealt with Monet's demands, Bazille was painting a family group portrait: a bizarre, uncanny painting called *Réunion de famille*. The family posed in the grounds of the family mansion, in groupings apparently intended to be informal. In some ways, the composition resembles Manet's *Music in the Tuileries* (informal, seated groups, standing couples, in the shade of the heavy branches of a tree). But there is something eerie about Bazille's picture. Everyone sits stiffly, like wooden

dolls, facing forward, locked rigidly in their poses as if the world has just come to an end and they have all been frozen in time. In the foreground, apparently abandoned on the gravel, lies a hat, a folded parasol and an untidy bouquet of strewn flowers, the scene looking for all the world as if someone has suddenly departed.

★

At the same time, in Paris, Manet was working on his latest subversive project. News had just broken of the shooting of Emperor Maximilian, whom republicans regarded as a hapless tool of Napoleon III in the Mexican war. Manet immediately began work on an unflinching depiction of the actual moment of the shooting. The painting was powerful: you can almost smell the gunpowder, hear the shot. All the Manet brothers were staunch republicans – anti-Bonapartist, anti-clerical Freemasons – and the painting left no one in any doubt of his political leanings. The painting was scandalous enough to be confiscated by the censor, who had it torn into three parts (it was later salvaged and put back together by Degas, who recognised its power as a work of art).

At this point, Madame Manet, devoted though she was to her son, felt she had to say something. She warned him that he was being reckless, not least because a substantial portion of his inheritance had effectively been squandered on the exhibition at the place de l'Alma. She had her own social position to consider, after all: the Manet circle included politicians and high-ranking civil servants, among them Tiburce Morisot, Chief Councillor of the Audit Office, whose daughters, Berthe and Edma, had begun to distinguish themselves at the Salon. Coincidentally, the eldest Morisot sister, Yves, had just become engaged to a Breton tax inspector who had lost an arm serving as a commissioned officer in the Mexican war. But that was no topic of conversation for a soirée. One of Madame Morisot's acquaintances – 'La Loubens' – attended one of Madame Manet's evenings at home, where she overheard the conversation of Edouard Manet and his painter friends. The talk, La Loubens told Madame Morisot, had been all about Berthe: Fantin-Latour remarked that he had never seen such a ravishing beauty. 'Then you should have proposed to her,' said Manet.

Berthe Morisot, twenty-seven in 1868, was the reserved, softly spoken daughter of Tiburce Morisot and his exquisitely pretty and highly intelligent wife, Cornélie (née Fournier). Berthe, wafer-thin and invariably dressed in black, with deep, dark eyes and low, dark brows, had learned to draw as a child. She and her sisters had taken lessons with Geoffroy-Alphonse Chocarne, a mediocre, academic genre painter who

taught them the rudiments of drawing in a gloomy room in the rue de Lille. In the corner of the room, his latest Salon entry was displayed on an easel – a portrait of a young woman in classical drapery, seated in a field of daisies. When Tiburce Morisot arrived to collect his daughters, he invariably found them – Berthe, particularly – reduced to stupor by Chocarne's uninspiring tuition. She eventually demanded a new tutor, and switched to Guichard, who warned Cornélie that Berthe had the talent to become a real painter: did she realise what that would mean? Cornélie, an unusually independent-minded woman, replied that she understood quite well.

Guichard soon recommended a more high-profile teacher, Camille Corot (who had earlier encouraged Pissarro). Corot took the sisters out to the countryside to paint from nature, and in 1863 Berthe and Edma enrolled as copyists in the Louvre, where they met Fantin-Latour, but by some odd freak of fate it was another five years before they would be formally introduced to his friend Edouard Manet.

In 1863, when Manet's *Déjeuner sur l'herbe* had been the talk of the Salon, Berthe and Edma had each exhibited two landscapes. Since then, they had spent their summers in Normandy, painting in the open air. In Paris, the family lived in the rue Franklin, in a large house with a garden full of trees, where Monsieur Morisot had a studio built for them. On Tuesday evenings, Madame Morisot gave informal soirées to which painters and poets were invited. The Morisot and Manet circles thus more or less overlapped, but still Berthe Morisot had not yet encountered the illustrious Edouard Manet.

In spring 1868, Yves Morisot married and moved with her new husband to Brittany. Berthe and Edma visited, and spent the spring and summer painting the landscapes and the barges, their blue nets spread wide, at Pont-Aven and Douarnez. Berthe painted from the window, where she also occupied herself writing irritable letters home. This was a hopeless place to paint in the open air: the weather kept changing and the boats moved. Why not move to the other side of the harbour? replied Cornélie. On the other hand, she could quite see that wherever Berthe was, the ideal place to be would be somewhere else. While they were away, she took the opportunity to sort out the 'great mess' in her daughters' studio. She wanted all the paintings that had been thrown into corners framed and exhibited at Cadart's gallery: if her daughters wanted to be real painters, she did not see why she should not concern herself with their commercial prospects.

When she returned to Paris, Berthe continued her studies in the galleries of the Louvre. One afternoon that summer, as she sat copying

Rubens's *Exchange of the Two Princesses*, Fantin-Latour introduced her to Manet. He registered her dazzling, almost-black eyes, and her strange, tantalising reserve. Chaperoned by their mother, Berthe and her sister Edma were soon being invited to Manet's mother's Thursday soirées, where the drawing room buzzed with the conversation of intellectuals, musicians, writers, critics and painters: Zola; Zacharie Astruc; the dazzling Alfred Stevens and his beautiful wife; Manet himself, charming, flirtatious and attentive; and his wife, Suzanne – clearly Madame Manet's special confidante – who entertained the company by playing Chopin on the piano.

The regular soirées given by the well-to-do were extremely elegant affairs, which the men attended in full dinner dress, with stiff shirt fronts and black tie. The women wore embroidered silk crinolines decorated with pearls and jet, their hair in elaborate coiffures, their powdered arms and shoulders bare, their feet in silk, Cuban-heeled slippers. Gleaming top hats, scarves, canes and shawls would be handed to the footman before the guests made their entry into the *salon*, which was hung with chandeliers, papered with the latest chic 'English' wallpaper – pastel striped, or in the latest William Morris design. A butler or maid circulated with drinks on silver trays; the talk was sparkling and brilliant.

At Madame Manet's soirées, the Morisot sisters met Degas, who found Berthe, dressed in the very latest fashion, her pink silk shoes decorated with rosebuds, instantly intriguing. Degas adored clothes. He was planning a treatise on 'ornaments for or by women,' exploring 'their way of observing, combining, sensing the way they dress'. It fascinated him that every day 'they compare a thousand more visible things with one another than a man does'. He was also a shrewd observer of the human psyche, noting that a portrait painter had to intuit far more about a sitter than he could ever actually include in a portrait. Manet, too, was intrigued by Berthe. Both girls were charming, he admitted to Fantin-Latour. As painters, it was a pity they weren't men, but they would surely further the cause of painting if each married an academician and managed to 'sow the seeds of discord in the ranks of that rotten lot'.

He was soon asking Berthe to sit for a group portrait based on Goya's *Majas on a Balcony*. Walking down the street one day, he had happened to notice two women seated on an apartment balcony, the interior opening up in shadow behind them, and it had reminded him of the Majas, Goya's women. On the balcony of his mother's apartment in the rue de Saint-Petersbourg, he posed Berthe with Fanny Claus, a violinist friend of Suzanne's; the painter Guillemet; and his son, Léon, glimpsed faintly retreating into the interior in the background. Manet's painting was a

witty, modern interpretation of Goya's depiction of female companion-ship. When Berthe and Fanny sat for him, he picked up straight away the tension between the two women, and sat them facing grimly away from each other, Fanny looking somewhat vacantly into the middle distance, Berthe gazing broodily in the opposite direction. He called them all back for endless sittings, until everyone (except him) was sick and tired of the idea. Guillemet remarked that they must have posed at least fifteen times, and that Fanny still looked atrocious. 'It's perfect,' they all assured him, 'there's nothing more to be done to it.' Cornélie observed that Manet was behaving like a madman, one minute convinced the painting was a masterpiece, the next, plunged into despair. 'All these people may be very amusing,' she remarked, somewhat acidly to Edma, 'but they are not very responsible . . . He has just painted a portrait of his wife. I think it was high time.'

For Berthe, this was an emotional and stressful time. Edma had recently fallen in love, with Adolphe Pontillon, a naval officer, whom she planned to marry the following year. Berthe now faced the prospect of daily solitude. She was especially close to Edma, with whom she had shared her formative years as a painter, and the prospect of exchanging close companionship for a life alone with her parents was deeply disheartening. Manet picked up on her black mood. While her mother made conversation with Alfred Stevens, who was something of a celebrity, Manet took Berthe aside and suggested, *sotto voce*, that she tell him all the worst things she could think of about his painting. Cornélie Morisot, overhearing, was unimpressed. She later complained to Edma that people like Manet had no brains. 'They are weathercocks, just using people for their own amusement.'

<div align="center">★</div>

The 1869 Salon opened on 1 May. It was a brilliantly sunny day, and in a dazzle of satin, silk, glittering jewellery and gold-tipped canes, crowds thronged on the staircase of the Palais de l'Industrie around the latest work by Puvis de Chavannes. Berthe and Madame Morisot made their way together up the staircase, greeting acquaintances one by one (Jacquemond, Alfred Stevens, Carolus-Duran), to Room M. On the way, they found Manet, dazed by the sunlight. 'He begged me to go straight up and see his painting,' Berthe told Edma the next day, 'as he was rooted to the spot. I've never seen anyone in such a state, one minute he was laughing, the next insisting his picture was dreadful; in the next breath, sure it would be a huge success.' He probably had to laugh, observed Cornélie, or he'd be crying: there were people who kept out of his way

to make sure they did not have to talk to him about his painting. He had already been asked the price of *Le Balcon*, he told them (presumably by someone who wanted to make fun of him, remarked Cornélie); Berthe, he said, was already bringing him luck.

He was also exhibiting *Le Déjeuner*,★ a strange combination of portraiture and still life, with sixteen-year-old Léon at the centre, in velvet jacket, cream trousers and straw boater, a boy on the verge of manhood, vividly lit, leaning against a table. Seated behind him is Manet's friend Auguste Rousselin, watching Léon with clear admiration and tenderness. On the table behind Léon a glass, a lemon and a plate of oysters catch the light, and on a chair in the foreground is a bizarre collection of objects: a sword, a Prussian helmet and a small black woman's hat with trailing black ribbons. The mood is complex and classical, like the Dutch masters; and the focus of the painting is clearly Manet's son.

In the same room, *Le Balcon* was exciting curiosity and speculation. The figure of Berthe had attracted attention, and the phrase *femme fatale* was already being bandied about. Degas bustled into Room M, found Berthe staring gravely up at herself, and hastily retreated. Madame Morisot announced she was 'afraid of getting a headache', and went to sit on the sofa, leaving Berthe to study the finished painting. 'I am more strange than ugly,' she told Edma. The painting reminded her of 'a wild or even unripe fruit'. Manet had accentuated her almost black eyes, in radiant contrast with her dazzling white dress, its dense white highlighted by the transparent sleeves.

Her hands are clasped at her *décolletage*, and she holds her closed fan – the only dash of red in the picture – at a protective distance as she stares broodily into space. Fanny, staring in the opposite direction, holds her rolled umbrella under her arm like a weapon; the faces of Guillemet and Fanny are dimly lit; the only area on which light is fully trained is the troubled face of Berthe. The picture is predominantly a portrait of her, focused on her air of compelling beauty, her mystery and the complex inner struggle reflected in her face.

Berthe and Cornélie moved through the Salon rooms, pausing to look at works by Fantin-Latour, Degas, Corot and Bazille, whose portrait of a young girl in a pale dress seemed full of light and sunshine. 'He has tried to do what we have so often attempted,' Berthe told Edma '– a figure in outdoor light – and this time he seems to have been successful.' Degas was

★This painting is sometimes referred to as *Luncheon in the Studio* (1868), perhaps to distinguish it clearly from *Le Déjeuner sur l'Herbe* (1863); it was actually painted in Manet's holiday lodgings in Boulogne.

also exhibiting 'a very pretty painting of a very ugly woman in black'. The jury accepted paintings by Daubigny, an established Barbizon landscape artist, and by Gleyre himself, but none of Gleyre's students had work accepted. Monet had sent two paintings, *The Magpie* and a seascape, but both had been rejected. Berthe was not exhibiting. She had spent the whole winter posing for Manet and reading *Madame Bovary* in a state of miserable desolation, abandoned by her sister, who was complaining that she missed her painting. But 'this painting', Berthe told her, 'this work you're mourning, is actually nothing but heartache and trouble . . . You have a serious attachment, and a man's heart utterly devoted to you. You should realise how lucky you are . . . A woman has a huge need of affection. To try to withdraw into ourselves is to attempt the impossible.' She spent the summer with Edma at Lorient, taking along a pile of Manet's books.

When she visited him to return the books, Berthe's mother Cornélie discovered Manet with a new protégée. Eva Gonzales, dark, spirited, ambitious, daughter of the popular Spanish novelist Emmanuel Gonzales, had latched on to Manet, who was teaching her to paint. This was unusual – Manet never took pupils. But with Eva, he seemed to be fired up with a mission, enthusiastically teaching her the rudiments of still life. His own still lifes – peonies, their petals smashed and creamy; fish with subtle pink flesh and shining silver scales – were sensuous and tactile, and he was endeavouring to share his methods with Eva. Friends gathered round to watch his energetic instruction: 'Get it down quickly, don't worry about the background. Just go for the tonal values. You see? When you look at it, . . . you don't see the lines on the paper over there, do you? . . . You don't try to count the scales on the salmon, of course you don't. You see them as little silver pearls against grey and pink – don't you? – look at the pink of the salmon, with the bone appearing white in the centre and then greys, like the shades of mother of pearl. And the grapes, now do you count each grape? No, of course not. What you notice is their clear, amber colour and the bloom that models the form by softening it. What you have to decide with the cloth is where the highlights come . . . Half-tones are for the *magasin pittoresque* engravers. The folds will come by themselves if you put them in the right place . . . Most of all, keep your colours fresh!' Before long, he was painting Eva's portrait, which involved elaborate preparations: her mother's permission, the transport of dresses, the involvement of household staff.

Cornélie found Eva sitting for her portrait, and Manet 'more excitable than ever'. Suzanne was there too: the poor girl was feverish, said Madame Manet, urging Cornélie to feel Suzanne's hands. Manet's wife was

evidently well disposed towards Berthe, since she forced a smile, and reminded Madame Morisot that Berthe had promised to write to her. (Suzanne's goodwill was never truly reciprocated. Coolly polite in her presence, Berthe always disparaged her in private.) Meanwhile, Manet had not moved from his stool. Eventually he asked after Berthe. But 'he has forgotten about you for the time being', Cornélie warned her daughter. 'Mademoiselle G has all the virtues, all the charms, she is an accomplished woman.'

When Berthe returned to Passy in August, the reunion of mother and daughter was cool. In Lorient, Berthe had painted a portrait of Edma which she now gave to Manet, to Cornélie's irritation. But he hardly seemed to appreciate it. He just lectured her, she complained to Edma. 'He holds up that eternal Mademoiselle Gonzales as an example; she has poise, perseverance, she can get her things finished whereas I am incapable of doing anything properly. In the meantime, he has started her portrait again, for the twenty-fifth time. She poses every day, and every night he rubs out the head . . .' Berthe was tired, listless; irritated beyond endurance by this rival. Some weeks later, Manet came to visit her, coming into her studio to praise her work and predicting great success for her in next year's Salon. But this was hardly a consolation. 'I'm so sad,' she told Edma. 'Everyone is abandoning me; I feel lonely, disillusioned and old.' Edma was happily married, and pregnant. Berthe's life, by comparison, seemed pointless, bleak and empty.

★

She was not the only one being reduced to despair. Both Monet's 1869 Salon submissions had been rejected. He was exhibiting some pictures in a shop window in the rue de la Fayette, and beginning to realise that he would have to settle in or near Paris if he was to keep in touch with prospective dealers and purchasers. But his father still expected him to spend the summer months at home in Le Havre. Though he had started paying Monet an allowance again, it was not sufficient for him to support himself, Camille and Jean. Moreover, Monet still dreamed of eventually settling in Normandy. The previous summer of 1868, wanting to explore the countryside near Paris, he had taken Camille and baby Jean to Gloton, on the outskirts of Bennecourt, to paint in the open air, where they stayed in an inn Zola knew. But on 20 June, he told Bazille, he was thrown out, stark naked, and after finding Camille and Jean temporary lodgings in Gloton, he returned to Paris. He was planning to leave that night for Le Havre, where he hoped Monsieur Gaudibert, a wealthy Le Havrais, would purchase some of his recent work. But the following evening,

before leaving, he was so depressed that he actually threw himself into the Seine. He was too good a swimmer to drown, and he immediately chastised himself for being so stupid. But for a moment, there had seemed to be no way forward. His family still refused to accept Camille and Jean, so Monet moved them to Fécamp, then to lodgings on the Le Havre–Etretat road, while he spent the rest of the year with his family in Le Havre.

In Le Havre, Monsieur Gaudibert came to the rescue with further purchases and commissions and Monet's immediate financial crisis was thus staved off. By spring 1869 he was back in Paris with Camille and Jean, but he knew they could not afford to stay there for long. By now he was forced to face the fact that if he was ever going to afford to live with Camille, they would have to live outside Paris. They found some rooms in the village of Bougival, just west of the city, where rents were cheaper. This move to the *banlieues* seemed a desperate measure, but in fact it was about to open up new possibilities, for him as well as for the other painters.

Just west of Paris, the Seine winds in a loop around a horseshoe of villages where the air is fresh and the light is soft and clear. First stop on the railway was Chatou/Chailly, two small villages where the bourgeoisie built their large villas within walking distance of the river. Next stop was Bougival, a large, busy village, which sprawled up into the hillside over-looking the Seine. Monet took Camille and Jean here, to 2, rue de la Vallée, a steep, cobbled street of houses with ramshackle courtyards near the place de la Chapelle, with its great copper beech. Not far away, the village women gathered to wash their laundry in a large concrete trough with a sloping roof. Bougival was sufficiently close to Paris for Monet to keep up his efforts to attract collectors, but for the time being there seemed to be little tangible prospect of counting on making a living.

Beyond Bougival, the river meanders onwards to Louveciennes, where Renoir went frequently, to visit his parents, who had settled there. In summer 1869 he regularly walked along the riverbank from Louveciennes to Bougival and up the steep streets to the rue de la Vallée, bringing Monet bread and tobacco from his parents' table, even though the Renoir family lived modestly themselves. Their house at 9, place Ernest Dreux, was one of a row of small workers' cottages in a quiet lane in the hillside of Voisins, a hamlet of Louveciennes. With its soft light and *grandes perspectives* across the valley of the Seine, Louveciennes, dominated at the top of the village by Madame Du Barry's château and park, was rich with market gardens and famous for its heavily laden pear trees. There was also, lurking at the edge of the village, a colony of tramps who did occasional

odd jobs in the orchards, but who mostly survived on charity. Their hovels stood at the borders of the forest of Marly, and they received regular visits from Renoir's mother, who brought them bread, bacon and cakes, in return insisting they wash their children. Some of the parents were indignant – when you're poor and haven't got an overcoat, said one, the dirt keeps you warm. But Madame Renoir was having none of that. She inspected hair and fingernails and stood over the children as they meekly slithered into the laundry tub.

Further along the river, north of Bougival, between Chatou and Chailly, for a mile or two the river forks into two, creating a 'dead reach', the Ile de Croissy. The island was strewn with poplars and weeping willows, with an air of mystery created by its tangles of brushwood and luxuriant meadows. This stretch of the river was dubbed the Parisian Trouville. As it moves slowly downstream, the surface of the water creates broad ripples, streaked by the reflections of the overhanging trees; the colours dazzle in the sunlight, luminous against the green riverbanks. At the fork of the river was a floating bar, or *guinguette* (open-air café-bar) on a jetty. La Grenouillère was suspended by gang-planks between the riverbank and an island with a weeping willow in a tub, an area known as the 'camembert', or flowerpot. Here, on sunny weekends, people flocked in huge milling crowds, gathering on the camembert to stand around and talk before progressing to the bar.

The bar attracted people from all walks of life – the leisured classes, working people on their day off, and the classless women who gave the place its name, *grenouillère* being both the French word for frogpond and colloquial slang for, as Renoir explained, 'not exactly prostitutes, but a class of unattached young woman, characteristic of the Parisian scene before and after the Empire, changing lovers easily, satisfying any whim, going nonchalantly from a mansion in the Champs-Elyseées to a garret in the Batignolles.' (Manet had playfully included a little frog in the corner of *Le Déjeuner sur l'herbe*). These women of the *demi-monde* stood for all that was 'brilliant, witty and amusing' in Parisian life. Renoir liked to use them as models, as they were usually 'very good sorts.'

On Sundays, the steam train, with clanging bells, yelling guards and enormous belching of black smoke and soot, disgorged jostling crowds of pleasure-seekers at the station at Chatou/Chailly. They poured out on to the platform, bulked out with hooped petticoats and bustles, frills, enormous hats decorated with feathers and flowers; sticks, parasols, picnic hampers, and all the paraphernalia of luggage required to strip off and bathe when they got to the river. At Chatou, horses and carts waited in the little square beyond the station and carriages lined the towpath

between the station and the riverbank. On the Chailly side, the road down to the riverbank – past huge, manorial houses behind high walls, set in verdant gardens and lined with horse-chestnuts, beeches and the last of the hawthorn blossom – was heavy with the scents of honeysuckle and lilac. The river was crowded with barges that met the carriages ferrying the crowds from the station. The *canotiers* were as merry as their passengers, singing as they handed down the ladies then punted them along.

By about three o'clock, the big floating bar would be swarming with people, laughter wafting across the water. Monet and Renoir came to paint, walking along the riverbank with their painting things from opposite directions, meeting half-way at La Grenouillère. Renoir painted huddles of people on the camembert, experimenting with little patches or *taches*, indistinct, wiggling strokes which he applied by putting down one mark next to another, creating subtle colour vibrations. He dashed bright white impasto across the blue water, suggesting reflections of bright light and the animation of the water created by the bathers and the boats. Monet, sitting by his side, was mesmerised by the vibrating reflections of colour clearly visible on the river's surface. Painting the same scene, he tried out new ways of painting water, putting down huge, thick broad strokes of brown, white and blue.

Monet's and Renoir's paintings are relatively sedate, compared with contemporary accounts of what went on at the Grenouillère. According to Guy de Maupassant, the crowd Renoir painted all came brightly decked out, the women with dyed hair, cheap scent and scarlet lipstick. The young men posed in fashion-plate frock-coats, pale gloves, canes and monocles. In the Grenouillère itself, as the afternoon wore on, people got steadily tipsier, singing with abandon, dancing the quadrille and flirting recklessly. Everyone came here: drapers' assistants, third-rate actors, infamous journalists, shady speculators, revellers and roisterers. Along the riverbank was a line of tents, into which the revellers disappeared. They reappeared dressed in striped bathing suits or frilled pantaloons, tunics, frilled hats and espadrilles, jostling and pushing one another into the water, the women bobbing up again to expose plenty of cleavage and wantonly streaming wet hair. (The Grenouillère 'coiffure' was much parodied by cartoonists.) Every Thursday evening there was a ball, the *Bal du jeudi soir*. The pontoon was lit up with lanterns. Courting couples spilled out on to the riverbank, to the music of accordionists and the phonograph. High on wine and absinthe, they danced the night away.

★

Back in Paris, Cézanne was painting portraits of Zola and another childhood friend, Paul Alexis. He had spent the previous summer at the Jas de Bouffan, his parents' house near Aix, painting dramatic, erotic works such as *The Orgy* and *The Temptation of Paris*, influenced by Delacroix, the Romantic poets and his own vivid imagination. In early 1869 he returned to Paris, where his life suddenly took a new turn. His friend the painter Armand Guillaumin, a government clerk who painted pale violet and orange landscapes and sketched brilliantly in charcoal, had a nineteen-year-old girl modelling for him. Hortense Fiquet was tall, with black hair, dark eyes and a sallow complexion, a girl from the Jura who had come to Paris with her mother, in search of work. Until now, Cézanne had had something of a love–hate relationship with women, chasing them out of his studio, like Degas, when he could not succeed in transposing their attractions into his work. But something about Hortense Fiquet (the vulnerability of her youth, perhaps – she was eleven years younger than Cézanne, who was now thirty) made him bold enough to woo her.

Hortense was born in Saligny, but she had arrived in Paris as a small child. Her father, probably a bank clerk, had abandoned the family, and Hortense made her living sewing handmade books, and on occasion by modelling. Her mother had died just before she met Cézanne, so she was very much alone in the world. Almost nothing is known about Cézanne's meeting and early years with Hortense, but Zola drew on her for his character Christine, in *L'Œuvre*. In his notes for the character he described a girl 'supple, slim as a reed, but with a full bust and tiny waist. Dark and downy, with black eyes and long eyelashes, a pure, gentle brow and small delicate nose, her most striking quality was her gentleness – a *tendresse exquise*. Childlike and inexperienced, Christine is nevertheless a passionate lover.'

Cézanne's portraits also suggest that Zola took inspiration for his character from Hortense, though the paintings also accentuate a heavy jaw. Cézanne's portraits always make her look slightly sullen, but in fact she was far more animated and volatile than his paintings suggest. She loved to talk: she soon grew tired of posing and resented the long hours during which she was expected to sit rigidly holding a pose. But she did it, sitting silently and somewhat stolidly as he painted and sketched her, filling copious notebooks with her portrait. In *L'Œuvre*, Zola invented and dramatised her first meeting with Cézanne, envisioning the beginning of a passionate romance. In this imaginary version, the character based on Cézanne is restlessly wandering along the banks of the river in the small hours of a hot, stormy July night. In torrential rain, with flashes of

lightning and roaring thunder, he runs through the streets to his lodgings, gains the ancient low, iron-encased door, and is about to reach for the bell-pull when he notices a terrified girl huddled in the doorway. He takes her into his own lodgings, up the rough, wooden steps of the back staircase to his attic studio, and gives her shelter for the night. Exhausted by her race across the stormy streets, Zola's Christine spends her first night in the artist's garret asleep in the only bed, safely tucked behind a screen. She sleeps late into the morning, even through dazzling sunlight. When the artist finally succumbs to the temptation to peep behind the screen he sees a beautiful, sleepy girl, 'slumbering peacefully, bathed in sunlight'. The shoulder-straps of her chemise have come undone, one has slipped off her shoulder, and she lies with her head on the pillow, her right arm folded beneath her, 'clothed only in the dark mantle of her loose hair'.

We cannot know if this is pure invention, or if Zola was inscribing in his fiction the heady, unexpected romance actually experienced by Cézanne. Art historians have noted that after meeting Hortense, Cézanne continued to express sexual torment in his work, if only for a short while longer. But there seems to be little doubt as to the intensity of his devotion to, and fascination with, Hortense, who appears to have quickly decided to move in with him. There would be no question of his taking her back to Provence, where his father (like the fathers of Monet, Sisley and Pissarro) would never agree to his son's living in sin with a penniless girl. Like them, he was likely to cut off his son without a penny if he knew of the liaison. Cézanne returned to the Jas de Bouffan, and Hortense stayed on her own in their cramped lodgings, surrounded by tubes of paint and harsh, violently painted canvases, in the dilapidated backstreets of Paris.

★

In the winter of 1869, Berthe Morisot's sister Edma came to stay at the Morisot family home in the rue Franklin, where she gave birth to her first child. Berthe painted a portrait of her sitting reading on the sofa with Cornélie. Puvis de Chavannes – a celebrated painter and friend of the Morisot family – paid them a call, and began fussing over the head of one of the figures, which in his opinion was not right and probably never would be. Reacting emotionally to his comments, Berthe went to visit Manet in his studio. The next day at one o'clock, Manet arrived in the rue Franklin to give a second opinion. The painting was fine, he said, even very good, except for the lower part of the dress. He took one of Berthe's brushes, and put in a few accents. But 'once started, nothing could stop him; from the skirt he went to the bust, from the bust to the head, from the head to the background. He cracked a thousand jokes,

laughed like a madman, handed me the palette, took it back; finally by five o'clock in the afternoon we had made the best caricature you have ever seen.'

Weeks of anguish followed. Berthe eventually steeled herself to send the painting to the Salon, whereupon she immediately lapsed into despair, working herself up into a frenzy and threatening to make herself ill. By spring 1870 she was still incensed, and determined to get the painting back. Madame Morisot wrote demanding its return, which she obtained; however, they then had the problem of what to say to Manet. Perhaps because of this, the picture eventually went back to the Salon, where it was successfully exhibited.

By now, Manet was very much part of the evolving group. Bazille made a brilliant charcoal sketch of him painting at his easel in frock-coat, top hat, chic slender trousers, immaculate collar and cuffs and fashionable slip-on shoes: the *boulevardier* at work. He and Bazille began to form quite a close friendship. Bazille had moved again, to a rented room in the rue de la Condamine, where he lived with the owner and his family and painted in a two-storeyed studio in the garden. He was still struggling to afford his lifestyle, borrowing money from society hostesses and dining every Sunday with the Lejosnes, whom he had talked into buying one of Monet's still lifes.

Unlike Cézanne, Bazille had not been lucky in love. His parents had given up trying to persuade him to marry; and anyway (like Degas) he thought a painter probably needed to be free of ties to work effectively. He made a large painting of his studio, which shows its huge, light window and staircase to the upper floor: among the friends grouped round the easel and chatting on the stairs were Manet, Monet, Renoir and Sisley. Manet came to visit, and painted in a figure recognisable as Bazille. Fantin-Latour also painted them all, in a different studio (probably his or Manet's), showing the whole group gathered round Manet, who radiates charisma and gravitas, seated elegantly at his easel. Bazille and Renoir painted each other as well: their portraits, in relaxed, casual poses, also suggest easy, intimate friendship.

The solidarity of the group seemed assured; but the painters still faced the problem of how to make an impact on the public. Despite Monet's initial success with his seascapes and his portrait of Camille, the Salon jury had for the past two years been rejecting him and most members of the group. With the exception of Manet, now so illustrious that they dared not reject him, the jury seemed to be making a point of excluding the group. Their problem, Bazille told his father (in an 1869 letter dated 'Vendredi soir'), was Salon judge Jean-Leon Gérôme, a respected

Academician who thought they were 'a band of madmen' and seemed determined to keep them out.

It was Bazille's idea to try to turn that animosity to their advantage. In 1869, an attempt to reinstate the *Salon des Refusés* was in progress. A petition was being circulated, signed by 'all the best painters in Paris'. But everyone knew it was unlikely to make any impact and Bazille, for one, decided he would never submit his work to the Salon again. 'It is really too ridiculous for a reasonably intelligent person to expose himself to this kind of administrative caprice,' he told his parents. The rest of the group agreed. After all, time was passing. It was now seven or eight years since most of the painters had met. The oldest of them (Pissarro) would soon be forty, and even the youngest (Berthe Morisot and Renoir) were both nearly thirty. They decided they would rent a large studio together, where they could exhibit as much of their work as they wished. They consulted Corot, Courbet, Diaz and Daubigny, who all promised their support and agreed to contribute work.

Only Manet made it clear that he would not wish to be involved. He had no intention of being diverted from the Salon. Despite his notorious reputation, he was ambitious. He still wanted medals, accolades and one day, perhaps – like his father – the *Légion d'honneur*. He knew all too well the results of undermining the establishment, and had no desire to court further disaster. Besides, he realised that few other potential outlets existed. In those days there were very few private dealers, though Paul Durand-Ruel, a small, dapper man, still clean-shaven in those days, had just opened a tiny gallery in the rue Lafitte. His father before him had dealt in paintings, and both men had an instinct for talent. Durand-Ruel *père*, moreover, had had a vision. He was a cultured and well-travelled man, able to spot not only a good painting but also a potential connoisseur. His vision of the prototypical future collector was the American in Paris. He had already sold some of the Barbizon paintings to American purchasers, and hoped some day to find an American market for other French works. In 1865, when Durand-Ruel *père* retired, his son Paul inherited the business. Paul's wife, who also had an original eye and shrewd judgement, took an active part in his decisions. Though reasonably prudent she also encouraged him to speculate, and the young dealer was beginning to make a few speculative purchases. For the time being, however, commercial success for Manet and his friends was still a distant dream.

# WAR

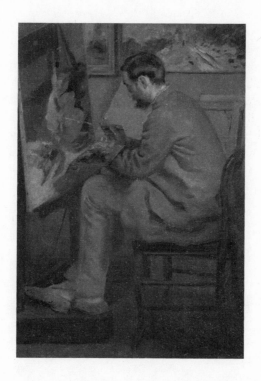

Auguste Renoir, *Frédéric Bazille at his Easel*, 1867

# THE SIEGE

*'I've no intention of being killed, there's too much I still want to do with my life.'*

— Frédéric Bazille

THOUGH MANET HAD NO INTENTION of exhibiting with the group, everyone evidently felt that Degas would be an asset. He had temporarily fallen out with Manet, over a double portrait he had painted of Manet and Suzanne seated together. He made Manet a gift of it and Manet reciprocated with a still life, a simple group of plums, which Degas thought was a fine example of Manet's work. But arriving at Manet's apartment one afternoon, Degas found his own canvas slashed: Suzanne was now headless. Picking up the painting, he left without speaking to them, and returned Manet's *Prunes*. They made it up, on the grounds that 'no one ever fell out with Manet for long'. But when he was invited to contribute to the group exhibition, Degas accepted with alacrity.

Plans were suspended while everyone except Degas, who hated the countryside, left Paris to spend the summer in the country. Bazille went to Méric, to see his newborn nephew and Sisley to Bougival. Monet and Camille were on their way to Normandy, leaving a number of paintings with Renoir for safe-keeping in Louveciennes. On the way, they stopped off at the home of Camille's parents in the Batignolles, where they were married, with Courbet as witness. Despite, or perhaps even because of, Monet's financial worries, Camille was given a modest dowry and her parents' blessing. In Normandy, they crossed the estuary from Le Havre to Trouville, where Monet painted the *Hôtel des roches noirs, Trouville* with its imposing Norman turrets and vast façade. Along the promenade, the fashionable paraded their finery as far as the immense Casino (its glass roof as elaborate as that of the Gare d'Orsay) and the popular *Bains de Mer*. On the beach, huddles of women in vast crinolines sat surrounded by a

muddle of parasols, children, dogs, and all the paraphernalia of the fashionable trying to profit from the sea air while still protecting themselves, in complicated arrangements of muslin, against the sun. Monet painted Camille seated on the beach with her parasol, her face veiled. When the wind blew grains of sand on to the canvas, he left them there. In the blowsy air of early summer, colour, light and air seem to be spun from the figure. The awkwardness of Monet's earlier figures (in *The Picnic* and *Women in the Garden*) had gone; Camille sits, dishevelled by the wind, in the pale sunlight, swathed in skirts and scarves against the sun and wind. The painting has a vivid immediacy: a glimpse of an ordinary moment on an ordinary day.

Pissarro, meanwhile, was in Louveciennes, at the other side of the village from Renoir's parents, where he, Julie and their two boys (aged seven and five) had found a house for rent on the main road to Versailles. Number 22, route de Versailles was a large, grey house with maroon shutters, covered with creeper, with a smaller house in the grounds, on the border of Marly-le-Roi, where in the seventeenth century Louis XIV had his country residence. Louveciennes suited Pissarro, it was quiet and rural, with pathways winding down the hillside from Madame du Barry's château to the river, and vegetable gardens and orchards in the small, adjoining lanes. Julie could grow vegetables and fruit in her own garden, and keep chickens. The weather was warm and sunny, and everyone was in good spirits. Nobody was in the least prepared for what was to come.

Bazille saw one incident in the streets of Paris that seemed in retrospect to have been a kind of premonition. In January, a young, intellectual journalist, Grousset, had challenged Prince Bonaparte to a duel. Infuriated, the Prince had shot down Victor Noir, Grousset's second, who issued the challenge. In the wake of Noir's death came one of the biggest anti-Bonapartist demonstrations in the last days of Empire. The workers took to the streets and Bazille, out watching the scene at two in the morning, got a first-hand glimpse of the republican fervour of the proletariat. Two hundred thousand working men were on their way to Noir's funeral. Bazille and some friends made their way to the place de la Roquette, where crowds had gathered round the guillotine. He was horrified. There were 10,000 people – urchins, filthy old men, criminals, assassins – standing, shouting and singing obscene songs. Some were selling coffee and sausages, and everyone was clamouring for the Prince. There were people in trees, being vigorously shaken down by others. The noise was unbearable, the spectacle abject and frightening. This glimpse behind the scenes of Louis Napoleon's glitteringly successful Empire was a revelation.

The luxury and prosperity of Napoleon's Second Empire was entirely confined to the *bourgeoisie*. Among the affluent, the Court still set an example of splendour, and the wealthy *jeunesse dorée* followed suit. Fortunes were spent on jewellery and costume, everything elaborately embroidered with satin and silk. But such conspicuous prosperity was inaccessible to the working classes whose labour produced such luxury, and who spent sixteen hours a day in dark, unheated *ateliers* ruining their health for a few sous a week. Furthermore, the fashion for ostentatious display was partly strategic: it diverted even the wealthy and powerful from Napoleon's precarious foreign policy. At home, all seemed to be well. Haussmann's newly emerging city of light and the new culture of material wealth were testimony to the success of Empire, played out in receptions, masked balls, plays, the Opéra, and concerts in the gardens of the Tuileries. The Second Empire was apparently more secure than ever before, and Louis Napoleon himself was popular and complacent. But his health was failing. He was suffering chronic pain from gallstones, and his judgement was affected by his physical discomfort. And although his prestige was unquestioned, his power was insecure as long as France remained vulnerable to the pugnacious ambition of King Wilhelm of Prussia and his ambitious ally, Bismarck.

In 1859, France had been the dominant military nation. She had recently won wars over two of her chief adversaries, Russia (in 1854) and Austria (in 1859). But she remained at risk *vis-à-vis* her third adversary, Prussia. In 1858, Prince Wilhelm acceded to the throne. The new regent was a professional soldier, who immediately began to strengthen the Prussian army. In 1862 he appointed Bismarck as Minister-President, and by 1868 had consolidated Prussia's position as the central European country. France still, however, did not really view Prussia as a force to be reckoned with. Militarists nevertheless knew that a Franco-Prussian war was inevitable.

In summer 1870, Bismarck proposed a Prussian successor to the Spanish throne. This made the threat of Prussia's power more real, since France, geographically linked to Prussia in the north-east, and Spain in the south, would thus effectively be encircled by Prussian powers. When news of Bismarck's plan reached Napoleon, he was furious, seeing it as a deliberate insult to France. Bismarck, protesting he had no such intention, immediately withdrew his proposal. There the matter might have rested, but Napoleon was unsettled. Rashly, he demanded an assurance that Bismarck would never again make such a threatening gesture, thus fatally revealing the extent of his insecurity. Instead of sending his assurances, Bismarck decided instead to publicise Napoleon's

request. Incensed, Napoleon rallied the support of Italy and Austria, who signed a secret treaty and on 19 July 1870, France declared war on Prussia.

At first, nobody realised what a major impact the war was to have on the lives of all Parisians. But it was soon clear that those who were unwilling to fight would need to leave the city, along with the women and children of those sufficiently well connected or affluent to have anywhere to send them. A National Guard was being hastily assembled, and all eligible men would be called up. The makeshift, unprepared army would have to compete with Prussia's superbly trained, impeccably organised forces, which by the end of the war totalled some 850,000 men. France could hardly have been less prepared. In theory, there were 250 battalions of infantry and 125 batteries of artillery at Napoleon's disposal; in practice there were cadres and equipment for only a small proportion of those. The men who were called up had no accommodation, equipment or proper uniforms. Military authorities suddenly had to deal with hordes of young men demanding to be housed, clothed and fed. From the start, there was a grave shortage of supplies.

<p style="text-align:center">★</p>

Cézanne wanted nothing to do with any war. Taking Hortense with him, he left their garret at 53, rue Notre-Dame-des-Champs, and made for Aix. Zola, who had recently married, returned to Provence with his wife, heading from there to Marseilles. Monet, still in Trouville, waited for the time being to see how events would turn out. Degas, Renoir, Bazille and Manet, who stayed behind, were all eligible to fight.

Degas joined the National Guard. Renoir had previously been exempted from military service, but he nevertheless had to report to the recruiting office at the Hôtel des Invalides, where he was found fit for duty. Though profoundly pacifist and terrified of gunfire, he was offered a place on the staff of General du Barrail, who was taking his cavalry division to Munich. They would be garrisoned there with blonde German women and excellent beer, he told Renoir. But Renoir's conscience was greater even than his natural pacifism: 'If the fellow replacing me had been killed, it would have haunted me for the rest of my life.' He was duly called up to a regiment of the cuirassiers and sent to Bordeaux where, despite the fact that he had never sat on a horse in his life, he was given a job training the horses. But then he had a stroke of good luck. When he admitted he knew nothing about riding, the NCO referred him to the lieutenant, who passed him up to the captain.

'What is your profession?' asked the captain.

'Painter,' replied Renoir.

'You're lucky they haven't put you in the artillery.'

The captain was a cavalryman who loved horses and hated the thought of their being butchered in the cause of war. His young daughter was passionate about painting, and he came up with an idea:

'You can give her lessons.'

'And I could perhaps learn how to ride a horse.'

'There's an idea!'

Within a few months, Renoir had become an accomplished cavalry-man − a post normally reserved for the sons of the old aristocracy. He proved a good horseman − he treated horses the way he treated his models, he said: he just let them do as they liked, and soon they did anything he wanted them to.

Bazille was also keen to join General de Barrail's staff, according to Renoir because 'he could see himself galloping about on a beautiful horse, dashing through a hail of bullets, and carrying the vital message which would decide the outcome of battle'. Renoir had his doubts; he thought the prospect of a victory for France was by no means certain. He told Bazille he was a fool, but Bazille was undeterred. In mid-August he enlisted in the Third Regiment of the Zouaves, formed in Montpellier. Then he was sent for 'basic training' in Algeria. By 30 August he was in Philippeville, having − due to his 'Montpellier connections' (Commandant Lejosne, in other words) jumped the ranks. He was now classed among the 'experienced soldiers', getting up at four in the morning, cleaning gaiters, peeling potatoes, carrying wood, sweeping floors and, because the canteen was filthy, eating in a café on the beach. 'This brutish life is getting me down,' he wrote home to his parents, 'but it won't be for long.' His accounts of his wartime experience are consistent with descriptions of the Imperial Guard, a reserve force carefully preserved by the French command and, for most of the war, kept well away from the action. By the end of August Bazille was waiting to be posted to Constantinople.

There was no question about what Manet would do. Intensely patriotic, he was unimpressed by Zola's desertion to Marseilles, and scathing about Fantin-Latour, who apparently spent the war hiding in his studio. Manet had no intention of deserting his country; he immediately signed up for the National Guard as a gunner. But he was well aware that Paris could soon become dangerous. He sent his mother, Suzanne and Léon to Oloron-Sainte-Marie, in the Basse-Pyrenees, well out of range of any action. He tried to persuade the Morisot women to go as well, but to no avail. Monsieur Morisot, as Chief Clerk of the Audit Office, was

required to stay in Paris. He felt much as the Manets did. There was no question of leaving Paris himself, but he was exasperatedly trying to persuade his wife and Berthe to leave. His fussing and fretting was getting on their nerves. 'He would drive an entire regiment mad,' complained Cornélie. But 'the thing is, things never turn out as badly as one anticipates, I am not worried; I think we will survive.'

'The stories the Manet brothers tell about all the horrors we are likely to face are almost enough to discourage even the bravest of us,' Berthe wrote to Edma in Brittany. But 'you know they always exaggerate, and at the moment they see everything in the blackest possible light'. She would not like it if her legs were blown off, Manet told her. At first it really did look as though there would be no real danger. She had many nightmares, anticipating the horrors of war in her head, but in the cold light of day she admitted that she did not really believe everything she had heard. Monsieur Morisot was busy removing from their apartment all the valuable First Empire furniture. Why is any of that more valuable than the mirror or the console in the studio? asked Berthe. Soon the house was practically stripped bare. She slipped off to Manet's studio, where he painted her on his red sofa leaning back stiffly on one elbow, grimly avoiding his eye, one foot pointed towards him, the other hidden beneath her white muslin dress, in a portrait he wryly entitled *Repose*.

Towards the end of August, the sound of artillery was discernible near Louveciennes. Julie was six months pregnant, and Pissarro needed to make sure she and their children were safe. On the main road to Versailles, they could hardly have been more vulnerable, and positioned as it was, their house would make an obvious billet. By September it was clear that they would be in danger if they stayed. In a great hurry, with hardly any time to pack, they left, initially for Brittany, where a friend of Pissarro's (a painter who also kept a studio in Montmartre) owned a large farm. Pissarro was fired up by the political implications of the war, unafraid of the fall of Napoleon III's Empire as a possible outcome, and keen to join in the fighting. But with the safety of his wife and children as his priority, he instead spent the autumn picking fruit in Brittany, where he entertained his hosts with his socialist convictions, and his excitement – which nobody shared – at the prospect of a new French Republic.

★

France's political climate was complex. There were shades of grey between the staunch monarchists who wanted the continuance of Empire, and the socialist workers, glimpsed by Bazille in the streets, who were ripe for revolution. Louis Napoleon's deputy was President Louis

Adolphe Thiers, a diminutive lawyer, aged seventy-three in 1870, who since 1863 had been Deputy of Paris. He was a personal friend of the Morisots, and had witnessed both Yves's and Edma's marriages. Thiers's dream was to establish a parliament run by the monarchy, his complaint was that 'le roi regne et ne gouverne pas' (the king rules without governing). Bourgeois and conservative, Thiers was strongly opposed to France's entry into the war, and he had the support of the monarchist majority of the National Assembly. His opponent was Léon Gambetta, another brilliant lawyer, aged only thirty-eight, who had already demonstrated, in successful and high-profile legal cases, his fierce republican, anti-Imperial views. Under Louis Napoleon's Empire, Gambetta – dashing, Byronic, a bit of a celebrity – was the leader of the republican Opposition; he had been elected in Belleville, a working-class *arrondissement*, in 1869. Manet hugely admired Gambetta, whose republican views he wholeheartedly supported despite the Manets' status as land-owning gentry and his own longing for establishment approval. Cornélie Morisot in particular was deeply disparaging of Manet's politics, regarding him as hot-headed and irresponsible, but despite the family's connection with Thiers, she was herself a liberal Bonapartist, concerned for the stability of France rather than, necessarily, the continuance of the monarchist Empire.

In August 1870, the streets of Paris were bathed in glorious sunshine. No one had any real idea what, if anything, was happening, or what to expect. In fact Napoleon – supported by his generals and goaded by his politically ambitious wife, Eugénie – was preparing for attack. On 2 August, French troops captured Saarbrücken, and all Paris rejoiced. But the city rejoiced too soon. This was to be France's only victory, and the war had barely begun. Two days later, the Prussian army swooped down on Alsace. On 18 August, they defeated the French at Gravelotte, on the road to Metz. The real turning point was on 30 August, when the Prussians defeated the French about 15 miles south-east of Sedan. The fighting went on for two days, the French generals determined that they would be victorious. Napoleon himself, in agony from his gallstones, continued to ride through the hail of bullets and exploding shells, hoping only for death with honour. He was on horseback for five hours before he finally had the white flag hoisted in surrender. Immediately he asked to see King Wilhelm, to negotiate peace terms, but his request was refused and orders came from Bismarck, Prime Minister of Prussia, that the entire French army at Sedan should surrender as prisoners of war. He made exception only for the officers, who had to pledge not to take up arms again until the close of the war. The prisoners included

Napoleon himself, who was removed to King Wilhelm's summer palace at Wilhelmshohe.

Communications between Sedan and Paris had been severed, and none of this news reached Paris until two days later, on 3 September, by which time Napoleon had already been driven off into exile. In a matter of days, the Second Empire was over. When news of the surrender finally reached the city, all Paris was up in arms. Crowds collected at every street corner, newspapers spread open beneath every gas lamp.

When the significance of what they were reading sank in, they began to move along the boulevards, waving flags and chanting, 'Down with the Empire! . . . *Dé-ché-ance! Dé-ché-ance! Dé-ché-ance!*' (Abdication.) But that was only the beginning.

By midday the National Guard had begun to collect in the streets. Because the Guard had been thrown together in such haste and consisted simply of all the able-bodied men Napoleon could get, including Manet and Degas, it was permeated with republicans. Categorised by *arrondissement*, it easily became divided against itself. Everyone seemed to be in it, including escaped criminals, drunks and anarchists. Gambetta arrived at the Town Hall, where he installed himself on a windowsill and made a dramatic announcement, appointing himself the new Minister of the Interior. A 200,000-strong crowd gathered outside the Royal Palace of the Tuileries. Princess Eugénie, who had herself only just received the news of her husband's capture, had to make a dash for safety through an underground passage to the Louvre, from where she was whisked out of Paris by her dentist. He smuggled her out to Deauville, and with a forged passport, she sailed to England. She got out just in time. The republican mob flung itself at the newly vacated palace, scrawling *Property of the People* across the entrance. Then they tore down all the street name plates and removed any shop signs on buildings and at intersections bearing the name or Imperial title of Napoleon or Eugénie. The workers of Paris were already celebrating the joyous revolution. No one expected a Prussian invasion: what would be the point, now that the Emperor had been removed?

When the battered army returned from Sedan, they joined the National Guard, who were camped out on the Champs-Elysées and stationed along the fortifications. Meanwhile, the Prussians were about to advance on Paris, and within days, Paris was preparing for a siege. The French force numbered over half a million men and 3,000 cannon. Soon the city was surrounded by an *enceinte* wall 30 feet high, manned by 93 battalions, with a 10-foot moat. The line of forts stretched for almost forty miles. The gardens and stable of the Tuileries were transformed into an artillery park.

The *cocottes* were turned off the streets and into workshops to make uniforms. In the Bois de Boulogne, 250 sheep – enough, it was calculated, to outlast a siege – grazed in preparation. Cabbages, pumpkins and leeks were brought in from the *banlieues*. The Champs de Mars was a heaving mass of troops. There was something of a carnival air, as the glorious weather helped to lull people into a false sense of security. But not for long.

On 4 September, Gambetta was appointed Minister of the Interior in the government of the Défense Nationale, and head of the 'légalistes' who wanted the establishment of the Republic. The same day, the Prussians began their advance. News of the Emperor's defeat and the proclamation of the Republic spread fast. Bazille, 'training' in Africa, was horrified, but nevertheless proud of the idea of a French Republic. About 100 of his 2,000-strong regiment were dressed, equipped and armed for battle. They were 'a filthy, greasy lot', he wrote home to Montpellier. 'I can't imagine where they've all crawled from.' Most seemed to be ex-convicts and rogues, taking advantage of an opportunity for free food and clothing.

In Provence, the authorities were looking for Paul Cézanne, who had failed to enlist. (In Aix-en-Provence, a tiny place, it was impossible to go unaccounted for.) The republicans had taken control of the town, electing Cézanne's father Auguste to the town council, where he appointed his son a member of the Art Committee. Paul Cézanne's failure to enlist was therefore quickly noted. However, in the heat of the Provençal sun, the investigation was not being carried out with any particular earnestness and was abandoned when a search of the Cézannes' property, the Jas de Bouffan, yielded nothing. By the time the search party arrived at the house, Cézanne and Hortense had already fled to nearby L'Estaque, a secluded coastal fishing village. Madame Cézanne, who knew where her son was, put the authorities off the scent, and Cézanne spent most of the war in L'Estaque. Zola hid out with them for a while, and described the haunting beauty of the place, where the pines glow emerald against the hot light, the sea is a lake of brilliant blue, at sunset almost black, and 'the red earth bleeds'.

Back in Paris, Manet was preparing for the worst. 'I think we poor Parisians are going to be caught up in a terrible drama,' he wrote to Eva Gonzales, who had fled to Dieppe. There would be looting and carnage, death and destruction if the situation continued. The militia was everywhere, camped out in billets, including Berthe and Edma's garden studio, and in the squares and boulevards – 'Paris is a sorry sight.' With Edma and Yves both safely in Brittany and her younger brother Tiburce at the Front, there was little for Berthe to do but play the dutiful daughter.

Most other women had been sent away to safety. By 10 September, Manet was writing to Suzanne to ask, 'Why haven't I had a telegram telling me you've arrived? . . . in other circumstances I'd be really worried . . . I'm glad I persuaded you to go – Paris is in a state of abysmal gloom. I'm surprised we have not had to lodge any militiamen, everyone in the neighbourhood has them . . . I've no idea what's going to happen . . . Tell Léon to behave like a man . . . I'll put as much as I can into safekeeping . . . I hope this won't last long.'

The Prussians were still expected any day. 'If there were any risk of fire here,' Manet told Suzanne, 'I would have the pianos moved . . . [but] I don't think the shells will get as far as that.' Two days later, he was already moving the pianos. On 13 September he and his brother Eugène went to the Ministry of the Interior to ask Gambetta if he could find a post for Eugène. Those who had fled Paris, Manet said, would pay for their cowardice when they returned. In Belleville, names of those who had deserted the cause were already being posted in the streets. Manet, Eugène and Degas were at a meeting in the *Folies Bergère*, where General Cluseret, an extreme left-winger, addressed the crowd. There was no doubt about Manet's (nor, somewhat uncharacteristically, Degas's) republican convictions. Already, the 'true republicans' looked ready to overthrow the government.

Manet and his other brother Gustave now went to close up their country house at Gennevilliers, returning via Asnières, which was deserted. Everyone had left, the trees had been chopped down and everything had been burnt; the grain stacks were on fire in the fields. The next day, Manet moved a dozen of his most treasured paintings, including *Le Balcon, Olympia* and *Le Déjeuner*, to the art critic Theodore Duret's cellar in the rue des Capucines. On the outskirts of Paris, rows of white tents littered the country lanes. Approached from the *banlieues*, Paris was a line of yellow ramparts dotted with the little silhouettes of National Guards.

On 18 September, the French advanced. When the Prussians counterattacked through the forest of Meudon the streets of Montmartre were soon filled with French deserters. There were 200,000 Prussians encircling the capital, and on 20 September, the French surrendered near Versailles. Paris was now severed from the rest of France: the siege was set. 'We've reached the decisive moment,' Manet wrote to Suzanne. On guard at the fortifications, he was sleeping on straw, and there was hardly enough of that to go round. There was fighting everywhere, all around Paris. In a hopeless move to try to stem the Prussian attacks, the French military blew up the two bridges connecting Bougival with Croissy,

across the Ile de Croissy (destroying the wooden Grenouillère). But the Prussians soon landed there and 3,000 troops, infantry and cavalry caused terrible damage to Bougival, Chatou and Louveciennes. Sisley and his wife fled Bougival and disappeared for the duration of the war, no one knew where, leaving behind them the paintings of his youth, which were all destroyed.

The French government attempted negotiations with Bismarck. When he announced that his peace terms included Alsace and part of Lorraine, Thiers saw that he would have to arm the provinces. Gambetta was put in charge of national defence in the provinces and plans were made for him to be sent to Tours, to organise the gathering of provincial troops. 'Everyone is furious at Bismarck's response and his outrageous pretensions,' Manet wrote to Suzanne on 24 September. 'Paris is determined to defend itself to the last and I think their audacity will cost them dearly.' On guard, he could hear the guns going all night long – 'we're getting quite used to the noise'. But he was tormented by the fear that none of his news was reaching her. The city's balloons had been hastily rounded up to take mail out of Paris, but found to be dilapidated. For some days they lay in the Bois de Bologne 'like a shoal of injured whales' before being hastily patched up and sent out of Paris, one of them carrying Manet's letters to Suzanne. To everyone's astonishment, they successfully left the city without being shot down. Manet was still hopeful, believing that with the support of the provinces France still had a chance of success.

By 30 September, he had still heard nothing from Suzanne. He continued to write to her, telling her that the siege was lasting longer than anyone had anticipated, and supplies of milk and meat were running short. It looked as if Passy could be bombarded, and the Morisots were finally beginning to consider leaving. 'Paris is now a huge camp,' Manet told Suzanne. 'From five a.m. until evening, the militia and the National Guards not on duty do drill and are turning into real soldiers. Otherwise life is very boring in the evening.' By nine-thirty the streets were deserted. The café-restaurants closed at ten o'clock. The Café Guerbois was open, but more or less deserted. Burning factories created a pall of smoke.

As the numbers of wounded and dead being carried back from the line rose, the anger of the Left was gathering strength. In a meeting at Belleville, 3,000 citizens succeeded in deposing the mayor of the 19th arrondissement. On 5 October, the Belleville and Menilmontant battalions (a 10,000-strong mob) marched to the hôtel de ville to make their presence felt. They were fobbed off. But they had made their first move.

By October, the weather was still warm and fine, with clear, starry nights. Manet warned Suzanne that he could no longer tell her what was

happening, as letters sent by balloon could easily fall into enemy hands.
Degas was posted to Bastion 12, a fortification north of Paris under the
control of his old schoolfriend Henri Rouart. On 7 October, Gambetta
himself was sent out in a balloon, bound for Tours, from a launching pad
high up on Montmartre where the Sacré Cœur now stands. He was
'risking his neck', as Manet remarked in his letters to his mother (the
basket was just waist high, the bag of coal gas highly inflammable; the
whole contraption lurched dramatically, as a large, clamorous crowd
watched Gambetta float away, in frock-coat and top hat, clinging to the
ropes of his basket, bravely trying to conceal his obvious alarm), but 'one
has to take risks'.

A few weeks later, the weather suddenly changed. Women queued for
food in the pouring rain, and smallpox had begun to spread. Mules and
horses were being eaten. Supplies of salt had run out, and children were
dying of scurvy. Gas supplies were short and had been cut off in all the
public buildings. Manet was suffering pain and swelling in his foot,
exacerbated by the torrential rain. Nevertheless he had asked to be
attached to General Vinroy's command, and was disappointed when he
was refused. Alone with a maid in his apartment in the rue de Saint-
Petersbourg, he still longed for his wife, to whom he continued to send
letters by balloon. 'I spent a long time, my dear Suzanne, looking for your
photograph – I eventually found the album in the table in the drawing
room, so I can look at your comforting face from time to time. I woke in
the night thinking I heard you calling me . . . Every day we're expecting
a major offensive to break through from the iron ring that surrounds us.
We're counting on the provinces, because we can't just send our little
army off to be massacred. Those devious Prussians may well try to starve
us out.'

At Le Havre, boats lined up on the quayside to take refugees across the
Channel to England, among them Monet and Camille. Pissarro, still in
Brittany, wrote to his mother Rachel (now living in London) to ask
permission to marry Julie. Rachel gave her permission, but the following
day she wrote and retracted it. She reacted similarly to the suggestion that
the Pissarros should join her in London. At first she thought her son
should definitely flee there to safety, then she decided she would be
unable to support him, and advised him to stay where he was. But she
warned him that he should not even think about getting involved in
French politics. 'You are not French. Don't do anything rash.' On 21
October, still in Brittany, Julie gave birth to a baby daughter, Adèle
Emma. But with all the strain of recent events, she did not recover well
from the birth. She was unable to feed the baby, and a wet-nurse was

hired. Pissarro occupied himself painting the Breton landscape, making studies of desolate-looking farm buildings, grazing sheep and solitary figures.

On Sunday, 30 October Bazille wrote home that he had been posted to the hamlet of Essarts-l'Amour, a few kilometres from Besançon, where he remained more or less oblivious of events in Paris. He had not even had a free minute to take leave to look around Besançon, he was so afraid of missing a departure order. He complained to his parents that he had not seen a single Prussian since he arrived. Apart from the occasional minor skirmish, he felt deprived of action. He was sleeping in a stable for light cavalrymen, attended by a devoted orderly and eating with the captains, lieutenants and sergeants. He had heard that Paris was surrounded by 40,000 men, but apart from that he knew nothing. He would be furious, he told his parents, if he had to return home without seeing a single serious encounter.

At the end of October the French surrendered Metz, and Thiers began to urge his government to accept Bismarck's peace terms: Alsace, part of Lorraine and a war indemnity of two billion francs. Word got round that the French government was prepared to accept peace at any price. The Left were incandescent with rage. On 31 October a storm broke out as crowds gathered on the boulevards, and the National Guard marched in all directions. The rue de Rivoli was packed with people, the crowd – beneath a jostle of umbrellas – thronging towards the *hôtel de ville*, the odd National Guardsman forcing his way through, waving his rifle in the air, shouting, 'Long live the Commune!' The Town Hall was mobbed, with workers dangling from the windows. The government agreed to hold elections, but the mobbing was reported in the press, and Bismarck got hold of the story. When Thiers returned to the Prussian camp to continue the armistice talks, Bismarck told him not to bother: given the activities of the Left, the French government probably no longer even existed. In Tours, Gambetta was determined to fight to the last, shrewdly calculating that the way to gain the support of the rural masses was to offer them the image of a reassuring and moderate republic.

On 7 November, Manet wrote to Suzanne, 'The Armistice has just been rejected, so the war will carry on worse than before – I've often regretted sending you away from Paris, but now I'm glad I did.' He and Degas had joined the artillery as volunteer gunners, and were on manoeuvres for two hours a day up to their ankles in mud. Paris was drenched, as the downpours continued throughout November. Manet, hunched in his military greatcoat, his paintbox and portable easel stuffed into his kitbag, sketched the women queuing outside the butchers' shops, a row of little figures

shivering in the downpour, freezing, feet in the mud, huddled under a line of umbrellas. The worst cruelty for him was not knowing whether any of his letters would ever reach Suzanne. 'I long for the day when I can catch a train and come and fetch you,' he wrote. He was still reassuring her that he was not in any real danger. But hunger was now becoming a terrible anxiety. The Manet family cat had disappeared, to the desolation of the Manets' maid, Marie. Maupassant wrote of sparrows being spirited away from the rooftops, and rats disappearing from the sewers. A newspaper cartoon showed a line of men and women, crouched on their hands and knees in the gutter, apparently in a queue for the drain. The caption read, 'The queue for rat meat'. Manet was lonely and dispirited. 'I don't feel like seeing anyone,' he admitted to Suzanne. 'I embrace you with love, and would give Alsace and Lorraine to be with you.'

By now, the dashing Gambetta in his balloon had arrived in Tours, where he began to marshal the provincial armies. At the same time, the Prussian army was gathering along Paris's Left Bank. The French launched an offensive, but the Prussians made murderous counter-attacks. On 10 November, Bazille, whose battalion seemed to be on an aimless march from Besançon through Dole, Chalon-sur-Saône and Verdun, received news of the capture of Orléans. 'News like this is good for the morale of the soldiers,' he joked in his letter home, 'but to keep them completely in line, one ought to shoot a few of the enemy.' His battalion had just stopped at Saint-Cloud, eleven kilometres from Beaune-la-Rolande. 'We are going to leave in four minutes. Apparently the enemy is nearby; I have just a few minutes to grab something to eat. I feel great. I may finally get to see a Prussian.'

The wounded were arriving back in Paris, driven through the streets in bloodstained horse-drawn omnibuses and along the river in the *bateaux mouches*. The relieving army in Tours had stopped in its tracks. But still the government refused to agree to Prussia's peace terms, partly, now, because of the fear of its own Red mob. Terrible cries of the wounded having limbs amputated could be heard from the Palais de l'Industrie, where only six months ago crowds had gathered in the sunshine for the opening of the Salon. Paris was strewn with wounded who were dying of septicaemia, often complicated by gangrene. Most hospitals had a 'death shed' into which those with septicaemia were moved, to prevent the lethal infection of the other patients. In the Grand Hotel, the biggest makeshift infirmary in Paris, were 500 wounded, moved there from the Palais de l'Industrie in an attempt to save them: they had been dying like flies, since the place was riddled with germs. Without ventilation, the stench was terrible. They lay three, four or five in a single room, 'like biscuits'.

On 7 December, news reached Paris of the defeat at the Loire. 'I think it was our last hope,' Manet wrote to Suzanne. By now there was no fuel, no laundry, and queues for food were a couple of hundred strong, patrolled by soldiers. Supplies were expected to run out before 20 January. In the slums of Clichy, women and children sat on their doorsteps, saying they were warmer there than in their icy houses. Prostitutes sold themselves for a crust of bread. As women and children froze and died, the men raged against the government. By 15 December, Paris seemed to have ground to a halt.

The French decided to try one last sortie out of Le Bourget, scene of the October disaster. The date set was 21 December; Manet was there. He recorded for Suzanne the 'terrible din', with 'shells flying above our heads from all sides'. Once again, the Prussians counter-attacked and the sortie failed. There would be no hope of an armistice by Christmas. By the end of the year, hearses had begun to appear in the streets. There were coffins outside the Madeleine, each covered with a soldier's greatcoat and a wreath of immortelles.

Nobody could get in or out of Paris. There was no news of Sisley or Bazille. Cézanne continued to lie low in Provence. Zola and his wife went to Bordeaux. In Brittany, Pissarro and Julie had suffered a terrible sadnesss: aged only two weeks, baby Adèle had caught an infection from her wet-nurse, and on 5 November the baby died. The tragedy immediately focused Pissarro's feelings. Temporarily he forgot all his political ideals and was concerned only to move his family somewhere completely safe. In December, he travelled with Julie and the two children to Lower Norwood, south of London, to join his mother Rachel and other members of his family. After all this time, Rachel still refused to acknowledge Julie. But the suburban surroundings of Norwood, with its soft colours and winding lanes, were salubrious for Pissarro. He began to paint them, responding to the warm greens, reds and browns of the landscape, even in the midst of melting snow. He painted small, box-like English houses in a living geometry curving across the central horizontal line of the picture frame, fascinated by the constructions afforded by the landscape. In nearby Sydenham he painted the avenue, with a large, tall house on the left and church behind, peopled by promenading ladies with parasols, and a horse-drawn carriage with its drivers seated up high. In the station at Dulwich he painted the country steam train, its single trail of steam cutting a swathe through the landscape. With its grey and white steam and glowing red headlamps, the train dominates the foreground, so that the narrow lanes and geometrical roofs seem to recede into the hillside as the train approaches. The Pissarros arrived in time for Christmas

and the fascinating English holiday traditions: Christmas log and pudding, and festooned, glittering trees.

For Julie, the move was traumatic. She could not believe that the peculiar sounds coming from the mouths of the English could be a language. She was completely unable to master it. Ostracised by Rachel, she stayed in their lodgings at Canham's Dairy, Westover Hill, when Pissarro took the children to visit their grandmother. Pissarro's cousins received her, but coolly, and since she spoke no English she was unable to make friends, or even to bargain for food at the market. In the suburbs of London, not all people were wealthy church-goers who rode in carriages and lived in the large houses near the church. Seven-year-old Lucien was shocked at child crossing-sweepers, and ragged urchins running about barefoot in the snow and slush. They mocked the clogs he still wore, shouting, 'Look! Wooden shoes! Wooden shoes!' But for Pissarro, life in Norwood was peaceful, blissfully safe, convivial and productive. In London he visited the museums and looked at paintings by Constable and Turner, and began to explore, in his own way, the effects of light on the River Thames. Socially, he was far from isolated. In Soho the French expatriates gathered at the hôtel de la Boule d'Or, in Percy Street, and at Audinet's Restaurant in Charlotte Street. Furthermore, Durand-Ruel, the dealer with a gallery in the rue Lafitte, had also fled to London, taking with him, for safety, a huge consignment of works. He set up a London gallery at 168, New Bond Street, and on 10 December opened the first exhibition of the Society of French Artists. In early January, Pissarro sent him a painting. It was charming, said Durand-Ruel. Encouraged by his wife, he asked Pissarro to name his price and send more work, which he did. Durand-Ruel bought two more paintings, of Sydenham and Norwood, and passed on a message: 'Your friend Monet asked me for your address. He is living at 1, Bath Place, Kensington.'

Monet and Camille had arrived in London in October, where they went to live first at 11, Arundel Street, near Piccadilly Circus, before moving to Kensington. Monet had been painting the Thames below Westminster, fascinated by the spectacle of boats disappearing mistily into the greyish yellow fog. He had been trying to sell his work, but with no success, when by chance he met the Barbizon landscape painter, Charles-François Daubigny, who had also fled to London. Daubigny was painting the Thames, too, and *had* been successful in selling his work. 'I know what you need,' he told Monet, 'I'm going to get you a dealer.' The next day, he introduced Monet to Durand-Ruel.

Winter 1870–1 was the bitterest in living memory. In Paris it snowed, and the snow froze over. Into the New Year, three or four hundred shells

a day still rained down on the streets of the city. On 15 January a government session mooted the possibility of surrender. In Belleville, speakers were calling for a Commune, and for a final sortie. In Passy, troops marched past the gates of L'Etoile. The Morisots had heard that their son Tiburce, though in good health, had been taken prisoner at Mainz. On 17 January Manet was back on the ramparts. 'Although I hate being under Military Command . . . it's better than being ill,' he told Suzanne. 'This evening I amused myself by doing your portrait from a photograph on a little piece of ivory. I long to see you again, my poor Suzanne, I don't know what to do without you.' By now, the whole country was covered with dead and wounded. People crossed the street on their hands and knees. The Belleville mob, drums beating, marched to the Town Hall of the 20th *arrondissement*, and pillaged all the food and wine. The leaders of the Left took up position in front of the building, and for the first time the French began firing at one another. Thiers now decided he would have to obtain an armistice, or face civil war.

On 18 January, King Wilhelm of Prussia, surrounded by German princes and generals, was proclaimed German Emperor at the Palace of Versailles. Paris fought bravely on, but not for much longer. Ten days later, after a four-month siege, the capital surrendered. The streets were eerily silent. The government immediately requested an armistice, and three weeks' truce was allowed for the election of an assembly to negotiate peace terms. 'It's all over,' Manet wrote to Suzanne on 30 January. 'I'll come and fetch you as soon as I can, and I'm longing for it.'

It was not until 12 February that he received some terrible news. On 20 November, during a minor attack on Beaune-la-Rolande, Bazille had been killed. He had not died 'romantically, galloping over a Delacroix battlefield', as Renoir put it, but 'stupidly, during the retreat, on a muddy road'. In the freezing weather, Bazille's father made the journey to Beaune-la-Rolande. For ten days he dug in the snow-covered battleground, looking for his son. Eventually he found his body. He hauled it back to Montpellier himself, on a peasant's cart.

# THE PARIS COMMUNE

*'Make way for the people!'*

O
N 8 FEBRUARY 1871 THE government's National Assembly was formed, with Thiers elected Head of Executive Power. The Assembly was a monarchist majority elected by rural France against the republican spirit of the metropolis, and it therefore alienated the working people of Paris immediately. The four-month siege had left the capital in a state of economic collapse. There were food riots when traders began profiteering by bringing out hidden stocks, and widespread unemployment. Thousands of demobilised soldiers wandered the streets in search of food and shelter, most of them living on the 1 franc, 50 centimes daily pay of the National Guard, which had become a form of unemployment pay. The first acts of the Assembly abolished this payment and authorised landlords to demand back-payment of all rents. The workers of Paris were incensed. The government had starved them, surrendered their country, and now seemed to be about to ruin them. Manet was furious with the government, 'doddering old fools, not excepting that little twit Thiers who I hope will drop dead one day in the middle of a speech and rid us of his wizened little person'.

Despite all his efforts to negotiate, Thiers had been forced to accept the Prussian peace terms: the handover of Alsace and Lorraine, and an indemnity of five billion francs, payable over a period of three years, during which time Prussian troops would occupy French soil. As a result of wily legal negotiations, Thiers managed to pay off the indemnity after just two years: he did so not only by securing substantial foreign contributions and loans, but also by collecting contributions from his populace and lifting wartime moratoria. In practice, having secured their victory, the Prussian soldiers had little interest in occupying the capital and did so in a desultory way. But there was more than a principle at stake for

the workers and unemployed of Paris, who faced the prospect of continued starvation.

When the Left began to form popular clubs, called 'republican' or 'vigilance' committees, the government effectively began to lose control over the capital. By the beginning of 1871, left-wing committees had already formed themselves into a delegation of twenty *arrondissements*, with a view to ousting the government of National Defence and installing a Commune. A central committee of all twenty *arrondissements* was set up, together forming the Commune of Paris. They now drew up their demands, which included elections for a municipal council, the abolition of the Prefecture of Police, that judgeships be made elective and that all restrictions on the right to hold meetings and form associations be removed.

On 6 January 1871 there were already 140 signatures to the *Affiche rouge*, the Commune's first official statement. 'The policy, strategy, administration of the government and all similar continuations of Empire are condemned,' it read; 'make way for the people! Make way for the Commune!' In late January and early February the vigilance committees joined forces with the Trade Union Federation and the International to form the 'Revolutionary Socialist Party'. In fact this was not a particularly strong force, but what really alarmed the government was the rapid assimilation by the militant Left of the demobilised National Guard, fired up with feelings of resentment and betrayal, who now began to form the core of the Paris Commune. The guardsmen had mostly whiled away their time during the siege drinking, smoking, playing cards and gossiping. (Berthe Morisot later – unfairly – remarked that Manet had spent most of the war changing his uniform.) But now, with no income, no work and no way of paying their rent, the unemployed and working-class National Guard were ready to fight.

On 1 March Napoleon III was deposed as Emperor and formally held responsible for 'the ruin, the invasion and the dismemberment of France'. Paris was in a state of devastation, and many businesses were ruined. From the Pyrenees, Manet wrote to Duret asking to borrow money, since 'this dreadful war will have ruined me for years to come, I'm afraid'. Renoir, deeply shaken by Bazille's death, left Paris for his parents' house in Louveciennes, to recover from dysentery. No one had seen anything of Sisley. His father's business had gone to the wall, and Sisley would never recover the family wealth. Broken by the war, his father died shortly afterwards.

When it was announced that the Prussian troops would occupy the district of Passy (so far the only district targeted), the National Guard at

Belleville declared they would fire their guns as the Prussians entered. The French militia was ordered out, and took up station on the banks of the Seine. Passy was in turmoil. A policeman was subjected to two hours of torture then drowned by left-wing rebels, as he begged for mercy and pleaded with them to blow his brains out. When she heard stories like this, Cornélie Morisot told Edma, she began to hate the Prussians less. Having survived the siege, the Morisots decided they would now have to leave Passy, and began to make preparations to move to Saint-Germain. In the streets of Paris, the shops were closed. Again, everyone seemed to be waiting. People stood watching at their windows; all the boulevards and the rue Royale were deserted. A few token Prussians entered an almost silent Paris. They found empty streets, and the façades of the town halls in all twenty *arrondissements* decorated with black flags. Signs on the locked shutters of cafés and bars read, 'Closed for national mourning'. The half-hearted Prussians simply wandered away after a few days, but to the Left, the occupation, however nominal, symbolised France's apparently total defeat and the loss of the nation's pride. The new Republic was unpopular and widely regarded as incompetent. Thiers – who was not elected President until May – was not even a proper head of state. In the minds of most Parisians, the responsibility for France's defeat rested squarely with the government.

Thiers realised that his only hope of controlling the capital was to disarm the National Guard. He had only 12,000 troops, and the National Guard numbered several hundred thousand. To secure the loans he needed to fulfil the peace terms, he had to have the confidence of the people, and with the absorption of the National Guard into the Commune he was rapidly losing all credibility. Moreover, he now faced the real threat of civil war.

<p style="text-align:center">★</p>

While Paris prepared herself for another crisis, Monet and Pissarro were still in London. In January, the Prussians had approached to within forty or fifty miles of Montfoucault and captured Le Mans. Soon they were shelling Louveciennes. On 22 February, a neighbour of Pissarro's warned him, 'your blankets, suits, shoes, underclothes you may go into mourning for – believe me. Your sketches . . . will be ornaments in Prussian drawing rooms.' By March, the Pissarros' house had been turned into a slaughter-house. Their neighbour's wife broke the news to Julie in London: the roof was smashed; the front door, staircase and floor had disappeared. The enemy had kept horses in the house, built sheep-pens in the kitchen and killed sheep, poultry and rabbits in the garden. They used Pissarro's

canvases, ripped out of their frames, as butchers' aprons and as floor coverings to catch the blood. After the soldiers left, the neighbour managed to save forty paintings and (a much greater triumph, in her estimation) the Pissarro family clock. But there had been about 1,500 paintings in the house (including some of Monet's). The best part of fifteen years' output was lost.

# 'THE WEEK OF BLOOD'

*'. . . picked a fine time to ask for her painting materials . . . Paris is on
fire!'*

— Cornélie Morisot

THE GOVERNMENT'S ATTEMPT TO capture the National Guard's
cannons early on Saturday, 18 March was the spark that lit the
May revolution of 1871. The plan was to occupy strategic points
in the city, capture the guns and arrest known revolutionaries. Thiers and
some of his ministers went to Paris to supervise the operation and sent
troops to Belleville, Butte-Chaumont, Menilmont, the Bastille, the *hôtel
de ville*, and a larger group to Montmartre – a prime site since the cannons
of the *Butte* overlooked all Paris. The troops arrived silently at dawn,
cordoned off the *Butte* and made their way to the Château-Rouge dance
hall and the Solferino Tower. By 4 a.m. the cannon were seized, but as
they had no horses there was no way of actually removing them.

When the citizens of Montmartre woke up and realised what was
happening there was an uprising. On hearing the news that two of his
generals had been shot, Thiers immediately decided to evacuate the
capital. That morning, he withdrew his army to Versailles, leaving Paris in
the grip of insurrection. Manet was incensed. 'We're living in a miserable
country where people are only interested in overthrowing the
government in order to join it. There just aren't any disinterested people
around, no great citizens, no true republicans . . . These people will
succeed only in destroying public perception of the sound idea that was
just beginning to gain ground, namely that the only government for
honest, peaceful, intelligent people is a republic.' Cornélie Morisot, for
once, agreed with him. 'Paris does not want to be tricked out of its
republic,' she wrote to Yves in early March. 'It wants the real thing, the
republic of the communists and disorder . . . There is nothing more
shameful than the conduct of these men of Belleville and Menilmontant,

who are only brave enough to fight their own countrymen, just to plunder and gratify their own passions.'

Twenty thousand guards were camped in the sun near the *hôtel de ville*, with the red flag flying. On 22 March, 800 pro-government protesters marched through the rue Vendôme shouting 'Down with the Committee! Down with the Assassins!' When the National Guard hit back, there was massacre. On 26 March, the Commune was formally declared at the *hôtel de ville*. Gustave Courbet, France's most controversial realist painter (who had witnessed Monet's marriage) stood for election in the sixth *arrondissement*, gaining sixth place. As one historian has noted, 'there were now two governments in France'.

On 2 April, unarmed marchers went to the Place Vendôme to seize the post of the National Guard. They were met with gunfire and twenty-five men were killed or wounded. Courbet was made Director of Museums, but his new appointment did nothing to dampen his republican convictions. On 16 April he was formally inducted into the Commune of Paris, and plotting to bring down the Column of the Vendôme, a plan Renoir found incomprehensible: 'he could think of nothing but the Vendôme Column. The happiness of humanity depended on its being pulled down.' Soon, the Communards were attacking Thiers's troops at Versailles. When on 17 April the Commune elected forty-seven artists to a central committee, many were nominated without their consent; some were not even in Paris. To his great embarrassment Manet's name was included; it was the one honour he vigorously refused, as did Félix Bracquemond and Jean-François Millet. The Communards by no means had the support of everyone – by mid-April about 700,000 people had left Paris.

Thiers's infantry had been moving on Paris since the beginning of April. On 1 May, his artillery began to bombard the city. Berthe Morisot's brother Tiburce was in the front ranks of Thiers's troops, and thought it unlikely that their forces would be strong enough to suppress the Communards. Most of the Grand Hotel was now closed, the windows padded with mattresses and barricaded with cannons. For Berthe, now in Saint-Germain, all this was the last straw. She asked if she could stay with Edma in Cherbourg, and if it would be possible to work there. She realised she must sound heartless, but she was at the end of her tether with enforced idleness. At Saint-Germain the sound of cannon could be heard all day; all she longed for was to be able to paint again. On 2 May, she left for Cherbourg.

Cornélie was also soon lamenting that 'Edma has picked a fine time to ask for her painting materials! Everything has surely been pulverised.' On

Sunday 21 May, as the Morisots were at lunch, Thiers's army entered Paris by the Porte of Saint-Cloud. Suddenly, there was a terrible hubbub in the streets, a rumbling of carriages over cobbles, people running, cavalry squadrons galloping, and cries going up. The call to arms – 'the great, tragic, booming notes of the tocsin being rung in all the churches' – was sounding all over Paris, drowning out the noise of drums and bugles. Cornélie Morisot got up from the table, flung down her napkin and ran into the street, where she saw Henri Rochefort being escorted to Versailles. Three days later, Thiers's troops began to suppress the Communards. The next day, a shell exploded on the Madeleine. The explosion was felt in Passy with such force that the Morisot home in the rue Franklin seemed about to collapse. The window panes were broken, the curtains fell to the floor in a heap of plaster; pictures tumbled from the walls. Dust and stones showered down over the whole district. Everyone was saying that once Paris was taken Thiers would resign, and without him there would be nothing to restrain the reactionaries. Ironically, the Communards would have returned Paris to a full-scale national monarchy. Prussian soldiers played music on the terraces as the Communards destroyed Montmartre. Shells fizzed, fragments of debris fell; houses were being blown away. The gunboat fired continuously. The 'week of blood' – *la semaine sanglante* – had begun.

'Paris is on fire! This is beyond any description,' Cornélie wrote to Edma on 25 May. After a month-long drought, a gale force wind was blowing across the burning city. Throughout the day, the wind kept blowing in charred papers: the Bank of France had been destroyed. Some of the papers were still legible. A vast column of smoke covered Paris; at night an eerily luminous red cloud hung over everything, like a volcanic eruption. Still the shooting went on. The Tuileries was reduced to ashes. The Louvre survived, but the Cour de Comptes (on the site of the Gare d'Orsay) was burnt down, its documents scattered to the winds. The Palais de la Légion d'honneur, the Conseil d'Etat and the Palais de Justice blazed like torches. 'Should Monsieur Degas have got a bit scorched,' remarked Cornélie, 'it will have served him right.' The *hôtel de ville* was ripped open from end to end. Tiburce Morisot (*père*) said he would like the debris to be preserved, 'as a perpetual reminder of the horrors of revolution'.

Forty thousand prisoners, divided into lines of seven or eight and tied to one another by their wrists with string, were marched to Versailles to be sentenced to death by the government. Courbet was court-martialled, and according to Manet, he 'behaved like a coward'. On 27 May Monet, in London, received false reports that he had been shot without trial, and

told Pissarro he thought the Versailles army had behaved shamefully. 'It's frightful and makes me ill. I don't have the heart for anything. It's all heartbreaking . . .' (In fact Courbet was imprisoned and heavily fined. Six years later he died in exile in Switzerland.) Those who escaped execution were imprisoned or deported to the penal islands. Edmond de Goncourt, passing the railway line at Passy, saw the prisoners lined up waiting to be marched to Versailles, their hair plastered to their faces by steady rain. They included men and women of all classes: he saw women in kerchiefs alongside some in silk gowns. On the late afternoon of Saturday, 27 May the National Guard took refuge in Père Lachaise Cemetery. Government troops followed, and the fighting went on all night amongst the tombs. At dawn on 28 May, the last of them were shot with their backs to the wall that became known as *le mur des Fédérés*. At least 20,000 Communards had been killed in the fighting or executed on the spot. About 1,000 of Thiers's soldiers were dead. By 31 May, there were tricolours in every window and on every carriage. Those who had fled Paris began to return to their twice-devastated city.

Renoir returned to Paris some time in early May, and only just escaped being killed. He set up his easel on the banks of the Seine and sat watching the yellow and gold of the sun on the water. He paid no attention when a group of National Guards stopped to look at his work. Deciding it was probably a plan of the area being drawn up to inform Thiers's troops, they hauled him off to the Town Hall of the sixth *arrondissement*, where there was a firing squad on permanent duty. As he was taken away to be shot, Renoir happened to notice a man in full dress uniform, a tricolour sash round his waist, surrounded by equally resplendent staff. Despite his military dress, Renoir recognised him as a stranger he had encountered, a few years earlier, in the forest of Fontainebleau. Renoir had been painting the forest when suddenly a young man, dressed in rags, had staggered out of the bushes. He told Renoir he was Raoul Rigaud, a republican journalist being hunted down by the authorities. Renoir gave him an artist's smock and painting kit, and told him to pretend he was a painter. Now, in the Town Hall, Renoir managed to attract his attention and Rigaud, now the Commune's Head of Police, immediately recognised him. When he rushed forward to greet Renoir the mob changed its tune. Renoir was led through two lines of soldiers to a balcony overlooking the square, where crowds had already gathered to watch the execution of the spy. Rigaud made them sing the 'Marseillaise' for 'Citizen Renoir', and Renoir leaned over the balcony making little embarrassed gestures of acknowledgement. He was given safe conduct passes and allowed to go free. Rigaud's act of kindness was almost certainly his last. On 24 May,

aged twenty-four, he was shot dead in the rue Gay-Lussac, where his body lay unattended for two days.

★

Manet returned to Paris in early June. His studio in the rue Guyot had been destroyed, but he was able to rescue some paintings and to collect the ones he had left in Duret's cellar. He took a new studio space next door to his apartment, on the ground floor of 51, rue de St Petersbourg, where Léon (now nineteen) lived, at the top of the road, near the Place de Clichy. He was still shocked by his experiences, fractious, tense and unwell. But on 10 June he contacted Berthe: he wrote that he was glad that her house in Passy had been spared, and hoped, as did his brother Eugène, that she would soon be back from Cherbourg. As they travelled back from Saint-Germain by riverboat, the Morisot parents gazed in anger at the remains of the Audit Office, the Hôtel de la Légion d'honneur, the Orsay barracks, and the ruins of the Tuileries. The Louvre had been nicked by projectiles. Half the rue Royale was demolished; the city was littered with the remains of devastated houses. 'It's unbelievable,' Cornélie told her daughters, 'you rub your eyes, wondering if you are really awake.'

Back in Paris Cornélie visited Manet, but found herself 'unable to say anything . . . except in a casual way. Really, that family is most unprepossessing.' Manet seemed tetchy and argumentative, openly picking fights with Eugène and assuring everyone that the only man worth supporting was Gambetta. As far as Cornélie was concerned, this made him practically a Communard: 'when you hear talk of that sort, there's no hope for the future of this country.' She attended Madame Manet's Thursday *salon*, but grumbled to Berthe and Edma that the heat was stifling, the drinks were tepid and the conversation was limited to 'individual accounts of public misfortunes'. Degas was there, but he looked fast asleep. Manet kept asking if Berthe was really coming back, or if she had found a new admirer. Suzanne, who was playing the piano, had somehow undergone a dramatic weight gain during her stay in the Pyrenees. Cornélie remarked to her daughters that Manet must surely have 'experienced a great shock at the sight of this bucolic blooming' – the size of poor Suzanne (who had always been plump, but from now on seemed to grow steadily plumper) obsessed the Morisots. But Cornélie was tired and disgruntled. 'All the cackle of these people seems very stupid and very boring after the upheavals we have just gone through . . . I think France is very sick.' In fact, Manet was still suffering badly from trench foot and nervous exhaustion. Eventually, he collapsed and was advised by

his friend Dr Siredey to get out of Paris. He went to Boulogne, a place he had always loved, where in the sea air he began to recover.

In late June, the Pissarros returned to Louveciennes. On 14 June in England, Pissarro had married Julie, at Croydon Register Office. No member of the Pissarro family was present; their witnesses were members of the French community who gathered in the cafés around Durand-Ruel's gallery in Bond Street. Both Pissarro and Monet had benefited hugely from their fortuitous meeting with Durand-Ruel, who now seemed set to become their principal dealer. In some ways, the future looked promising. But the return to Louveciennes meant going home to a scene of horror. The house was filthy with excrement and scraps of bloodied canvas. The Prussians had used Pissarro's paintings, the neighbours now revealed, not only for butchering animals but for other 'low and dirty tasks.' Village women washing clothes at the local laundry had also been seen wearing painted canvases as aprons. Julie, pregnant again, started to put their house in order. Pissarro plunged into his work, painting Louveciennes and Marly. The Monets returned to Paris in the autumn. They took up residence in the hôtel de Londres et de New York, just behind the Gare Saint-Lazare, and Monet took over a studio his friend Armand Gautier was renting in the nearby rue d'Isly. They sent an invitation to the Pissarros: Camille Monet was keen to see Julie.

★

Berthe returned from Cherbourg in the autumn, sorry to have left it now that the weather, after a cool summer, had turned beautiful and warm. 'She could have worked as much as she likes,' remarked Cornélie to Edma, 'at least, so she says.' Manet was back in town, and talking about painting Berthe again. 'Out of sheer boredom,' Berthe told Edma, 'I shall end up by suggesting it myself.' Despite his brief, pre-war flirtation with Eva Gonzales, Manet still seemed to be fascinated by Berthe. Back in Paris, he was keen to resume their sittings, and their subtle mutual attraction continued, undeclared but undeniably powerful, especially for Berthe. His magnetism irritated her since he appeared to be able to exert and withdraw it at will. Her sister Yves and her daughter Bichette were staying with the Morisots in Passy, and Berthe was trying to paint them, but she was getting tired of it. 'The composition looks like one of Manet's. I can see that, and it annoys me.'

The news from London was that there, painters were making money. Fantin-Latour and James Tissot, friends of Manet and Degas, were both making a fortune from their scenes of fashionable English life. 'They tell me you're making a mint,' Degas wrote from Paris to Tissot. 'Do give me

some figures. Within the next few days I may make a flying visit . . .' But there was money to be made in Paris too, from the right kind of painting. Manet's friend Alfred Stevens stood to make 100,000 francs in 1871, and had bought a large house, at 67, rue des Martyrs, where he was doing up a lavish studio in the latest Chinese style. Manet asked Stevens to hang one or two of his (Manet's) own canvases in his studio, as Stevens was attracting wealthy collectors.

Painters were beginning to realise that there was money to be made through the new dealers. Berthe had already made a sale or two through a dealer. But Cornélie was sceptical. Degas was hugely complimentary, but a few compliments from fellow artists seemed to have gone to Berthe's head. 'Are they really sincere?' Cornélie asked Edma. 'Puvis has told her that her work has such subtlety and distinction that it makes others miserable . . . Frankly, is it as good as all that?' Furthermore, how was any of this supposed to help her marriage prospects? 'Whenever she works she has an anxious, unhappy, almost fierce look . . . This existence of hers is like the ordeal of a convict in chains, and I should like to enjoy greater peace of mind in my old age.'

She was concerned for Berthe's future, and confided her worries to Edma. 'We must consider that in a few more years she will be alone, she will have fewer ties than now; her youth will fade, and of the friends she supposes herself to have now, only a few will remain . . . I know that now the activity and artistic milieu of Paris hold great attraction for Berthe. She should be careful not to yield to still another illusion, not to give up the substance for the shadow . . . How I wish the dear child had all this turmoil of feeling and fantasy behind her.'

<div align="center">★</div>

The Commune was eventually liquidated, and Thiers regained control of the capital. 'They were madmen,' said Renoir of the Communards, 'but they had in them that little flame which never dies.' When the full extent of the arson and killings was revealed, friends of the defeated became scarce. Degas, whose allegiance with the Left had sustained him through his own experiences in the National Guard, was (as one biographer has remarked) 'like an actor who stands still while a change in the scenery puts him in another place'. In many ways, that was to be the story of Degas's life. Either drastically or subtly, the events of 1870 and 1871 changed everybody. For Renoir, in particular, it was a time he would always be reluctant to talk about. Many years later, he still brooded over the memory of Bazille, 'that pure-hearted, gentle knight'.

# FORMATIONS

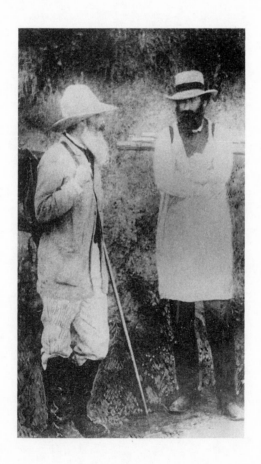

Camille Pissarro and Paul Cézanne, c. 1874

# RECOVERY

*'A good woman. A few children of my own. Would that be excessive?'*
— Edgar Degas

B Y JANUARY 1872 GOVERNMENT forces had regained control of Paris, and the city slowly began to recover from the devastation of the war. The politics of the new Republic, monarchist in its leanings, took no account of the Far Left. The remaining leaders of the Commune were tried by court-martial and executed or imprisoned, including Courbet. (The following year, in July 1873, he fled to Switzerland.) Thiers was successfully securing foreign loans to pay off the war indemnity, and German occupying forces were gradually withdrawing eastwards towards the new border of France and Germany.

The economic reparation created a temporary boom, in which some businesses flourished. The dawn of the new Republic was marked in Montmartre by the construction of a startlingly white cathedral, the Sacré Cœur, funded by public subscription, which was being built high up on the *Butte* near the site of Gambetta's unforgettable departure by balloon. In Clichy, Haussmann's reconstruction continued, and streets around the Gare Saint-Lazare were being renamed to symbolise France's position at the centre of Europe: St Petersburg, Parme, Berne. Renoir went out to paint the fashionable crowds as they crossed the Pont Neuf. He sent his brother Edmond on to the bridge to waylay pedestrians with bogus enquiries, so that he could sketch them as they passed.

On 15 January, Edmond de Goncourt noticed 'a block of private carriages in the rue de la Paix, like the ones outside the *Théâtre-Français* on a first night. I was wondering which great personage had so many important people flocking to his door, when I looked up above the carriage entrance and saw the name: Worth. Paris has not changed.' For Charles Worth, Paris's most celebrated couturier, the business boom created exciting new opportunities. He abolished the crinoline with its

'hangman' structure and yards of heavy silk, and introduced a collection of new, svelte lines, ruched tight across the waist and hips and gathered behind in a bustle. Sleeves were very short, worn with long, tight gloves, and necklines were cut wide and low. Berthe Morisot was photographed in one of the new dresses, looking haughty, sulky and very seductive.

Other businesses, however, were ruined by the war. Sisley's father's emporium was destroyed, and the Parisian branch of the De Gas family bank suffered significantly. But the changed economic climate created new opportunities for buying and selling art. As Renoir remarked later, 'the golden age of the middle man, the buyer and seller, the shrewd dealer, now began.' The big industrialists, who had replaced the nobility as the new, commercial aristocracy, were rapidly being joined by a proliferation of successful merchants. Picture dealers were refurbishing their shops, restyling them as 'galleries'. Durand-Ruel opened a second gallery in the rue Lafitte, a street adjacent to his first, in the rue le Peletier. Before long, the rue Lafitte was being nicknamed 'the alternative Salon': it seemed to consist more or less entirely of small galleries. Durand-Ruel and other enterprising dealers began to buy directly from artists, to build up their stocks by name, and to establish artists' reputations, rather than simply purchasing individual paintings as they had in the past. Durand-Ruel was keen to extend his network of artists and was already holding public exhibitions in his galleries. He was gambling his capital, prepared to take risks, on the lookout for new, avant-garde works, and using all the latest marketing tactics.

In January, hoping to recreate in Paris the success he enjoyed in London, he visited Alfred Stevens's sumptuous studio, where he saw two of Manet's paintings, *The Salmon*, a still life luscious with pink flesh and shimmering silver scales, and *Moonlight over the Port at Boulogne*. Durand-Ruel paid 1,600 francs for the two pictures and took them back to his gallery in the rue Le Peletier. The next day, he went to the rue de Saint-Petersbourg to see Manet in his studio. He bought twenty-three canvases, for a total of 35,000 francs, and asked to see more. A few days later he was back, buying another 16,000 francs' worth of paintings. By 15 February, Manet had received 15,000 francs on account. The next afternoon, he was in the Café Guerbois. 'Do you know of a painter who can't make 50,000 francs a year from his pictures?'

'Yes, you!' came the reply.

Well, you're wrong, said Manet: he had just sold over 50,000 gold francs' worth in a single week. He would not have cash in hand, however, as Durand-Ruel always paid artists in instalments.

Through Manet, Durand-Ruel met Degas, and began to buy his works

too. Claude Monet's friends looked like safe bets for a prosperous future. Monet had seemed to be firmly established in Gautier's rue d'Isly studio, which for the next two years was rented in the name of 'Monnet'. His new affluence had made him personally as well as professionally ambitious, and he was keen to find a place to live where he could continue to paint out of doors, yet still have access to Paris and his new studio. Through Durand-Ruel, Manet and Monet had begun to get to know one another better, and the elder painter put the younger in the way of an opportunity. Because of his family property there, Manet had influential friends in Gennevilliers and in Argenteuil, just the other side of the river. He put Monet in touch with the widow of the former mayor of Argenteuil, Madame Aubry, who agreed to let him one of her houses for an annual rent of 1,000 francs. He moved to Argenteuil, with Camille and Jean, just before the New Year.

<p style="text-align:center">★</p>

The villages and small towns of the *banlieues*, built in a patchwork around the loop of the Seine, varied hugely in size, architectural appearance and general ambience. Most of them were predominantly rural, serving the city with agricultural produce grown in market gardens and brought in by train to Les Halles. Each village had its speciality: Bougival's cherries; Argenteuil's figs, melons and asparagus; Gennevilliers's cabbages, pears and onions (greatly enhanced in size and appearance since 1868, when a new drainage system was established, pumping across the fields of Gennevilliers all Paris's sewage). But increasingly, the land was also being industrialised. Among the prosperous new factory owners in the suburbs was Degas's old school friend, Henri Rouart. Argenteuil, north of Paris, where the Seine joins the Oise, was the most heavily industrial. It was linked to Paris by two railway lines, which terminated in the Gare Saint-Lazare and the Gare du Nord, and dominated by factories producing plaster, railway stock and chemical works, the factory chimneys belching out smoke across the land. Though its market gardens were fertile, its associations were more industrial than rural, and the town was regarded as at the height of its prosperity. On the boulevard Heloïse were large houses built in grand style, and Parisians flocked to Argenteuil to attend the summer regattas, where they gathered on the riverbanks and patronised the town's chic restaurants.

Increasing numbers of workers were pouring out to the *banlieues*, where rents were cheaper, the air was healthier, fresh food was more readily available and conditions were more sanitary. At harvest time, men slept in the fields, hoping to be on site early enough to find employment in the

morning. Many of them had originally migrated to Paris from the provinces (Normandy, Brittany, Bourgogne) in search of labour, then, with Haussmann's clearing operation, gradually been moved out again. But it was not only poor labourers and industrial workers who inhabited these suburban villages and towns. For a long time, the suburbs had represented gentility: wealthy Parisians – the Manets, for example – owned land and country estates; and with the rise of the middle classes, more modest *manoirs* and country villas were springing up. A new trend was emerging: the middle classes, with apartments in Paris, were renting small houses with modest gardens in the *banlieues*, which after several years they would hope to buy. They spent the week in Paris, moving out to their country houses for the weekends. Monet's house in Argenteuil, at the foot of the rue Saint-Denis (today called the boulevard Karl Marx), parallel to the railway, with the river visible from his garden, thus placed him within the orbit of the rising, property-owning middle classes.

Monet's house was spacious, with parquet floors, French windows, and a ravishing country garden teeming with colour in summer. He could stand on his lawn and watch the boats coming and going, and all the activity of the riverside. On sunny days, a table was spread with a glistening white cloth beneath the large horse-chestnut tree, and the family lunched out of doors, little Jean playing on the grass. Monet painted the scene, with Camille's hat hanging in the bough of the chestnut tree, its ribbon trailing from the branches. Both of Argenteuil's railway bridges had been destroyed by the Prussians, and though there was still scaffolding on the railway bridge being rebuilt nearby, you could cross it, and Monet would walk over and set up his easel on the Gennevilliers side of the river.

The spring of 1872 was fresh and radiant. Gardens and orchards seemed to bloom all at once. Sisley and his wife Marie-Eugénie, back in Paris after the war, visited Monet and Camille in their new country home, and Monet painted Camille and Marie-Eugénie among the apple blossoms. Suddenly, there was enough money to buy a small boat. To Manet's great amusement, Monet had a wooden cabin built on it and set it up as a small floating studio, just big enough to take his easel. Manet painted him in his studio boat, knees drawn up, hat brim turned down, floating on the river, absorbed in painting the water. Inside the house, Monet painted Camille through the French windows, framed by the open, russet-coloured shutters festooned with flowers. She wore pale pink and blue dresses that summer, with little white collars and pretty hats all decorated with flowers. In some paintings, posed against the banks of flowers, she seems to rise up from a haze of pulsating colour.

Further downstream, beyond Gennevilliers, just beyond the site where the pont d'Argenteuil had been destroyed by the Prussians, was a secluded reach and the arm of the river encircled a small island where boats were moored and hired. Here, Monet came in his studio boat to escape the smoke and bustle of the town itself, and paint the reflections on the water. Sisley and sometimes Manet came to join him. For Monet, these were halcyon days. At Argenteuil, all that summer and the next, he painted the Seine and his garden, Camille seated peacefully under the trees, little Jean riding his horse-tricycle down the garden path. Renoir visited often. That spring, Renoir's companion Lise Trehot had suddenly married a rich architect, and Renoir no longer had much desire to spend his summer days in Marlotte. At Argenteuil, he and Monet resumed their old habit of painting the same views seated side by side. Life was beginning to change for the better; 1872 seemed to be a year not only for recovery but also for putting down roots. In June, Monet's father died and he received a small inheritance, and at the end of the year the first semi-annual payment of interest on Camille's dowry was due to be made. (She received 300 francs of interest on a capital of 12,000 francs, invested at 5 per cent a year.) Prosperity no longer seemed an impossible dream.

The Argenteuil regattas were enormously popular, drawing large crowds and keen yachtsmen. In summer 1872, Gustave Caillebotte sailed his yacht from his family's summer residence at Yerres to Argenteuil, where he made the acquaintance of Monet. Caillebotte, twenty-four, a serious, fine-boned young man with large, deep-set eyes, was reserved, *sportif* and very wealthy. The Caillebotte country estate, where he spent the summer months with his parents and two brothers, was a large, fashionable pastiche of an eighteenth-century château. In Paris, the Caillebotte family lived at 77, rue de Miromesnil, one of Haussmann's grand new avenues in the affluent financial district, near the vast, elaborate Town Hall of the first *arrondissement* and close to the boulevard Haussmann. The Caillebottes' neighbours included Georges Bizet, Gabriel Fauré and Marcel Proust, all of whom led glittering social lives and held celebrated salons for the rich and famous. But the Caillebottes played no part in this world. They prided themselves on their discretion, restraint, and on the fact that they had made their fortune through hard work. Their apartment in the rue de Miromesnil, with none of the flashy ostentation of their neighbours, signalled tasteful and serious wealth through its very austerity. Caillebotte's brother Martial (a gifted pianist and composer) was Judge of the Tribunal of the Seine; Grandfather Caillebotte was a lawyer. The entire family was humourless, strait-laced and very proper. As Bazille had, Caillebotte was studying medicine to please his family, though he was an

exceptionally talented painter, who initially had artistic ambitions. He had studied art at the Ecole des Beaux-Arts for a while, but became disillusioned. Before he met Monet, he had given up painting and spent his leisure time making skiffs, which he raced in regattas on the river. (He was also a skilled boatbuilder.) But meeting Monet revived his passion for his art. He began to paint again, producing finely drawn interiors and scenes of modern life. Monet, evidently seeing that he had talent and potential, introduced him to the other members of the group.

Durand-Ruel continued to exhibit and promote the work of the group, and for a while it looked as though their financial troubles would be solved. This turned out to be too much to hope for. Soon after he and his wife returned from London Madame Durand-Ruel was taken gravely ill, and in spring 1872 she died. Without her to counsel him, Durand-Ruel began in the months following her death to massively over-purchase. At first, Monet was among those who benefited. Of the 12,000 francs he earned in 1872 for the sale of 38 paintings, 9,800 francs (for 29 paintings) were through Durand-Ruel. Most of these paintings remained in store for many years. Moreover, there seemed to be no sign of the balance of 20,000 francs Durand-Ruel still owed Edouard Manet.

On 1 July 1872 Manet took over the lease of a new studio, still in the rue de Saint-Petersbourg, this time on the ground floor of number 4, at the foot of the road, close to the Gare Saint-Lazare. It was a vast space (a former fencing school), softly lit by four large windows with balustrades, overlooking the rue Mosnier (now the rue de Berne) on one side, and on the other, the pont de l'Europe. The interior was elaborate, with sunken oak panelling, high ceilings with gilt mouldings, and a roofed gallery with open arches along the sides, its large bay concealed by a satin curtain. It was so close to the station that the air seemed to be permanently filled with smoke, and the ground shook and trembled as the trains roared past, punctuating Manet's sittings with shrieking whistles. He was busy furnishing it with a piano, a green garden bench, a Louis XV console table and cheval mirror. The wall was cluttered with paintings – Le Déjeuner sur l'herbe, Olympia, Le Balcon, and a colourful portrait of a clown. In the corner, backed by a vast, green Japanese tapestry of birds and flowers, was his crimson sofa, covered with cushions. (The clown, when he came for sittings, stood incongruously in the middle of the room, in his clown's costume, amidst all this luxury.)

Two weeks after moving in, Manet gave a studio-warming party, where Berthe was one of his principal guests. He was in his flirtatious mode, telling her how much he wanted her to pose for him and talking excitedly about all his successes with Durand-Ruel. With Suzanne back at

his side, he was his old self, confident again in his powers of attraction and rediscovering his love of women, which Suzanne, all her life, tolerated philosophically — as did many nineteenth-century wives. (She may also have been disinclined to criticise him, given the discretion with which the Manet family had handled her marriage and the upbringing of her son.) She herself was fond of telling the story of how she watched her husband unobserved as he pursued a beautiful stranger down the street. When he turned back and realised Suzanne was watching him, he told her, 'I thought she was you.' Soon, Berthe was making her way across Paris alone, travelling from Passy to Clichy along Haussmann's broad, tree-lined avenues, past the Etoile, along the avenue Victor Hugo and onwards to the rue de Saint-Petersbourg, where she stepped down from her carriage and made her way into Manet's resplendent new studio.

He posed her sideways, cross-legged on a studio chair, and holding close to her face a black Spanish fan, spread wide, the spokes suggestively covering everything but her mouth. As she lifted her arm, the transparent, gauzy black fabric of her sleeve fell to her elbow, revealing bare, white flesh. She wore pink shoes, her right foot pointed to reveal her ankle almost to the calf. In the portrait, Manet emphasised her pink shoes, to draw attention to her exposed lower leg and naked forearm. The portrait is teasing and seductive, fraught with subliminal desire. When he had finished it, he painted her again, standing this time, one hand clasped to her throat (as if holding together, or about to undo, the collar of her robe), one foot, still in pink, provocatively exposed.

Manet was fascinated by the eloquence of a tellingly placed foot. 'You can deduce everything about a woman from the way she holds her feet,' he once said to Mallarmé. 'Seductive women always turn their feet out. Don't expect to get anywhere with a woman who turns her feet in.' The background of *Berthe Morisot with a Fan* (1872) is blood-red, painted in bold, wet streaks, and the position of the figure, off centre, draws attention to this visceral swathe of colour. All the indisputable eroticism of Manet's aesthetic is distilled into these portraits. In *Berthe Morisot with a Pink Shoe* (1872), she stares directly at the painter, demonstrating her uncanny ability (as Paul Valéry, who married her niece, later put it) to *voir le présent tout pur.* In his paintings of Berthe, Manet was exploring something new, searching, in this nuanced connection between painter and model, for the *sensation élémentaire,* the *sensation de vivre* which Valéry elsewhere equated with the *frisson* of being in love. In *Berthe Morisot Reclining* (1873), painted a few months later, the element of seduction is unmistakable. Her dark eyes seem to follow the viewer round the room, and her reclining pose is indisputably provocative.

How to describe that depth charge of desire? Years later, Valéry alluded to it discreetly in a posthumous appraisal of his 'Tante Berthe', in which he included a digression on the apparently fundamental celibacy of the artist's soul. In this, he suggested that the aesthetic sensibility, the *mode sensible*, as he called it – teeming with unconscious references and coincidences – might actually be the level at which the artist lived most vividly. In a separate appraisal of Manet, Valéry acknowledged Manet's great gift (his 'triumph'), and reflected on the central paradox of his vision: the driving desire to tell the truth, together with his 'sensual and *spirituel* transmutation' of things on to canvas. Manet both recognised his and Berthe's profound mutual attraction and, at some deep level, originated it in his art.

In July 1873, Berthe's sister Edma gave birth to a second daughter. Berthe painted the new mother, pale and fragile in a dark dress, leaning over the cradle, and depicted her subtle vulnerability. August was approaching, but Berthe was reluctant to spend the summer as usual, with Edma and her children. Instead she was considering going to the Basque country, to stay with her elder sister Yves. No solution seemed ideal, least of all the prospect of staying in Paris after most everyone had left for the country. Manet and Suzanne were about to revisit Holland, the scene of their honeymoon. There would be nobody left in town.

For the last five years, Madame Morisot had been sporadically pressing suitors on Berthe, to absolutely no avail. By now, everyone except Degas seemed to be married, or at least in love. Even her younger brother had recently married. Berthe received no shortage of attention, but nobody seemed quite suitable. She had vaguely imagined herself as a single, independent artist, but there were very few precedents for successful single female artists, and that life was in any case looking less and less attractive as time went by. Cornélie was exasperated, still complaining to Edma that this desire for independence was a mere illusion, an ambition Berthe would surely bitterly regret when, in a few years' time, she found herself alone. Berthe had one acquaintance, the notorious 'Marcello', who had made a virtue of being single, but she was regarded as a 'willful eccentric'. (Some just called her a lunatic.) Anyway, on the evidence of her complicated feelings for Manet, Berthe was a romantic. She clearly wanted to be in love.

Pierre Puvis de Chavannes had been a prospect since 1868. At forty-eight, he was seventeen years Berthe's senior, but in many ways he was more than suitable. Respectable, and from an affluent family, his work (though initially mocked and misunderstood) was now accepted by the establishment, his mythological scenes adorned the walls of the Panthéon,

and he had the *Légion d'honneur*, but as a potential lover he was never quite convincing. Even Madame Morisot was in no hurry to insist on him as the final choice. Another possibility was Manet's younger brother Eugène, with whom Berthe had been friendly since 1868. The summer they met, there had been talk of their taking a scandalous trip by themselves to Bordeaux, a place Edouard loved. The elder brother had been all for the idea, hoping it would end in scandal and force Berthe to marry Eugène. He wickedly alluded to this plan when Madame Morisot paid him a call. She found him at his easel painting a portrait of his wife, 'labouring to make of that monster something slender and interesting'. He talked about the seaside idea as he continued with his painting. 'He claimed he had wanted to arrange it so as to compromise the two of you,' Cornélie told Berthe in dismay, 'so that you would become his sister-in-law.' The hapless Suzanne had exclaimed, ' "I would so much have liked to have Mlle Berthe as a sister-in law!" . . . What a case! He's mad, he has no common sense.'

The plan was obviously out of the question. And yet, something about it went on niggling at everyone, while Cornélie went on inventing reasons why it could never succeed. The Manets' politics were too radical; she had heard rumours of illness in the family. The problem was that the couple had not begun a romantic attachment early enough in their acquaintance. It was obviously all Berthe's fault: 'having wanted to think things over or chase after the realization of a dream, you were left with neither enough strength of character nor enough independence of heart to feel committed to each other.' Yes, it was surely out of the question. 'I would prefer someone else,' concluded Cornélie, 'even if he were less intelligent, and from a less congenial background.' But who?

Eugène Manet was reconsidered. 'I keep telling Berthe not to rule him out,' Madame Morisot told Edma, though she admitted she thought him indecisive, unreliable and 'three-quarters mad'. But 'everyone agrees that it's better to marry and make some sacrifices than to remain independent and in a position that is neither one thing nor the other'. She suggested Eugène pay them a call. Berthe hesitated, and when Eugène arrived at the appointed time, he found only young Tiburce at home. Still, Madame Morisot could not let go of the idea. A seaside holiday was again mooted, this time in the form of a jolly trip involving both mothers, which meant that Berthe would be amply chaperoned (and the couple could be scrutinised for suitability). The Manets began to talk about Saint-Valéry-en-Caux. The plan came to nothing. Eventually, Berthe decided to spend the summer with Yves in Saint-Jean-de-Luz, a tiny fishing village on the Spanish border.

Saint-Jean-de-Luz was not a success. No sooner had they arrived than Berthe was longing to leave. There was nothing to look at and no one to talk to; she spent her time writing letters to Edma: 'I do not like this place, I find it arid and dried up. The sea here is ugly. It is either all blue – I hate it like that – or dark and dull.' The temperature was unbearable (even in a remote fishing village she would have been encumbered with petticoats and hoops), and at night she struggled with fleas: 'I have never in my life seen so many.' All she wanted was to be back on the Ile de France with Edma. They went to Bayonne, which seemed slightly more pleasant, but back in Saint-Jean-de-Luz, 'everything is in full sunlight, and basically, nothing is very nice'. Everyone seemed to speak Spanish (which she neither spoke nor understood) and there was nowhere for fashionable society to meet. There was one consolation, however. 'Heaven knows,' she told Edma, 'I don't have to protect myself or be afraid of admirers. I am surprised at being so unnoticed. It is the first time in my life that I have been so completely ignored.'

Back in Versailles, Puvis de Chavanne still held out a glimmer of hope. He had asked Berthe to write to him from Saint-Jean-de-Luz and she did so, sharing with him her frustration, her boredom, the lack of society, and her intolerance of the intense heat. 'I pity you for having so much sun,' he replied. 'A quarter of it would drive me insane. I hate nothing so much as that light which like a merciless spear pierces your eyes, your ears, in short, everything; it is just like those flies which also know exactly where to attack you.' He could imagine her there, he told her, in a white house with brown shutters. Really, things were no better for him. 'I am so busy that at night I collapse on my bed like a dog.' No, not exactly the most romantic of suitors.

A few days later, the temperature dropped a little and Berthe ventured on to the beach, where to her surprise she found some very elegant people. But that was not right either: they would be bound to consider her out of their league. There was, moreover, no question of her being able to paint the place. 'There is constant sun, good weather all the time, the ocean like a slab of slate – there is nothing less picturesque than this combination.' Eventually, Yves came up with a plan. They would go to Madrid and see the Prado. They contacted Manet, who put Zacharie Astruc, the painter who had first shown Manet round the city, at the sisters' disposal.

In Madrid they visited the museums, looked at the Spanish Old Masters, and saw all the Goyas and Velázquezes admired by Manet. The city itself interested Berthe not at all; as far as she was concerned it had no character. But 'the gorgeous Astruc' was good company. At the end of the

summer, she was back at Maurecourt with Edma, relieved to be with her favourite sister and painting again in the familiar, cool, light of the Ile de France. She painted Edma, baby Blanche, and three-year-old Bibi as she ran across the grass, chasing butterflies. In Paris, she visited Manet the day before he left with 'fat Suzanne' for Holland, finding him 'in such a bad mood that I don't know how they'll get there'. He told Berthe he had given her address to a rich client who wanted pastel portraits done of his children. She spent the rest of the summer paying visits to Edma in Maurecourt, and worrying about whether she dared ask the rich gentleman for 500 francs per portrait.

★

It was now more than ten years since most of the group had arrived in Paris and signed up at Suisse's and Gleyre's studios. In 1872, with no secure prospect of regular purchasers or dealers, the group seemed more likely to disperse than to consolidate, especially as the painters all became caught up in their respective private lives. By autumn 1872, both Pissarro and Monet had moved out to the *banlieues*. Pissarro was living in Pontoise, a rural, medieval town on the River Oise. Where despite the proximity of the sulphur factory there were still market gardens and orchards, and windmills ground the local flour. The family had been forced out of Louveciennes: their house had been so badly damaged that the cost of repairs made it impossible for them to stay there. In fact, the move was fortuitous since Pissarro loved Pontoise, where winding paths down the wooded, terraced hillsides offered fascinating shifting perspectives, vivid with red roofs and green, tangled foliage. Because he needed to remain visible to Durand-Ruel and other dealers, Pissarro also took a studio in Pigalle. On nights spent in Paris, he slept in his studio, and passed many hours in the Café Guerbois, quietly listening to Manet and the others and contributing the odd, carefully considered word. When Cézanne occasionally turned up in the café in his filthy blue trousers he would find Pissarro there, ready to talk to him.

Cézanne and Hortense now had a young baby, Paul, born on 4 January 1872 at their home in the Jussieu district, where the wine barrels rolled across the cobbles in the early hours of the morning, making 'a clatter to raise the dead.' When Cézanne's childhood friend Achille Empéraire (a dwarf whose head put Cézanne in mind of a cavalier by Van Dyke) came from Aix to visit, he was shocked by their solitary life. Cézanne seemed to be 'abandoned by everyone. He no longer seems to have an intelligent friend.' There was no going back to Aix, moreover, as the news of baby Paul was being kept from Cézanne's father. But in Pissarro, Cézanne had

a loyal friend. In the Café Guerbois, Pissarro introduced him to Paul Gachet, a homoeopathic doctor, brilliant, eccentric, with a startlingly pale face and wild, yellow-dyed hair, who that spring had bought a large country house for himself and his family in Auvers, just across the river from Pontoise. (A few years later, Van Gogh painted him there, remarking that even his hands were blond, 'like a pale carnation'.) Gachet specialised in alarming predictions: he announced that Renoir's friend Georges Rivière, a young journalist, should prepare for a grisly death at twenty-five, from gangrene of the facial bones. 'Gachet believed it absolutely.' (Or perhaps he just had a quirky sense of humour.) But he was compassionate, kind and, like Pissarro, understood the demands of small children.

Pissarro invited Cézanne, Hortense and baby Paul to Pontoise for a visit, during which they could also see Dr Gachet in Auvers. Cézanne and Hortense both got on well with Julie, and Cézanne enjoyed teasing the Pissarro children, who would always remember his 'large, black eyes, which rolled in their sockets at the least excitement'. Life in Pontoise was extremely noisy, overcrowded and eventful. Pissarro's mother Rachel, who had been ill that summer, was being cared for there by Julie, whom she still could not abide. Rachel was demanding and temperamental. Sometimes she could not contain her own irritability, and hit Julie with her stick. Julie also had to feed her husband, Rachel, the children, and their frequent visitors, and as Pissarro loved to be surrounded by other artists, the house was usually full. When Zola and his wife arrived, they were treated as honoured guests: Julie gave them a live mother rabbit, about to give birth.

Along with her other responsibilities, Julie also attempted to organise Pissarro's career. Concerned for his commercial prospects, she identified some local collectors and invited them to dinner, which she served wearing her best silk dress. Half-way through, Cézanne arrived, still wearing his filthy work clothes and scratching himself all over. 'Please forgive me, Madame Pissarro, it's these fleas again.' Pissarro made frequent journeys to Paris, where he worked in his studio and visited dealers, and Cézanne was supposed to be doing the same, but he loved Auvers and Pontoise. He lingered so long with Julie and the children one evening that he missed his train to Paris, where he was supposed to join Pissarro. Cézanne and Pissarro's son Lucien sat down together at the kitchen table and composed an explanation: 'I take up Lucien's pen at an hour when the railway should be transporting me to my *penates*. In other words, I've just missed my train. I don't need to add that I'm your guest until Wednesday. So, Madame Pissarro asks you to bring back from Paris some

milk powder for little Georges, and Lucien's shirts from his Aunt Félice. Goodnight, Paul Cézanne.' The pen was passed to Lucien, who added, 'My dear Papa, Maman wants you to know that the door is broken so come quick because robbers could come, please bring me a paintbox. Minette [Jeanne] wants you to bring her a bathing suit. I am not writing well as I don't feel like it. Lucien Pissarro, 1872.'

Auvers, where Cézanne and Pissarro visited Gachet, consisted of little more than one village street containing a few thatched houses, the Town Hall (a pretty building, like a doll's house) and artisans' shops. In a street winding away from the main street up into the hillside, set in its own small park, was the Château de Léry, and up the sloping hillside in the other direction was the medieval church. (Van Gogh later painted this at an angle, from the road beneath; it is therefore instantly recognisable, and seems to consist of evocatively jutting angles.) In adjoining lanes were small, low artisans' cottages in crumbly grey stone, the verges tumbling with irises, purple-blue against the pale stone. The place was essentially rural: photographs of the period show rustics with pitchforks posing for the camera in ankle-length labourers' smocks and hobnail boots; someone took a photograph of Pissarro and Cézanne with two friends, posed against a grassy wall, with a distant glimpse of blurry trees. They too carry huge sticks, and stand surrounded by painting equipment, but they are dressed in shirts, collars, trousers and waistcoats, felt hats, smart boots and shoes. One of them even has a bow-tie. They must have cut quite a dash among the locals.

Dr Gachet's house was set in the hillside above the main street, with a terraced garden full of flowers and looking down into the valley of the Oise. The house and garden were always full of stray cats, chickens and a ragged, featherless ancient rooster. In the attic, Gachet painted, drew and etched (his particular passion). He had his own printing press, and made etchings of the heads of cats, birds and the human skull. This skull – rather worn round the jawline – he kept in his attic, together with his bottles of sodium choloride, sulphuric acid and ammonium, two startlingly large syringes, and two small clay models of cats. In the garden, he worked at a table painted bright orange (later immortalised by Van Gogh, in his *Portrait of Dr Gachet*).

Cézanne went often to the Gachets' house, where he joined Dr Gachet in his studio or painted still lifes using flowers from the garden. In the surrounding lanes he painted hillsides, setting up his easel at bends in the narrow roads and studying the unusual geometry of the place, where the lanes converged as they wound round the hillside, houses appearing at odd angles at their intersections. In Auvers he painted *La Maison Penn'du (The*

*House of the Hanged Man*). There was no hanged man, this was Cézanne indulging his boyhood passion for word-play: the house's Breton owner was a Monsieur Penn'du. Looking down the terraced hillside towards the Oise valley, the hill slopes down in shades of deep green, broken by the occasional tall poplar. In spring, the slopes were scattered with spangles of blossom so that everything was bathed in a warm, blue light. Cézanne loved this landscape and, for once in his life, began to feel settled.

From Pissarro he learned to move outside the turmoil of his imagination. Pissarro taught him to control and harmonise his powerful emotions, and discipline his observations. Pissarro, now over forty, became something of a father figure, working painstakingly with Cézanne, who – somewhat astonishingly – listened to his advice. In Norwood, Pissarro had studied closely the geometry of landscape, with its complex construction of lanes, roofs and descending rows of houses. In Pontoise and Auvers, he shared these insights with Cézanne, who finally stopped seeing the art of painting as a kind of tortured, visual romantic poetry. He began to take radical new steps forward in his art. With Pissarro, he discovered his own method of modelling forms and blocking in colour, using colour rather than contour to determine geometric form.

'Lighten your palette,' Pissarro encouraged him, as Diaz had once advised Renoir. 'Paint only with the three primary colours and their derivatives.' He taught Cézanne to look at the reverberations of light and air, and to watch these rhythms at play with form and line, encouraging him to forget about 'accurate' drawing. Forms did not have to be drawn, they could emerge, if one would only look at the landscape and paint what he saw – 'the essential character of things'. When Cézanne seemed unable to leave a painting alone, Dr Gachet would tell him: 'That's enough now, you can't improve on that, just leave it.' (Gachet was one of the first admirers of Cézanne's work, and became his first purchaser.) Surrounded by friends, Cézanne began to feel less turbulent and tormented. By the end of the autumn, he and Hortense were already thinking about making their home in Auvers.

★

In September, Berthe returned to Paris to face the prospect of another solitary winter with her parents. After the war, the Morisots had moved to an apartment at 7, rue Guichard, a large, Haussmann-designed building, newly built in 1869, with wrought-iron balconies and huge double entrance doors, in a narrow road leading directly off the rue de Passy on the edge of the Bois de Boulogne. In her new neighbourhood

Berthe was the object of much curiosity, with her dark, burning eyes, artistic leanings and aura of mystique. She had little or nothing in common with women of her own social milieu, and was lost without the companionship of her sisters. She was soon back in Manet's studio, where he painted her looking wintry in her dark, outdoor clothes, the fine black net of her hat veiling her mouth and chin, the black ribbons of her hat (like the one seen on a chair in *Le Déjeuner*, Manet's still life/portrait of Léon) muddled with her dark hair, in a state of subtle disarray.

He called this painting *Berthe Morisot with a Bouquet of Violets*, though at first glance the bunch of violets can barely be seen. It nestles at the clasp of her jacket, adding to the impression that her clothes have been hastily reassembled. Perhaps Manet himself pinned the violets (which usually signified a love token) to her coat. This time, he posed her against a plain grey curtain on a white ground, the neutral ground dramatising the effect of the blacks and accentuating Berthe's aura of mystery, huge eyes and '*distraite* and far-away look'. Paul Valéry always believed that in this painting Manet found his poetry, interpreting in it Berthe's subtlety, dissonance and complexity, detecting in her something *retiré*, dramatic and quasi-tragic. But it was in his depiction of her eyes that Manet worked his most essential magic. Her eyes, as recalled by Valéry, were 'almost too vast, and so *puissamment* deep, that Manet, capturing their magnificent, moody darkness, forgot the greenish colour they actually were, and painted them pure black'. Before or after she left his studio, he arranged her bunch of violets next to the red fan she had held closed, in *Le Balcon*, together with an unfolded billet-doux, on which he wrote a simple inscription, 'To Mlle Berthe . . . E. Manet.' Then he painted this composition, in a simple still life. After she left him, Berthe realised he had made no mention of a promise he had made earlier, to show one of her recent paintings to Durand-Ruel. 'I am keen to earn some money,' she told Edma, and 'beginning to lose all hope . . . I am sad, sad as can be . . . What I see most clearly is that my situation is impossible from every point of view.'

<p style="text-align:center">★</p>

Late into the evening, Paris was teeming with people. Everyone gathered in the cafés, bars and café-concerts, small rooms cluttered with tables, with a small stage at one end, hung with a red plush curtain which jerked back to reveal singers and dancers gaudily got up in tight satin costumes and long black gloves. Degas, particularly, adored these places. His brother René was in Paris, visiting from New Orleans, where their mother Celestine's older brother Michel Musson had settled with various

members of the De Gas family, making a prosperous living from cotton manufacture and their share in one of Louisiana's banks. René was keen to explore the night-life of Pigalle, and fascinated by the café-concerts, where the audience drank absinthe, and singers with heavily painted faces belted out idiotic popular songs. Degas, enchanted by his brother's deep Southern drawl, was trying to learn the accent. His favourite phrase was 'turkey buzzard', which he had been practising for a week.

René had arrived in the summer, and found his brother living in a 'delightful bachelor's apartment' at 77, rue Blanche, alone with the flirtatious Clotilde (his cook and housemaid). At the time, Degas was painting a society portrait of a woman in a garnet-coloured dress: 'a pure masterpiece,' René wrote home to his wife, 'his drawing is ravishing.' But he was anxious that Degas, now thirty-eight, seemed heavier, with grey streaks in his hair, and was probably working too hard. Always anxious about his eyes, he was nevertheless working on small pictures, which tired him and exacerbated his eye-strain. He was full of curiosity about New Orleans, 'pondering all sorts of things about the natives and tireless in his questions about all of you,' René told his wife Estelle. 'I really think I'll bring him along.' Gradually, the idea of a visit to New Orleans began to take shape – an opportunity for Degas to meet the nieces and nephews he had never seen. At this point, his housemaid Clotilde dramatically announced that her dream was to go to America. Her window of opportunity swiftly closed, though, as René decided she was 'too intelligent a girl not to drop us very quickly, find a rich husband, and set herself up in a cookshop of her own'.

In early October, René and Degas left Paris for London, where they booked their passage to America and visited Durand-Ruel's gallery in New Bond Street. Degas was still convinced that England was the new buyer's market. He looked up Agnew, a London picture dealer, and went to Chelsea to visit Whistler, who showed him his work: 'that fellow Whistler has really hit on something in those views of the sea and water that he showed me.' But the more British art Degas saw, the more convinced he became that French art was the more distinctive, 'simple and bold'. His prediction was that once the French naturalist painters had sharpened and developed their draughtsmanship, the value of their work would ultimately be recognised – a view that none of his friends in Paris, least of all Pissarro, shared.

Later that month the Degas brothers went to Liverpool, where they set sail for New York, *en route* to New Orleans. Degas was most impressed by the sleeper cabin, 'a marvellous invention . . . you lie down at night in a proper bed . . . and even put your shoes at the foot of the bed [to be

polished] while you sleep'. The sea voyage to New York took ten days, a long time to be among the English – 'such reserve.' But on 11 November they finally arrived in New Orleans, and were greeted at the station by the entire family: Grandfather Achille looking over his spectacles, accompanied by all René's children (including one inscrutably aged 'twelve to fifteen months') and their cousins, six in all. 'Ah, my dear friend,' Degas wrote home to his friends in Paris, 'what a good thing a family is.'

The De Gas family home was an immense mansion on Esplanade Avenue, where the comings and goings of New Orleans itself (political disruption, carpetbaggers, and continuing slavery, despite its largely nominal abolition) were not apparent. Many years later, Degas told the dealer Ambroise Vollard about Fontenelle, the Negro he met on the family plantation.

'How do you suppose a rascal like that ever came by such a fine name? But he wasn't satisfied with it. The minute the cannon was fired to announce the end of slavery, "Monsieur" Fontenelle went straight to town and had some visiting cards printed with his new name:
CHARLES BRUTUS
Coloured Free man.
Then the newly freed man hurried back to his master's for supper, anxious to be home in time to serve the soup.'

In Esplanade Avenue, nothing had changed since the days of the plantations. The avenue was lined with palms, elms, live oaks and magnolias, and palatial houses built by the early Creole dynasties. Michel Musson's house, where René and his family lived, was elaborate and grand, with an ornamental cast-iron gate and fence, a lawn planted with flowers and magnolias, and a two-storey veranda with elegant columns. The entire extended De Gas family seemed to live there, in separate apartments on three floors. Degas was given a room in Michel's apartment, and a second-floor gallery, running the length of the house's façade, to paint in. He was soon put to work painting everybody's portrait, the work hampered by wriggling children, impossible lighting, and nobody taking it seriously.

René's wife Estelle was blind, and Degas was awed by her. He painted her seated, her voluminous skirts deflecting the effect of her obviously sightless eyes. He wrote home frequently to his friends, musing in his letters on the possibility of a new future, one he had never really contemplated before: 'a good woman. A few children of my own, would that be excessive . . . ? It's the right moment, just right.' If not, he supposed

his existence would simply continue in the same old way, 'but . . . filled with regrets.'

In Louisiana, he saw 'villas with columns in different styles, painted white, in gardens of magnolias, orange trees, banana trees, negroes in old clothes like characters from *La Belle Jardinière*, . . . rosy white children in black arms, . . . a brilliant light which strains my eyes.' The tall funnels of the Louisiana steamboats could be seen from the end of the main street, and he was fascinated by the local steam-powered streetcars. But most of all, he liked looking at 'the negresses of all shades, holding in their arms little white babies, so white, against white houses with columns of fluted wood and in gardens of orange trees'.

He admired 'ladies in muslin draped on porches at the fronts of their little houses, . . . shops bursting with fruit, and the contrast between the lively hum and the bustle of the offices with this immense black animal force'. He observed that the women of New Orleans, 'even amidst their charms', had 'that touch of ugliness without which, no salvation' – which did nothing to diminish their gracefulness. The beauty of the black people made a deep impression on him, he revealed in his letters to Tissot: 'The black world, I have not the time to explore; there are some real gifts of colour and drawing in these forests of ebony. It will seem amazing to live among white people when I get back to Paris. I love silhouettes so much, and these silhouettes walk.'

But there was too much to take in. Paradoxically, the hot colours and profusion of subjects made him long for the cool concision of his old subjects: the distillation of muscles in movement – ballerinas' legs, laundresses' arms – against the tawdry colours of flickering gaslight, the cool, grainy texture of unlit, plain greyish-white walls. The Southern light was almost too powerful to see in, let alone to transpose into paint. 'What lovely things I could have done if the daylight were less unbearable to me,' he wrote home to friends in Paris. He would need far fewer stimuli, to distil what he saw into even one good drawing: 'art does not expand, it repeats itself. One can only collect oneself by seeing little'. He was reminded of the story of Rousseau, who retired to Switzerland to paint, got up every day at dawn, began a work that would take him ten years, and was forced to abandon it after ten minutes: 'my case exactly'. With his eyes only half open, he had seen more than he could ever take in. 'Manet would see lovely things here, even more than I do. Even he would not make any more of them . . . Well then, long live fine laundering in France.'

One morning as he lay in bed, he heard a French voice wafting across the air, as a worker called across to his mate, '*Ohé! Auguste . . .*' The voice

made Degas long for Paris. He decided he would make plans to be back by January. At the last minute, his return was delayed by a new idea: he suddenly decided that the New Orleans cotton office would be an interesting, modern subject for a naturalist painting. It might be a good thing to send to England; he knew of a man, a wealthy spinner, who had a picture gallery in Manchester and might be interested in it. He stayed in New Orleans for another three months, working on variants of his portrait, depicting the working men in their shirt-sleeves and merchants in top hats and canes among bales of cotton. By spring 1873, he was more than ready to return to Paris, and his laundresses.

# THE GROUP CHARTER

*'Everything is gaiety, clarity, spring festivals, golden evenings, or apple trees in blossom.'*
— Armand Silvestre on the first Impressionist exhibition

BUSINESS WAS BOOMING IN THE tiny Café Guerbois. It had become a popular location for wedding parties and other celebrations, and the artists who still met there could hardly hear themselves speak. They moved their patronage to the much more spacious Café de Nouvelle Athènes, 'the white nose of a block of buildings, stretching up the hillside into the Place Pigalle opposite the fountain,' as the writer George Moore, newly arrived in Paris, described it. It was crowded with writers, artists and hangers-on 'literary and pictorial', gathered round small marble tables, discussing painting, writing, politics and the merits of realism. A high partition separated the glass front from the main body of the café, forming a kind of cubicle. In the right-hand corner of this area, the painters regularly gathered, and here two tables were reserved for Manet, Degas and their friends. Moore, occasionally taking notes, sat watching from his table in the corner.

'The glass door of the café grated upon the sanded floor, and Manet entered.' Moore noted down his 'satyr-like nose', broad shoulders and unmistakable swagger. 'The glass door of the café grates upon the sand again. It is Degas, a round-shouldered man in a suit of pepper and salt . . . His eyes are small, his words are sharp, ironical, cynical. Nothing very trenchantly French about him . . . except the large necktie.' The repartee would start up immediately. Moore sat listening, enraptured. One evening, Manet noticed him and leaned across: 'Are we disturbing you?' Moore explained that he was a writer. 'I tried to write once,' said Manet, proudly, 'but I gave it up.' On another occasion, Moore bumped into Degas excitedly hurtling along the street. 'I've got it!' he told Moore. Got what? 'The *Jupiter*, of course.' Grabbing Moore by the elbow, he marched

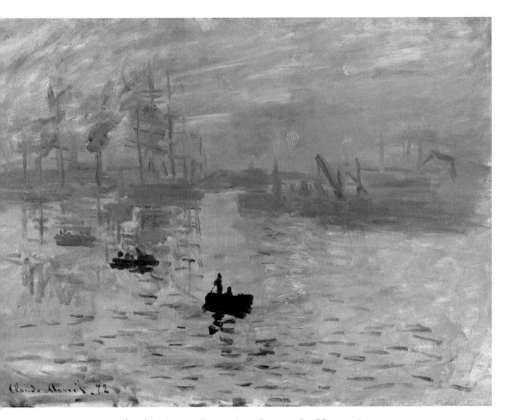

1. Claude Monet, *Impression: Sunrise, Le Havre*, 1872

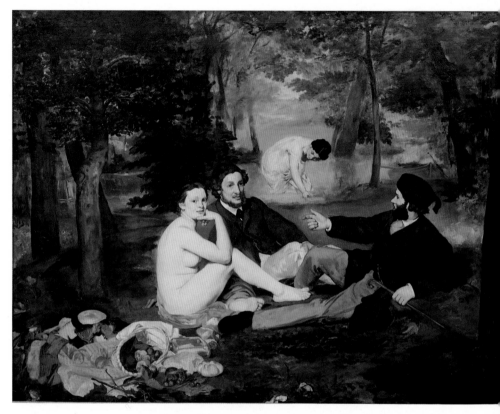

2. Edouard Manet, *Le Déjeuner sur l'herbe*, 1863

FACING PAGE
3. Paul Cézanne, *A Modern Olympia*, 1873-4
4. Claude Monet, *La Grenouillère*, 1869

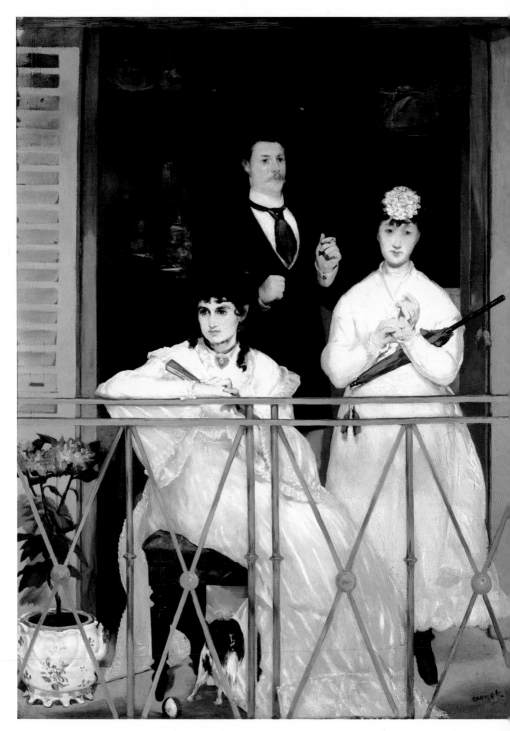

5. Edouard Manet, *The Balcony*, 1868–9

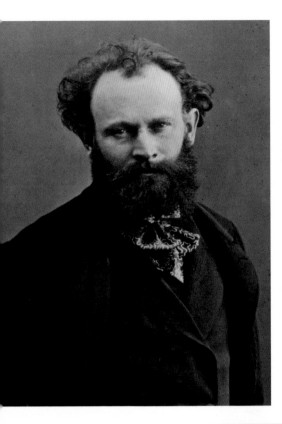

6. Andre Chadefaux,
Edouard Manet, c.1872–4

7. Andre Chadefaux,
Berthe Morisot, c.1872–4

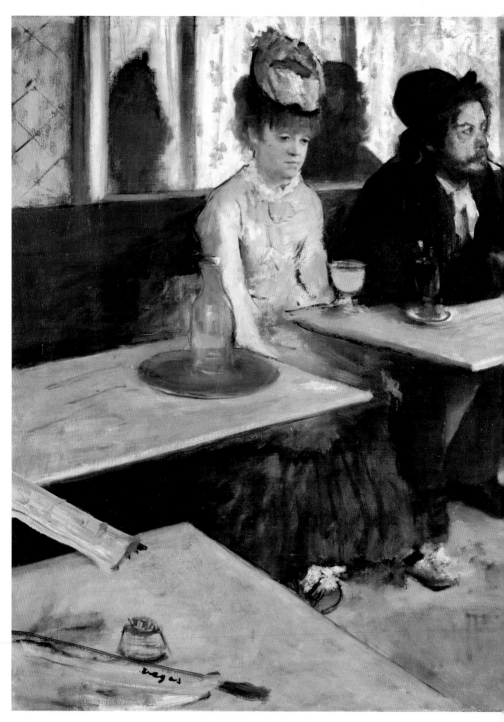

8. Edgar Degas, *In the Café*, or *Absinthe*, c. 1875-6

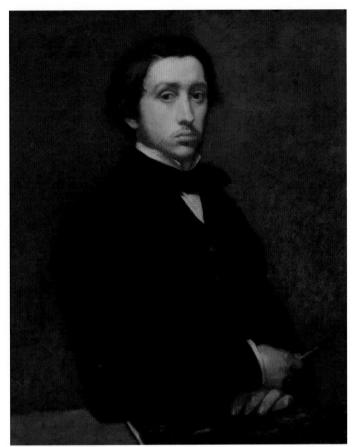

9. Edgar Degas,
*Self Portrait*, 1855

10. Gustave Caillebotte, *Self Portrait*, 1888

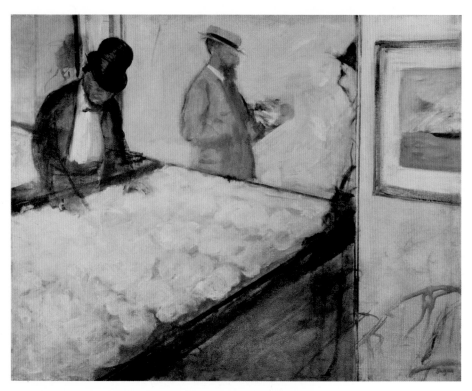

11. Edgar Degas, *Cotton Merchants in New Orleans*, 1873

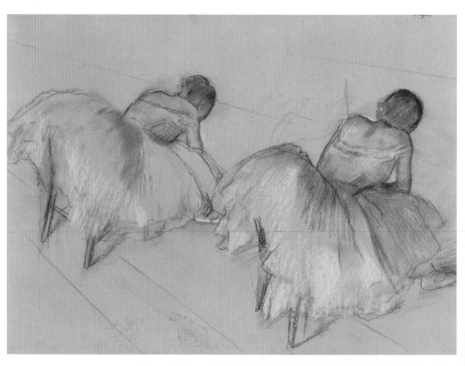

12. Edgar Degas, *Two Ballet Dancers Resting*

him down to the rue Blanche and up the stairs to his apartment. There!
On the wall hung Ingres's *Jupiter*. But next to it was a pear, just a speckled
pear painted on six inches of canvas, pale, fleshy, tactile and luscious. 'I
think I like the pear better,' said Moore. Degas seemed unsurprised. The
pear was Manet's. 'I put it there, for a pear like that would overthrow any
god.'

After long absences in the country, Monet and Sisley would appear in
the café, bringing twenty or thirty new paintings. Pissarro habitually sat
in the corner; from time to time, Cézanne would make an entrance. In
spring 1873, the group was beginning to make new plans. Monet, in
particular, was keen to resuscitate Bazille's idea of a group exhibition.
Thiers, now President of the Republic, had appointed a new Director of
Fine Arts, who could surely only take things from bad to worse. Though
a republican, Louis Blanc was hardly an artistic radical. He had recently
opened a Musée des Copies within the Ecole des Beaux-Arts, but this new
venture was no more exciting than it sounded: it was exclusively devoted
to copies of the Old Masters. This hardly constituted progress. The Salon
upheld its usual retrograde standards. The only one of the group accepted
in 1873 was Manet, with *Repose* (one of his portraits of Berthe) and *Le Bon
Bock*, his painting of an old man in a bar, contentedly puffing at his pipe
over his glass of beer. The latter, a glimpse of modern life inspired by the
portraiture of the Spanish Old Masters, or perhaps by Frans Hals, whose
paintings Manet saw in Holland that summer, was seen as an up-to-date
version of a traditional genre painting, full of sentimentality and tradition.
*Repose*, on the other hand, earned him nothing but scorn. In *Le Charivari*
and *L'Illustration* cartoonists pastiched the picture, with derogatory
captions that played on Manet's depictions of Berthe's darkness and
disarray: *A Lady Resting after Sweeping the Chimney; Seasickness; The Goddess
of Slovenliness*.

*Le Bon Bock* was almost absurdly successful. Photographic reproductions
went on sale in all the bookshops, *tabacs* and fancy-goods stores. A shop in
the rue Vivienne displayed Manet's palette, decorated by the artist with a
glass of beer, in the window. In the Latin quarter, *Le Bon Bock* became an
inn sign. The picture was popular because it was easy to appreciate: the
public saw in it a version of republican liberalism that made them feel
good about themselves; it seemed accessibly anecdotal. It was also painted
in acceptable tones of pink and grey, without any of Manet's usual
virtuoso contrasts of black and white. Manet seemed unconcerned by the
public's reaction to either picture. He was painting Victorine Meuret
again (his model for *Le Déjeuner sur l'herbe*), working in his vast new studio
surrounded by crowds of admirers. The notorious Nina de Callais was also

sitting for him – she had a reputation as a talented musician and amateur poet who kept a regular salon, frequented by the gayest wits of Paris, on an inheritance of 1,000 francs a year. She posed for Manet reclining on a sofa and a pile of cushions, with an array of Japanese fans pinned to the wall, surrounded by bizarre bric-à-brac, cats, exotic birds and monkeys, head in hand, looking wistful and dissolute. He called the painting *Lady With the Fans (Nina de Callais)*. Soon afterwards, he received a letter from her estranged husband, referring Manet to a legal agreement made with his wife, wherein she was permitted to take any name she liked, except his. 'Since you are seeing her,' he demanded, 'perhaps you would be so good as to remind her of this agreement.' Manet replied curtly, excusing himself for not interfering in De Callais's affairs, and assuring him that the portrait would not leave his studio. (Nina died the following year, in July 1874, leaving instructions – in the form of a poem – that she wished to be placed in a flowerbed, following a requiem sung in Notre Dame, where she wanted hangings 'as white as the women' and a piano playing.)

Claude Monet, working alone in his studio in the rue d'Igouville, was also prospering. In 1873 his rate of sales went on increasing. In addition to Durand-Ruel, other dealers and collectors (some of them rich commercial bankers) had already begun to buy his work. He was determined to capitalise on his success, and was still convinced that a group exhibition would maximise all the painters' chances in the market. He happened to know the caricaturist and photographer Nadar, who was in the process of vacating a large studio on Haussmann's new boulevard des Capucines, a prime commercial site. When Monet told him about the group's plans, Nadar said that if Monet could organise an exhibition, he was welcome to borrow these premises.

Only Manet was still resolutely against the idea. His success at the Salon was important to him, he still wanted a medal, and he saw no virtue in provoking the Académie des Beaux-Arts by exhibiting in a context blatantly designed to undermine its values. Even in the unlikely event that the group exhibition was a success, there was surely more to be achieved by going the conventional route. Whatever the painters' views of the Salon it was still the focus of critical and press attention, and still, moreover, the place where dealers went looking for new talent. Manet was also politically shrewd enough to realise that a venture such as Monet's would look like a deliberate attempt to insult the new republican status quo. When Monet approached him again, Manet just said, 'Why don't you stay with me? Can't you see I'm on a winning streak?'

Degas, despite his friendship with Manet, disagreed with him about the exhibition. Degas was all for it. He even suggested asking Berthe to join

them – a potentially shocking idea, since it represented the introduction of a woman into the company of a politically radical, all-male group. Out of the question, said Manet. She was sitting for him again, this time reclining voluptuously on his crimson sofa in a low-cut gown, a black velvet choker accentuating the contrast between her naked white throat, dark hair and sparkling black eyes. She held the painter's gaze, one eyebrow infinitesimally raised – the painting dazzles with languid provocation. Degas ignored Manet and wrote directly to Cornélie, explaining that the exhibition they were planning 'had such a realist scope that no realist painter can be exempted. We also consider that Miss Berthe Morisot's name and talent are too important to us to do without.' Shrewdly he suggested that Edma might also like to participate. Referring in passing to Manet's objections, he asked Madame Morisot to intercede with Berthe on behalf of the other painters. Soon, Berthe received a letter from Puvis de Chavannes. His view was the same as Manet's. He acknowledged that this year her work had been rejected by the Salon, but urged her, nevertheless, to avoid the risk of seeming anti-establishment. Naturally, in principle he approved of the idea of an independent exhibition, but he did have one or two reservations: the timing, the location, the proposed admission fee . . . She really should be careful not to draw attention to herself in this way. 'Unfortunately you don't have the heavy artillery on your side,' he tactlessly reminded her. That settled it. Berthe was, in any case, keen to be included. She had just sold a portrait to Alfred Stevens, and welcomed a new outlet to exhibit and, hopefully, sell her work. Since, for an upper-middle-class woman, meetings at the Nouvelle Athènes were definitely out of bounds, Degas and Renoir promised to keep her in touch with developments; she would be a fully paid up, active member of the group.

In Argenteuil, Monet began to make definite plans. He saw the independent exhibition as a way of establishing a completely new, businesslike future for the group, a way of promoting and selling their work which would also eventually enable them to support one another and protect their newly accumulated assets. His idea was to set up not only an exhibition but a co-operative society. He wanted to form a joint stock company. Somewhat ironically, Pissarro, the confirmed anarchist, was his right-hand man. In many ways they made a good team: Monet had the driving ambition, Pissarro, the deep belief in co-operative action. For Monet, the enterprise was commercial; for Pissarro, what they were planning felt more like the mutualist associations and 'collective reason' advocated by the social theorist Proudhon. Monet had already found his first subscriber, his brother Léon. Then, on 5 May, Zola (who had not

been directly involved in the group's discussions) gave a young protégé of his, Paul Alexis, a platform in *L'Avenir nationale*, the national newspaper owned by Gambetta. In six columns, Alexis made a public appeal to the as yet only partially formed 'artistic corporation', publicly encouraging them to form a society. He urged them to organise their 'management committee' and announced that a plan for subscribers and exhibitors was already underway. Any interested parties should contact him, Alexis.

To any supporter of the new Republic, the article looked subversive. The Commune's anti-establishment collectives were all too recent a memory, and talk of corporations and committees ran the risk of appearing inflammatory. Alexis's vocabulary made the artists look like a group of left-wing intransigents. Any publication that even hinted at anti-government propaganda would inevitably have been suppressed in 1873, and *L'Avenir nationale* was swiftly prosecuted; on 26 October it was forced to cease publication. But Monet was delighted. He immediately wrote to Alexis. 'A group of painters assembled in my home read with pleasure the article you published in *L'Avenir nationale*. We are all very pleased to see you defend ideas which are also ours, and we hope that, as you say, *L'Avenir nationale* will kindly lend us its support when the Society we are in the process of forming is finally established.' Alexis quoted from the letter in a second article, published on 12 May, announcing that he had received many such letters testifying to the formation of a new association. This was reckless. The article – and Monet's reply (printed before the paper ceased publication) – looked like sheer provocation, at least to some members of the Salon jury, who were quick to make the connection. 'One step more,' remarked the critic Gustave Geffroy, 'and their paintings would have been handed over to the firing squad.' Nevertheless, Pissarro travelled from Pontoise to Argenteuil to help Monet draft a charter.

The plan was indeed revolutionary, since the group's main aim was to dispense with judge, jury and reward system. Pissarro left the draft with Monet to work on and returned to Pontoise, where he spent the summer playing piggy-back in the garden with his three sons, and working in Auvers with Cézanne and Dr Gachet. Cézanne was all too ready to join the as yet unformed society. In Argenteuil, Monet painted the poppy fields, while he mulled over the terms of the charter and showed it to one or two people for their comments. Manet came over from Gennevilliers to paint. Since his visit to Holland he too had been keen to experiment with the effects of light. His *plein-air* painting was never quite convincing unless he was painting the sea. Manet loved surfaces and responded sensually to interiors; somehow the river never flowed in his work, as it

did in Monet's. Degas was aghast when he saw what Manet produced out of doors. But Manet happily pursued his experiments. That summer he painted *The Swallows* – figures seated in a field, with dark black jets of paint circling low across the foreground – and *On the Beach*, a portrait of Suzanne seated heavily on the sands in a white muslin dress, her red-shod feet turned out. (Two years later, his latest *plein-air* painting, *Argenteuil* – a close-up of a boatman wooing a young woman, both seated on a wall, the river in the background – was discussed in a long article in *Le Temps*. 'He forgot all about Argenteuil and geography and turned the Seine into a deliciously blue Mediterranean sea,' commented the critic: 'it proves conclusively that Manet is anything but a realist.' The following year, when it appeared in the Salon, the *Figaro* reviewed it. 'Behind the figures is an indigo river, solid as a lump of metal, straight as a wall. In the foreground is Argenteuil, looking more or less like jelly.')

In September, Monet asked Pissarro to come back to Argenteuil to revise the charter. He was determined that the final draft should not be open to misinterpretation. There were arguments over the phrase 'co-operative society'. Renoir, now firmly in Durand-Ruel's stable and making some good new sales, insisted they strike it out. Eventually, the charter was drawn up (the definitive version was eventually dated 27 December 1873), for a joint stock company with shares, articles of partnership and other routine provisions. Each member was to contribute 60 francs a year, at the rate of five francs a month. Fifteen elected members would form the council, and a third of them would be renewed annually. The Society would receive a commission of 10 per cent on all sales. Pissarro felt it should have broader responsibilities, such as providing support for a painter's family in the event of his death, but this idea was thrown out. Pissarro also wanted the hanging of paintings in the exhibition to be determined by vote or drawing lots; now it was all getting too complicated, said Renoir. The name was agreed upon: Société Anonyme Coopérative (joint stock company) des Artistes, Peintres. The initial group comprised fifteen artists, with a plan to enlist more. Now they just needed subscribers.

Degas, in his Pigalle studio, was painting his laundresses. He also had a pass to attend rehearsals of the ballet, at the Opéra in the rue le Peletier, where he sketched the *petits rats* in the wings. He watched the ballet classes, studied ballet scores and made detailed notes. Then his models would repeat the poses in his studio (he sketched in the backdrops and scenery from memory). He had started referring to his apartment, in American parlance, as 'my home', and he was making it more homely by the minute. It suddenly came to him that poor Clotilde was too young for

him: 'like a housemaid in a theatrical comedy'. He dismissed her, and she was replaced by the more motherly Sabine Neyt, large, cosy and comforting, who bustled about wearing a red-checked plaid shawl. Degas painted her, in *The Rehearsal*, fussing over a group of dancers. Edmond de Goncourt visited him in his studio at 77, rue Blanche, and watched him, spellbound. 'He conjures up before you laundress after laundress, in their poses and graceful foreshortenings.' He listened in wonder as Degas explained how he went about his work – like a ventriloquist in paint: 'He speaks their language. He can technically explain the *downward* way of pressing, the *circular* way of pressing, etc . . . And it is really quite amusing to see him, standing on tiptoe with rounded arms.'

As Bazille had been, Degas was fascinated by the world backstage. The girls in the corps de ballet were lowly paid working girls, usually with ambitious mothers, who lived in shacks on the hillsides of Montmartre, and the wealthy *boulevardiers* who frequented the Opéra sometimes corrupted them. His old school friend Ludovic Halévy, now a librettist for the Opéra, had been producing a series of short stories, the humorous adventures of two young dancers, Pauline and Virginie Cardinal, in which he described the Opéra almost as if describing Degas's paintings of the ballet. Degas was compelled by the dancers' natural grace. He was also intrigued by the unusual angles and gaslit space of the theatre itself. The Goncourts described it in their journal – 'tenebrous and glimmering . . . forms that disappear into shadows in the smoky, dusty silence'. (Perhaps Degas's paintings of the ballet would be even more magical seen by gaslight.) In the 1870s, the audience observed the action not only on stage but within the auditorium, and especially in the boxes, as opera glasses were raised and lowered. Renoir loved the Opéra, adored watching the audience observing itself, and hated it when the convention of plunging the audience into darkness was introduced: it seemed to him quite unreasonable to be forced to watch the stage.

Manet, too, was painting the Opéra, producing a bizarre, decadent painting, *The Masked Ball at the Opera*, of men in capes and gleaming top hats, interspersed with one or two women, totally draped in black, their faces hidden behind black masks. Moving among them are brightly clad, whorish-looking women in laced boots with bare calves, arms and faces. The crowd is huddled beneath the balcony, from which one white-stockinged, red-booted leg dangles provocatively. In the bottom right-hand corner of the picture is a glimpse of the hem of a woman's black cloak. She has evidently retreated in a hurry: her programme – which (in the style of the 'billet doux' in the still life he painted for Berthe Morisot, *A Bunch of Violets*) bears Manet's signature – and pink notebook have

fallen to the ground. Perhaps she has caught sight of her husband or *beaux* in the company of a prostitute, or of a woman she recognises, despite the mask. This is one of Manet's most opulent and cryptic paintings, full of intrigue and suggestion. (On the night of 23 October the Opéra burned to the ground, before he had finished his painting. Six thousand costumes, all the instruments, thousands of musical scores, and the sets for fifteen operas and ballets were destroyed.)

In early December Monet arrived in Paris, determined to collect the five signatures necessary to consolidate the charter. He returned to Argenteuil with none. Baffled by the lack of interest in his cause, and leaving the other painters busy with preparations for the exhibition, he took off for Le Havre to paint seascapes; now Degas was to lobby for signatures.

Degas had more luck than Monet – by the New Year of 1874 he had collected enough signatures for the exhibition to go ahead. He was now facing personal financial difficulties, following the death of his father in February. The long-term consequences of the temporary post-war boom were beginning to make themselves felt. The siege and the Commune had totally disrupted the economy, and with plummeting prices and rising unemployment, things looked set for a world depression. Small concerns, such as the De Gas bank, ran into difficulties, particularly when companies such as Crédit Lyonnais and the Société Générale came into their own. For most of his life, Auguste De Gas had traded in a different economic climate, and he could not have foreseen the need to be prudent. In 1833 he had had assets of 150,000 gold francs, but he had gradually let his fortune erode. It was only when he inherited his portion of the estate that Degas became fully aware of the implications of his father's business strategies. One of the Parisian De Gas uncles managed to negotiate enough fresh credit to keep the family bank going for a while longer. Though this was not a long-term solution, at least it meant that for the time being, Degas could extricate himself from family business concerns and throw himself into the plans for the group's independent exhibition.

Like Monet, he viewed the exhibition as a potential business opportunity. His friends had been surprised by his readiness to be involved, given his closeness to Manet, but since he had already exhibited six times at the Salon, he did not see why exhibiting independently should compromise his reputation. Unlike Manet, moreover, he hated the Salon's reward system and had no desire for medals or rosettes. He saw the independent exhibition as an opportunity for greater exposure, and was already thinking about possible spin-offs. He had sketched out a one-man show of ten dance pictures and had even got as far as designing the poster,

with a ballet shoe logo. His idea was that the independent show would take the painters beyond the realm of academic arguments and jealousies, and out on to the boulevards.

Durand-Ruel, by now anxious to shift some of the stock he had been accumulating, was planning a small exhibition of his own, in his rue le Peletier gallery, accompanied by a lavish, three-volume catalogue of 300 works, with a preface by the art critic, Armande Silvestre. In this essay, the painters were for the first time identified as a group. Silvestre pointed up the similarities between Monet, Sisley and Pissarro, and claimed that as a group, the painters were different from other contemporary painters. Their work made an immediate, fresh impact on the viewer, their approach was, 'above all, harmonious'. He deflected comparison with Manet, whose methods, he explained, were not technically comparable, and highlighted the group's style, 'based on a fine and exact observation of the relation of one tone to another'. Here he exaggerated, claiming that their methods were scientific, based on a scale of tones. In reality the painters' methods were largely intuitive, loosely based on the techniques Pissarro had taught Cézanne: to model forms by capturing the rhythms of light and air rather than being tied to 'accurate' drawing. Above all, Silvestre stressed the extraordinary freshness of the group's work. 'A blond light pervades them, and everything is gaiety, clarity, spring festivals, golden evenings, or apple trees in blossom.'

All this boded well, but Degas was still convinced that it should be made quite clear that the group had no political agenda. The group identity could to some extent be manipulated, and to this end it was important to find the right name. He suggested 'La Capucine', a name which would have associated the group with its commercially ambitious location. The word was, moreover, inoffensive – it means nasturtium. Perhaps for that reason, nobody else was convinced. In the end, they made do with the blander and more straightforward 'les Indépendantes'.

By this time, Pissarro was beginning to have doubts about the whole enterprise. He had been talking to Manet's friend, the art critic Théodore Duret, who agreed with Manet that the Salon was surely a better place to get the attention of dealers and critics. Why didn't Pissarro put his efforts into making a better selection of his works, sending only the most 'finished' to the Salon? There, he reminded him, 'you will be seen by fifty dealers, patrons, critics, who would otherwise never know you existed . . . you've got to succeed in making a noise, and show that you can attract and defy criticism, by coming face to face with the larger public. You will never achieve all that, except at the Salon.' Pissarro anguished over this advice. Julie was expecting a fourth child, and concerned only with being

able to feed her family; the risk of destroying his prospects was not to be taken lightly. But eventually his sense of group loyalty won out; he decided to stay with the newly formed Society.

In spring 1874, Monet returned from his trip to Le Havre. He brought back a painting he had made from a hotel window of the sunrise, a bright orange disc in a sky vivid with orange reflections, streaked in all directions with quick diagonals. It was simple and catchy: he thought he would include it in the exhibition. In his absence, his friends had continued to organise and campaign, and there were now thirty participants proposed for inclusion. The committee consisted of Monet, Degas, Pissarro, Renoir, Sisley and Berthe Morisot. There was one unresolved issue: the inclusion (or not) of Cézanne. Of the six-member committee, only Pissarro wanted him. Berthe had met him, and thought he was a boor. Degas agreed. Manet, though he had no wish to be included himself, was consulted. 'What, get myself mixed up with that buffoon? Not likely!' It cannot have helped that the work Cézanne planned to submit, along with two landscapes of Auvers, was called *A Modern Olympia*. A curious pastiche of Manet's *Olympia*, it was intended as a witty interpretation, but by any standards it was sketchy and peculiar. While everyone else pondered the question of his inclusion, he moved Hortense and Paul back to Paris, to an apartment in the rue Vaugirard, in readiness for the exhibition. The matter was inadvertently settled by Degas, who pushed for the inclusion of Boudin, Bracquemond and Meissonier – all fashionable painters – for the sake of credibility. As far as Pissarro was concerned, that settled it. If outsiders were to be included, there could be no justification for excluding one of their own. All grudgingly agreed, and the organisation continued, with Cézanne as one of the group.

Plans were well advanced when Pissarro suffered a terrible, unforeseen tragedy. In March, his nine-year-old daughter Jeanne (nicknamed Minette), a pretty, fragile child, with long, thin limbs and huge, round eyes, fell ill with a respiratory infection. Dr Gachet was called, but Minette did not recover, and on 9 March she died. Julie was five months pregnant, and deeply shaken. She was distraught with grief, and terrified that the new baby would be affected. Minette was the second daughter the Pissarros had lost, and the tragedy shook them all. Despite this heartbreaking bereavement, Pissarro continued to rush between Pontoise and Paris, helping to organise the exhibition.

By April, preparations were almost complete. Nadar's fashionable, glass-fronted premises were about to display the work of a radical, unknown society of painters. They had agreed to draw lots for the hanging positions, and the pictures were hung in two rows (unlike the

Salon's policy of filling the walls four deep with pictures), the larger ones above, the smaller ones below, against Nadar's dramatic blood-red, hessian walls. Berthe's delicate celebration of Edma and her newborn child, *The Cradle*, hung next to Cézanne's *A Modern Olympia* – perhaps in the hope that the chastely archetypal image of mother and child would divert the public's eye from Cézanne's bizarrely primitive brothel scene. Other paintings shown were Degas's *Dance Class, Laundress* and *After the Bath*; Monet's *Boulevard des Capucines;* Renoir's painting of a box at the Opéra, *La Loge*; and Pissarro's *Hoar-Frost* and *Chestnut Trees at Osny*. Renoir's brother Edmond, who published the catalogue, asked Monet to supply him with a list of titles. For his painting of sunrise over Le Havre, Monet suggested, perhaps absent-mindedly, 'impression'. The title was printed as *Impression: Sunrise*.

The exhibition opened, shortly before the official Salon, on 15 April. It ran until 15 May, in the evenings as well as the daytime, to maximise the number of ticket sales. The crowds pressed down the rue des Capucines, pushing and jostling their way in to see the show. Two hundred arrived on the first day, and about a hundred every day thereafter. (By the time it closed, 3,500 people had visited it.) The public flocked in, screamed with horror and alerted their friends, who were also aghast. There was pandemonium. The newly affluent middle classes, department store owners and merchants, who had moved into Haussmann's smart new apartments, wanted art to supply them with the education they lacked, not taunt them with feelings of inadequacy. They expected exhibitions to make them feel elevated, not to undermine them with images they could not understand. The Barbizon landscape artists, who had done away with conventional framing devices, were acceptable to them, because their works could be hung in bourgeois drawing rooms. But even the landscapes of the *Indépendants* seemed to them unfinished and incomprehensible, and some of their works seemed more suitable for the walls of the *maisons closes*. The reaction of the audience was practically a repeat performance of the 1863 *Salon des Refusés*. Why on earth would they want to pay good money to look at pictures of laundresses, the Opéra's *petits rats*, or a ploughed field? 'Look at these ugly mugs! Wherever did he dig up those models?' Some demanded a refund. Renoir's *La Loge* (a close-up of the interior of a box at the Opéra) came in for particular ridicule. But if they ridiculed Renoir, they were incited to real anger by Degas and Cézanne, whose strange angles and peculiar perspectives seemed simply nonsensical.

The crowd recognised no names, except perhaps Boudin and Bracquemond. All these people must be impostors. They had funny

names – 'Morizot, Cesanne' – and their pictures were beyond the pale. Mademoiselle Morizot had painted a reasonable painting of a universal subject, yes, here was a good picture of a mother and a baby in a cradle – but the rest of them were obviously out to make fools of everyone. Women in bustles, silk shoes and elaborate hats were reduced to raucous laughter, gentlemen spluttered, tottered on their canes and went purple in the face. The torrents of abuse went on and on. While audiences mocked Monet, Degas, Renoir, Pissarro, Cézanne and even Berthe Morisot, Meissonier (who specialised in paintings of war subjects) elsewhere quietly sold *Charge of the Cuirassiers* for 300,000 francs. Manet remarked sarcastically that the painting was of course very good – 'everything is steel except the cuirassiers'.

Though the conservative press ignored the exhibition, the left-wing papers did cover it. *Paris-Journal* praised the new 'school', especially Monet, but criticised the group's inclusion among such established painters as Boudin and Bracquemond. Critics who might have been supportive – Duranty, Astruc, Silvestre – were silent, possibly out of sympathy with Manet. Zola visited the show, but did not comment. There was one quasi-favourable reaction, in *Le Siècle*. The reviewer, Castagnary, referred his readers back to Durand-Ruel's exhibition in the rue le Peletier, reminding the public that this was another opportunity to see the works of the painters who, 'debarred by the officials and other academicians', had banded together. Certainly, they were difficult to appraise, but Durand-Ruel had backed them, and some of their qualities (including the possible influence of Japanese art) had already been acknowledged. This work was 'neither tiresome nor banal. It is lively, it is vivid, it is delicate: in short, it is ravishing.' But Castangary had one reservation: could work like this last? The painters were clearly trying to invent an artistic system. Perhaps, once they had managed to establish it, each would eventually find his feet and move on (except for Cézanne. There was clearly no hope for him). Renoir was furious. 'What are we supposed to do about these stupid literary people, who will never understand that painting is a craft! You make it with materials, not ideas! The ideas come afterwards, when the painting is finished.'

Other reviewers simply resorted to reporting conversations they overheard in the exhibition rooms. The 'Art News' column of *La Patrie* noted that there were at least a dozen paintings that the Salon would have accepted. 'But the rest . . . !' Did the reader recall the first *Salon des Refusés*, where there were 'naked women the colour of a bilious Bismarck, jonquil-coloured horses . . .'? Well, that Salon was the Louvre, the Pitti, the Uffizi, compared with this. Some said the show must actually be

another *Salon des Refusés*, this time covertly organised by the Salon to expose the *refusés* and justify the jury's decision to reject them. Others, that it was just the work of some practical joker, amusing himself by 'dipping his brushes into paint, smearing it onto yards of canvas, and signing it with different names'. Yet another, that these were obviously Manet's pupils – yes, jibed another, the ones he's refused to take on . . . 'Wasn't Monsieur Manet himself refused this year . . . ?'

Ironically, despite his refusal to be involved, the public took it for granted that Manet must somehow be behind it all. The more notorious the group of painters became, the more the public assumed he must be their leader. The presence of Cézanne's *Modern Olympia* hardly helped. Reviewers of the Salon (where Manet was in fact exhibiting one work) had also got hold of the connection. 'M. Manet,' reported Jules Claretie in *L'Indépendante* on 20 April, 'is among those who assert that in painting one can, and indeed should, content oneself with the *impression*. We have seen more of the impressionists at Nadar's. M. Monet – a more intransigent Manet, – Pissarro, Mlle Morisot etc., seem to have declared war on beauty.' Surely things could not get any worse. But they did. Three weeks later, the day before the close of the independent exhibition, another brief notice appeared, in *La Patrie*'s 'Exhibition News' column.

> There is an exhibition of the INTRANSIGENTS in the Boulevard des Capucines, or rather, you might say, of the LUNATICS, of which I have already given you a report. If you would like to be amused, and have a moment to spare, don't miss it.

The most cataclysmic review of all was by Louis Leroy in the satirical journal, *Le Charivari*, on 25 April. He wrote his entire article as a spoof, posing as an art critic being shown round the exhibition by a landscape painter, the fictitious 'Monsieur Joseph Vincent, a pupil of Bertin's' who had been honoured with medals and decorations by several governments. Together, the two wander from room to room, as the critic records his mounting consternation. In the first room, they find Degas's *Dancing Girl*.

'What a pity,' remarks Vincent, that 'with such a knowledge of colour, he does not draw better.'

They move on to Pissarro's *The Ploughed Field*. The artist assumes his glasses must be dirty, and hastens to clean them. He puts them back on his nose and exclaims, 'Shades of Michelangelo! . . . But what on earth is that?' It represents ploughed furrows, obliges the critic, and that is hoar-frost.

'Those? Ploughed furrows? That is hoar-frost? But they're nothing but

palette scrapings, put down in parallel lines on a bit of dirty canvas. There's no head or tail to it, no top or bottom, front or back.'

'That may be so; but it is an impression, nevertheless.'

'Well, it's a weird impression.' The word was an easy target, and from now on the critics showed no inclination to let go of it.

Vincent and the critic then move on to Monet. They can just about cope with his fishing boats, but then they see that he has actually tried to paint a view of the street they are standing in, *Boulevard des Capucines*. More paroxysms.

'Ha ha ha! That one's a real success! There's an impression, or I don't know what is. But will you kindly tell me what all those little black dribbles at the bottom of the picture mean?'

'Why, they are pedestrians,' explains the critic.

'And that's what I look like when I walk along the boulevard des Capucines? Good Heavens! Are you trying to make fun of me, by any chance?' They continue on through the rooms, each room causing more offence than the last, until they get to Cézanne's *House of the Hanged Man*. This is the turning point. The artist, 'Vincent', now begins to see the point. 'His madness was not pronounced at first, but the signs of it were evident when he unexpectedly switched over to the Impressionists' point of view and came to their defence.' The secret of this art is that its lack of finish is intentional! Thus, if Mademoiselle Morisot wishes to paint a hand, 'she gives as many brushstrokes, lengthwise, as there are fingers, and the thing is done'. Now they are approaching number 98 in the catalogue, Monet's *Impression: Sunrise*.

'What does this one represent?' asks Vincent. 'What does the catalogue say?'

   '*Impression: Sunrise.*'

'Impression! Of course. There must be an impression somewhere in it. What freedom . . . what flexibility of style! Wallpaper in its early stages is much more finished than that.'

The spoof continues, as they discuss the fact that, if this painting shows flexibility of style, Meissonier's painting must be . . . 'overdone!' Now that they have grasped the principle, they wander back through the rooms, to have another look at Cézanne's *Modern Olympia*. No, even the enlightened can find no explanation for this: 'A woman bent double, while a Negress [maid] is taking off the last of her [mistress's] veils and exposing her in all her ugliness to the fascinated gaze of a dark-skinned puppet.' Finally, as they leave, Monsieur Vincent stops in front of a

policeman. Mistaking him for a portrait, he comments, 'It's pretty bad. There are two eyes, nose and a mouth in front. The Impressionists would not have bothered with such details.' 'You'd better move on,' says the policeman. With this, Vincent begins to do an Indian scalp dance before the policeman, shouting, 'Wah! I am Impressionism on the march. I've got my palette knife ready . . . Wah-wah-wah-wah-wah!'

<div align="center">★</div>

By the time more favourable reviews (mostly by friends of the artists) began to trickle out, it was too late: the *Charivari* piece naturally stuck in everyone's mind. Renoir gamely nominated himself as recipient of the worst insult: 'they ignored me'. But despite this show of stoicism, the press coverage had already done enormous damage. The commissions for portraits, which the painters had begun to depend on for a living, now ground to a halt. Manet had been right: the exhibition of 'impressionists' served only to augment the status of the Salon painters, whose work commanded higher and higher prices. The 'impressionist' name, moreover, stuck. It hardly helped the painters' case, since it neatly summed up the public's objections to their art and helped identify them in public perception as casual, unpolished, sloppy, anti-establishment rebels.

Cézanne was deeply ashamed. As soon as the exhibition closed, he fled home to Aix and the draughty Jas de Bouffan, leaving Hortense and two-year-old Paul in Paris. Back in Aix, he faced an immediate problem. This was his first return home for three years. His parents seemed thrilled to see him – particularly his father, who immediately withdrew his allowance, since naturally he would not need it to live at home. How, then, were Hortense and Paul to survive? They could not live on thin air. Cézanne now began on the task of manipulating his father.

It has sometimes been suggested that Auguste Cézanne would probably willingly (even happily) have accepted the fact of his grandson's existence, and that, since he must have known something was amiss, what really irritated him was being taken for a fool. Cézanne (*fils*) himself had been born out of wedlock. Given the perverted logic that sometimes exists in families, this may have been why (perhaps with good reason) he still feared his father's anger. In fact, albeit relatively abstemiously, Auguste Cézanne had been supporting his son all along. He had bailed him out at every juncture, made his peace with his disappointment over Cézanne's choice of career, travelled to Paris with him to find suitable lodgings and, until now, provided him with a regular allowance. If nobody told him what was going on, what exactly was he expected to do? Cézanne, typical of

him, described his thoughts elaborately in writing, playing on his father's supposed desire to keep him at home and innocently pleading to be set free. 'I do enjoy being with you,' he wrote, 'much more than you seem to think. But once at Aix I've lost my freedom. When I want to go back to Paris I always have to struggle to get my way. And though you don't actually forbid me to leave, you always manage to upset me because I know you don't really want me to go. I beseech you to stop trying to hamper my freedom to come and go. Then I could come rushing back to you willingly. I ask you, Papa, for just two hundred francs a month. That would enable me to stay for ages at Aix' – where his father appeared to want to keep him – 'and I would work with pleasure here in the south, where I have so many opportunities for painting.' With a small allowance he would also be able to come and go at will.

At this point, the Director of the Aix Museum arrived at the Jas de Bouffan. He had read the press reports of the independent exhibition, and was curious to see, with his own eyes, the work of the new 'school'. Cézanne showed him his recent paintings. The Director closed his eyes, and turned his back. Recovering himself, he announced that Cézanne must persevere, since 'patience is the mother of genius'. Something worked – the letter, the Director's visit, or Auguste Cézanne's desire to see how long the charade could possibly continue. Soon, Cézanne was writing to Pissarro, 'I'll tell you nearer the time when I'm coming back and how much I've managed to get out of my father.' Auguste had agreed to finance Cézanne's return to Paris, 'and that's already a lot'. But it looked as if the dream of a home in Auvers, with Pissarro, Dr Gachet and friends, was over.

<div align="center">★</div>

In Paris, the painters were doing their accounting. Sales – predictably – had been lamentable. Sisley had done best: he had made 1,000 francs. Monet and Renoir made less than 200 francs; Pissarro, 130; Degas and Berthe Morisot sold nothing. Berthe did not need to make money, and Degas, though he sold nothing at the exhibition, had actually sold seven of his exhibition pictures before the catalogue went to press. He was also beginning to accumulate private collectors. But Pissarro, with a new baby due shortly, was overwhelmingly despondent. Shortly after the show closed, there was even worse news. Durand-Ruel, despite his attempts to clear stock and make new sales, was forced to face the fact that his business was rapidly failing. He had no choice but to suspend all payments to the painters, whom he had been compensating regularly on account. For Pissarro, in particular, this was the final straw. The new baby Félix

(nicknamed Titi), born on 24 July, was some consolation, but Julie was mourning her daughter, and Pissarro was at his lowest ebb.

Monet was also concerned for the future, though he was accumulating some loyal clients, including the celebrated baritone singer, Jean-Baptiste Faure. After the exhibition closed, Ernest Hoschedé, a wealthy department store owner with deceptively hard little eyes and a huge cigar, bought *Impression: Sunrise* for 800 francs, and four other paintings, for 1,000 francs each. Nevertheless, Durand-Ruel's withdrawal of support was a bitter blow, which threatened to undermine the potential of all the painters. Monet immediately saw that he could not afford to rest on his laurels. Even with Faure's and Hoschedé's recent purchases, he earned less in 1874 than he had the previous year. He was having trouble paying the rent on the house in Argenteuil. At the end of May, he gave up his rue d'Isly studio and faced the fact that he could no longer afford the rent on his beloved house at Argenteuil. He found a cheaper, one-storey house, with a smaller garden. But this, too, had to be paid for. The rent (400 francs less than he had been paying Madame Aubry) would be a tight squeeze, but at least the move meant that he could enjoy another summer in Argenteuil.

After the stressful events of the spring, Argenteuil still meant peace and relaxation. Manet came to visit, and painted *The Monet Family in the Garden*, with Camille reclining on the lawn, her head propped casually on her hand, smiling up at the painter, legs outstretched, ankles crossed, wearing little yellow summer shoes. Her son leans in to her side, a bare-legged, hot, bored child on a lazy summer's afternoon. Monet, in the background, potters about with his watering can, a couple of hens by his side. Manet clearly put everybody at ease. While he was painting, Renoir arrived. He set up his easel and began to paint the same scene. Manet leaned over to Monet. 'Who's your friend?' he joked; 'tell him to give it up, he's got no talent.'

★

Berthe Morisot was also about to leave Paris for the summer. Since the New Year she had been living alone with her mother: her father died early that year, on 24 January 1874. The family was still in mourning. Berthe had so far managed to protect Cornélie from the critics' reactions to the exhibition, but shortly afterwards, Cornélie received Berthe's first tutor, Joseph Guichard, who followed up his visit in writing. 'Madame, the kind welcome you gave me this morning touched me deeply . . . I was suddenly transported back to the time when I guided your delightful girls in the arts, as teacher and friend.' But he had been to the boulevard des

Capucines, and felt it his duty to tell her the worst. 'When I entered, dear Madame, and saw your daughter's works in this pernicious milieu, my heart sank. I said to myself, "one does not associate with madmen except at some peril; Manet was right in trying to dissuade her."' These people were 'touched in the head'. But the worst of it was seeing dear Berthe's exquisite work side by side with Cézanne's: 'the two canvases actually touch each other!' Berthe's involvement with this group of lunatics seemed to Guichard a negation of all her years of hard work. He hinted that they were all not only sick, but sinning. 'As a painter, physician and friend, this is my prescription: she should go to the Louvre twice a week, stand before Correggio for three hours, and ask his forgiveness.' Instead, she visited Manet, who painted her in her mourning hat, head in hand, her sleeve falling away from her wrist. Eyes brimming with sadness, even anguish, she looks haggard. It was around this time that Manet talked to her seriously about Eugène, encouraging her to take the emotionally complex step of marrying his brother.

The plan for a seaside holiday, to include both Berthe and Eugène (but not Edouard), was promptly being revived. Madame Morisot was still wary of Eugène. Though he had inherited sufficient wealth to secure a regular income, she still saw his lack of career as a moral failing. On the other hand, he had great respect for Berthe, and Cornélie valued his admiration of her daughter's work. He was a reasonable amateur painter himself. There was no denying that he was highly strung and at times a bit clumsy, but he was also reserved and diffident, enormously supportive and encouraging, and seemed to have a gift for dealing shrewdly with demanding personalities. He was imaginative and romantic, but he also liked strong women. (In 1889 he wrote a novel, called *Victimes!*, about an intrepid woman whose dark eyes were 'filled with liquid flame'.)

Both mothers, Berthe, Eugene, Edma and the young Pontillon children all boarded the train to Fécamp on the Normandy coast, just north of Le Havre. Fécamp was a popular spot for seaside bathing, but smaller and more discreet than either Trouville or Bordeaux, where the Manets were frequent visitors. Here, away from their familiar social milieux, the mothers would be able to promenade, or sit bolt upright on the beach in heavy finery under elaborate parasols, while the two not-so-young things (Berthe was by now thirty-two) painted boats in the harbour.

The choice of a seaside venue was significant. The match-making potential of the *bord de mer* was widely (if discreetly) acknowledged. Gradually throughout the nineteenth century, the French had begun to adopt the British habit of seaside holidays, particularly in Brittany and

Normandy, where promenading was a fashionable social custom, and where whole families arranged themselves on the shingle, fully dressed, under a clutter of parasols. This was the middle-class version of the summertime leisure enjoyed by the working classes at the riverside. The cult of bathing was all the rage. Unlike the riverside spots, where inebriated revellers plunged recklessly into the water, seaside bathing was far more restrained, as it was still considered dangerous. But the fashionable bourgeois also held that the sea air had beneficial properties, and they treated themselves to a few moments of brief immersion. Some were carried into the water by a *baigneur* (a specially appointed medical assistant, employed for the purpose), and treated the ocean rather like a spa. Others would sit in a wooden cabin that was carried, rickshaw-style, into the water, which filtered in through the gaps in the wooden boards. Another method was to wade out, holding on to a rope attached to a stake driven into the sand, watched by the *baigneur*, who would be timing the immersion. (The idea of rushing into the water and allowing the waves to plunge over the head would be unthinkable for another ten years.) Once in the water, you were counselled to swim, if you knew how, and if not, 'dansez, et faites le phoque ou la grenouille': just dance about like a seal or a frog. In 1874, bathing was already *à la mode*. Young women bathed wearing a short tunic (revealing fully the ankles and calves), frilled pantaloons, a beribboned hat and espadrilles. Even when paddling at the water's edge, it seemed necessary, on emerging, to wring out the hem of one's striped cotton dress, revealing the ankles and a flash of lacy bloomer. Because of the extraordinary glimpses of flesh it allowed, trains carrying hordes of Parisians to the seaside on grounds of health (the pretext for taking a holiday, or forcing an engagement) were dubbed 'the marriage trains.'

Both Berthe and Edma sported the latest fashion in beach-wear, Madame Manet announcing frankly to Eugène that 'Madame [Edma] Pontillon's triumph is her bathing suit.' One day as he and Berthe painted together at the harbour, Eugène announced his intentions. By the end of the painting session, Berthe had agreed to marry him. Once his proposal was accepted, discretion obliged Eugène to return to Paris, as it would have been unseemly for Berthe to continue her holiday in the presence of her betrothed. This allowed him the opportunity to give full expression to the romantic side of his nature, which he tempered with his appreciation of the fact that he was about to marry a professional artist. His letters were masterpieces of tact, discretion and flirtation: '. . . I doff my hat to the beautiful artist, as you are called by a friend of my mother's, . . . a good judge of women.' He was missing Fécamp, and the charming

strolls along the promenade where he and Berthe had been sure of meeting. He was wandering the streets of Paris, thinking of her, 'but nowhere did I catch a glimpse of the little shoe with the bow that I know so well'. When would he be able to see her again? He was 'on very short rations after being spoiled'.

<p style="text-align:center">★</p>

In the autumn, everyone except Pissarro was back in Paris, including Cézanne, who rejoined Hortense and Paul in the rue Vaugirard, having secured a sufficiently sizeable allowance to support them, though the charade of their secret existence continued. He seemed to have reached a new phase of artistic resolve: not, he had assured his mother, to please idiots, with their interminable need for 'finish', but for the sake of his own continuing education. Manet and Degas were regularly seen again in the Nouvelle Athènes. Berthe and Eugène began to make plans for their wedding, arranging for a civil ceremony at the Town Hall on 22 December, followed by the customary religious ceremony at Notre Dame de Grace at Passy. Because the Morisots were still in mourning, the marriage took place discreetly, in the presence of only family and their immediate circle, with Berthe dressed in ordinary day clothes. Degas made them a wedding present of a portrait of Eugène, seated patiently on the beach, lost in contemplative reverie. Manet painted *Berthe Morisot in Three-Quarters View*, looking rather formal, with uncharacteristically tidy hair, raising her left hand to show the ring on her third finger. This was allegedly the last portrait he painted of her, though marriage did not stop her from visiting him. She was back in his studio six weeks later.

In mid-December, Renoir chaired a meeting at his studio, where the accounts from the exhibition were presented to the group. Liabilities were 3,713 francs. Cash in hand: 278 francs. Each exhibitor owed 184 francs and 50 centimes. Unanimously, they decided to liquidate the Society.

PART FOUR

# DANCING AT THE
# MOULIN DE LA GALETTE

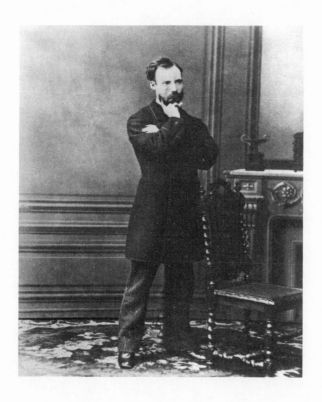

Auguste Renoir, c. 1867

# DEALERS AND SALESROOMS

*'Paint the truth, let them talk.'*

— Edouard Manet

EARLY IN 1875, ZOLA'S PUBLISHER, twenty-six-year-old Georges Charpentier, was walking through the streets of Montmartre when he noticed a small canvas signed by an unknown painter (Auguste Renoir), propped up against the wall of a modest picture dealer's. On this freezing January day, the painting reminded him of carefree summer days, and of modern life: it depicted an oarsman standing on the riverbank, and seated at his feet, a young woman in a white dress, reading a newspaper. Charpentier went into the shop and asked to buy the picture, but the dealer told him it would be coming up for sale at the auction rooms in the hôtel Drouot, in March. He made a note to remember to attend the sale.

Charpentier had recently inherited his publishing business from his father. He lived with his wife Marguerite, in *haut bourgeois* style, in a fashionable new apartment, at 11, rue de Grenelle. The publishing offices were on the ground floor. The Charpentiers lived exactly the lifestyle that Haussmann's new Paris was designed to promote and develop, in a city which, in 1875, was still very much under construction: the life of the streets was dominated by pavers, construction workers and copious white plaster dust. Only the hillside of Montmartre, despite having been absorbed into the city of Paris, was still rural, with gardens, vineyards and the old windmill, which (even though it was no longer a working mill) meant that the *quartier* retained the character of old, pre-industrial Paris.

It was Renoir's idea to put paintings up for sale in the hôtel Drouot auction rooms. The rue Drouot was just a few streets from the apartment he rented with his brother Edmond in the rue Saint-Georges, towards the foot of the *Butte*, and he noticed they had begun to include the sales of paintings among their regular sales. He was aware that when serious collectors wanted to revitalise their collections, they held auctions at the

hôtel Drouot, and that the sales were well attended by the new class of acquisitive consumers, who seemed to buying as if there was no tomorrow: furniture, ornaments, jewellery, clothes, and all the other accoutrements of the rising middle class. They also wanted paintings for the walls of their new apartments. Renoir mentioned this to Monet who, always ready to seize a commercial opportunity, was more than willing to participate. Sisley also agreed. The only other member of the group who could face showing work after the humiliations of the previous year was Berthe Morisot. She stood to lose nothing, and was keen to go on exhibiting, so the four of them sent pictures, due for auction on 24 March, with a private viewing on the 22nd, and a public one on the 23rd.

Durand-Ruel agreed to assist in the preparations. A catalogue was printed, with an introduction by the critic Philippe Burty, who more or less echoed the sentiments of Armand Silvestre's earlier preface to Durand-Ruel's exhibition catalogue: the painters were 'achieving with their palettes what the poets of their time express, but with an entirely new emphasis: the intensity of the summer sky, the poplar leaves transformed into golden coins by the first hoarfrosts; the long shadows cast on the fields by the trees in winter; the Seine at Bougival, or the sea along the coast, quivering in the morning breeze; . . . like small fragments of the mirror of universal life'.

Eugène was very happy for Berthe to participate, and Edouard Manet, though he had no intention of exhibiting himself, agreed to help. Someone (probably Monet) asked him if he could put in a good word with Paris's most ubiquitous and talked-about new critic, Albert Wolff, and Manet wrote to him straight away. 'You may not appreciate this sort of painting yet,' he assured Wolff, 'but you will come to like it. In the meantime, it would be kind if you would say a word or two about it in the *Figaro*.' Not such a great idea. Wolff was a strange anomaly, with a dangerous set of chips on his shoulder. A minor draughtsman and book illustrator, he was far from stupid; there were those who even thought him full of wit and common sense. But he was a notorious dandy, notable in the cafés for his fey mannerisms, tight corsets and heavy use of cosmetics. He was also a recently naturalised German (he had flown in over the treetops, according to Degas) and memory of the Franco-Prussian war was still fresh. His main priority was to maintain credibility with the *Figaro* by extending its readership, which seemed to enjoy nothing quite so much as an energetic hatchet job.

Wolff did not even wait to attend the sale. On the eve of the auction, his notice appeared in the *Figaro*, under the sinister title, *Masque de Fer* (the Iron Mask). 'All these pictures,' he wrote, 'have more or less the effect . . .

of a painting you have to squint at from a distance of fifteen paces. The impression the impressionists create is that of a cat walking across the keys of a piano, or a monkey with a box of paints.' Duly primed, the crowds gathered, once again, to caterwaul and jeer. There was pandemonium in the salesrooms, as each picture was raised (sometimes upside-down) for viewing, to roars of abuse, raucous mockery and shrieks of laughter. Rarely had the salesroom audience had quite so much fun. Pissarro (though not exhibiting) was there to see Berthe's pictures come up for bidding. As her first painting was raised, a cry of 'Whore!' went up. Pissarro went across and punched the man in the face. The auctioneer called the police.

But this time, the audience was not entirely composed of philistines. The Manet family and Berthe's cousin were there to raise the bids, and some investors braved the cat-calls to invest in impressionist works at competitive prices. Charpentier bought paintings, and so did another young *amateur*, a quiet tax collector named Victor Choquet, who had just begun to invest his modest private income in works of art. Also among the buyers were Caillebotte, who at this point emerged as a serious purchaser of impressionist work; Degas's friend Henri Rouart; high-profile bankers Henri Hecht and Charles Ephrussi; and Ernest Hoschedé, who the previous year had bought Monet's *Impression: Sunrise*.

Again, reviewers criticised 'purple-coloured landscapes, red flowers, black streams, yellow or green women and blue children'. *Le Charivari* reminded readers of last year's group exhibition in the boulevard des Capucines, in 'the old premises of Nadar-le-Grand', reporting that they now had a chance to see these disruptive painters – dubbed 'the impressionist school' – again. They had already tried once to undermine the Salon: their efforts were not successful. Nevertheless, four of these audacious individuals (one, a woman) were evidently trying again. 'This style of painting, both coarse and ill-defined, strikes us as an affirmation of ignorance and a negation of beauty and truth . . . It is all too easy to attract attention by producing trashier works than anyone else dares.' But thanks to the few serious collectors dotted amongst the audience, the show was not a complete failure. For Renoir the auction consolidated two new relationships, both to prove crucial in the future. Georges Charpentier had been as good as his word, bidding for Renoir's painting amongst the jeering crowd. Charpentier, delighted with his purchase, wanted more works by the unknown painter, and sought Renoir out. When they met, they felt an instant liking for one another, and Charpentier took Renoir to meet his young wife, Marguerite.

The Charpentiers had been married for only three years, but their

salons were already well known. Marguerite was young, accomplished and clever; wealthy and popular, she was the envy of many. She was physically striking, with dark, heavy looks and a buxom figure, though her *haute couture* did not altogether camouflage the shortness of her legs. One of her friends told her she resembled Marie-Antointette: 'Oui, Marguerite, c'est Marie-Antoinette. Mais raccourcie par en bas' (with a shorter bottom half).

Marguerite was extremely taken with Renoir, and invited him to her soirées, where she brought together some of the most celebrated figures of the day, introducing a modern touch with her taste for diversity. Among the writers, artists, actresses and politicians – including Gambetta, now the idol of Parisian society, for whom every lady in the place lowered her *décolletage*, Edmond de Goncourt and Flaubert, who, according to Degas, looked like 'a retired colonel turned wine-merchant' – Marguerite integrated more risqué characters. These included stars of the café-concerts, notably Yvette Guilbert (later immortalised by Toulouse-Lautrec, as well as by Degas), who performed popular songs at the soirées; one evening she was recognised by one of Marguerite's grand acquaintances from the faubourg Saint-Germain. 'My dear,' she exclaimed, 'I bet you don't remember me. We used to meet often a long time ago, before you became a star, when you were still a little seamstress.' 'Of course I remember,' replied Guilbert. 'I'll never forget how difficult it was to get you to pay your bills.'

At the end of a day painting in his lodgings, Renoir would run down the steps of Montmartre, in his starched collar and false shirt-front (a popular device at the time), along the dirty, ill-paved backstreets, through the place de Clichy (still a construction site) and on, to the rue de Grenelle. Totally without envy, he enjoyed the Charpentiers' fine apartments, with their lavish interiors, elaborate refreshments and luxuriously dressed women. He was fond of Marguerite, but had no aspirations to live the life of the Charpentiers. Privately he thought Haussmann was destroying Paris: the new avenues were all very well, but the houses in Montmartre, overpopulated and insanitary though they were, at least had gardens. He was suspicious of the values and priorities of commerce: he said he wanted a bathroom for his toothbrush and his bit of soap, and the chance to see paintings in Louis XV frames, sculpted and decorated with gold leaf; but he would not want his bathroom sculpted and decorated in gold leaf. Over the years, he was regularly invited to Madame Charpentier's soirées. He attended when he could, once absent-mindedly handing the astonished footman his top hat, scarf, gloves and overcoat to reveal that he had forgotten his dinner jacket and was wearing

only his shirt-sleeves: 'very democratic,' remarked Gambetta. However, he also told Renoir that, though he admired the impressionists' work, he could not allow himself to be viewed as a supporter of 'revolutionaries'. The Charpentiers soon became familiars. Renoir was always a welcome guest, and when he was busy working on a painting, he was unembarrassed about sending his excuses: his head was a muddle, he would tell Marguerite, and if he allowed himself to be distracted now, his ideas would be dissipated. He was always invited again.

One of Marguerite's regular guests was the eighteen-year-old actress Jeanne Samaray. She was a vivacious redhead, very actressy, with huge, dark eyes, a small, retroussé nose, pale, luminous skin, a wide mouth and perfect pearly teeth. She wore tailored outfits that showed off her tiny waist and ample bust, and blouses with huge purple bows, but she managed to combine dramatic panache with a degree of fragility, which captivated Renoir. (When, decades later, Renoir's son Jean saw her portrait, he remarked that she was a real 'Renoir': he could just imagine her 'doing her morning marketing in the rue Lepic, her basket full of fresh vegetables. She would have carefully felt the melons to see if they were ripe, and looked with a critical eye at the whiting to make sure it was fresh. At night, when she put on her lovely white dress and her make-up to go on stage, she would be transformed into a queen, an agreeably curved queen, whose body invited caresses.') In the setting of Madame Charpentier's salon, with its luxurious carpets, fashionable Japanese wall hangings, chandeliers, grand ornaments and Chinese lacquered tables laden with pink and white flowers, Jeanne's beauty must have been seen to intoxicating advantage. She lived with her parents in the rue Frochot, just off the place Pigalle. They were soon approaching Renoir, with a request to paint their daughter: 'Jeanne admires you so much.'

The Samarays' apartment in the rue Frochot faced east and west, and the light was good only between one and three in the afternoon, after which the whole apartment was too harshly lit. So Renoir painted hurriedly, rushing into their apartment at one o'clock, sometimes so keen to start work that he forgot to say hello. Sometimes he went to see Jeanne perform at the Comédie-Française, pointing out that this was a great sacrifice, it was not a place you went to have fun. Before long, he was painting her in his own apartment, explaining that they had to find somewhere else for the sessions, Madame Samaray's little cakes were too much of a temptation. In the rue Saint-Georges, the lovers could be alone together. But Renoir was 'not the marrying kind', said Jeanne. 'He marries all the women he paints – but only with his brush.'

Soon he was also painting Marguerite Charpentier's portrait, a lavish

affair in which she positively smoulders with bourgeois chic, ravishingly up to date in her opulent clothes. Victor Chocquet then commissioned him to paint a portrait of his wife. Chocquet had been dazzled by the paintings he saw at the hôtel Drouot, Monet's as well as Renoir's. 'When I think,' he told Monet, 'that I've lost a whole year. I could have been looking at your work a year ago, how can you have deprived me of such pleasure!' Renoir made his way to the Chocquets' smart apartment in the newly completed rue de Rivoli. Chocquet brought out one of his prized Delacroix portraits to show Renoir the kind of thing he wanted, and Renoir set to work. (The following year, he painted Chocquet himself – 'the portrait of one madman by another,' teased Renoir; Degas later bought it.) Renoir and Chocquet got on well straight away, and Renoir considered that Chocquet might also benefit his friends. If anyone was ever going to purchase Cézanne's work, perhaps Chocquet was the man. Cézanne used to frequent a little shop selling artists' materials, in the backstreets of Pigalle, where the proprietor, 'Père' Tanguy, an ex-Communard, gave artists credit and spent many a happy hour smoking with them in the back of his cramped, dark shop. Renoir took Chocquet to Tanguy's to show him some of Cézanne's works, and Chocquet immediately bought a small nude. As they made their way back through the streets of Pigalle and Clichy, Chocquet began to imagine his purchase on the wall. 'It should look great between a Courbet and a Delacroix,' he joked. Then he stopped. 'But what's my wife going to say?' Madame Chocquet was told that Renoir had bought the picture; Chocquet was just looking after it for him.

Cézanne, with his blunt manner and old, blue paint-splattered smock, and Chocquet, *fin*, diffident, serious, were not an obvious duo. But like Dr Gachet, Chocquet saw the point of Cézanne. His support and friendship made a big difference to Cézanne, who began to feel optimistic again. During 1875, he moved with Hortense and Paul to the quai d'Anjou, where Guillaumin, his old friend from Suisse's, had already found a studio. (Having resigned in 1867 from his job as a railway employer, Guillaumin was back at work two years later, having failed to make his fortune as an artist. Fiercely socialist, he now had a night-shift job cleaning the drains.)

The emergence of these new private collectors, even if they were not able to buy constantly or in huge amounts, kept up the morale of the painters, saving them at this time from complete depression and despair. They included Caillebotte, who with his substantial purchases at the hôtel Drouot sale, staked out his inclusion in the group, which he now joined as a painter as well as a collector. Renoir's friend Georges Rivière (who

had so far survived Dr Gachet's gory predictions) recorded his involve-
ment in the press, commenting that 'a newcomer, Gustave Caillebotte, a
painter himself, has brought to the impressionists a degree of financial
backing which will substantially strengthen their case'. Caillebotte painted
fine, psychologically charged interiors, reflecting his own repressed and
stifled social environment, and he was a brilliant painter of wood, which
he rendered supple and tactile in his work. In a painting of his brother
Martial at the piano, the instrument is a live, resonant thing. Over the next
few years, in the company of his impressionist friends, he produced some
of his finest work – beautifully drawn evocations of the street life of Paris
in the process of change; street scenes with decorators, builders, and the
gentry taking the air on the pont de l'Europe. Like Degas, he worked
systematically, with preliminary drawings or photographs to establish the
forms. He then squared the drawing and transferred the image on to a
canvas, which was already divided according to strict geometrical
proportions. His work had a crisp, architectural quality, and a uniquely
urbane realism. As a man, he was intensely private, but in his reserved way
he was devoted to the impressionist cause. Renoir acknowledged him as
the first 'patron' of impressionism, who supported the artists with no idea
of speculation; 'all he wanted was to help his friends. He went about it
very simply: he only bought the pictures that were considered unsaleable.'
(As an old man, Renoir ruefully reflected that perhaps if Caillebotte had
not been so visible as a patron, he might have been taken more seriously
as an artist.)

Their three new patrons – Charpentier, Chocquet and Caillebotte –
gave the group a new injection of energy; with Caillebotte, they even
began to think about holding another group exhibition the following
spring. Berthe Morisot's *Interior* had fetched the highest bid of the hôtel
Drouot auction: Ernest Hoschedé bought it, for 480 francs. But the future
of the impressionists was by no means assured. Renoir sometimes had to
rely on the Charpentiers for support; luckily, despite the emergence of
dealers and middlemen, the age of patronage was not entirely dead. Other
patrons were beginning to emerge, and the silent presence of purchasers
in the background gave the impressionist venture continuing credibility.
Over the next two decades, Chocquet collected regularly (on his death in
1899, he left sixty impressionist works). Tanguy purchased twenty
impressionist paintings between 1874 and 1894. There were others whose
purchases, twenty years on, would seem substantial (Comte Armand
Dorier, thirty-one paintings; Emmanuel Chabrier, twenty-four
paintings). Gustave Arosa was collecting steadily: by 1878, he had twenty-
seven impressionist works. In the art market, it looked as if impressionist

works were being purchased with some regularity. But the occasional, steady purchase of the work of one or another member of the group hardly increased the stability of the lives of the painters.

After the auction, Monet returned to Argenteuil for the rest of the spring. His desire to stay there had recently begun to take on the status of a campaign. He was acutely aware of the difference Durand-Ruel's changed circumstances were making. 'It's getting more and more desperate,' he complained to Manet. 'Could you send something, on whatever terms, to a broker? Only, be careful who you deal with . . . And you couldn't possibly send me a twenty franc note by return, could you?' Manet went to see him. He confided to Théodore Duret that Monet was in 'a sorry state', completely broke, and had urged Manet to buy ten or twenty pictures. 'What about it?' Manet asked Duret. 'Would you be willing to join me, and we would each give him five hundred francs? Of course, we would have to hide from him the fact that we were actually the buyers . . .' To complicate matters, the attraction of Argenteuil as a subject for paintings was gradually beginning to pall. Under the strain of his financial worries, Monet was no longer so inclined to play host to his friends; and the place no longer represented endless, blissful sunny days. He began to introduce into his paintings of Argenteuil something of its wider reality: chimneys, smokestacks, and the proximity of the railway. Spending less time painting the water and the garden, he was taking more notice of the industrial landscape. He went down to the spot where the train crossed the river and painted the dockers as they unloaded coal for the gasworks at Clichy. On fine days he travelled up by train to Chatou, ran up debts at the local hotel, and painted the Saint-Germain railway bridge. Back in Argenteuil, he painted Camille in a scarlet Japanese kimono and peculiar blonde wig, posed with a clutter of fashionable Japanese fans, a portrait – which he later admitted he thought was 'rubbish' – obviously done with its commercial prospects firmly in view.

Manet was in Gennevilliers, at work on a painting which made Degas gasp with dismay, *Le Linge* (1875), a curiously static rendering of a woman and small child bent over their laundry in a garden. The child grimly grips a small bowl balanced on a chair, while the woman wrings out an unconvincing piece of linen in the shape of a strange, cumbersome white cylinder. This, protested Degas when he saw it, was the limit. 'Never say *plein-air* to me again! Poor Manet! How could the artist who painted the *Maximilian* and *Christ with the Angels* turn out a thing like this?' Manet was quite unperturbed. When he introduced Degas to new friends he explained that 'he does cafés from nature!' (The following summer, Degas painted his own *plein-air* scene, *La Plage*. He spread his flannel vest on the

floor of the studio and had the model sit on it: 'You see, the air you breathe in a picture is not necessarily the same as the air out of doors . . . a crumpled napkin is all you need to do a sky.') This summer, the whole Manet family was in Gennevilliers, including Eugène and Berthe, who was fascinated by all the new villas springing up, fenced in by narrow gardens, their washing lines flapping in the breeze. She was painting the laundry, too, in *L'Enfant dans les blés* and *Hanging the Laundry Out to Dry* (perhaps it was she who inspired Manet's controversial effort). She was happy and settled with Eugène; she told her brother Tiburce, 'I have found an honest and excellent man who, I believe, sincerely loves me. I have entered into the positive life after having lived for a long time by chimeras.' But she was longing for a child.

Madame Morisot, counselling her daughter to 'take advantage of the good times, and of your youth', was nevertheless fretting about her son-in-law's future prospects. While Berthe and Eugène were in Gennevilliers, she went to Grenoble, where she tried to talk her brother Octave into manoeuvring Eugène into a government post. (Octave had a senior position in the Ministry of Finance, and claimed to have influence with Gambetta.) She willingly conceded that Eugène was too honest, and too easygoing, ever to make a large fortune (which, by most people's standards, the Manets already had). But in Grenoble, there was a recently abolished post of tax collector which could probably be reinstated by a word or two in Thiers's ear: Thiers had 'acted similarly' on previous occasions. The salary was 1,700 francs (roughly four times what Hoschedé had just paid for Berthe's *Interior*). If all of this was intended to rouse Eugène to action, the plan failed. Eugène seemed quite happy reclining on the grass beside pretty models, posing for Berthe, and revisiting his childhood haunts. She could rest assured, he told his mother-in-law, of his ability to fill any suitable position. She was concerned not so much about that, Cornélie assured him, as by the likelihood that no one would offer him one. But Eugène was not budging, and the matter seemed to be closed. Madame Morisot turned her attention to the latest Zola novel, valiantly tackling his naturalist prose in the hope of gaining some insight into what the impressionists were really about. But it turned out to be no less frustrating than trying to get Eugène to earn an honest wage, 'insulting my intelligence and putting a lead weight on my stomach'. She turned back with relief to Topffer's *Le Presbytère*, with which she found herself instantly back in 'an atmosphere of lofty and touching sentiment, of that subtle gaiety and graceful eloquence which make our French language so charming . . . No, decidedly I am not yet of the new School.'

Back in Paris, Berthe took her new paintings to a dealer, Poussin, who

fussed about the poor market, his overheads and the general state of the ecomony until Berthe, like Degas, began to feel she might do better in England. Rumours had reached Paris of Tissot's affluent London life, with butlers to serve champagne on ice and to polish the leaves of his exotic poolside plants. London was also associated with the glamorous and celebrated Whistler, and Berthe (whose governess and some of whose forebears had been English) had a romantic view of the place. Anglophilia was the new fad; Berthe decided she wanted to be there.

In early July, armed with letters of introduction provided by illustrious friends, Eugène and Berthe sailed to the Isle of Wight, arriving in Cowes in regatta week and taking in the pale, windy island as it teemed with high society in all its finery. They stayed in a place called Globe Cottage, where as usual she found it impossible to settle. It was difficult to paint the jetty with so much coming and going, it was too vivid with motion. She resorted to sketching Eugène as he sat at the window staring stiffly out at the harbour, but discovered that he was unable to sit for long before it 'all becomes too much for him'. When they went out, she noticed the children, 'bare-armed, in their English clothes'. The beach at Cowes was 'like an English park plus the sea', but she only had the strength for a watercolour; 'I'll never be able to face setting up my easel to do it in oils.'

They moved on to Ryde, where they discovered that everything seemed to take place on the pier: promenading and bathing, as well as the docking of the boats. Berthe stepped elegantly on to the pier, wearing her black hat with large lace bow, whereupon all the sailors in the port burst into peals of laughter. Again, she tried to work, but 'the wind was frightful, my hat blew off, my hair got in my eyes . . . three hours after leaving we were back at Globe Cottage'. All in all, Ryde was 'even drearier than Cowes'. She discovered one picture dealer, but was unimpressed by English painting: '. . . This has made me give up whatever illusions I had about the possibility of success in England.'

They were still there for Cowes Week, from 3 August. But it was galling to be stranded in a social scene she had no part in. 'Cowes has become extremely animated,' she was writing to Edma. 'A few days ago the whole of the smart set landed from a yacht. The garden of the Yacht Club is full of ladies of fashion. At high tide there is an extraordinary bustle. But all that is not for us – we are only humble folk, too insignificant to mingle with this fashionable society. Moreover, I do not know how one would go about it, unless one had a fortune of several millions and a yacht, and were a member of the club . . . From the little I have seen of [this social set], it seems to be as dull as it is wealthy.' They also went to the Goodwood Races, where she observed the fashionable upper classes,

who simply seemed elegantly bored. The real problem was her own state of mind. Everything seemed pointless, except those English children with their bare arms. 'I am horribly depressed tonight,' she confided to Edma, 'tired, on edge, out of sorts, having once more had the proof that the joys of motherhood are not for me. That is a misfortune to which you would never resign yourself, and despite all my philosophy, there are days when I am inclined to complain bitterly over the injustice of fate.'

She tried once more to work, setting up her easel in a field. But this time, ironically, she was thwarted by the local village children – 'more than fifty boys and girls were swarming about me, shouting and gesticulating' – and eventually turfed off by the owner, who explained that she needed permission to paint on his land. She even tried painting on a boat: it had worked for Monet. But there they had to contend with 'the infernal lapping of the water'. Again, she took to the sitting room. She was hardly doing anything, she complained to Edma: couldn't she see her way to sending little Blanche and her nurse over for a visit? 'I could make lovely pictures with them on the balcony . . .'

On 19 August, Berthe and Eugène left the Isle of Wight for London, where they explored the parks and buildings, and trekking around Kensington until they were both exhausted: 'we race about like lost souls'. In the National Gallery they saw the eighteenth-century masters and the Turners, which inspired her to look at the Thames. On the Embankment, for the first time since they left Paris she found a scene that fired her imagination: 'the glimpse of the dome of St Paul's through the forest of yellow masts, the whole thing bathed in a golden haze'. They took river trips to Greenwich and Kew, and steamboats from Hampton Court to the Kent coast. Ramsgate and Margate reminded Berthe of Fécamp. She painted three seascapes, and their English trip seemed to be salvaged. By the time she returned, she had painted seventeen landscapes. But she was disappointed by the lack of opportunity to make inroads into English society. Madame Morisot was unsurprised. True, by visiting in August they had picked an impossible month; but surely one always did better in one's own environment. She had been trying to find purchasers for Berthe's Gennevilliers pictures, but no one seemed to be buying. Eugène took over, suggesting she send them to the Dudley Gallery in London. Despite their recent experiences, neither he nor Berthe seemed quite prepared to give up the dream of London.

Degas was also still trying to find English purchasers. He had been to London to meet William Morris and Whistler, and was planning another visit. He had sent a painting to Deschamps's gallery in New Bond Street: 'sell it as you promised me,' he urged Deschamps – 'quickly, and

somewhere it'll do me justice. I need it, as you know . . . It's time I made headway in England, and I'm counting on you to give me a leg up.' Degas was seriously worried about his future prospects, even though he was actually doing better than the other impressionists. He already had a healthy group of regular buyers, including Henri Rouart, Ernest Hecht and Ernest Hoschedé. He also had one collector in England, Captain Henry Hill of Brighton, who had bought two paintings in 1874 and was continuing to buy his work. In Paris, twenty-year-old Louisine Elder (who in 1883 became the second wife of Henry Osborne Havemeyer, millionaire head of the American Sugar Refining Company) was looking around the new galleries. With her friend Mary Cassatt, a young American painter living in Paris, she happened to look in on Durand-Ruel's gallery where they saw Degas's work for the first time. Mary Cassatt immediately fell in love with *The Ballet Rehearsal on Stage*, which she persuaded Louisine to buy and take back to New York. To the young Louisine, the strange, almost abstract image of stage-flats, dancers and specks of light resembled nothing she had ever seen before on canvas. 'I scarcely knew how to appreciate it, or whether I liked it or not, for I believe it takes special brain cells to appreciate Degas. There was nothing the matter with Miss Cassatt's brain cells, however, and she left me in no doubt as to the desirability of the purchase,' she later remembered. This auspicious moment marked the first arrival of an impressionist work in New York. But it would be another decade before the impressionists as a group finally made their entrance in America.

The De Gas family problems were showing no sign of amelioration and things went from bad to worse when, on the afternoon of 19 August, Degas's hot-headed, good-looking brother Achille was involved in a dramatic incident outside the Bourse. He was enjoying the sunshine, leaning against the Corinthian pillars, when someone flew at him with a jasper-knobbed cane, whereupon Achille pulled a revolver and fired three wild shots, one of which grazed his opponent in the face. The man turned out to be the husband of a girl with whom Achille had had an illegitimate child.

Legrand was taken away for first-aid treatment, while Achille spent thirty-six hours locked up in the local police station. When the case went to court on 24 September, it was reported in *Paris-Journal*, the *Figaro* and even the London *Times*. Both men were imprisoned after trial, the wronged husband for a month, Achille for six months. Degas must have been at the trial, as he made some grim sketches of criminals in the dock, their faces eloquent with fear.

Degas's reaction to this harrowing event was to lose himself in the

underworlds of café society, the dance halls and café-concerts, where amongst the absinthe drinkers and garish performers it was almost as if he was acting out the degradation he felt. He said nothing to his friends about his family situation, he simply turned his attention to his new subjects, the underdogs of Parisian life. He posed two friends, the actress Ellen Andrée and the engraver Marcellin Desboutin, for a new painting, *Dans un Café,* seating his models bleakly together at a marble table, Desboutin with his glass of tea, Ellen with her absinthe. Ellen sat staring glumly at nothing, head slightly bowed, feet planted firmly and inelegantly apart; while Desboutin, staring in the opposite direction, puffed gloomily at his pipe. (Ellen complained afterwards that Degas had misrepresented them: it was Desboutin who, in reality, was the absinthe drinker.) It was a topical subject: in 1875, alcoholism raged among the working classes, as Zola discovered when he put together a dossier of notes for his new novel, *L'Assommoir (Downfall).* It had been reported in *L'Ouvrière* that on Sundays, working women even doped their children with soporifics, so that the mothers could be left in peace at the gin parlours. This choice of subject did nothing, of course, to endear purchasers to Degas's painting.

★

As winter 1875 approached, the depressed economic climate meant that future prospects for the group seemed increasingly grim. Renoir and Monet began to talk about organising a second impressionist exhibition. They were clutching at straws, but they reasoned that any opportunity to exhibit was better than not exhibiting at all, the only important thing being to keep going. Degas was unconvinced. Given the devastating reactions both to their first group show and to the hôtel Drouot sale, he was beginning to suspect that the 'impressionist' tag could only continue to give people a hook to hang their prejudices on. Nonetheless, when the group gathered that autumn in the Nouvelle Athènes, everybody was talking about exhibiting again.

By spring 1876, preparations for the new show were already under way. This time, Durand-Ruel offered to lend his gallery in the rue le Peletier for a month, and the painters were preparing to open on 30 March, with 252 canvases, among them two by Bazille, included as a memorial. Manet again declined an invitation to join them. Pissarro anguished for a long time over Degas's conviction that they should remove the collective name, still convinced that the way forward was as an identifiable, democratic group. For some months, he even considered forming a new, more overtly political association, *L'Union,* with Alfred Meyer, a fellow socialist, but he eventually dropped the idea in favour of exhibiting again

with the group. Everyone (except Manet) was on board. Degas contacted Berthe Morisot. 'If possible, come and take care of the placing. We are planning to hang the works of each painter in the group together, separating them from any others as much as possible . . . please, do come and direct this.'

The paintings were arranged by artist, those considered 'easiest' in the front rooms, with the most 'difficult' at the back. Berthe sent nineteen pictures, including *Washing Lines*, and her paintings of England. Degas, whose twenty-four works included *The Cotton Office* and *In the Café*, had a room of his own (at the back). He also took the unprecedented step of including photographs of works not on show. Monet's eighteen works included *The Japanese Girl*, which made a vivid splash of red in one of the front rooms. But the sensation of the show was Caillebotte's *The Floor Strippers*, a huge painting of men, crouched on their hands and knees, naked to the waist, stripping the floor in one of Haussmann's new apartments.

This second exhibition marked the start of Caillebotte's active involvement in the group. He exhibited eight paintings (though for some reason he was not included in the catalogue – because his inclusion was a late decision?), and more or less financed the exhibition. He had recently come into a considerable inheritance following his father's death (in 1874). Later that year, his younger brother Réne had died, aged twenty-six, and Caillebotte feared that he too would die an untimely death. He drafted his will, leaving substantial funds to support future impressionist exhibitions. *The Floor Strippers*, an astonishing work, in which the men's back and shoulder muscles are tactile and taut, and you can almost feel the pressure of their arms and smell the wood as the shavings come curling off the floor, had a naturalist power which no one could fail to appreciate. Prominently visible on the hand of one of the men is a gleaming wedding ring. The private life of Caillebotte himself was a mystery to the group, and everyone seems to have kept a respectful distance. Now that he was practically funding the exhibition, his role within the group was sensitive. His commitment and the prominence of his work this year meant that he had suddenly become indispensable, which irritated Degas, who up to now had been assuming something of a managerial role.

In the rue le Peletier, the audience gathered for the exhibition. It was a smaller crowd than had turned up two years previously in the boulevard des Capucines, but the public still seemed to have come primarily to mock. Victor Chocquet stood protectively in front of Cézanne's paintings, talking them up and pointing things out (Cézanne himself stayed away in L'Estaque this time). Monet's *Japanese Girl* excited much

admiration and sold for 2,000 francs. Crowds gathered to stare at *The Floor Strippers*. Predictably, everyone gaped and jeered at Degas's *In the Café* (which subsequently gained a new title, *L'Absinthe*). George Moore was there, and even he was surprised: 'Heavens! What a slut. A life of idleness and low vice is upon her face, we read there her whole life.' But Captain Henry Hill of Brighton bought the painting (purchasing it either in person or through a dealer). It was shipped to England, where in September 1876 he lent it to the Third Annual Winter Exhibition of Modern Pictures in Brighton, under a title presumably designed to suggest that it was making no great claims for itself as a work of art: *A Sketch at a French Café*. When the group met to add up their sales, they discovered that attendance this time had not been particularly high, but thanks to Caillebotte, they were at least able to pay Durand-Ruel 3,000 francs for the rent of the gallery. They also repaid themselves the 1,500 francs each had advanced, and a dividend of three francs each.

In the press, there was at least some attempt to give the show a fair hearing. Henry James (aged thirty-three in 1876) was in Paris, and reviewed it for the *New York Tribune*, commenting that to the impressionists 'the beautiful . . . is what the supernatural is to the Positivists – a metaphysical notion which can only get one into a muddle, and is to be severely let alone. Let it alone, they say, and it will come at its own pleasure; the painter's proper field is the actual, and to give a vivid impression of how a thing happens to look, at a particular moment, is the essence of his vision.'

In Paris, Duranty wrote the most substantial review, which he later extended into a thirty-eight-page pamphlet published at his own expense as *The New Painting*. He set out what he took to be the tenets of the new 'school', reminding readers that these new revolutionaries were actually exhibiting in illustrious company, along with Millet, Jongkind, Boudin, Fantin-Latour and Whistler. However, what the public should really be concentrating on was not their politics, but their ideas. The painters had discovered a new way of painting light, and of depicting everyday human life. In their work, ordinary man was being celebrated in all his quirkiness and individuality. But Duranty went on to undermine this praise by adding that some of the works nevertheless seemed to him too 'visionary', since surely even a good realist had first to be a good draughtsman. Some readers picked up on hints of his allegiances with members of the group, assuming that his references to paintings of the cotton office, the wings of the Opéra and laundry betrayed the fact that he had been requisitioned by Degas to review the show. His summing up – 'I wish fair winds for the fleet . . . I urge the sailors to be attentive, resolute and patient . . .' – may

have implied an acknowledgement of the role of Caillebotte (the keen yachtsman) in the group.

Other reviewers seemed to follow suit, in the sense that they all tempered their positive comments with caveats. In *L'Opinion nationale*, Silvestre praised the strength of the painters' convictions, but criticised their 'ideal' for being incomplete. *Art* compared this exhibition with the 1874 group show, reporting that here was nothing new, simply 'the worst increasingly being grafted onto the bad, the execrable and the non-existent.' *Le Moniteur universel* called the painters 'artistic intransigents hand in hand with political intransigents'.

But in some ways the most upsetting review was Zola's, since he had supported them in the past, and now suddenly changed tack. In *Le Message de l'Europe*, he singled out Berthe Morisot – 'new charm, infused by feminine vision' – and identified a revolutionary spirit that in years to come would surely eventually win over the Académie des Beaux-Arts and transform the Salon. But he fatally added that he was disappointed in the exhibition itself, in which little seemed to have been achieved since the last exhibition, two years earlier; it was unclear where this new movement was heading. Zola's position was probably political. While the exhibition was on, the first instalment of his new novel, *L'Assommoir*, appeared in *Le Bien Public*: 'It's not grubbiness, it's not crudity, it's pornography,' sneered the *Figaro*'s reviewer – why should the impressionists succeed, where Zola failed? (He need not have worried. By the end of the following year the novel had sold over 50,000 copies, surpassing his – and Charpentier's – wildest dreams.)

However, Zola's reservations were mild compared with those of Wolff, who reviewed the group again in the *Figaro*. This time he really let rip, taking the opportunity for a stab at Durand-Ruel as well as the painters:

The rue le Peletier is certainly having its troubles. After the fire at the Opéra, a new disaster has befallen the district. An exhibition of so-called painting has just opened at Durand-Ruel's. The innocent passer-by, attracted by the bunting outside, goes in to have a look. But what a cruel spectacle meets his terrified gaze! Here, five or six lunatics deranged by ambition – one of them a woman – have put together an exhibition of their work . . . Some people are content to laugh at such things. But it makes me sick at heart. These self-styled artists call themselves 'intransigents'. They take canvas, paint and brushes, splash on a few daubs of colour here and there at random, then sign the result. The inmates of the Ville-Evrard Asylum behave in much the same way . . . Try telling M Pissarro that trees are not purple, or the sky the colour of butter; that the things he paints

cannot actually be seen anywhere in nature . . . Try getting M Degas to see reason; tell him about drawing, colour, execution, purpose . . . Try to explain to M Renoir that a woman's torso is not a rotting mass of flesh, with violet-toned green spots all over it, indicating a corpse in the final stages of decay. There is also, as in all famous gangs, a woman. Her name is Berthe Morisot, and she is a curiosity. She manages to convey a certain degree of feminine grace in spite of her outbursts of delirium.

Not a thought had been spared for the public, he concluded snidely. Why, only yesterday a man had been arrested in the rue le Peletier after leaving the exhibition because he was biting everyone in sight.

The new insult to Berthe horrified everyone. The aspersions being cast on her morality infuriated the Manet family; Eugène challenged Wolff to a duel. Berthe herself seemed unperturbed. She shared Monet's view that this was merely the sort of thing critics said. They reviled Delacroix, Goya and Corot, said Monet. If they had praised us, we might have been worried. As far as he was concerned, Wolff's article simply demonstrated how important it was for the group to go on exhibiting independently.

Despite her attitude, Berthe did dash off precautionary letters to her aunts: 'If you read some of the Parisian newspapers, among others the *Figaro*, so beloved of the right-thinking public, you must have learned that I am part of a group of artists who opened a private exhibition. You must also have seen what favour this exhibition enjoys in the eyes of these gentlemen. On the other hand, we have been praised in the radical news-papers, but you don't read those! Well, at least we're getting attention, and we have enough self esteem not to care. My brother-in-law is not with us. Speaking of success, he has just been rejected by the Salon; he, too, is perfectly good-humoured about his failure.'

Manet had sent *Le Linge* to the Salon, and had for once been rejected by the jury. To add insult to injury, Eva Gonzales, exhibiting as 'a pupil of Manet', was accepted. Nothing daunted, Manet held his own private *Salon des Refusés*, where he exhibited all his rejected paintings and other works, in his studio at 4, rue de Saint-Petersbourg. The invitations to his 'retrospective' were headed, '*Paint the Truth, Let them Talk*'. New crowds flocked to the ultra-fashionable studio, hung with the latest Japanese wall hangings, and were surprised to find that the dashing bohemian was actually a social sophisticate. This discovery made news in the press: 'He lives in a house where the concièrge makes the model for *Le Bon Bock* go in by the servants' entrance . . . he certainly does not mix with the rabble . . . He astonished me with his classical views,' wrote one reporter. Manet's reputation was restored, and his flirtation with *plein-air* was

officially over. 'You can do *plein-air* painting indoors,' he told Berthe, 'by painting white in the morning, lilac during the day and orange tones in the evening.'

Victor Chocquet was keeping Cézanne (still in Provence) apprised of the latest news. He had seen 'the slating attack by 'Sieur Wolff', Cézanne told Pissarro, about whom he was concerned. Pissarro was still very depressed. In Pontoise, he painted the summer festival, but *Festival at l'Hermitage* is a muted scene, depicting people moving among a few modest tents and stalls, their faces averted, the vitality of the painting determined only by the complementary reds and greens of the landscape and tents. In a touching display of role reversal, Cézanne was attempting to raise Pissarro's spirits by inviting him to visit him in L'Estaque, where Cézanne was painting a commission from Victor Choquet, 'two little motifs from the sea'. L'Estaque was 'like a playing card', he told Pissarro, 'red roofs over the blue sea'. There were subjects here which would take three or four months' work, but that was possible in the Midi, where the colours hardly changed. The olive and pine trees kept their leaves, and the sun was 'so tremendous that objects seem silhouetted not only in black and white but in blue, red, brown and violet.'

He told Pissarro that if he ever exhibited with the group again, he hoped it would be without Monet. (The blatant commercialism of *The Japanese Girl* was presumably what annoyed him.) He also warned Pissarro against Alfred Meyer, who he thought was merely jealous, thinking up the idea for *L'Union* only as a way of undermining the impressionists by setting up a rival group. If the painters were not careful, interested viewers would soon be 'faced with nothing but co-operatives'. But in his own way, Cézanne was still fiercely loyal to the group, though, somewhat loftily, he had decided to compromise as far as the Salon was concerned. 'If the impressionist profile can help me, I'll exhibit my best things with them and just offer the Salon something more neutral.'

The assumption that Monet was fast becoming a rich man was, of course, something of an illusion. (Monet was oblivious of Cézanne's feelings, and hotly defended him against those who felt he was a thorn in the group's side.) Still desperate to maintain his home in Argenteuil, he was aware that his prospects were not noticeably improving. *The Japanese Girl*, despite making a good sale, had been the subject of yet more sneering derision in the press; Chocquet had shown no particular new interest, and Monet did not seem to be acquiring any other significant patrons. He was indeed selling very little. He was torn, because his interest in the riverside life of Argenteuil was beginning to pall and he needed some new material. But domestically, he had no real desire to leave, and was reluctant to admit

to himself that he could no longer afford to live out the dream of a bourgeois gentleman in the *banlieues*. He began to look towards Paris for new ideas. From Chocquet's fifth-floor apartment in the rue de Rivoli, he painted the Tuileries. Then he went to the eighth *arrondissement* and painted the grand and glorious eighteenth-century Parc Monceau, the property of Ernest Hoschedé.

The idea to paint the Parc Monceau had come in the form of an invitation from Hoschedé himself, who was a friend of Manet's. In July, Manet and Suzanne were house guests at his immense, palatial summer residence, the Château de Rottembourg at Mongeron, near Paris. Ornate and imposing, the château stood in vast grounds resplendent with roses and animated by strutting turkeys with bright scarlet gizzards. After Manet and Suzanne left, Monet, too, received an invitation. Hoschedé provided a studio in one of the pavilions in the grounds, and gave him a few small advance payments to paint a number of large-scale pictures to decorate the walls. Monet set to work, painting the flowers and the turkeys, with the château looming grandly in the background.

Ernest Hoschedé knew Manet through the homeopathic physician Dr De Bellio, also a collector of works of art – another of the group's life-saving contacts. According to Renoir, De Bellio was always on hand in a crisis. Every time one of them urgently needed a few hundred francs, they would go to the Café Riche at lunchtime where De Bellio could always be found. He could usually be relied on to buy any picture from an artist in crisis, without even bothering to look at it. Unlike De Bellio, Hoschedé had all the appearance of a successful tycoon, with pudgy fingers and fat cigar, black and white spotted tie, bowler hat, handlebar moustache and hard, defiant eyes. Manet painted him that summer at Montgeron, seated jauntily at a little table in the grounds, dressed in a straw boater and with a carafe and glass of wine at his elbow. His daughter Marthe hovered anxiously at his side, her tiny, startled eyes and small, pursed mouth apparently betraying all the cares of which Hoschedé appeared to be oblivious.

For some years, Hoschedé had been enjoying the life of a fabulously wealthy merchant. He had inherited his fortune from his father, a shop assistant who had married a cashier. After years of hard work, husband and wife had together built up a prosperous textile firm. Since the death of his father, six years earlier, in 1870, Hoschedé had been running the family business. But he was a bungling businessman, far too sweet-natured ever to be a successful tycoon. The business was actually in crisis, but Hoschedé had no idea what to do about it. He was married to a woman from a family even more fabulously wealthy than his own. Alice née Raingo's father was

one of the most prominent members of the large Belgian community in Paris, and had dealt in bronze *objets d'art*, supplying the Imperial household; among the Raingos' circle was Baron Haussmann himself. Hoschedé had fallen hopelessly in love with Alice, aged seventeen, despite the misgivings of his doting mother, who feared from the start that with her 'wit, intelligence in plenty, . . . strength of will' and delicate beauty, Alice would turn out to be more than a match for her son. 'Ah, Ernest, Ernest! What fate awaits you!' she had lamented to her diary twelve years earlier. She was about to be proved a prophetic woman.

Alice, with her dowry of 100,000 francs, and 15,000 francs for her trousseau (compare Camille Monet's dowry of 500 francs), married the mild-mannered Hoschedé, and the couple produced five children. All had the stocky build of both parents and their mother's blue eyes and abundant, curly fair hair. Ernest took his father's place in the business, where he bustled around trying to look busy. When Alice's father died in 1870, he left two and a half million gold francs, and Alice inherited a ninth of this, including the château. The couple enjoyed a lavish and ostentatious lifestyle, transporting their friends out to the château for the summer by private train. Increasingly, they were living on Alice's fortune. Hoschedé's reaction to business worries was to go on spending. Since his father's death in 1874 he had poured vast amounts into his art collection. The following year, in September 1875, he had finally been forced out of the family business, but with some associates he simply formed another company (Tissier, Bourley & Co., founded on 1 August 1876, with a capital of 2.9 million francs and sixty sales staff). His finances continued to be unstable, to say the least, but he gave no sign of knowing this, nor did he ever really grasp it. He owned land all over Paris and beyond; the parc Monceau was simply one of his purchases.

In summer, he and Alice gave house parties for illustrious guests, and separate ones for their artist friends, since the Hoschedés were impressed at least as well by talent as by status. Manet and Suzanne were favourite guests, especially among the Hoschedé children, who were allowed to stay up late to listen to Suzanne play the piano and Manet ask 'astonishing questions about country things'. The presence of Claude Monet, pottering about the garden with his easel, painting the roses and the turkeys, must have added a certain cachet to the more bohemian occasions.

On the other side of Paris, at the corner of the rue Poissonnière and the boulevard Poissonnière, the workers kept Hoschedé's factory running. The firm was in a network of dark, winding streets mentioned in Zola's *L'Assommoir*, 'jagged and mutilated, twisting away like dark, winding sewers', running directly off the junction of Haussmann's newly plastered,

gleaming white boulevards Magenta and Ornano. Here, the workers who lived in run-down shacks on the edge of Clichy and the hillside of Montmartre, toiled in ill-lit, abject conditions for up to sixteen hours a day in the service of Hoschedé's massive, if dwindling fortune.

# SUMMER IN MONTMARTRE

*'Boum-boum!'*
— the *Cirque Fernando* clown, as he turned his somersaults

FROM MONTGERON TO MONTMARTRE was an almost inconceivably huge step down the social scale. Renoir, for the first summer he could remember, had money in his pocket, and it came from sales of his work to Hoschedé, Chocquet and Charpentier. Madame Charpentier had just given him (for a 'princely sum') a commission for a portrait of herself and her young daughters. This would keep him in work throughout the winter, painting the Charpentiers' lavish, gilded drawing room, the decorative blond children and their gigantic pet dogs. It also gave him sufficient funds to spend the summer on a project which had long been dear to his heart. He wanted to paint the working (and out of work) people of Montmartre, dancing in the sunshine at their local open-air bar, the Moulin de la Galette.

Life on the Montmartre hillside, or *Butte*, was still essentially rural, with green, leafy trees shading the cheap taverns. The alleys were crumbling, dirty and dilapidated, with ramshackle shanties and hovels muddled together behind the great windmill, but there were vineyards on the slopes, and the inhabitants lived on vegetables grown on sparse strips of land behind the houses, or scavenged by those who lived in the shacks. These working people had not been moved out of Paris, since they were not cluttering up lucrative space at the centre of the city; but now the Montmartrians were often out of work. When they could find employment, the women, familiarly dubbed *guisettes*, worked as florists, laundresses and seamstresses. It was a predominantly matriarchal culture, where layabout *beaux-pères* fathered the children, drank in the bars, and were supported by the labour of the women. With the coming of the factories in the wheat fields around Saint-Denis, supplies of grain for the Montmartre windmills dwindled away, and the open-air café at least kept

the mill in use, saving it from dereliction. It was transformed almost instantly into a successful bar, with a terrace for dancing, and was named the Moulin de la Galette after the coarse pancakes which were the *specialité du jour*; some just called it *le radet* (bar, or counter).

On sunny days, the Moulin was teeming with people, entire families gathered round tables, drinking the special house pomegranate juice, wine or beer and eating *galettes*; on summer afternoons the young girls, watched over by their mothers, danced on the terrace, the sun on their bare arms and shoulders. In the evenings the gaslights came on, and the young gathered to dance in their best, tawdry dresses and trinkets. The place was usually full of prostitutes, but in the summer they too were on holiday: this was not a place to tout for trade. Mostly, the girls were workers on their days off, enjoying a rest during the 'quiet season'. (Nobody ever said they were out of work, they were just resting between jobs.)

After about 1860, Parisians from every walk of life dressed smartly on Sundays. Servants wore their mistresses' cast-offs, and seamstresses ran up cheap versions of the latest fashion. Women of the *demi-monde* followed so fast on the heels of *haute couture* that even they had abandoned crinolines. Bustles were getting smaller, and for the aristocracy, a note of austerity was considered the height of good taste. Gaudy satins in bright colours, complicated hair decorations, and trashy jewellery which sparkled in the sunlight were all now the province of the lower orders. Dancing was hugely popular, especially in the open air: in squares, courtyards, parks and streets; in the 'Casino' in the rue Cadet; and on Thursdays, Saturdays, Sundays and fête days at the Moulin de la Galette, where music was played by ten ragged musicians on a raised podium. In the 1870s, the entrance to the Moulin gained a gate, topped by a semi-circle of cheap gaslights and a sign: *SOIREES jeudi samedi fêtes MATINEES*. But the dance hall was still just a big shed constructed around two windmills. At the back, directly behind the dance hall, were slums, battered corrugated iron lean-tos and broken shacks and shanties.

Renoir regularly went to the Moulin to sit in the sunshine and watch the pretty girls with his friends, some of whom – Frank Lamy, Norbert Goeneutte and Frédéric Cordey – he had known since the early days at Gleyre's. Another regular at the Moulin was a man called Lhote (no one knew his Christian name, or where he lived) who worked at the Havas News Agency. Once an officer in the Merchant Marines he had travelled all over Europe on foot, and seen the Velázquezes in the Prado and the Giottos in Florence. He once went to Jersey with Renoir, and seduced the clergyman's daughter while Renoir painted. Others were government

employees, including Pierre Lestringuez, a man with intelligent eyes and a red beard, who worked in the Ministry of the Interior and in his spare time indulged his passion for the occult by hypnotising his friends. Another civil servant and recent addition to the group was Georges Rivière, 'the very prototype of a provincial lawyer', who later became Secretary to the Finance Minister. He met Renoir in 1874, immediately began to spend all his leisure time with him, and became one of his closest companions. These disparate friends all made willing dancing partners for the girls at the Moulin de la Galette.

The Montmartroises were some of Renoir's best models, though it was not always easy to get them to pose. In fact, the girls loved nothing better than to pose, but they also loved the chase. They would say that they knew what models got up to; no sooner had they agreed to pose than they would turn up on a canvas, totally nude, in the shops in the rue Lafitte. Renoir had enormous charm, patience and diplomacy; he also worked out that the best way to get the girl was to charm the mother. He sat down with them at the tables, bought *galette* for the children and plied the girl with drinks until she was unable to resist – so long, she said, as he didn't make her take off her blouse.

If rigid virtue was not the currency of places like the Moulin, neither was vice. (Renoir later told Julie Manet that he was struck by the sensitivity of these people, and indignant at the grossness with which Zola portrayed them in his novels.) This was a new class of people, still abjectly poor, but aware of social change and social mobility and proud of their territorial rights as Parisians. It was a village community, with its own complicated moral code. Mothers fiercely protected their daughters, even, like the ambitious mothers of the *petit rats*, harbouring for them dreams of a new life, more prosperous than their own. The moral hierarchy was subtle: it went from *honnête fille* to *femme entretenue*, passing through a whole range of types which defied demarcation. Only the Montmartroises themselves could really judge why Zelia was more *honnête* than Mathilde. They all knew one another, and each had her reputation to protect. Once a girl took a lover, her mother would have no truck with him if he so much as hinted that he might stray from her daughter. Lovers came and went, and rarely lasted long. But once a girl had 'fallen' she was taken care of by her mother and the baby became part of an ever-extending family. The 'fall' was practically inevitable. Girls were put out to work at twelve, and at home many were fatherless and had known only unstable 'stepfathers' who seemed to drift about on the wind, spending their days in the wine shops, supported by the work and wages of the women of the household. Occasionally, a baby had to be taken by the midwife straight

to the Foundling Hospital, but usually it stayed in the family home, among the general muddle, deprivation and grime.

Out of these hovels, where four or five lived to a room, emerged the young, fresh, decorative girls in their cheap, shiny clothes. According to Rivière, none of them ever seemed troubled by the poverty of their lives, the Moulin was invariably full of singing and laughter; in a place like this there was no use worrying about tomorrow. The Moulin, with its happy, animated, noisy crowd, became Renoir's artistic dream. One day, as he was working in his studio in the rue Saint-Georges, Lamy came in with some stretchers. He noticed a sketch of the terrace of the Moulin, which Renoir had made from memory, and told him he absolutely had to paint the place. It was a tempting idea, but carrying it out would be complicated. Renoir would have to find models, and a garden, he said. He thought about it for a while, then realised that actually it would need to be painted on the spot. If he could find cheap lodgings right at the top of the hillside, perhaps he could stay up there while he worked on the picture, and store the canvas somewhere overnight.

One blisteringly hot morning, he and Rivière set off from the rue Saint-Georges and walked high up the hillside. By chance, their searches took them up past the Sacré Cœur, along the rue Cadet and round into the rue Cortot, high up on the northern side of the hill. The rue Cortot was a narrow street bordered with ancient, broken-down houses and long, crumbling walls. Below, trees stretched their branches across the tops of the walls, and gave shade in the burning heat. As they climbed, half-way up the street on the left they saw, suspended above a huge, old door decorated with scrolls and mouldings, a placard which read *Logement Meublé à Louer* (furnished lodgings for rent). The seventeenth-century style house, its walls covered with ivy, was one of the oldest in the road. It had once been a kind of lean-to attached to a more imposing building, but the grand house had disappeared.

Pushing open the door to the courtyard, Renoir found two low buildings, joined by a corridor on the first floor, beyond which stretched an enchanting garden. They went through the first door and crossed the corridor, finding themselves outside again, on an unkempt lawn untidy with daisies. Beyond it, a path planted with trees crossed the whole width of the garden; behind that was an orchard, a herb garden and thick shrubs, in the midst of which pushed columns of poplars. The two rooms were to let, for 100 francs a month; the first-floor corridor would be perfect for storing canvases. Straight away Renoir moved into the left-hand side of the building. (The right-hand side is now the Musée de Montmartre.)

In summer 1876, he painted some of his best-known works in the

garden at the rue Cortot, including *La Balançoire*, in which the elegant lady in blue leaning pensively against the swing is Jeanne, one of the Montmartroises who danced at the Moulin de la Galette. Renoir had approached her in his usual manner. Jeanne's mother arrived for the first sitting in a state of grim determination, dragging behind her the beautiful but angry daughter whose furious frown enchanted Renoir. He painted her all that day and the next, with Lamy and Rivière, who had both set up portable easels, at his side, while Jeanne maintained her furious silence. Her mother sat nearby, happily recounting the story of her own life. Eventually, once her mother had satisfied herself that Renoir and his friends were all charming young men with no sinister intentions, Jeanne was allowed to sit by herself.

She now effected an instant transformation, taking a keen interest in Lamy and Rivière. Everyone chatted affably, and Lamy told some old sentimental, romantic stories. Then, focusing her attention on him, Jeanne began to sing some of the latest numbers from the cafés-concerts. It emerged that what had angered Jeanne was her mother's treating her as though she were a little girl. She had a secret lover, with whom she spent whole days at Bougival while her mother thought she was working at the dressmaker's. She had been sulky about posing because she was losing precious time she could have been spending with him. Renoir solved the problem by asking to meet the young man, and becoming Jeanne's greatest alibi. As she posed for *La Balançoire*, she languidly delivered a string of stories about what she and Henri D. got up to when she was not posing for Renoir.

When the painting was finished, Renoir turned his attention to the business of painting the Moulin. Today, the whereabouts of the large painting described by Rivière is unknown (the painting of Le Moulin de la Galette in the Musée d'Orsay does not fit Rivière's description of the huge canvas that had to be lugged back and forth from the rue Cortot to the Moulin. Or perhaps Rivière, never an infallible story-teller, exaggerated its size.) Every afternoon, he and Renoir carted a large canvas from the first floor of the rue Cortot, down the hill and round the corner to the Moulin. The painting, according to Rivière, was done entirely on the spot, which was not always easy: when the wind blew, the big stretcher threatened to fly away like a kite, high above the *Butte*. Every day those who were posing for the picture came down to the Moulin and watched it take shape; while Renoir worked, a large crowd would gather. Jeanne's sister Estelle posed for the girl in the foreground, seated on a green bench; at the table with their glasses of pomegranate juice are Lamy, Goeneutte and Rivière. Dancing with the girls are Cordey, Lestringuez,

Lhote and other painters. In the middle of the painting, in a pair of fancy tight trousers, dancing with Margot, one of Renoir's favourite Montmartroises, is Cordenas, a Spanish painter from Cuba who lived in the rue d'Aboukir. His ambition was to become a real Parisian, and to achieve this he moved to Pigalle, put his name up on the front of his house, and danced every day at the Moulin de la Galette.

Among the dancers is one of the Moulin's most loyal clients, Angèle, a pretty girl of eighteen with an elegant figure, gleaming black hair cut in a fashionable fringe or bangs, small turned-up nose, and fleshy mouth. She had an impressively rich *vocabulaire argotique*, and Renoir loved her slang, her cat-calls and her outlandish gossip. She told stories of all the pimps of Montmartre and knew every notorious bandit, recounting blandly the dreadful misdeeds of men who were obviously her heroes. When she could, she worked for a florist or posed for painters, and she changed lovers frequently. Because she worked regularly and lived with her mother, she was regarded as someone who was quite uncorrupted; she just enjoyed going out a lot. These outings were disapproved of by her mother, who told Angèle she was obviously tired out, the rings under her eyes gave her away. One morning, she arrived at Renoir's studio in the rue Saint-Georges after a long night out. Still half-dressed, she fell asleep in an armchair, a cat on her lap, and Renoir painted her as she slept. She appears, too, in his later painting, *Le Déjeuner des canotiers*, among the strapping young men whose company she so enjoyed. Shortly after she posed for that painting, she was swept away by a rich gentleman. She regularly came back to Montmartre to visit her old friends, show off her new finery, and keep up with the gossip.

Renoir had little time for Baron Haussmann's plans to change the face of Paris. The pleasures of free love and dancing in the sunshine meant far more to him than the accumulation of profit, and he saw the recon-struction of Paris as a sacrifice to the cause of property values. 'What have they done to my poor Paris!' he grumbled. 'I love theatre settings, but in the theatre.' All that summer, he painted the Moulin in the sunshine, making many detailed studies, then working them up into a final composition. He became a familiar figure in Montmartre, far more at ease here than in the formal world of the salons. He and Rivière lunched at the Moulin, or a couple of streets away at the Lapin Agile (still standing today, at the corner of the rue des Saules and the rue Saint-Rustique). Lit by a narrow window, the café was littered with bottles and furnished with low tables and wooden benches; outside was a vineyard, enclosed by an old, cracked wall. They ate the *plat du jour* and drank dry white *picolo* wine in earthenware pots. Renoir painted the Moulin with the figures to the left

and right of the foreground cropped, so that the viewer has the impression of glimpsing an actual slice of reality: looking at the painting, you are almost there among the dancers and the laughter. But if Renoir made the hillside of Montmartre into an earthly paradise, it was not entirely through the workings of his imagination: the workers did dress in their best Sunday finery; they did wear all the dresses, hair decorations and jewellery they could beg, steal or borrow. The girls were radiant and the sun shone all that summer, making the place resplendent and dazzling it with colour and light.

The Cirque Fernando arrived from Spain, and was an immediate success. The clown's 'Boum-Boum!' (delivered as he turned his somer-saults) became a popular conversational tic throughout Montmartre. Degas, who loved the circus, came up the hillside to paint one of its performers, Miss LaLa, walking the tightrope, and to watch the jugglers and acrobats entertaining the audience by gaslight. He loved the exaggerations of artificial light, whereas Renoir preferred the natural sunlight, which for him introduced an element of joy. Renoir hated the idea of suffering, and though seeing the poverty and deprivation of Montmartre and its uncomplaining people caused him heartache, the sunshine always cheered him. While the young mothers danced, the children hung about in the streets, with runny noses, ragged clothes, some of them without shoes. Renoir, as he dashed through the streets, would sometimes stop to wipe a nose or hand out milk or a biscuit. Infants left alone in their cradles made him anxious; he worried about what would happen if there was a fire, or if a cat sat on a baby's face as it slept. He was especially moved by the plight of the infants who, because of lack of care and food, often died in their first few months or had to be taken to the orphanage.

He decided to create a 'pouponnat' (tiny tots' centre) to care for them, and even broached the subject with Madame Charpentier, hoping she might be able to help him set it up as a charity. But for the time being, Madame Charpentier was preoccupied with other things, including the social obligations attaching to her husband's new celebrity authors. Renoir decided something had to be done immediately, so he set about organising it himself, giving a benefit fancy dress ball at the Moulin. Towards the end of the summer, the weather broke and the canvas of the *Moulin de la Galette* had to be put away in the first floor of the house in the rue Cortot while he set about making preparations for the ball. Lamy and Cordey painted the scenery, a brightly coloured garden and proscenium arch to frame the improvised stage. Rivière wrote a verse recitation, the actions to be performed by dancers. Renoir composed the

tunes, and a tenor called Canela (who spent his days trying to decide whether to be a singer or a painter) performed the songs. The models made flags, flowers and paper chains. Straw hats, decorated with red velvet ribbons, were to be given out free: the young seamstresses spent several days helping Renoir make them.

The show sold out, and was a spectacular success. The band was brilliant, the applause brought the house down; the dancing went on all night. But the proceeds were hardly enough to do very much for the *enfants trouvés*, especially since the most expensive, front-row seats (two francs) were all given away as complimentaries to distinguished guests. The event did collect enough to pay for the medical care of one poor girl suffering from phlebitis after a miscarriage, and there was a whip-round for baby clothes and blankets for the newborn poor. But the audience *was* the poor. Though there was certainly no lack of enthusiasm, nobody had anything to give. The charitable venture had to be dropped until Madame Charpentier was able, some years later, to take it up again (she set up a nursery, La Pouponnière Nouvelles Etoiles des Enfants de France).

★

Back in Paris, the painters continued to look for new supporters. In September, Mallarmé wrote an article, published in England in *Art Monthly Review*, in which he defined impressionism as a new 'school', identifying Manet as its guiding light. Unlike the other reviews of 1876, this was wholly positive, and the first to detect the quality of movement or *passage* which now typified much of the impressionists' work: 'the ever-present light blends with and vivifies all things,' he wrote. The idea was that 'nothing should be absolutely fixed, . . . so that the bright gleam which lights the picture, or the diaphanous shadow which veils it, are only seen in passing, in the actual moment during which the viewer looks at the scene, which, composed as it is of reflected and ever-changing lights, palpitates with movement, light, and life.'

Another new supporter was Eugène Murer, a writer, amateur painter and *pâtissier*, who began to keep an open table at his *pâtisserie*/restaurant at 95, boulevard Voltaire, for his impressionist friends. Every first Wednesday in the month he gave a dinner for artists, which drew collectors (including Ernest Hoschedé) as well as painters, and where everyone tasted his speciality *pâtés en croute* (he had maintained his reputation during the war with his delicious rat vols-aux-vents). In November 1876 he held a raffle, with a Pissarro painting as first prize. If he charged one franc per ticket, he said, and sold a hundred tickets, there would be 100 francs for Pissarro; even better, if they raffled four pictures,

Pissarro would get 400 francs. Pissarro promptly sent four paintings. Julie thought it was a brilliant idea, and that they should definitely make a habit of it. She sent her personal thanks to Murer, and encouraged Pissarro to take two more paintings with him, just in case. The raffle was held, and the prize won. But the winner, a little servant girl, was disappointed in her prize. 'If it's all the same to you,' she said, 'I'd rather have a *pâtisserie.*' Everyone was happy: Pissarro got his wages, the winner got her cream bun; and Murer (not for the first or last time) got an impressionist painting for a song.

None of these events was going to make anybody a fortune, however. As each member of the group became increasingly anxious about the future they began to quarrel and fall out. Cézanne was still sulking about Monet, who he thought was making money; Caillebotte contined to irritate Degas. Berthe, still anxious about her own prospects, spent the autumn in Cambrai with Edma. 'The entire tribe of painters is in distress,' Eugène reported from Paris. 'The dealers are overstocked. Edouard talks of cutting down expenses and giving up his studio. Let us hope the buyers will return.' All three Manet brothers – Edouard, Eugène and Gustave – were convinced that France's economic recovery was being thwarted by political wrangles. The government's foreign policy was repressive, and those with fortunes to protect were being forced to speculate. Manet's friend Felix Bracquemond had reverted to painting porcelain to make a living, and without the patronage of the Charpentiers, Renoir would probably have had to do the same.

In fact, Berthe's financial prospects were about to improve substantially, though at personal cost. Though discreet about the matter, Cornélie Morisot had been unwell for some time. She was suffering from cancer, and during 1876 she became increasingly frail. In December she died, aged fifty-six, a great sadness for Berthe. Shortly afterwards, with a new inheritance in prospect, Berthe and Eugène moved from the rue Guichard to 9, avenue d'Eylau (now the avenue Victor Hugo), one of the wide, tree-lined avenues leading directly from L'Etoile. Their apartment was smaller than the rue Guichard apartment, but the street was smarter and more central, marking them out as ever more fashionably prestigious. Yves, with her children, joined them in late December to await the arrival of her new baby, due in the New Year. The other impressionists, who were all (with the exception of Caillebotte) trying to make a living from painting, continued to struggle.

Monet was still at the Château de Rottembourg, where he had been since the summer. By early November, he had begun to worry about Camille. He wrote to Manet's friend Dr De Bellio, expressing anxiety

about her, alone with the children and practically penniless in Argenteuil. When Ernest Hoschedé left the château to sort out his business affairs in Paris, Monet found himself alone with Alice and her children – a compromising situation in those days, particularly as his wife clearly needed him. A month later, ominously, he was still there.

# THE ATMOSPHERE OF
# THE BOULEVARD

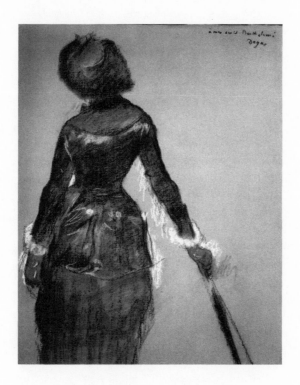

Edgar Degas, *Mary Cassatt at the Louvre*, 1879–80

# STREET LIFE

*300,000 flags fluttering from all the windows . . .*

FOR THE NEXT FEW YEARS, THE painters continued to struggle, both professionally and in their private lives, although occasionally their prospects temporarily improved. In January 1877, Monet rented an apartment in the rue Moncey, near the Gare Saint-Lazare, where he had an idea which was a masterstroke of enterprise. He dreamed up a plan so utterly fantastic that whenever he thought about it (even forty years later), Renoir laughed out loud. Monet had been thinking, he said, about the moment in the *Charivari* review of the first group exhibition when the artist has to clean his glasses. 'Poor blind idiots!' he said to Renoir, 'they want to see everything clearly, even through fog!' This had given him an idea: he would paint fog. The Gare Saint-Lazare was the foggiest scene in modern life: the steam trains coming and going, in great flourishes of black and grey, into and out of the station. 'I've got it!' he announced to Renoir: 'the Saint-Lazare! I'll show it just as the trains are starting, with smoke from the engines so thick you can hardly see a thing. It's a fascinating sight, a real dream. I'll get them to delay the train for Rouen for half an hour. The light will be better then.' 'You're mad,' said Renoir.

But Monet resorted to old tactics. He put on his best clothes, ruffled the lace at his wrists, and twirling his gold-headed cane went off to the offices of the Western Railway, where he sent in his card to the Director. The usher, overawed, immediately showed him in. The visitor introduced himself modestly as 'the painter, Claude Monet'. The Director knew nothing about painting, but was reluctant to show his ignorance; he knew that some painters were celebrities. Monet announced the purpose of his visit. 'I have decided to paint your station. For some time I've been hesitating between your station and the Gare du Nord, but I think yours has more character.' Permission was granted. All the trains were halted;

the platforms were cleared; the engines were crammed with coal so as to give out all the smoke Monet could possibly want. He finally left, carrying half a dozen or so new paintings. The entire personnel, the Director at their head, bowed him out. 'I wouldn't even have dared to paint the local grocer's window!' said Renoir.

Ironically, this turned out to be a far more effective project than the group exhibition. In the immediate term, Monet's Gare Saint-Lazare paintings saved everybody, since despite his resolution to stop purchasing, Durand-Ruel could see at once that these were extraordinary inter-pretations of modern life. He decided to take a new gamble. He bought all the Gare Saint-Lazare paintings, and in addition advanced small sums of money to all the other members of the group. Though this was not a long-term solution it helped to raise morale.

With money in his pocket again, Monet returned to Argenteuil. From then on, he commuted between Argenteuil and Paris. For the time being, Alice seemed to have been forgotten (though the rue Moncey was hardly inaccessible from the Château de Rottembourg). In Argenteuil, Monet seemed to have renewed his determination to live like a gentleman (or a lord, as Renoir had remarked). In the newly rented pink house with green shutters in the rue Saint-Denis, he resumed the lavish life of a bourgeois gentleman, for all the world as if he could afford it. He employed two servants and a gardener, and was having extensive work carried out on the house and grounds, hiring a local artisan called Braque (whose son Georges later became the famed contemporary of Picasso). Monet also employed an array of laundresses, florists and food and drink suppliers, regularly ordering copious supplies of tobacco and red wine. Pleyell and Wolff, the musical instrument makers, also became creditors. He behaved as if the small rented house in the rue Saint-Denis were a *manoir*: the Château de Rottembourg on a modest scale. He regularly entertained, and seems to have been assuming that (as was the custom in the *banlieues*) he would one day purchase the property.

The problem was that none of these people were being paid. When they began insisting he settle their bills, Monet reacted as if he were being unjustly hounded. Though he was in fact still making healthy sales (by the end of the year he had earned over 15,000 francs – at a time when the average income of a Parisian doctor was 9,000 francs) the economy had not improved, and prospects continued to be grim. Despite his latest gamble Durand-Ruel was still in trouble; neither Charpentier nor Chocquet was especially interested in Monet's work; and the world recession raged. Monet had begun to wonder whether Manet was right: perhaps group exhibitions were not the answer. Nevertheless, by the

beginning of the spring, the impressionists were already making plans for a third exhibition.

They continued to argue among themselves. Degas was convinced that they needed to recruit new, younger members, find new venues, and consider publishing a journal or other publicity material: anything, to keep the venture alive. For him, the group represented the survival and advance of modern art. Pissarro still hung on to the idea of the group identity as a political principle. Monet, though he was becoming doubtful about their prospects, was nevertheless convinced that if they were to survive as a group, they should be sticking to the original members, not undermining the group's integrity by admitting newcomers.

At least they now had some reasonably reliable supporters. Charpentier and Chocquet hovered in the background, ready with commissions; on a more modest scale, Cézanne's friend Père Tanguy, a passionate socialist, was still doing his best to support the group, supplying paints and canvases on credit and taking unsaleable pictures with no strings attached. Murer the *pâtissier* was increasingly willing to buy their work. (Within ten years he acquired sixteen Renoir paintings, twenty-five Pissarros, twenty-eight Sisleys, ten Monets and eight Cézannes.) He also gave Renoir and Pissarro employment, commissioning Renoir to decorate a frieze with brilliantly coloured garlands of flowers, and Pissarro to paint the walls of the restaurant with landscapes of Pontoise.

Since the New Year, Caillebotte had been determined to organise another group show. He now came through with the resources, finding premises in the same street as Durand-Ruel's gallery, this time at number 6, rue Le Peletier, and advancing the rent money himself. 'This exhibition *will* happen,' he kept saying; 'it has to'. He was convinced that the painters had a future, and determined to hold on to their ideals. He was also methodical and diplomatic, somehow resolving disputes within the group and pulling everyone together. He, Renoir and Degas all contacted Berthe, who was willing to exhibit with them again.

Degas and Caillebotte were the two self-appointed organisers. They disagreed about everything: the costs, profits and timing; the location; the hanging. Still under discussion was the question Cézanne had first raised: whether it was possible, without disloyalty to the group, to exhibit both with the impressionists and at the Salon. 'Can one exhibit at the Salon and with us?' Degas asked Berthe, 'very serious!' For him, exhibiting at the Salon was a betrayal, and defeated the whole object of their exhibiting independently. He felt it was more important to go on developing the group and introducing new blood. But Caillebotte, Monet, Renoir and the others were still resisting those they regarded as interlopers.

As usual, Manet wanted nothing to do with any of it. He was still trying to finish his portrait of Faure, and painting what he knew and loved best: the seductive women of the *demi-monde*. One of his models was the actress Henriette Hausser, mistress of the Prince of Orange (nicknamed Citron). While Manet was painting Citron, Charpentier brought out Zola's *L'Assommoir* in book form. With its risqué glimpses into the world of the *maisons closes,* the book was the talk of Paris. Manet read it, and borrowed the name of the central character – Nana – for the title of Citron's portrait. She is a plump, radiant *cocotte*, occupying herself at her mirror, laced in her blue satin corset and wearing a white chemise and high heels. A gentleman caller in top hat and cane waits for her on the sofa, scandalously watching as she makes her preparations. The painting went through many sittings – Manet was still working on it in the New Year of 1878 – but Citron was a willing sitter. In the winter, he painted her again in *Skating*, where she posed as a spectator of the voguish new winter sport now popular in the Champs-Elysées and the Bois de Boulogne. He was back in his element, painting the people of Paris, and the interiors of the cafés and café-concerts, humming with heat and noise, heady with the fragrance of coffee and tobacco.

For his private exhibitions at 4, rue de Saint-Petersbourg, he created a makeshift gallery with a curtain which divided his studio from his viewers' gallery. He stood eavesdropping behind the curtain, keen to overhear compliments. One afternoon, he heard someone stop before the ill-fated *Le Linge*. A charming female voice said, 'But that's really good!' Emerging from behind the arras, Manet thus made the acquaintance of Méry Laurent, mistress of the celebrated American dentist, Dr Thomas W. Evans, who had smuggled Princesse Eugénie from the Château des Tuileries in 1870. Linked with a number of artists and great men of letters, Méry was one of the most captivating beauties of her day. She seemed to encapsulate both the old glamour of Empire, and the modernity of the new Republic. An exemplary product of the *demi-monde*, she had married a grocer at fifteen, but left him to join a cabaret. She met Dr Evans when he was in the audience of a show at the Châtelet and he fell in love with her at first sight as she emerged naked from a shell decorated with silver stalactites. She became his pampered consort, kept in luxury on an allowance of 50,000 francs a year. 'To leave him,' she explained to Manet, 'would be a wicked thing to do. I content myself with deceiving him.'

Manet was hooked. Soon they had an arrangement. In the evenings, as soon as the Doctor went out, Méry waved a handkerchief from her window in the rue de Rome. Enter Manet, into a boudoir littered with fur-upholstered sofas, exotic wall-hangings, and chic occasional tables

covered in ornaments. It was a world of tasteless luxury and pure pleasure, designed to divert gentlemen of means from their tasteful marriages and worldly responsibilities. Suzanne turned a blind eye to it, and Manet both enjoyed it in his private life and celebrated it in his art.

On 4 April, the third impressionist exhibition opened at 6, rue Le Peletier, billed as, simply, *Exposition de Peinture Par . . .* and organised and financed by Caillebotte. This time the show was meticulously planned, with spacious and opulent premises and even a specially published magazine. The group was at least no longer unknown to the public ('Immense progrès!' remarked Georges Rivière). The choice of title had caused fierce divisions within the group. Caillebotte, who wanted to keep the word 'impressionist' – and who was financing the show – nevertheless lost the argument. At 6, rue Le Peletier they exhibited in a sumptuous empty apartment on the first floor of a large building, in five large, well-lit rooms. There was no limit to the number of works per painter, and the paintings were vital scenes of modern life, celebrating the open air gaiety of the Moulin de la Galette, and the smoky bustle of the streets of Clichy. Renoir exhibited twenty works, including *Le Bal au Moulin* and *La Balançoire*. Monet showed thirty, including seventeen Gare Saint-Lazare paintings. Eleven of the Monets, including *The White Turkeys*, were lent by Hoschedé; De Bellio and Charpentier also lent works. Caillebotte showed *Street in Paris, A Rainy Day* and *Le Pont de l'Europe*. He did two paintings of the new bridge across the railway track, one depicting a smart couple hastening across, the enormous steel girders softened by the little red bow on the woman's shoes. The second showed a close-up of the great planks of steel, the steam from the incoming train billowing up from below.

Georges Rivière initiated a small weekly journal – *L'Impressioniste* – to publicise the exhibition, and in it he extolled the show himself, in suitably purple prose: 'Where can we find more grandeur, more truth and more poetry than in these beautiful landscapes, so calm and so full of that kind of pastoral religiosity that covers the green fields with a melancholy tint.' Grandly, he compared the painters' work with the prose of Victor Hugo in *Les Misérables* '. . . the same epic dignity, the same force, simple in its solemnity'.

Rivière edited all the contributions, and Renoir contributed articles – on architecture and decorative art – to each of the first two issues, writing that the vulgarity and ugliness of modern architecture was more of a threat to modern life than war: Delacroix's *Jacob Wrestling with the Angel*, a mural in the chapel of the church of Saint-Sulpice, was for Renoir the only acceptable decorative work of the modern epoch. News vendors stood on

street corners yelling '*L'Impressioniste! L'Impressioniste!*' all the way along the boulevard des Italiens. The few copies sold did not cover costs, and the paper only ran for four weeks.

The exhibition attracted some aristocratic viewers, which was something new. But if the social calibre of the crowd had changed, its reactions were the same as before. In fact, aristocratic hostility turned out to be even fiercer than that of the middle classes. Even so, hostility was outstripped by sheer surprise. Renoir's Montmartre paintings seemed to the new audience utterly incomprehensible: workers enjoying the sunshine on their day off? What had that to do with high art? Cézanne exhibited some watercolours, delicate drawings in gouache and wash. Chocquet was again there to defend him, giving impromptu lectures and pointing out things to the crowd, but still they jeered. Monet's paintings of the Gare Saint-Lazare were particularly perturbing, the great steam trains lined up, obscuring the panorama with thick, black smoke, everything – figures, street lamps, station roof, the train itself – blackened with soot. Nothing like this had ever been seen before. By comparison, some of Caillebotte's work seemed almost conventional, with its careful geometry and acceptable proportions; however, his tones – predominantly pale, with strong contrasts – were shocking. From the first day, the crowds made it obvious that they still regarded the painters as dangerous revolutionaries, and this attitude was general, irrespective of social class. Rivière watched a rich banker stand frowning in front of *Le Bal au Moulin*, then go to the door and demand his money back. This gesture was copied by other visitors, some the rich owners of celebrated collections.

A few days after the start of the show, Degas's friend Ludovic Halévy, the popular satirical dramatist, arrived at the back door of the offices of *L'Impressioniste*, to see Rivière. He asked questions about the exhibition and bought several copies of the paper. A few months later, Halévy's new play, *Le Cigale*, opened at the Théâtre des Variétées. The central character was an impressionist painter. His jokes about painting shook the auditorium, but Rivière and Renoir were in the audience, laughing as loud as the rest. Some time after the exhibition closed, the critic Arsène Houssaye asked Rivière for a few notes on the paintings, urging him not to mention either Cézanne or Pissarro (the worst offenders of high-class taste). Rivière's notes appeared in the press in November under the title '*Les Intransigeants et les impressionistes: Souvenirs du salon libre de 1877*'. The article was favourable, highlighting Renoir and mentioning Degas, Monet, Sisley, Morisot and Caillebotte. In the circumstances, this was a big step forward.

But despite all the publicity, reviews of the show had again been mainly

hostile: 'children entertaining themselves with paper and paints do better' (*La Chronique des Arts*); 'if this is what an impressionist work looks like now, what in Heaven's name will it look like when the last brush stroke has been added?' (*Le Moniteur Universel*). The painters met at Murer's to discuss this latest setback. Pissarro was very disheartened. Renoir joked that it was all very well for Pissarro, but he too had been trudging the streets with a picture under his arm, trying to find purchasers. Everyone he encountered said, 'You're too late, Pissarro's just been here. I've taken a picture from him out of common humanity. Poor chap . . . all those youngsters.' No one said 'poor Renoir'. His having no children didn't mean he could live on thin air.

Unlike Pissarro, however, Renoir did have his commissions from Charpentier. For Pissarro, there was nothing to do but return to Pontoise and continue the works he had begun in early spring. He was painting the cherry blossom which irradiated the terraced hillsides, picking up the bright, pale blue of the rooftops and sky, and painting the hillsides after rain, bathed in fresh, wet light. Back in Paris in late spring, he trudged through the streets of Montmartre and Pigalle trying to find small dealers prepared to take a chance on a painting or two, while Julie, in Pontoise, waited patiently for his return. It rained all spring and through into early summer and her husband seemed to be gone for weeks on end. She kept his spirits up with news, assuring him how much the whole family was looking forward to his return:

'What dreadful weather always raining the poor flowers were hardly open when the rain killed them our big red poppies didn't even have time to appear before they disappeared and the roses, poor roses it's so sad and what mud, impossible to put your feet out of doors.

'The whole meadow is flooded at the moment I'm writing to you with a footwarmer under my feet. Anyway in spite of all these inconveniences we are well, all in good health, I hope you are the same. It's so cold that the asparagus haven't come out, nor have the peas or the beans I planted. Most of them have rotted I'll have to plant them all over again. Luckily we're not ready to eat them yet, by the grace of God. Write to us and tell me what you're doing I sent you the letters from [cousins] Amélie and Alice you haven't told me if you got them you couldn't care less could you. As for me, until soon, we send you love *de tout coeur*.'

Even the Pissarros – who would normally rather scrape a living by picking potatoes than live on money they had not earned – were eventually forced to ask for credit on groceries and clothing for their children. Caillebotte sent 750 francs in exchange for three paintings. Pissarro began to make and decorate pottery, for firing in the nearby

ceramic factory at Osny, and to decorate ceramic tiles based on designs from his paintings and sketches: landscapes with shepherdesses, cowherds, apple and cabbage pickers. Over the next two years, he painted thirty or forty of these.

Cézanne stayed on in Paris for a while, also in a fruitless search for purchasers, then returned in summer to Auvers and Pontoise, where he discovered that Pissarro had a new protégé, twenty-nine-year-old Paul Gauguin. At that time a successful young stockbroker, Gauguin was jaundiced with the bourgeois life, and wanted to give it all up to paint. With Pissarro and Cézanne he spent summer 1877 in the countryside around Pontoise, painting out of doors. He bought one of Cézanne's paintings, but Cézanne was not particularly comfortable with this new upstart who had suddenly appeared from nowhere and staked his claim on Pissarro, the group's father figure. In Paris, when Pissarro brought Gauguin to the Nouvelle Athènes to meet the other painters, Monet despised him. Like Cézanne, he saw him as a young dilettante, and thought he had no talent. Degas, on the other hand, saw him as an opportunity. He was keen to incorporate him into the group: more potential for disagreement.

Despite the general failure of the exhibition, there were signs that the critics were gradually beginning to be won round. With the reviewers, Monet's Gare Saint-Lazare paintings had fared better than most. In the Figaro, 'Baron Grimm' (probably Wolff) referred, in a backhanded compliment, to 'the disagreeable impression of several locomotives whistling all at once'. The Moniteur Universel also recognised 'the impression produced on travellers by the noise of engines coming and going'. The power of the paintings was beginning to filter through.

But developments in Monet's private life were about to assume dramatic proportions. The first signs of this were indirect. Early in summer 1877, Ernest Hoschedé was summoned by his associates to Paris. He failed to appear. He was nowhere to be found in Paris, and missing from the Château de Rottembourg. Secretly, with a friend who was concerned that Hoschedé might otherwise commit suicide, he had fled to Belgium, terrified of financial ruin, public disgrace and Alice's fury. From Belgium, he wrote her a desperate letter. 'My beloved wife! What can I call you now? I struggled heroically for a whole month . . . then I lost my head . . . I wanted to kill myself . . . I can't stay in Paris. Am I to go on living for your sake and for the sake of our beloved children? Don't blame me . . . Tell me whether or not I should go on . . . Don't let anyone try to find me, or I will kill myself.'

Alice, alone with the children in the Château de Rottembourg, was

pregnant. Her child had been conceived the previous November, while Monet was still at the château. Throughout July and August 1877 she was besieged by creditors, and forced to prepare inventories of all her possessions. On 16 August, Hoschedé's bankruptcy was announced, and Alice was ordered to leave the château, which was reclaimed along with Hoschedé's remaining assets. All the furniture was repossessed. All the art collections were seized, including fifty impressionist paintings (by Monet, Manet, Renoir and Sisley). These were consigned for auction and sold at rock-bottom prices. The servants vanished, except for one devoted maid, who refused to leave her mistress, declaring that she would stick by Alice and work for nothing. With this poor woman, Alice and her five children left on 20 August for Biarritz, hoping to be taken in by one of her sisters. On the way, the train had to be stopped. Alice gave birth to her sixth child, Jean-Pierre Hoschedé (son of either Hoschedé or Monet – though Monet never acknowledged him as his son) while a bewildered station manager kept the other children occupied in an adjoining carriage. Monet's preoccupation with trains had become bizarrely prophetic.

Monet was still in Argenteuil with Camille, who since the spring had also been pregnant. Monet now confided to Manet and to Dr De Bellio that Camille was seriously ill, with a condition arising from a cervical ulcer, which the local Argenteuil doctor thought might be either cancerous or tubercular. Surgery was suggested, but nothing was done. Camille's condition was potentially very dangerous. As if this were not enough, in the wake of the Hoschedés' financial disaster it was becoming clear that Monet, on a smaller scale, might well be heading in the same direction. His wife clearly needed proper medical attention, and it seemed unlikely that he would be able to provide it.

By the autumn, everyone's situation was precarious. Both Manet and Degas were apologising to Faure for the delays in completing the singer's portraits. Faure hated all Manet's interpretations of him, and they had squabbled through some thirty-eight sittings. Eventually they compromised, and Manet produced a portrait suitable for the Salon. Degas spent the whole summer putting Faure off. He was still painting the backstreets, brothels and bars of Pigalle. The De Gas family fortunes continued their downward spiral, so Degas was forced to leave his pleasant house and garden at 77, rue Blanche and move to a small apartment in the nearby rue Frochot. In geographical terms he simply moved a few streets away, remaining in the same area of Pigalle, on the same side of the Place Blanche, but his circumstances were less desirable. Though he seemed quite cheerful about the move, Ludovic Halévy's son Daniel observed that from then on, 'his vision of the world darkened. The rather unsociable

Degas whose image has persisted dates from then. I think he had enjoyed receiving his friends in his pleasant house in the rue Blanche; I think the studio in the Cité Pigalle was the first refuge of his anti-social feelings . . . it is impossible to underestimate the extent to which his inner being was shaken.' But he still had his Ingres drawings on the walls, said Degas – that was all that mattered. 'To have no clothes and own sublime objects – that will be my *chic*.'

Shouldering responsibility for the decline of the family fortune, he was now supporting his brothers. He told Daniel Halévy that this was an ancient Neapolitan tradition: if a man's fortunes failed, his brother was obliged to take responsibility. (Years later, Halévy discovered that there was no such ancient Neapolitan tradition; Degas's attitude was all to do with his personal sense of family honour.) After the collapse of the De Gas fortune and subsequent disgrace of Achille, Degas's life was never quite the same. 'He could not bear the thought that the honour of the family name had been tainted.' He was also still in mourning for his father. In his notebook at about this time, he made plans for a series of views of modern Paris, in which his residual grief permeates his vision of the streets:

> Draw all kinds of everyday objects placed . . . in such a way that they have in them the *life* of the man or woman – corsets that have just been removed, for example, and which retain the form of the body . . .
>
> . . . Do a series in aquatint on *mourning*, different blacks – black veils of deep mourning floating on the face – black gloves – mourning carriages, undertakers' vehicles – carriages like Venetian gondolas.
>
> On smoke – smokers' smoke, pipes, cigarettes, cigars – smoke from locomotives, from tall factory chimneys, from steam boats etc . . .
>
> On evening – infinite variety of subjects in cafés – different tones of the glass globes reflected in the mirrors.
>
> On bakery, *bread*. Series on bakers' boys, seen in the cellar itself or through the basement windows from the street – backs the colour of pink flour – beautiful curves of dough – still lifes of different breads, large, oval, long, round, etc. Studies in colour of the yellows, pinks, greys, whites of bread . . .
>
> Neither monuments nor houses have ever been done from below, close up as they appear when you walk down the street . . .

He began to take his sketchbook into the backstreet brothels, making graphic, unflinching drawings. (A great many of these 'pornographic' sketches, never before seen, were found in his studio after his death.) Much has been made of his so-called voyeurism, but these 'glimpses

through the keyhole' – his own words, one of the titillating ways clients appraised the prostitutes – were not only realistic, they were also bound up with Degas's experiments in perspective. These drawings were comparable with his sketches of dancers seen from below or above stage, and with his studies of the receding spaces and partially visible silhouettes which fascinated him backstage at the Opéra. They were also comparable with the other impressionists' experiments with steeply rising perspectives and cropped frames. When Degas began to paint women crouching in their tubs, their bodies twisted into contortions, he was again experimenting with perspective and point of view.

Degas's anti-social reputation extended to his treatment of models, with whom he still sometimes got impatient, shouting at them when they lost the pose, or making insensitive comments about their bodies. But he was treating them no more brusquely than the choreographers treated their *petits rats*. He never stopped seeing the models' bodies as material, to be posed and rearranged in the service of his art, not (as Manet and Renoir sometimes did) as opportunities to charm the opposite sex. He could also be very kind to them, anxiously contacting Duret to enquire if he could do anything to help one of them when she became ill. Asked by friends what his models thought of him, he said, 'Oh! Women can never forgive me. They hate me, they can feel that I'm disarming them, I show them without their coquetry, in the state of animals cleaning themselves . . . I'm sure of it; they see me as the enemy. Fortunately, since if they did like me, that would be the end of me.' However, towards the end of 1877, he formed his only close relationship with a woman – with Mary Cassatt, the American painter who had persuaded her friend Louisine Elder to purchase Degas's *Ballet Rehearsal* at Durand-Ruel's.

★

Mary Cassatt was tall and imperious, with a tiny waist, small eyes and a strong jawline. She was certainly not conventionally pretty, but as she quite reasonably remarked to Louisine, that was hardly her fault. She dressed immaculately in the latest svelte, tailored fashions, smart boots and chic hats, and held herself very straight. She had a loud voice, an atrocious accent when speaking French and an exquisitely sinuous and expressive back, which fascinated Degas. Like him, she approached her work with discipline and technical rigour. She had studied at the celebrated college of Philadelphia, then briefly in Paris with the academic painter Charles Chaplin, before leaving for her grand tour. She had travelled through France, Holland, Belgium, Italy and Spain, exploring the museums and copying from the Old Masters. She had also learned the rudiments of

print-making in Italy, and had a good knowledge of Japanese art. She was back in Philadelphia in 1870 and remained there for the duration of the war, returning to Paris in 1872, aged twenty-eight, when she made her Salon début. Since then, she had exhibited at the Salon every year. Degas in fact remembered seeing her painting of Tennyson's *Ida* at the Salon of 1874, and thinking at the time that 'here is someone who feels as I do'.

In 1877, she was joined in Paris by her parents and younger sister Lydia, who left their home in Pittsburgh to settle permanently in Paris. The Cassatts were a prosperous and close-knit family. Mary's father Robert was a retired stockbroker and real estate agent, and her brother Aleck was Chairman of the American Railroad Company. One trigger for the Cassatt parents' removal to Paris may have been Robert's recent retirement, but the main reason was almost certainly the welfare of Lydia, who was chronically ill with Bright's disease (a serious deterioration of the kidneys). The sisters were very close, Lydia was increasingly fragile, and the Cassatts were anxious that the family (with the exception of Aleck, who remained in Pittsburgh with his wife and children) should all be under one roof. In October they all moved into an apartment in the rue Beaujon, on the then very fashionable side of Pigalle.

Mary and Degas had a lot in common: strong family ties, a background of power and wealth, and an almost fanatical dedication to their work. They grew fond of each other, and Degas began to accompany her and Lydia (Mary's chaperone) to fashionable soirées and salons, milliners' shops, galleries and the Louvre. Mary admitted that after persuading Louisine to buy *Ballet Rehearsal* she had gone back to the gallery to look at his works again. 'I used to go and flatten my nose against the window and absorb all I could.' Degas observed the sisters with amusement and affection, and sketched them in their typical attitudes: Lydia perched on a bench, reading a guidebook, while Mary, balancing herself on her cane like a choreographer instructing a *corps de ballet*, leaned sinuously round to peer closely at the ancient Egyptian exhibits. He was fond of Lydia (with whom he shared a love of literature), as well as Mary. They began to be regularly seen about together, and Degas introduced them to some of his nieces and nephews, who modelled for Mary. (In her painting of a horse-drawn carriage in the Bois de Boulogne, *Driving*, the models are Lydia and five-year-old Odile Fèvre, Degas's serious little niece.) Mary particularly loved painting children, since she found them 'so natural and truthful. They have no *arrière pensée*.'

The devoted daughter of a doting father and demanding mother, Mary, despite her staunch air of independence and appearance of modernity, had been subtly removed by her familial obligations from the sphere of

romantic potential. Her attachment to Degas seems to have been chaste, but – on her side, at least – discreetly romantic. When (some years later) Louisine Elder pressed him on the subject of Mary, Degas replied, 'I could have married her, but I could never have made love to her.' In fact, Degas seems to have opted for lifelong celibacy, despite the resolutions he had begun to make in New Orleans. Moreover, in his straitened circumstances, with the burden of his family responsibilities, lack of disposable income and a brother in prison, he could hardly have been deemed an appropriate suitor for Katherine and Robert Cassatt's daughter, though the Cassatt parents grew very fond of him. His devotion to Mary, however, was clear. It manifested itself most revealingly when Mary's dog went missing.

Mary had a particular fondness for griffons, unlike Degas, whose dislike of all dogs was so intense that in most households they had to be locked up if Degas was expected. (The dealer Ambroise Vollard once invited him to dinner. 'With pleasure,' replied Degas. But 'no flowers on the table, . . . I know you won't have your cat around and please don't allow anyone to bring a dog.') Any dog running out to meet him would announce Degas's arrival with sounds of thumping and yelping. But calling at his apartment one day, Georges Rivière glimpsed, peeping out unmistakably from the corner of the room, a little wrinkled face. Mary's dog had been left with Degas for safe-keeping, while she attended to some business. When this little dog (or one like it) disappeared one day, Degas made arrangements for a replacement. He wrote to a man he knew who bred griffons, who was clearly familiar with Degas's usual view of dogs:

> In your kennels or apartments, or among your friends and acquaintances, could you find me a little griffon, thoroughbred or not (a male, not a bitch) and send it to me here in Paris at your convenience or by parcel post? I won't look at the price . . . I think it in good taste to inform you that the person who wants this dog is Mlle Mary Cassatt and she has addressed herself to me because I am famous for the quality of my dogs and my affection for them as well as for my old friends, etc. etc . . .
>
> She wants a young dog, a very young one, so that he will love her.

Degas soon realised that Mary Cassatt would be a definite asset to the group. In spring 1877 – for the first time since her arrival in Paris – her work had been rejected by the Salon. She was therefore delighted by the opportunity to meet other painters, with new ideas. They all loved her, especially Caillebotte and Renoir, who was amused by her accent. Renoir ran into her one day, a wasp-waisted figure in a Worth dress, 'carrying her easel like a man'. 'I adore the brown tones in your shadows,' Mary

complimented him: 'tell me how you do it'. 'The same way as you pronounce your Rs,' replied Renoir. She took an instant liking to Pissarro, and even seemed to understand Cézanne, who she agreed made a startling first impression, but she could see that beneath the surface he was very sensitive, even childlike. 'When I first saw him,' she said, 'he looked like a cut-throat, with large red eyeballs standing out from his head in the most ferocious manner, a rather fierce-looking pointed beard . . . and an excited way of talking that positively made the dishes rattle.' But he soon revealed 'the gentlest nature possible, *comme un enfant*, as he would say . . . I am gradually learning that appearances are not to be relied on over here. Cézanne is one of the most liberal artists I have ever seen. He prefaces every remark with *pour moi* . . . but he grants that everyone should be . . . true to nature from their convictions, and he doesn't believe that everyone should see alike.' When Degas invited her to exhibit with the group, she accepted with alacrity: 'Now I could work with absolute independence without considering the opinion of a jury.'

<div align="center">★</div>

Towards the end of 1877, Ernest Hoschedé set about the business of trying to limit the damage to his fortune. In October he contacted Monet, asking him to buy back one or two paintings somehow salvaged from the distrainers. But Monet was rapidly sliding into his own financial decline. He finally decided that the only solution was to leave Argenteuil and move back to Paris, where he could collect his thoughts and seek further advice about Camille. He began a new round of attempts to borrow money from his friends; Caillebotte, Chocquet, De Bellio and Zola all received desperate pleas for help. (Meanwhile, the artisans and laundresses of Argenteuil were struggling to feed their families, all faithfully waiting for Monsieur Monet to settle his debts.) The plan was to leave on 15 January 1878, thereby hopefully avoiding the seizure of his furniture and paintings. The Monet family – with Camille ill, in pain and due to give birth in less than two months' time – duly began preparing to leave their beloved Argenteuil for ever.

# LA VIE MODERNE

*'to transfer the atmosphere of the artist's studio to the boulevard . . .'*

THE NEW YEAR BROUGHT NO solutions for anybody. True, there were gradual indications that the critics were beginning to understand what the impressionists were aiming for – glimpses of the modern world in action, contemporary scenes viewed with the immediacy of real life. But the painters' struggles continued since, inconveniently, only the translation of this vision into acceptably bourgeois portraiture seemed to result in lucrative commissions, and without these, it was difficult to survive. Because of this, one or two members of the group began to feel they had no choice but to go their separate ways. In some senses the group began to split apart in the late 1870s. But as friends, despite their differences of opinion, they remained firm. Degas, Caillebotte and Pissarro were still convinced that exhibiting independently was the way forward. All three wanted another group show, and Mary Cassatt was very keen to join them. She was fired up with the cause, and already giving up opportunities to exhibit in America, out of solidarity with her new friends. 'There are so few of us that we are each required to contribute all we have. You know how hard it is to inaugurate anything like independent action among French artists, and we are carrying on a despairing fight and need all our forces, as every year there are new deserters,' she told the Society of American Artists in New York.

Monet was among the first to threaten desertion. In anguish in his private life, he was also becoming cynical about the effect of the group identity on his prospects, and told the other members that he had no intention of exhibiting with them again. He had arranged to leave Argenteuil on 15 January, but had very little idea what he was going to do next. Manet sent him 1,000 francs 'against merchandise' to pay for a cheap apartment in Paris, and De Bellio chipped in with 200. Five days later, the

removal men had loaded up the cart, but Monet had nothing to pay them with. Caillebotte sent a loan of 160 francs. Monet was soon sending out further appeals, this time to Dr Gachet, whom he begged for assistance for Camille. Gachet sent 50 francs, and between them Caillebotte, De Bellio and Manet produced another 1,000. Caillebotte bought Le Déjeuner, Monet's summer painting of the garden at Argenteuil, the table laid in the sunshine out of doors. Within a few days, Monet found an apartment in Paris, a fairly large, third-floor apartment with five rooms at 26, rue d'Edimbourg, between the rue Moncey and the Parc Monceau, for 1,360 francs a year. The Monets had no time to move before their son Michel was born, on 17 March 1878, in Monet's studio in the rue Moncey. Manet witnessed his birth certificate, along with Emmanuel Chabrier, a young collector who had just come into an inheritance, and who appears in Manet's Masked Ball at the Opéra. The following month, Chabrier bought 300 francs' worth of Monet's paintings.

Unpredictably, given the group's history, the first member to actually defect was Renoir. He could see that his portrait of Madame Charpentier and her children was obvious Salon material. The picture of two little golden-haired children, dressed alike in blue satin and white chiffon, posing with their mother in their luxurious drawing room, with lavish drapes and rugs, extravagant arrangements of flowers and a bowl of grapes glistening on a side table, epitomised everything Salon viewers aspired to, despite the extraordinarily informal grouping of the sitters. Leaning in close to her daughters, Madame Charpentier combined a touching image of maternity with the very height of sophistication. Renoir, never one to be constrained by a political principle (his politics broadly amounted to the view that whoever you voted for, the government got in), was in no position to turn his back on an opportunity.

Cézanne now decided he was disgusted with both Renoir and Monet, and disillusioned with Paris. For the time being, he retreated to Provence, seeking refuge and tranquillity in L'Estaque (where he was secretly hiding Hortense and Paul), though he remained fiercely loyal to Pissarro, and to the group's original, democratic ideals. With his parents in nearby Aix, the farce of his private life continued. His father still showed no sign that he knew anything about Hortense or young Paul, and Cézanne was still playing along. Auguste Cézanne surely by now had an inkling of what was going on, but it was clear whom Cézanne had inherited his stubbornness from. Cézanne would have done anything rather than admit the truth; Auguste would have done anything rather than admit he knew it. Madame Cézanne was still aiding and abetting her son. Hortense was becoming fractious in sleepy L'Estaque, and yearning for some city life, so

Madame Cézanne found some cheap lodgings for her and young Paul in Marseilles. Zola was put in the picture and asked to go on keeping the secret. When he wrote to Cézanne at the Jas de Bouffan, he always took care not to mention Hortense or little Paul. Cézanne now began a peripatetic existence, shuttling between Marseilles and the Jas de Bouffan, where he worked furiously in his large attic studio, which no one was allowed to enter.

As in many such charades, it was only a matter of time before an innocent bystander unwittingly spilled the beans. Chocquet it was, who innocently referred in a letter to 'Madame Cézanne and little Paul'. His meaning was unmistakable. Auguste, who opened all his son's letters, now had all the evidence he needed. Cézanne was threatened with the loss of his entire allowance, he told Zola. Chocquet's letter had exposed everything to his father, who was 'already on the lookout, filled with suspicions, and who had nothing better to do than open and read a letter sent to me although it was addressed to M. Paul Cézanne, *artiste peintre*'. Zola simply advised his friend to take care. When little Paul contracted some minor illness, Cézanne travelled to Marseilles to see him; when the return train failed to deliver him back to the Jas de Bouffan in time for dinner, he walked twenty miles rather than arouse further suspicion. Monsieur Cézanne now revealed that he had a sense of humour. He began to stop his friends in the street and invite them to congratulate him: 'I'm a grand-father, you know! He's been seen coming out of a toyshop carrying a rocking horse. You're not going to tell me it was for him!?' Still Cézanne persisted. 'I am doing everything I can,' he told Zola, 'to make sure he doesn't get hold of any definite proof . . . P.S. Can you please send sixty francs to Hortense at Marseille?' Auguste Cézanne now halved his son's allowance, using his old reasoning: clearly, he hardly needed a fortune while he was being supported by his father in Aix and his mother in Marseilles. Still, Cézanne stuck to his story, sending more appeals to Zola: 'He's heard from a number of people that I have a child and he's trying everything he can think of to catch me out. He would like to take it off my hands, he says . . .' Zola sent funds.

Cézanne and Zola had drifted apart as their lives diverged, and for some time had had very little to do with each other. The success of *L'Assommoir* had turned Zola into something of a recluse. These days, according to Edmond de Goncourt, he looked 'like a brutish Venetian, a Tintoretto turned house-painter'. He had purchased a large, ungainly house in spacious grounds, with a billiard room and even its own *lingerie*, at Medan, just south of Giverny. Goncourt had visited him in this 'feudal-looking building which seemed to be standing in a cabbage-patch', and which

Zola had renovated at enormous expense, producing 'a mad, absurd senseless folly'. The first floor was reached by a mill ladder, and 'you have to do something like the horizontal leap in a Deburau pantomime to get to the lavatory'. Zola retreated into his study, where he worked night and day surrounded by Romantic bric-à-brac, suits of armour, Balzac's motto, *Nulla dies sine linea*, over the fireplace, and in one corner, a harmonium with a *vox angelica* which he played to himself in the evenings. As the sun went down, Goncourt noted in his journal, 'melancholy rose from that treeless garden and childless house'. Cézanne visited, and felt uncomfortable, unwelcome and out of place. But he still kept Zola abreast of all the latest moves in the Cézanne family power game. There had been a moment in Cézanne's life when he had appeared to be about to break loose, when, with Pissarro as his new father figure, he had seemed to be trying to put down roots in Auvers. But with no real prospect of earning an income for his work, the project had become impossible. Pissarro now seemed far away, with problems of his own.

Pissarro continued to be anxious and disheartened. Julie was increasingly worried that her family would simply starve. She had three mouths to feed: Georges was seven, Félix only four; and Lucien, at fifteen, seemed to her to show no more sign than his father of ever being able to earn a decent living. To Julie's despair, Lucien's greatest asset seemed to be his artistic talent which, to her dismay, Pissarro was encouraging. Having already lost two of her children, she was terrified for the future of the others, and could not understand why Pissarro could not simply take his paintings to shops and get them sold. For some time, Caillebotte had been sending him fifty francs a month. At the end of January, he sent 750 francs, but he warned him that he could no longer help him regularly every month. Murer sent 20 francs as payment for a painting, and Mary Cassatt bought a painting, and cheered up the little Pissarro boys by taking them out for a ride in her carriage. Collectors arrived in Pontoise and praised Pissarro's work highly, but these visits never seemed to result in a sale. Pissarro was becoming paralysed with anxiety, and Julie was pregnant again.

And so, at long last, was Berthe Morisot. She discovered that she was expecting a child in spring 1878, and on the best medical advice withdrew from all social life, refraining even from painting. She lay quietly in the avenue d'Eylau longing for the autumn and hoping for a boy 'to perpetuate a famous name': her child would be born a Manet. Anyway, she confided to Edma, 'each and every one of us, men and women, are in love with the male sex'.

While Berthe rested behind closed doors, Paris was caught up in the

excitement of the 1878 *Exposition universelle*, the great event of the year. The streets were alight with festivities and celebrations. It opened on 1 May, to the sight of 300,000 flags fluttering from all the windows in the streets. Twelve million visitors flocked to the city. Everyone, including Manet, threw grand and glittering parties; crowds pressed into his studio to see his latest work and drink champagne. His circle was becoming ever wider, and his studio buzzed with *boulevardiers*, industrialists, financiers, politicians, and large numbers of elegant women. A singer from the *opéra bouffe* sang popular songs. Hats decorated with birds of paradise mingled with top hats; the place dazzled with *haute couture*. Manet's studio had become the place you went to be seen. The in crowd gathered there regularly, including the glamorous Gambetta and other recently appointed ministers: in the new Republic, politicians were the new celebrities.

Predictably, the art being exhibited at the *Exposition universelle* included no impressionist work, except for a little *Tête de femme* by Mary Cassatt. She had been working with Degas's help on a painting she had been sure would be accepted, *Little Girl in a Blue Armchair*, a close-up of a frowning child with falling-down socks (the daughter of one of Degas's friends) splayed sulkily and realistically in an armchair, indignant with boredom. Degas had helped Cassatt with the background, steeply rising perspectives, cropped furniture and colour contrasts, and she knew the painting was good. But the jury of the *Exposition* consisted of just three people; they were unknown, and one was a pharmacist. Manet and Antonin Proust went to see the works on show, which were mainly by popular Salon artists. 'How can they ridicule people like Degas, Monet and Pissarro, joke about Berthe Morisot and Mary Cassatt and laugh at the Caillebottes, Renoirs, Gauguins and Cézannes,' said Manet, 'when all they can produce themselves is stuff like that!'

The Cassatt parents visited the exhibition, hoping to make new acquaintances, but found it disappointingly devoid of American visitors. The family had moved to a new, fifth-floor apartment at 13, avenue Trudaine, still on the fashionable side of Pigalle, where they stabled their horses and garaged their carriage. For the first time, Mary now had a studio outside her home, provided by her father on the understanding that it must support itself. 'This makes Mame very uneasy,' he told her brother Aleck, 'as she must either make sale of the pictures she has on hand or else take to painting *pot boilers* – a thing she never yet has done and cannot bear the idea of being obliged to do.' But the studio at least meant that during the day she was independent. Manet, though he himself had no wish to exhibit with the impressionists, quickly acknowledged her inclusion in, and potential importance for, the group.

He was still painting modern Paris, and his paintings reflect the subtle changes apparent in the street life of the city, with its gradual new mingling of people from different social strata. He had begun work on a large painting of the Reichshoffen Brasserie, a café-concert near the Place Clichy. *Nana* had been rejected by the Salon on grounds of impropriety, so he was exhibiting it in the window of a milliner's shop. Commerce was no longer the province of the aristocracy: with the new department stores and omnibuses, shop windows were places where people of all classes lingered. Ironically, while Renoir moved increasingly in *haute bourgeois* circles, Manet was in the cafés, painting shady interiors, and dancers and actresses on their evenings off. ('I was painting modern Paris while you were still painting Greek athletes,' he taunted Degas. 'That Manet,' said Degas, 'as soon as I started painting dancers, he did them.') In Manet's studio, Citron was sitting for *The Plum*, Manet's version of Degas's *Dans un Café*. Discarding her usual *demi-monde* finery, she sat this time at the café table, chin in her hand, wearing a pale, strawberry pink dress, her arm hooked round her green plum in brandy, the popular drink of the day, cigarette poised, gazing vacantly into space.

Manet's *plein-air* days seemed to be over; in the year of the *Exposition universelle* he threw himself back into the life of the city. The new Republic was evolving, manifesting itself in the life of the boulevards, where workers in smocks and caps, headscarves and shawls mingled with the aristocracy in their opera hats, corsages, feathers and furs. The sound of the streets was changing: workers shouted across to one another as they went about their business, and the social classes mingled in the streets. Manet painted the rue Mosnier, white with the dust of new plaster, with pavers at work in the foreground, while in the background a closed hansom cab stands at the kerb, waiting discreetly, perhaps, for the emergence of a gentleman caller like Nana's. The painting also includes a hint that, if the physiognomy of the new republican Paris was visibly emerging, the war had nevertheless not been forgotten: an amputee makes his way down the street on crutches, disappearing out of the receding picture plane into the distance. Manet worked feverishly throughout summer 1878 – so much so that, unusually for him, he occasionally emerged from his work complaining of exhaustion.

On 30 June, Paris took to the streets again, for the National Festival of the Republic. In the district where the clothing trade was clustered – rue Montorgueil, rue Mosnier, rue Saint-Denis – the bunting was spectacular, the old Gothic gables blazed with red, white and blue flags. Manet painted *The rue de Berne with Bunting*, the street covered with great, flat streaks of hectic scarlet red, while Monet painted the rue Saint-Denis and the rue

Montorgeuil from a stranger's balcony, a cacophony of riotous colour disappearing in a blaze of scarlet, the crowds seething below. De Bellio bought Monet's picture, 'in settlement of debt'. A few days later, the ruined Hoschedé, with debts of more than two million francs owing to 151 creditors, bought his painting of the rue Saint-Denis, for 100 francs. A few days later, he sold it for 200.

As Paris celebrated the festivities, Ernest Hoschedé's creditors finally moved in on him to claim their dues. Durand-Ruel reclaimed 12,500 francs; his rival Georges Petit, 70,000. Worth, the couturier, reclaimed over 10,000 francs. The Château de Rottembourg, which belonged to Alice, was mortgaged for over 204,000 francs and sold to Alice's daughter Blanche, for 131,000. All the furniture in the Hoschedés' boulevard Haussmann apartment was sold. Claims were made by members of the Raingo family, including Alice herself (whose property was administered separately from her husband's). She was claiming over 90,349 francs, in a 'division of assets', hoping to recover part of the sum allocated for division among Hoschedé's creditors. (In the event, she received 'only' 250,000, from a total of over 906,879 francs recovered.)

The previous summer, on 5 and 6 June 1877, Hoschedé's art collection – more than 100 paintings – had gone up for auction at the hôtel Drouot. Within a fortnight of the sale, Hoschedé was sentenced to a month in prison, for non-payment of debts. Forty-eight of the paintings were impressionist works. These, being of minor interest, were sold on the second day, when the heat had gone out of the sale. The highest sale was 505 francs; most pictures went for between 35 and 500 francs. The Hoschedés' greatest concern (apart of course from the collapse of their fortune) was for the devaluing of Monet's works. Georges Petit, acting partly or wholly for Monet, bought three pictures, for a total of 173 francs. De Bellio got *Impression: Sunrise* for 210 francs. Mary Cassatt bought Monet's *The Beach at Trouville* for 200 francs. Faure and Chocquet both bought works by Monet (which meant that, to Monet's extreme annoyance, Chocquet now had three of his paintings for just over 200 francs). The lowest price was seven francs, for a painting by Pissarro, nine of whose works went for a total of 400 francs. The sale was a disaster for him: his paintings were devalued and he still faced a daily struggle to make ends meet. He was reduced, again, to lugging his paintings around the streets, desperately looking for the one purchaser, he said, who would save his life – he must surely exist somewhere. Within a year of the sale, his prices at auction had dropped an average of 100 francs. 'Once again,' he told Murer, 'I don't have a penny.' In the Nouvelle Athènes, George Moore sat in his corner watching the painters talk. He noticed Pissarro,

giving no sign of his depression or anxiety, surrounded by young students from the Ecole des Beaux-Arts, who hung on his every word. At forty-eight, his beard was white and he was almost bald: he looked like a wise prophet, or 'Abraham in an *opéra-bouffe*, with his long hoary beard'. He would arrive at the café, his beard streaming, his paintings under his arm. 'Hail to Moses,' someone would call across to him.

Despite the June 1878 festivities in the capital, the weather never seemed to get warm, there was almost no sunshine, and the rains kept on coming. While Pissarro roamed the streets of Paris, Julie, in Pontoise, was at her wits' end. She had nothing to pay their creditors, nothing to pay the rent, and the rain had ruined her vegetables. Then a note arrived from Théodore Duret, to say that he was unable to buy any paintings for the moment. Julie sent it to Pissarro in Paris, with her news scribbled on the back: the cow had fallen into the water. Where was her husband, anyway? 'Two weeks have gone by and you are no richer, no pictures, no work. I don't understand anything. Winter is coming, and you have spent the whole summer in Paris and you told me yourself that everyone you know is away. What are you doing? I am very tired of this life.' She was completely at a loss to understand why selling paintings had to be so complicated. She knew about the auction houses, dealers and patrons, and could not understand why Pissarro could not just sell his work to them. What was his problem? She was convinced he was simply not trying. 'Your mother believes that business deals can be carried off just like that,' Pissarro told Lucien. 'Does she think I enjoy running in the rain and mud, from morning until night, without a penny in my pocket, walking to save on bus fares when I am weak with fatigue, counting every penny for lunch and dinner? I can assure you, it's no fun. All I want is one thing – to find someone who has enough belief in my talent to be willing to help keep my family and me alive.'

He did manage to find one or two new purchasers. The Arosa brothers (wealthy bankers) bought eight paintings, and Portier, a young dealer, was beginning to show an interest in his work. But Pissarro was still mainly dependent on the goodwill of Murer and Caillebotte, who went on buying pictures to help him. The problem was that the circle of potential purchasers was so small, and everyone – Monet, Sisley and Renoir, as well as Pissarro – was knocking on the same doors. 'What I have suffered you can't imagine,' he told Murer. 'But what I'm going through now is even worse, much more so than when I was young, . . . because now I feel as if I have no future. Even so, if I had to do it again, I still think I wouldn't hesitate.'

In September, however, once her new baby Ludovic was born, Julie

decided enough was enough. She began a new campaign, to get Lucien out to work. Pissarro was full of misgivings, but Julie was adamant. 'Art is for the rich,' she said; 'your job is to put food on the table.' Pissarro's stepbrother Alfred Isaacson said he could find Lucien a job in England, in a textile factory. This prompted Alfred into action. He found Lucien a job wrapping parcels in Paris, where he stayed in the rue Poissonnière with his formidable grandmother Rachel, now dramatically wizened and bed-ridden, aged eighty-three. She was living there with her niece, Amélie, a milliner, who made Lucien tasteless soup. In the daytime, he mis-addressed parcels, sending packages intended for India, to China. His employer told Pissarro, 'Your son is a good lad, but he has no head for business, I doubt if he ever will have.'

In the rue Moncey, Monet was becoming increasingly stifled and disillusioned. He had begun to long for the countryside. One morning in August, leaving Camille and the children behind, he got up early and headed for the Gare Saint-Lazare. He took the eight o'clock train heading west, following the meandering river, towards Mantes, where he took a horse and cart which rattled for ten kilometres up the slope of Saint-Martin la Garenne. There, the river bent round into a bow of small islands. The chalk cliffs on the right stretched to Roche-Guyon and beyond; the left bank was a forest of trees. From here he could see Vétheuil, an ancient village clustered on the bank of the Seine, old houses with grey/brown roofs nestled round the church, pale hills ranged mistily into the distance. In Monet's painting of this scene, *Vétheuil: Effet de gris*, the village, seen from across the river, looks almost like a moated castle, a château in a romantic dream, rising high above the rippling water. The colour of the roofs gave the landscape a soft, grey aspect and a remote, ethereal quality. He was seduced by its beauty. On 1 September, he announced to Murer, 'I have set up shop on the banks of the Seine at Vétheuil in a ravishing spot.'

Vétheuil, off the beaten track and inaccessible by rail, promised the obvious advantage of reducing the Monets' cost of living. The dis-advantage was that the journey to Paris took the best part of a day; Monet would effectively be cut off from life in Paris, but since the prospect of selling his work seemed only to be diminishing, this was no argument for staying there. In Vétheuil, he took the end house of a row at the edge of the village, on the Mantes road. Now, the extent of his commitment to Alice was startlingly revealed. He would be taking with him not only Camille and their two sons, but also Alice and all her children: twelve people, and their servants. The private tutor left in disgust; the cook, grumbling all the way that her wages had not been paid, grudgingly went

with them. Spiteful rumours immediately began circulating. Camille and Alice had only one proper dress between them, said the gossips, and they took turns to go to Paris, depending on whose turn it was to wear it. (Since they were spectacularly different sizes, this seems unlikely, even if Camille had been capable of making regular jaunts to Paris, which she was not.) 'It's the sight of my wife's life in danger which terrifies me,' Monet told De Bellio as he left for Vétheuil. 'I can't bear to see her suffering like this and not be able to give her any relief . . . Two or three hundred francs now would save us from penury and anxiety.'

Their arrival in Vétheuil was far from comfortable. The weather had never improved, and the barn, which they were using as a sitting room, was impossible to heat. Camille was beginning to resort to tots of alcohol against the cold, which did nothing to help her condition. A month after they arrived, Monet was in touch with Dr De Bellio again, begging him to come to Vétheuil and attend to Camille. Nursing her fell to Alice, who was so upset by the situation that Camille asked Marthe, Alice's eldest daughter, if she knew why her mother seemed so sad. At this point, Ernest Hoschedé re-emerged, making up for the missing tutor by giving the children lessons. Monet was still prospecting for clients, and spent the rainy days writing endless letters to Paris. Almost half the Monet/ Hoschedé income was being provided by De Bellio. Murer, subjected to yet another begging letter, replied that he trusted Monet was treating his other clients with a little more respect. Despite the grim circumstances and dismal weather, during his first two years at Vétheuil Monet painted 178 landscapes. He began to find local purchasers, and in October even managed to earn 1,890 francs.

Camille's condition was not improving, and the supply of charity from De Bellio, Murer and others seemed to have dried up. Responsibility for the rent devolved on Hoschedé. The household was already straining under the weight of two families, and rumours of their debts began to circulate. Monet responded characteristically to the situation, by moving to the other side of the village and taking a bigger house. On 18 December 1878, he signed the lease. There were three floors, including the maids' attic and – rare luxury – an 'English' water closet. There was also a garden, with steps leading up to the house, on which Monet arranged his blue and white pots of flowers. The household now lived like the Pissarros, on rabbits which they kept in hutches, and chickens from their own chicken run. Monet terminated the lease on his Paris apartment in the rue d'Edimbourg, and moved studios from the rue Moncey to 20, rue de Vintimille, a small, ground-floor apartment rented in the name of Caillebotte, who paid the rent. In Vétheuil, Monet continued to paint the

landscape, its misty apple trees, and muggy grey light reflected in the river. When the weather made it impossible to paint out of doors, he painted the two babies, Michel Monet and his little friend (or half-brother) Jean-Pierre Hoschedé.

<p align="center">★</p>

In Aix, further dramas unfolded when a letter from Hortense's estranged father was forwarded from Paris to the Jas de Bouffan. Auguste Cézanne, somewhat understandably, had had enough. He confronted Cézanne with the letter, but still Cézanne hotly denied everything, childishly insisting that since Hortense was not actually mentioned in the letter, the envelope must have been addressed to someone of the same name. Auguste's next move was a surprise: he gave his son 300 hundred francs. Still, Cézanne was immovable. His father obviously felt guilty about something, he told Zola. He had probably been 'carrying on with that nice little maid while my mother's back was turned'. Auguste Cézanne was eighty-one.

A much more likely reason was that Monsieur Cézanne was responding to the text of the letter. Hortense's father was ill, and she needed to travel to visit him in Paris. Whatever the reason for Auguste Cézanne's decision, the pretence, which had lasted nearly ten years, casting a shadow over Cézanne's entire relationship with Hortense and jeopardising the grandfather's relationship with his grandson, now simply fizzled out: a decade-long damp squib. Hortense left for Paris, while for a month Cézanne took care of their son. Some say that perhaps Auguste had been observing Hortense for some time, and seen that she was a responsible and loyal woman. That autumn, she had already risked discovery by going to Aix to visit Cézanne's old friend Empéraire, who was ill and unable to work, with a family of three children who were practically starving. She had been seen around Aix attending to their needs. Whatever Auguste's reasoning, Cézanne's domestic situation was now out in the open. In the New Year he consolidated it, referring openly to Hortense, in a letter to Victor Chocquet, as 'my wife'.

<p align="center">★</p>

On 14 November 1878, Berthe Morisot's months of anxious waiting were over. Julie Manet was born, a big, ugly baby with a broad head 'as flat as a paving stone.' Berthe was blissfully happy, announcing that she now felt 'just like everybody else!' She could barely conceal her joy, affecting disappointment that the new baby was not a boy, since 'to begin with, she looks like a boy'. They had thought of calling her Rose, but she did not look like a rose, more like 'a big inflated balloon'. But she was a happy

baby, 'as sweet as an angel'. Berthe was deeply proud of Julie's heritage: 'My daughter is a Manet to the tips of her fingers,' she told Edma, 'already she looks like her uncles.'

Edouard Manet witnessed the birth certificate of his niece. He had been working ceaselessly all year, even attempting a portrait of the awful critic Wolff, in which, most people said, he had 'caught the man's spirit with merciless accuracy'. (Wolff, predictably, hated the painting, and was calling Manet an 'incompetent fumbler'.) The past few months had been stressful for Manet, since as well as hosting a string of glamorous parties and taking on substantial projects, he had also been moving from his studio at 4, rue de Saint-Petersbourg to a new one at 77, rue d'Amsterdam. The new studio needed months of extensive repair work; at the same time, Manet was moving his family into a new apartment (still in the rue de Saint-Petersbourg – they moved from 49 to 39). As winter approached, he began to feel increasingly drained. Doing all he could to hide his exhaustion, he continued to sparkle, turning up at every party, vying with Degas and Caillebotte in the Nouvelle Athènes, and charming his usual entourage of women. But there was something on his mind. From time to time he had noticed a pain in his foot, and the occasional fit of giddiness. He consulted the family doctor, Dr Siredey, who was reassuring but, Manet sensed, evasive. He continued to be apprehensive. It occurred to him that perhaps he had rheumatism. The nagging worry began to wear him down, but he said nothing to anyone but Dr Siredey. After all, this was not the first time he had felt tired with the approach of winter. Two summers ago, when he and Suzanne came back from the Château de Rottembourg, he had also felt exhausted. For as long as he could, he kept his worries to himself.

One evening in late December 1878 as he was coming out of his studio in the rue d'Amsterdam, he suddenly felt a 'lightning pain' in the small of his back, which knocked him to the pavement. Dr Siredey was called. He clearly knew what was wrong, but it took him some time to break the news to his patient. He mentioned the painter's busy life, his nervous constitution; but Manet was not fooled. He looked up his own symptoms in a medical dictionary, and his worst fears were confirmed. He was suffering from locomotor ataxia. Manet was in the tertiary stages of syphilis.

Soon he could walk only with a stick. Siredey told him about a man named Alfred Béni-Barde, a chap about the same age as Manet, who was a specialist in hydrotherapy, the popular treatment for nervous disorders. Béni-Barde had two clinics, one in Auteuil, the other in the rue Mirosmenil, in the first *arrondissement*. Anything, said Manet, as long as it

worked. 'When the Béni-Bardeuses see me going down the steps of the baths laughing, I shall be cured. It shouldn't be long now . . .'

<div align="center">★</div>

In the Nouvelle Athènes, Degas and Caillebotte were squabbling over their plans for a fourth independent exhibition, for the summer of 1879. This time, though, Degas was adamant about the name; they were not going to call themselves impressionists any longer. It was a red rag to a bull. Caillebotte thought the opposite: that they were gradually making headway, and should build on the identity they had already established. The compromise they reached was wordy; the show was billed as the *4ème Exposition faite par un groupe d'artistes indépendants, réalistes et impressionistes.* On the question of introducing new talent into the group, Degas and Caillebotte agreed. They were both keen to include Gauguin, now seriously embarking on his career as a painter, to the consternation of his Danish wife, Mette, who not only had a natural taste for luxury, but two children to support. This made her a natural ally for Julie — the Gauguins spent much of the summer with the Pissarros in Pontoise. Degas also wanted to involve a new social acquaintance of his, Jean-François Raffaelli, a young French-Italian painter, twenty-nine in 1879, who painted in a style similar to Manet in his early years and already had an audience for his work. He had studied with Gérôme and in Italy (his grandparents were Florentine), was very friendly with Gustave Geffroy, through whom Degas may have met him, and frequently exhibited in the Salons de la Société des Artistes Français, and later in the Salons of the Société Nationale. Both Gauguin and Raffaelli exhibited, along with other new protégés of Degas, including his friend Henri Rouart — fifteen contributors in all.

Yet again, the question of the Salon arose. But this time, the argument was short. Degas would not brook the inclusion of anyone who was sending to the Salon. Pissarro agreed. Unfortunately, that necessarily meant that some members of the original group would be forced to transfer their loyalties. Renoir, signing himself 'a pupil of Gleyre', sent *Madame Charpentier and her Children* to the Salon where, despite the unusually relaxed poses of the sitters, it attracted great admiration from wealthy collectors, including Paul Bérard. The Bérard family's summer retreat was a grand Norman, XVIII-century-style château at Wargemont, near Dieppe. When Bérard saw the painting, he immediately invited Renoir to Wargemont to paint Madame Bérard and their children. The château at Wargemont was a vast affair, with acres of cultivated parkland, lavishly adorned with flowers, stretching right down to the sea, and lush

stretches of lawn shaded by magnificent beeches. In summer the château filled up with large parties of friends, family and acquaintances enjoying the gardens and the sea air.

At thirty-eight, Renoir had found a place in a world of luxury and prosperity. This lifestyle was never one he (unlike Monet) aspired to. For Renoir, it was merely an enjoyable diversion and a vital source of income. He never forgot his Montmartroises, and did what he could for them if they ran into trouble or became ill. But he loved Wargemont, where he found new, enchanting *motifs*; friendly society and lucrative work. He entered fully into the spirit of life there, going with the children to the beach, and with the servants by bus to market in nearby Dieppe. All that summer he worked at the château, most of the time in the open air, in his canvas shoes and fisherman's broad-brimmed straw hat. In his portraits of the children he emphasised the luminosity of young skin and shining hair, painting Marthe Bérard in her collar, lace cuffs and shining patent shoes; then again, at the seashore, in jauntier mood, in her striped beach clothes and straw hat. One hand in her pocket, the other brandishing her fishing net, her thin little legs planted firmly apart, she smiles happily at the artist. Like Mary Cassatt, Renoir loved painting children. He enjoyed their exuberance and natural radiance, sketching them unawares as they played unselfconsciously.

Later that year, the Bérards commissioned him to paint some decorative panels for the château. He painted screens of roses and bright green vegetation, and on the panels a *Fête de Pan*, graceful nymphs decking out the god's torso with garlands of flowers, celebrating the return of spring. In some ways his commissions were taking him backwards, in more traditional directions, but for the time being he was unconcerned by this. Though the impressionist exhibitions had enabled him to follow his own course and to experiment with new artistic techniques, there was no question that the way forward for him as a painter was to accept every lucrative commission, and see where it took him. Since Degas was imposing his embargo on Salon exhibitors, Renoir had no choice but count himself out of the group exhibition.

★

Sisley was also anxious to move in new directions. In late 1875 he had moved to Marly-le-Roi, the village adjoining Louveciennes which had been Louis XIV's summer retreat, with its great royal park, decorated with fountains, landscaped by Le Nôtre. Sisley had lived at the foot of the park, where by taking a short walk up the hill he could see the viaduct and the Machine de Marly, a spectacular feat of engineering which pumped water

up the hillside into the fountains of nearby Versailles. He was fascinated by these architectural feats of technology, as well as by the narrow winding and sloping streets of the village, and was happy in Marly. When he dined with the group at Murer's restaurant, the *pâtissier* noticed his laughter: 'the most subtle of the impressionists, with the soul and the brush of a poet', he had also seemed to be the brightest spark of the group. But in 1877 Sisley had been forced to leave Marly for Sèvres, where rents were cheaper. In April 1879 he had to move again, within Sèvres, to a still cheaper apartment at 164, Grand Rue. Since then, he had become increasingly depressed and pessimistic about his prospects as an artist. Now, he told Théodore Duret, 'I can't go on treading water like this. I think it's time I made a decision. It is true that our exhibitions have made us better known, and that has been useful, but I don't think we should isolate ourselves like this any longer. I have decided to submit some works to the Salon. If they are accepted, and I may be lucky this year, then I think I could make some money. With that in mind, I'm hoping the friends who really care about me will understand my decision.' When his work was rejected, he was plunged into deeper despair. He began to contemplate moving yet again, to somewhere even cheaper, perhaps one of the small villages bordering on the forest of Fontainebleau. The following year, in 1880, he did find lodgings there, in the village of Moret-sur-Loing.

Cézanne, still obsessed with the idea that his father's one wish was to control him, was also largely keeping out of things. He had left Aix at last on good terms with his father and with his full allowance restored, but he was still convinced that the only way he would ever be free was with a guarantee from Auguste of another 2,000 francs a year. Cézanne, Hortense and Paul were living in Melun, where Cézanne was painting bathers gathered on the riverbank, working at his figure painting, and developing the ideas Pissarro had shared with him into new studies of figures grouped in the open air. (He had probably been studying Caillebotte's bathing figures, too; there are some similarities of form.) Like Renoir and Sisley, he was moving in new directions, and reluctant to subject himself again to the kind of mud-slinging that seemed to be the inevitable result of the group exhibitions.

The last of the dissenters was Monet, who was still deeply embroiled in the problems of his private life. In early March, he told De Bellio that he was too depressed even to consider exhibiting with the rest of the group:

I am absolutely sickened with and demoralised by this life I've been leading for so long. When you get to my age, there is nothing more to look

forward to. Unhappy we are, unhappy we'll stay. Each day brings its tribulations and each day difficulties arise, from which we can never quite free ourselves. So I'm giving up the struggle once and for all, abandoning all hope of success. I no longer have the strength to work in such conditions. I hear my friends are preparing another exhibition this year but I'm ruling out the possibility of participating in it, as I just don't have anything worth showing.

This sort of attitude infuriated Degas, who saw any show of reluctance as a gross act of disloyalty, whatever the circumstances. He was as angry with Renoir as with Monet, and irritated by Caillebotte's apparent tolerance. 'Do you invite these people to your house?' he asked him. He even temporarily fell out with Pissarro, for congratulating Renoir on his success. Caillebotte contacted Pissarro in Pontoise. 'If there's anyone in the world with the right not to forgive Renoir, Monet, Sisley and Cézanne, it is you, because you have experienced the same practical difficulties as they have, and you haven't weakened. But the truth is that you are less complicated, and fairer, than Degas . . . You know there is only one reason for doing any of this, the need to make a living. When you need money, you just have to do whatever you can. Although Degas tries to pretend that that's not actually the reason, I know very well that it is.' But the rift between Degas and Pissarro did not last long; if anything, it seemed to strengthen the bond between them. Degas was actually 'very fine and sympathetic to people in trouble', Pissarro told Lucien.

Berthe Morisot still remained to be approached. In spring 1879 she was deeply bound up with four-month-old Julie, involving herself with the baby perhaps more than was typical for a woman of her class, and accompanying Julie and her nurse on their walks in the Bois de Boulogne. Her world now revolved around the infant. In principle, she was quite happy to continue her involvement with the group. She had no desire for the exposure of the Salon, with all the social pretensions it involved, and no need to make money, so the ambience of the group, in the context of which her style of painting seemed to fit, suited her. She was also very fond of the other painters (with the exception of Caillebotte, with whom for reasons best known to herself she never really hit it off), especially Renoir, Degas and Monet. But naturally she did not have a great deal of new work; while she was expecting Julie, and since the birth, she had painted only decorative fans. Degas wanted her with them, however, and contacted her to ascertain that she had no intention of submitting to the Salon. He marked her down as a contributor, and suggested Mary Cassatt might like to visit her, to consolidate her own inclusion in the group.

The two women were not obvious soul mates: two more dissimilar personalities would have been difficult to find. We can imagine Mary Cassatt, perched in Berthe Morisot's smart apartment overlooking the fashionable avenue d'Eylau, attentively leaning forward in her chair, ankles tidily together, in her dark, ultra-stylish fitted jacket, gloved hands clasped over her little fur muff, dashing in a red silk scarf. She would have listened intently, head on one side, eyes alert and sparkling as Berthe spoke rapidly and softly, almost *sotto voce*. It has been suggested that they never really got on, but Berthe was so self-contained that she could appear aloof with even her closest friends. There is no real evidence that they disliked each other. Mary followed up her visit with a note of encouragement. 'You will reclaim your place at the exposition with *éclat*,' she assured her. 'I am very envious of your talent.' She sent 'many kisses to Miss Julie, and a thousand best wishes, to her mother, from their affectionate friend'.

Berthe's inclusion that year went unrecorded in the catalogue, but she must have exhibited work of some kind, for after the exhibition, Manet wrote cryptically, 'I'm delighted to see you are a resounding success, and have pushed you-know-who into fifth place.' Degas had allocated a room for the exhibition of his decorated fans, to which Marie Bracquemond and Pissarro also contributed, so perhaps Berthe's work appeared there. As well as being used as decorative accessories, fans were often framed and exhibited with paintings, so the room devoted to fans would have included serious work. When the exhibition was about to open, it still looked as if Berthe, Degas and Pissarro would be the only three members exhibiting from the original group. But at the last minute Monet weakened, and sent twenty-nine paintings, which Caillebotte hung for him, as Monet was still not prepared to attend the show.

The exhibition took place in premises at 28, avenue de l'Opéra. Mary Cassatt showed all her pictures in bold red and green frames (upstaging even Monet and Pissarro, who the previous year had framed all their pictures in avant-garde white). Just as it was opening, and too late to be listed in the catalogue, Gauguin turned up, with a statuette. Oddly, despite all the frayed emotions which preceded it, the exhibition was an unprecedented success. It attracted nearly 16,000 paying visitors, all expenses were met, and each painter made a profit of 439 francs, instead of the usual losses. (Mary Cassatt supplemented Monet's earnings by purchasing a landscape, *Printemps,* for 300 francs.) Charpentier (encouraged by his wife Marguerite) launched a new magazine, *La Vie moderne*, designed to promote the work of the group. The magazine's publishing premises included an adjoining art gallery, with direct access from the street. An editorial in the first issue announced the aim of the

gallery: 'to transfer the atmosphere of an artist's studio to the boulevard'. It would be open to everybody, a place where 'the collector can drop in at his convenience, thus avoiding possible friction, and with no fear of imposing himself'. This idea was the epitome of modernity: art, it seemed, was about to come to the streets.

Even the critical reception was an improvement on that of previous exhibitions, though the cartoonists, as usual, took the opportunity to pastiche the event. (*Le Charivari* picked on Caillebotte's *Canotier au chapeau haut de forme* – an Argenteuil river scene with a man in a top hat rowing a boat. In the *Charivari* cartoon version, entitled *(Steam)boating in Argenteuil*, the top hat is a smoking chimney.) But on the whole, there was less hostile criticism and a greater show of understanding. In *La Vie moderne*, Armande Silvestre pedantically celebrated, on behalf of *Messrs les Indepéndants*, the demise of *Messrs les Impressionistes*. Huysmans, in *L'Art moderne*, referred to Degas's technical virtuosity in his painting of Miss LaLa walking the tightrope at the Cirque Fernando: 'the exact sensation of the eye following Miss LaLa as she climbs to the top of the Fernando by the strength of her teeth . . . [Degas] dares to make the circus ceiling lean wholly to one side.' Zola, in a letter published in the St Petersburg *Messenger of Europe*, also praised Degas, for his 'astonishing truthfulness'. The tide was beginning to turn.

This fourth show also had the effect of consolidating and deepening the painters' friendships. Degas, Mary Cassatt, Caillebotte and Pissarro had worked closely together to organise the exhibition, in the process discovering a shared fascination with print-making, which Mary had studied in Rome. Once the exhibition was over, all four of them continued to work together. Degas owned a printing press, which enabled them to experiment with the medium. Between them they invented the *manière grise* – to get lightly shaded tints or tonal areas – and discovered a method of rubbing the copper plate with a pencil-shaped emery stone, to simulate grainy areas. Pissarro had made his first etching in 1863, and had since then continued to make occasional etchings on Dr Gachet's printing press; until now, though, he had worked only in line. Tonal variation was the group's great discovery, and they worked with much excitement and enthusiasm. Degas to Pissarro: 'I hurried to Mlle Cassatt with your parcel. She congratulates you as I do . . . Here are the proofs . . . you can see the possibilities there are in the method . . . '

They shared discoveries, and exchanged technical advice. 'You must practise dusting the particles,' Degas advised Pissarro, 'to get a sky of uniform grey, smooth and fine . . . Take a very smooth plate (essential, you understand). Degrease it thoroughly with whitening. Previously you

will have prepared a solution of resin . . . this liquid then evaporates and leaves the plate covered with a coating . . . of small particles of resin. In allowing it to bite, you obtain a network of fine lines, deeper or less deep, according to whether you allowed it to bite more or less . . . Your soft ground seems to me to be a little too greasy. You have added a little too much grease or tallow. What did you blacken your ground with, to get that bistre tone behind the drawing? It's very nice . . . The next one you send, I'll have a print done in coloured ink . . .' Colour printing was a radical new discovery, which Mary Cassatt, particularly, exploited to the full. The medium suited her. Her etchings were very expressive, with bold, sweeping, fluid lines – very different from either Degas's or Pissarro's. The technology enabled her to develop her figure drawing, exploring new rhythms, tricky twists in the posture of a figure, and different lengths and breadths of line. It was a major turning point for her, which some years later produced examples of her most striking and original work.

Soon they were making plans for a monthly, illustrated journal of prints, to be entitled (suggestively?) *Le Jour et la nuit*. Degas started to make prints especially for it, including a soft-ground variant of one of his favourite subjects, Mary and Lydia at the Louvre. They began to put together a business plan for publication of the journal, which initially Caillebotte agreed to guarantee. Degas contacted Félix Bracquemond, who had expressed interest in being included. 'Come and talk it over with me. No time to lose! . . . We must be quick and make the most of what we've gained . . . so that we can show the capitalists some definite programme.' Mary Cassatt, he added, was 'full of it'. He also planned to include the engraver Marcellin Desboutin, and young Raffaelli. But despite their enthusiasm and his initial promise, Caillebotte withdrew his support, and the first issue was put together by Degas, Cassatt, Pissarro and Bracquemond. Degas still had high hopes for it. 'We are bound to cover costs,' he told Pissarro, '. . . at least, that's what several print collectors have told me.'

Mary Cassatt's friendship with Degas was significantly deepened by their work together on this new project. Despite his efforts to bring the two women together it was Degas, rather than Berthe, to whom Mary became close at this time, when Berthe was still adapting to the disruptions in her private life brought about by baby Julie. The apartment had to accommodate a nursery, and a resident nurse. 'Life is largely a question of money,' she complained to her sister Yves, 'which I don't like at all.' The family doctor recommended a healthy seaside holiday, to benefit the baby's lungs, but they could not, said Berthe, afford a summer

retreat (by which she presumably meant the purchase of a large coastal villa). She was suffering mild attacks of depression, and Eugène had been getting migraines, so they took a short break in Beuzeval, then spent the rest of the summer in Paris.

Manet also stayed in Paris, painting Isabelle Lemonnier, Charpentier's sixteen-year-old sister-in-law. Manet adored her, and painted her again and again, whispering endearments as he worked. 'His brush moves softly across the transparent, pearly surface of her skin, light and penetrating as a caress,' observed one onlooker. He was also painting Ellen Andrée, Degas's model for *L'Absinthe* – at least, that was the plan. At Père Lathuille's restaurant one evening, Manet happened to see Lathuille's son in his military uniform. He decided to pose him with Ellen Andrée on the terrace of the restaurant, in 'a proper *plein-air*, so that the features of the figures mesh with the vibration of the atmosphere'. He would make a sketch at Père Lathuille's, and finish the painting in his studio. He wanted Lathuille himself, in his long white apron, as a *volontaire en bonne fortune*, hovering in the background – 'Just move about here and there, and keep talking while I work.' The models posed, the picture was begun, and everything was working beautifully. The couple harmonised effectively and Manet was delighted. But when the time came for the third sitting, they waited in vain for Ellen Andrée. The next day, she was missing again. Finally she appeared, full of excuses to do with rehearsals at the theatre. Manet was furious, and told her that in that case he would do the picture without her. Lathuille's son brought another companion and took up the pose again, but it was not the same. 'Take off your uniform and put on my jacket,' said Manet, handing it across. He started scraping paint off the canvas. The entire conception would have to be changed.

After he had ruined seven or eight canvases, the painting suddenly seemed to come right, except for the hands, and one or two other details. It just needed one more evening, Manet said. During that final evening, he turned the canvas round. It was finished, it just needed a frame. Otherwise it was 'a hundred per cent'. The hand in the glove was not perfect, but 'with three strokes, *pique, pique, pique,* it'll be fine'. Leaving the painting on the easel, they went off to Père Lathuille's for dinner. Phew, said Manet, 'I've got something for the Salon next year.'

His Salon submission taken care of, he retired to the Nouvelle Athènes, where he began work on a portrait of George Moore, fascinated by his white face and sticking-up red hair, like 'half of a smashed boiled egg'. He invited Moore to his studio to continue the sittings, and Moore discovered what was behind the curtain separating Manet's picture gallery from his studio. The space was almost empty but for more pictures, a sofa,

a rocking chair, a table for his paints, and a marble table on iron supports, like the ones in the cafés. Again and again, Manet scraped off the paint and started again. But 'every time it came out brighter and fresher, and the painting never seemed to lose anything in quality'. Finally, Manet was satisfied. The finished work, Moore thought, rendered him 'as green in complexion as if he had been drowned.' Despite all this feverish activity, Manet was not feeling any better. His left leg had begun to show signs of paralysis. But for the time being, he reacted only by pitching himself ever more determinedly into his work.

<p style="text-align:center">★</p>

In Vétheuil, Camille Monet lay on a chaise-longue, watching the children play. Occasionally, she would lean down and stroke the hair of one of Alice's daughters. She was in too much pain to look after her two little boys, and Alice and her daughters, Blanche, Marthe and Suzanne, were taking care of all the children. By May, Hoschedé could see that Camille was gravely ill, perhaps with no more than a few days to live. Monet was in despair. He was severely depressed, he told Manet. His wife was ill, the children were all sickly; the weather was unbearable. His paintings were not successful. His whole miserable existence was a failure.

He now began to take it out on Hoschedé, provoking and taunting him with his own guilt. Snidely, he implied that Hoschedé had been treating him as a mere interloper. If that was his role, perhaps Hoschedé thought of himself as master of the household. In which case, why didn't Hoschedé ask him to leave? He was just putting a further strain on the Hoschedés' resources. 'No-one but myself knows the pressure I'm under, or trouble I have finishing paintings I'm not satisfied with, and which seem to please very few others. I am utterly discouraged. I can no longer see or hope for a way ahead . . . I have to face the fact that I can never hope to earn enough from my paintings to go on living in Vétheuil . . . Anyway, I can't imagine we are very good company for you and Madame Hoschedé, with me becoming ever more bitter and my wife ill the whole time. We must be . . . a hindrance to your plans, and I regret now that we ever started living in arrears.' He was heartbroken, he said, to have to speak to Hoschedé in this way, but surely if the Monets left it would be a relief to everyone, and they would be doing him a favour, since they had virtually become his dependants. Hoschedé should tell him what he (Monet) owed him, since this 'idyll of work and happiness' could obviously never become a reality. Hoschedé managed to sell one of Monet's Vétheuil landscapes to Duret, for 150 francs. Alice started giving piano lessons. Caillebotte saved them with an advance of 1,000 francs, and

paid the first quarter's rent – a further 700 francs – on the rue Vintimille studio.

But the landlady in Vétheuil wanted a further 3,000 francs, and the grocer and draper were both demanding to be paid. Monet was also running out of paints. He went to Paris in search of new clients, but came back empty-handed. Alice now began to blame Hoschedé for his long absences: it all suddenly seemed to be his fault. In August, Monet sold nothing at all. Degas's friend Henri Rouart advanced 100 francs, Caillebotte came up with another 200. Monet tried De Bellio. 'With your permission,' replied the doctor, 'I went round to the rue Vintimille to see your paintings, before taking some friends round to see them. I have to tell you, dear friend, you can't expect to make money from unfinished work. You are stuck in a vicious circle, and I don't see how you're going to get out of it.' Zola thought the same: Monet was producing shoddy, rushed work, which bore all the signs of his desperate need to sell. By mid-August Camille was still hanging on to life, but she could no longer eat. Monet appealed again to De Bellio:

> For a long time I have been hoping for better days ahead, but alas, I believe the time has come for me to abandon all hope. My poor wife is in increasing pain, I can't see how she can get any weaker . . . We have to be at her bedside all the time, attending to her every need . . . and the saddest thing is, we can't always give her what she needs, as we don't have the money. For a month now, I have not been able to paint because I've run out of colours, but that is not important. Right now, I'm just terrified by the sight of my poor wife's life in jeopardy, it's unbearable to see her suffering so much and not be able to help . . . One more favour, dear M. de Bellio, please help us out of your own pocket. We have no resources whatever . . . Two or three hundred francs now would save us from hardship and anxiety; with another hundred I could get the canvas and paints I need to work. Please do what you can.

But Monet had cried wolf once too often. 'I am very sorry to hear that Madame Monet is in the sad state of which you paint so bleak a picture,' came the reply. 'But let us hope that with care, with a *great deal of care*, she will recover.' Alice was a devout Catholic. Seeing that Camille would surely die, she was concerned that she should receive a proper Christian burial, which she was not entitled to as the Monets' civil marriage had never been consecrated in a religious ceremony. On 31 August, Alice contacted the priest at Vétheuil and asked him to solemnise the Monets' vows. The next day, Hoschedé sent news to his mother. 'Thanks to Alice,

Camille yesterday received the last sacraments. She seems calmer now.'

On the morning of 5 September 1879, Camille said goodbye to her two little boys. She died that morning at ten-thirty, aged thirty-two. Monet dashed a note straight off to De Bellio, to tell him that Camille had died after ghastly suffering; Monet was now alone in the world with his two sons. He had one more favour to ask De Bellio. 'Could you retrieve from the *Mont de Piété* [pawnbroker's] the locket for which I'm sending you the ticket. It's the only keepsake my wife had to hold onto and I would like to put it round her neck before she goes. Please . . . send it tomorrow, as soon as you get my letter, to the main office in the rue des Blancs-Manteaux before two o'clock. You could send it by post; if you do, I'll get it before she is laid to rest.'

Hoschedé reassured his mother that Camille had died peacefully. Alice followed this up with the truth. 'Her death was long and horrible,' she told Madame Hoschedé, 'and she was conscious until the last minute. It was heart-breaking to see her say goodbye to her children.' Alice and her daughters laid out Camille's body, and spent two days in vigil over her. Monet joined them, transfixed by the rapidly changing appearance of his wife's face, 'watching her tragic forehead, almost mechanically observing the colours which death was imposing on her rigid face. Blue, yellow, grey, what do I know? I had come to this,' he told friends. 'How natural, to want to reproduce the last image of her, who was leaving us for ever. But even before the idea came to me to record her beloved features, something in me automatically responded to the shocks of colour. I just seemed to be compelled in an unconscious activity, the one I engage in every day, like an animal turning in its mill.' At two o'clock the following Saturday, Camille was buried in the churchyard at Vétheuil. Pissarro and Julie sent condolences. 'You, more than anyone,' Monet told Pissarro, 'must understand something of my anguish. I am devastated. I have no idea where to turn, or how to organise my life with two children.' Alice now took over. She began by destroying all Camille's correspondence with her mother. From now on, Alice made the rules.

The winter of 1879–80 was bitterly cold. The rent had still not been paid, and Monet, Alice and Hoschedé were saved from eviction by De Bellio and Caillebotte. When severe frosts came, the only available vegetables, transported to Vétheuil on a cart from nearby Fontenay-Saint-Pierre, were staggeringly expensive. Hoschedé left to try once more to settle his affairs in Paris. In Vétheuil, creditors were constantly stampeding through the house. One seized a vase arranged with a magnificent bouquet of flowers (creditors presumably included florists who were supplying huge bouquets in midwinter), and smashed it over the piano.

Thick snow soon covered the ground. Alice, stripped of her château, her furniture, her *haute couture*, was doing the housework and sawing up firewood.

By early December, it was finally beginning to dawn on even the extraordinarily mild-mannered Hoschedé that his wife was spending long periods of time alone with Monet. He sent for her to join him in Paris, but Alice had an answer ready. 'If we're spending at this rate in Vétheuil, how frugal are we going to be if I join you in Paris?' She stalled him by promising to talk it over. Hoschedé left Paris, to begin the journey home to Vétheuil. The flowers in the orchard were frozen, the window panes were frozen; the local cabbie's horse and cart was stuck in the snow-drifts. Hoschedé took three hours to get from Mantes to Vétheuil, the snow was packed so tight. Enormous blocks of ice floated in the Seine. The temperature fell to minus twenty-five degrees. Then the Seine froze over completely. In mid-December, stranded in Vétheuil in freezing conditions, Hoschedé began to blame Monet. Alice defended him. Hadn't Monet, with his supportive friends and sales of his work, got Hoschedé out of a tight spot? And the poor man was working so hard.

Monet was braving sub-zero temperatures to go out and paint his winter landscapes, while nearby a traveller died of exposure and someone else was found frozen to death beneath the snow. At Vétheuil, people crossed the river by walking across its surface, and the Hoschedé–Monet children were out playing on the ice. As the bitter winter wore on, resources dwindled away to nothing. There were Christmas presents only for the smaller children. Jacques Hoschedé had to miss Midnight Mass as he had grown out of all his decent clothes. On 28 December, Alice announced she had five francs left to run the household. That day, Monet set off again for Paris in the freezing weather, with his winter landscapes. The local postmistress paid his fare.

In Paris, he began to do the rounds again. The weather had virtually paralysed the city; the snow was packed in thickly, the effect of huge flurries. Journalists described conditions as 'Siberian'. Monet went to see Theodore Duret, who bought *Winter Effect*, for 150 francs. Chocquet bought nothing. De Bellio listened to the sorry tale, but was unable to help. Throughout the country, everything seemed frozen to a standstill.

# DIVISIONS

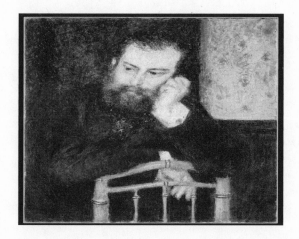

Auguste Renoir, *Alfred Sisley*, 1876

# NEW TENSIONS

*'Degas is never ready for anything . . .'*
— Katherine Cassatt

IN JANUARY 1880 PARIS WAS also under thick snow. In his lodgings on the hillside of Montmartre, Renoir lit his fire every morning. In the evenings, he kept warm in the *crémerie* just opposite his studio in the rue Saint-Georges, one of the small shops which sold dairy products, and in an adjoining room, served a *plat du jour* on three or four tables. In the corner of the shop, a stove heated the place, and the stew. Dessert was a piece of cheese. The diners were nearly always regulars. This *crémerie* was run by Madame Camille and her daughters, who fussed around Renoir, giving him the runniest bits of Brie and slipping extra bits of food into his pockets. Madame Camille thought it was high time he found a wife. He was obviously incapable of looking after himself – 'so well-bred, and so helpless'. Her heart's desire was to marry him off to one of her daughters, but Renoir seemed happy as he was, painting society portraits during the day, and enjoying life in the cafés and bars of Montmartre in the evenings.

It was now twenty years since the painters had first met in the studios of Gleyre and Suisse. The oldest of the established group (Pissarro) was now fifty. Though the youngest (Caillebotte) was only thirty-two, the new generation – Raffaelli, Gauguin and others – was already beginning to make its mark. During the last two decades, the original impressionists had come before the public, offended it, found and lost dealers; made and lost money. They had experimented with *plein-air* painting and were now discovering print-making. Degas was beginning to sculpt. Their lovers had become their wives; their surviving children were growing. Bereavement had cast its shadow over their lives. At forty-eight, Manet, who never exhibited with the impressionists, was still regarded by the public as the leading light of a movement he had never really believed in. Renoir, perhaps temperamentally the least likely to have defected to the Salon, was

now a regular Salon exhibitor. Equally unpredictably, the core group now seemed to consist of Degas, Caillebotte, Berthe Morisot and Pissarro. Cézanne remained a faithful friend, still loyal and committed. But Monet, initially the charismatic leader, now penniless and in chronic emotional turmoil, was still threatening to turn his back on the others and exhibit at the Salon.

During those twenty years, Paris itself had changed from a dark, disintegrating medieval city to the elegant, prosperous city of light which had been Baron Haussmann's dream. The railway line now connected the city with the riverside villages and towns of the *banlieues*, as well as with the increasingly popular coastal resorts. The railway, which Zola would describe in his novel *La Bête humaine* as a monstrous great steel skeleton, already sprawled in all directions across France, hissing and belching out steam and smoke. In the suburbs, factory chimneys, steel bridges and viaducts were familiar sights.

In Vétheuil, on 5 January at about five in the morning, Alice was woken 'by a terrifying noise, like thunder', a booming sound, mixed with cries, which seemed to be coming from nearby Lavacourt. Madeleine, the maid, was banging on Monet's window, trying to get his attention. Quickly Alice ran to the window and, dark as it was, could see blocks of white falling; the break-up of the ice floes. The final thaw was as dramatic as the freeze had been. Walls were smashed, trees were snapped off at their trunks. All the gardens were scenes of destruction. There were lights going on and off, and the sounds of petrified voices, all through the night. It was two hours before anyone dared go out: there were rumours of corpses floating on the river. As day dawned, Monet, Alice and the children hired a carriage and rode out to look at the 'heart-rending' beauty of the landscape.

Monet immediately set to work painting the rapidly fluctuating scene. He depicted the landscape of Vétheuil entirely in shades of purple and grey, as if stricken; then explored the river's surface as it changed from orange and blue to white and green, then, at sunset, to pink and gold. It was as if this drama of nature had shocked him awake; he was out again at all times of day, painting with conviction for the first time since Camille's death.

In Paris, too, the thaw came in great avalanches of snow and ice, but it remained bitterly cold. By 21 January the temperature was still below zero and in many places the snow was firm. It was mid-February by the time normal winter temperatures returned, and the seamstresses from the workshops in Pigalle again began making their way up the hill to the Montmartre bars and *crémeries*. One of Madame Camille's regulars was a

pretty girl with red hair, a retroussé nose and a healthy appetite. Her name was Aline Charigot, and she was nineteen. She lived with her mother, and worked for a tailor at the foot of the *Butte*, making copies of dresses from the shops in the rue de la Paix for the tradespeople of Notre Dame de Lorette. Aline was a hard and deft worker. 'If you continue like this,' the tailor told her, 'you'll go far . . . But you'd do better to make a good marriage.' She should find herself a wealthy man, 'and not too young. With a pretty little face like yours it won't be hard to find one.' But it was too late: Aline had already fallen for the penniless artist with a nervous habit of stroking his nose and pulling on his moustache. There hardly seemed much hope of Renoir's offering her a fortune. Though he was painting portraits of the wealthy, he was proud of the fact that, at nearly forty, he still went through life with 'the pleasant sensation of not really having any possessions, just my two hands in my pockets'. He never appeared to have a bean, and when he did, he gave it away. Aline began to visit him in his studio, and soon she was modelling for him. She understood nothing about art, she said, but she loved watching him paint.

Once Madame Camille's daughters saw what was happening they gallantly gave up gazing wistfully at Renoir, and switched instead to the business of making sure he fell in love with Aline. Madame Camille took her aside. 'Don't tell your mother, whatever you do,' she cautioned – good advice, according to Renoir. Madame Charigot had been abandoned by her own husband, and had 'a knowing smile that made you want to kill her'. For the time being, Madame Charigot would have to be kept in the dark. Renoir adored Aline. He loved her looks, her naturalness, her unpretentious love of food. She had a rich Burgundian accent: he even loved the way she rolled her Rs. She had an easy way with children, and was happy in the countryside. Like Renoir, she was absolutely without pretension, and very popular. Everyone seemed to like her. Degas, observing her at a fashionable soirée, wearing a simple dress, told Renoir she looked like a queen among fakes.

For a while, Renoir was happy to keep to himself, especially since his exhibiting at the Salon was still a sore point with the other painters. Monet's intention to follow suit had somehow become a rumour. On 24 February 1880, the *Gaulois* ran a spiteful and sinister article announcing 'the sad loss of M. Claude Monet', one of the 'revered masters' of the Impressionist School. His funeral would take place on 1 May (the Salon opening day), in the 'Church of the Palais de l'Industrie' (where the Salon was due to be held); the signatories were allegedly 'M. Degas, leader of the School', M. Raffaelli, successor to the deceased', Miss Cassatt; M. Caillebotte; M. Pissarro; . . .' and other 'ex-students, ex-friends, and

ex-supporters'. The announcement was followed by a brief description of Monet's life at Vétheuil, where, it was reported, he lived with his family and supported the ruined Hoschedé, who now spent his life in Monet's studio being fed, clothed and generally tolerated.

Monet was incensed, but all attempts to get a letter of protest printed failed. Pissarro made a show of solidarity by assuring him that none of them really believed he intended to exhibit at the Salon. In mid-February Monet made the trip to Paris, where he did the usual round of dealers and collectors, which yielded a mere 100 francs. On 8 March, he told Duret he had decided to send to the Salon. He submitted two paintings of the thawing ice floes at Lavacourt, using his rue de Vintimille address, where Caillebotte was still paying the rent.

His decision may have had something to do with the Salon's new rules. The right to exhibit had been extended to anyone who had already shown work three times, and Monet had exhibited in 1865, 1866 and 1868, so perhaps, like Renoir, he was reluctant to pass up an opportunity. But the jury selected only one of his submissions, which was so badly hung that the colours could hardly be seen. One good outcome was that Charpentier, seeing his work there, offered him an independent exhibition in the gallery of *La Vie moderne*. In June he exhibited eighteen paintings, of Argenteuil and Le Havre as well as his new landscapes of Lavacourt and Vétheuil. Not a single one sold. Madame Charpentier herself offered 1,500 francs for *Floating Ice*, which Monet sold her after first stalling while he tried to get 2,000 for it elsewhere.

For the first time, Monet's works were therefore missing from the group exhibition which opened on 1 April, at 10, rue des Pyramides, this time billed simply as 'La 5e Exposition de peinture par . . .', on eye-catching posters with bold red lettering on a green ground (Mary Cassatt's favourite colour scheme). The opening of the exhibition was planned to coincide with the launch of *Le Jour et la nuit*.

The fifth group exhibition (dubbed, in the Monet/Hoschedé household, 'the Caillebotte exhibition') illustrated how far the group had evolved since its instigation. The names of the exhibitors appeared on the posters after another big fight between Caillebotte and Degas, who did not want to include names. His reason is unknown, but it may have been because Berthe Morisot and Mary Cassatt helped finance the exhibition and therefore felt any advance publicity of their own work would be unethical. Furthermore, the inclusion of a large painting by Marie Bracquemond seems to have been a late decision, possibly too late for her name to be added to the posters. This meant that the list of names would exclude all three women, but Caillebotte was inflexible. 'I had to give in

and let him put them up,' Degas told Felix Bracquemond; 'when will people stop wanting to be *stars*. Mlle Cassatt and Mme Morisot were quite adamant about not having their names on the posters. It has turned out exactly the same as last year, and Mme Bracquemond's name will not appear. The whole thing is ridiculous.' So the billboards blazed a trail for Raffaelli (with 36 works) and Gauguin (with six) as well as other new-comers, yet the posters included none of the women. The names listed were Bracquemond [Felix], Caillebotte, Degas, Forain, Gauguin, Guillaumin, Lebourg, Levert, Pissarro, Raffaelli, Rouart, Tillot, Vidal, Vignon and Zandomeneghi.

These squabbles diverted everyone from the fact that Degas was far from prepared. Nothing he had promised seemed to be ready; least of all – and gallingly for Mary Cassatt, who had put so much work into it – the publication of *Le Jour et la Nuit*. Mary was quite heartbroken by this, and the entire Cassatt family rose up in indignation. 'Degas, who is the leader,' Katherine told Aleck in Philadelphia, 'undertook to get up a journal of etchings and got them all to work for it so that Mary had no time for paintings, and as usual with Degas when the time came for it to appear he wasn't ready, so *Le Jour et la nuit*, which might have been a great success, has not yet appeared. Degas is never ready for anything.'

The problem was finance. Without Caillebotte (who as well as paying Monet's rent in Paris was financing his visits to Paris, and also helping Pissarro), there was no one to foot the bill. Eventually, they decided to frame the prints intended for reproduction in the journal and show them at the exhibition, in advance of publication (the first and only issue of the journal). Mary Cassatt's second appearance with the impressionists therefore included her etchings as well as her paintings, alongside Degas's *Mary Cassatt at the Louvre, Musée des Antiqués*, and one of his etchings of Mary and Lydia in the museum of the Louvre. That work, so pains-takingly made, seemed to testify to the ongoing friendship between Mary and Degas, but in fact the non-appearance of *Le Jour et la Nuit* put their friendship under significant strain.

She was particularly disappointed given that Degas had by now become a family friend. He often dined with the Cassatts, invited them to his soirées, and went with them to private views and the theatre. Mary had been more or less continuously in his company for the last few months, perhaps even beginning to indulge some romantic feelings towards him. She had become quite flirtatious, and was more than ready to indulge his interest in her as a model as well as a social companion. Now, she was shattered by his apparently cavalier attitude towards the work they had been so seriously absorbed in for several months. She

made no secret of the fact that she was angry, and the friendship became turbulent. 'Oh!' she protested to Louisine Elder, mocking Degas, 'I am independent! I can live alone and I love to work.' Sometimes she saw nothing of Degas for months, then 'something I painted would bring us together again and he would go to Durand-Ruel's and say something nice about me, or come and see me himself . . .' (None of the wealthy Cassatt family had hit on the obvious solution of offering support for the journal themselves.)

The journal was not the only missing item in the fifth impressionist exhibition. There also appeared, tantalisingly, a glass case. This was supposed to contain a sculpture, which Degas had also been unable to finish in time for the show. But the exhibition went ahead, despite the defections of Renoir and Monet, squabbles between Caillebotte and Degas, the non-appearance of *Le Jour et La nuit* and the empty glass case.

In early summer, Mary's brother Aleck, his wife Lois and their three children arrived in Paris, prior to the whole family's decamping to Marly-le-Roi for their summer vacation. Lois wrote home to her sister, 'the truth is, I cannot abide Mary, and never will'. But she took full advantage of Mary's up to date knowledge of the Paris fashions. Soon crowds of tailors were arriving every morning, laden with boxes of *haute couture*. The children loved their aunt, especially Eddie, who liked to sketch at Mary's side, aunt and nephew comparing notes. Mary painted the younger children all grouped around their grandmother listening to a story. When she sold *Katherine Cassatt Reading to her Grandchildren*, the whole family fiercely objected and she had to buy it back.

In Marly-le-Roi, on the loop of the Seine just beyond Louveciennes, the Cassatts had a view of the vast, elegant parklands landscaped by Le Nôtre, on the site of Louis XIV's country château, which had been razed to the ground in 1870 by the Prussians. Here, a few years earlier, Sisley had lived and worked. The royal parklands were (and still are) resplendent with grand vistas, vast sweeps of lawn, and avenues of limes; and Mary could ride in the nearby forest of Marly, where in the seventeenth century the king rode to hounds. The royal château and park were modelled on Versailles, and a major feature of the park was its water garden, refined with stone statues. At the foot of the slope, the king had built a unique construction, the *abreuvoir*, or horse trough, which collected the waters which flowed across the park, a grand, elaborate two-storey construction bordered by railings bearing the *fleur de lys*, where the king's horses, and those of his visitors, could bathe as well as quench their thirst. When he lived here in 1875–6, Sisley had painted seventeen paintings of the horse trough, playing down its grand royal cachet and history and portraying it

simply as an aspect of the village – in his paintings it looks like little more than a village pond.

The house the Cassatts rented for the summer was on the broad avenue running parallel to the château and park, linking the foot of the village and the *abreuvoir* with the main road to Versailles, where the Pissarros had lived, at the edge of Louveciennes. This road, called the Côte du Coeur Volant, which would have borne the king's carriages through Marly, effectively marked the division between Marly and Louveciennes, so that the houses at the top of the road were geographically in Louveciennes, and those at the foot, in Marly-le-Roi. The Cassatts' house was actually called the Coeur Volant, a large, imposing country villa in a leafy garden, with the vast aqueduct rising up at the foot of their garden. Robbie Cassatt, who loved the aqueduct, would have been able to run to the bottom of the garden and wind his way in and out beneath its tall arches. The place also suited Lydia, who could sit quietly on the green garden bench and read or sew, since the air was fresh and clear. Mary painted her, fragile and pale, a wraith-like creature with delicate fingers, absorbed in her crochet, seated beside a tidy herbaceous border. Like Sisley, in her paintings of Marly Cassatt ignored the nobility of the place and its royal connections, confining herself instead to the intimacy of the garden.

A few miles away on the other side of the river, just north of Chatou/Croissy, not far from where the Grenouillère used to be, Renoir and Aline were spending their summer afternoons at the hôtel Fournaise. The hôtel, a brick restaurant with an outdoor terrace and an adjoining boat-building workshop, was where the boaters gathered on sunny days, to eat and drink in the sunshine. Alphonse Fournaise, a boat-wrecker, had bought the house in 1857 and enlarged it into a restaurant, where his wife did the cooking and his daughter Alphonsine waited at the tables. His son, also called Alphonse, hired and maintained the boats. Alphonse *père*, red-haired, with a flaming, maritime beard, was nicknamed 'the Admiral of Chatou'. On weekdays, the hôtel Fournaise had a decidedly male atmosphere, like a well-frequented outback ranch: men on horseback would ride up, tether their horses and sit outside at tables in their bowlers and shirt sleeves, drinking coffee and smoking. But at weekends, the place burst into life. The men brought their women, all dressed in their summer dresses and decorative hats, and the tables were laden with fruit and wine. Renoir, who brought Aline here to woo her, always looked back on it with nostalgia: in those days, there was time for living, and they made the most of it. That summer, he painted *Luncheon of the Boating Party* on the terrace of the hôtel Fournaise, the long table strewn with bottles, the crowd relaxed after a long lunch, a riot of colour and conversation. By this

time, he was almost one of the family. He often ate there in exchange for a painting; the walls were soon cluttered with Renoirs. (The place still exists today, the walls decorated with impressionist reproductions, and with a replica of Caillebotte's boat in the boatyard.)

In *Luncheon of the Boating Party*, Aline sits in the foreground, a small griffon dog on her lap. Caillebotte also loved the place, and almost certainly appears on the right side of the picture. The female figure he is talking to resembles Mary Cassatt; if it is she, the little dog on Aline's lap could be the very one ordered for Mary by Degas. Caillebotte loved Aline and looked after her like a younger sister. Ellen Andrée and her friends were also very taken with her; Ellen said she should let them polish her accent, they could make her into a true Parisian. But Aline had no desire to become a true Parisian. Like Renoir, she preferred the simple pleasures of life. She was good at rowing and loved the water. Renoir taught her to swim by tying a rope round her waist, and she was soon swimming like a fish. The hôtel Fournaise guests lingered until late into the night. At dusk, the tables were pushed back for music and dancing, and Renoir stumbled about treading on Aline's feet, while she waltzed perfectly.

At nearly forty, Renoir had found the love of his life. But he was growing anxious about his work. That summer he went through something of a crisis, aware that he was being pulled in a new direction but unsure where he was really heading. He had doubts about the future of impressionism, but he was far from confident he was developing a viable alternative. He worried about stagnating; he also wanted to use the money he was making from his portrait commissions to continue to study. Degas thought he was mad, that having made his decision to become a Salon painter, he should just enjoy the money, but Renoir was aware that he was not really developing technically.

As far as Aline was concerned, there was nothing complicated about it: the only important thing was that Renoir had to paint. She saw no point at all in anguishing about styles or the search for new subject matter. But since he was worrying about having no new motifs, she suggested they go to Burgundy, to her native Essoyes, where they could live cheaply and he could paint undisturbed. But Madame Charigot was having none of it: her precious, gifted daughter, tied for life to a penniless artist? At the same time, Renoir was reluctant to leave Paris. A small village in Burgundy, away from the Salon and his newly acquired collectors, might end up being a retrograde step. There seemed to be no solution. Aline, in distress, returned to her employer and tried to pick up her single life again, attempting, as far as possible, to avoid seeing her new lover. Renoir took – for him – unprecedented and drastic action. All that autumn and winter,

he anguished about what to do. After deliberating for several months, he decided he must go travelling. The following spring he left, without Aline, for Algeria.

<div align="center">★</div>

Meanwhile, six miles west of Paris, Manet was in Bellevue, a village on the border of Meudon. He spent the whole summer there, and stayed on until November. Dr Siredey was still anxious about his condition. He had recommended a hydrotherapy clinic here at the foot of the *terrasse* of Meudon, where the treatments were supposed to be better than Béni-Barde's. On 30 May Manet left Paris, accompanied by Suzanne. They rented a villa at 41, route des Gardes, at the top of the hill overlooking the Seine, where Manet was trapped, enduring water treatments and listening to Suzanne play the piano, for five months. He hated it even more than Béni-Barde's. 'I'm doing penance,' he wrote to Méry Laurent in Paris, 'as never before in my life. Still, if it works it will be worth it.' But by now the 'lightning' pains in his leg had become more or less constant.

To his friends, he continued to put a brave face on things. But he found the isolation unbearable. 'I'm living here like a shellfish,' he complained to Zacharie Astruc. The countryside was all very beautiful, but only if you didn't have to live in it. He longed for Paris, and yearned for people, writing letters every day to Méry, Eva Gonzales, Antonin Proust and the Bracquemonds. Berthe visited him, and Léon, now twenty-eight, came every weekend and entertained him with stories about the Paris Stock Exchange, where he was working. Manet sent lovely, flirtatious letters to Isabelle Lemonnier, decorated with drawings of flowers, horse chestnuts or mirabelles. In his languid, flowing hand he scrawled verses across the drawings: '*A Isabelle / cette mirabelle / mais la plus belle / est Isabelle.*' To Méry, he grumbled about the view. 'It wouldn't be so bad if I could see the rue de Rome, but no, it's always that wretched Pantheon' – visible in the distance – 'what a thing to have to look at.' He begged for news of 'the life I hold so dear'. It took a visit from Ernest Hoschedé to restore his sense of humour. Hoschedé had just been appointed manager of *L'Art et la mode*, a 'magazine of elegance'. On 5 July, he lunched at Bellevue with Manet. 'He is hope incarnate,' Manet told Zacharie Astruc. 'He deserves to succeed, and he really does try his best, but he started by getting a Belgian to do his first *Paris fashion* plate. Will he never learn?'

One Sunday afternoon in late summer, Antonin Proust visited him. They went outside and looked down the hillside towards the Seine, and Manet suggested a walk, to take advantage of the clear air and look at the flowers. 'It'll be easier for me to get down the hill than up,' he said, 'but

better to be climbing than falling. Let's go to the *terrasse* at Meudon.' They followed the long avenue, admiring the ancient trees which lined it, Manet grumbling all the time about the 'ugly barracks' Parisians were building as country retreats. Slowly they climbed the avenue towards the *terrasse*, Manet walking with difficulty, stopping to rest at each bench. When they eventually reached the *terrasse*, Manet stood looking at Paris, spread out beneath him in the limpid sunlight. He said, 'It's odd, looking down at Notre Dame. It looks so small from here, and it's vast. The men who made that must have had a good dinner.' Then a little girl came up to him, and offered him some bunches of flowers.

'What does your mother do?' Manet asked her.

'She's a laundress at Bas–Meudon,' the child told him.

'What about your father?'

'He doesn't do anything.'

'What do you mean, he doesn't do anything?'

'Well, sometimes he goes out at night to catch a rabbit in the woods, but in the winter he works, he unloads the coal boats.'

'And that's how you all live?'

'Oh no!' said the child, drawing herself up straight, 'I sell flowers. Some days I take home two francs.'

'Well!' said Manet, 'here are three.' Turning towards Proust, he said, 'You give her three as well.'

The little girl rushed off excitedly with her six francs.

'Now you see how infuriating it is to be in the state I'm in,' said Manet. 'If I'd been well, I could have rushed home and got my box of paints.'

They made their way slowly back up the hill, Manet still thinking about the child. 'It's so strange,' he suddenly said, 'the contrast between the awkwardness of a child and the assurance of a woman.'

From that day on, Proust was aware of the seriousness of Manet's illness, which exasperated him and prevented him from painting for months at a time. He tried to divert himself by reading romantic novels and the Goncourts' book on the eighteenth century. When he discovered that Isabelle Lemonnier had been unwell, he wrote to Mme Charpentier begging for news of her, to 'reassure the lonely exiles'. He also wrote kindly to Hoschedé's daughter Marthe, who had asked him for his autograph. 'Dear little Marthe, I also collect autographs of people I like best, so you can imagine how welcome your letter is . . . We'll be in Bellevue until the end of October; the stay has done me so much good I'm sorry to be going back to town.' He was anxious to be back in Paris, to start work on a new idea he had, for a painting of Henri Rochefort (born marquis de Rochefort-Lucay), who had been transported to a penal

settlement in New Caledonia in 1871 for his part in the Commune. In 1874 he escaped in a small boat, and he had since been in exile in London and Geneva. In 1880, the general amnesty enabled him to return to France, an event Manet wanted to celebrate; the painting was perhaps also an oblique expression of his own longing for reprieve.

When he finally returned to Paris on 3 November, Manet began work on *Escape*, into which he appears to have poured all his feelings of shock and psychic alienation. In the evenings he threw himself into the street life of Paris, frequenting the café-concerts on the Champs-Elysées and the *Folies Bergère*, where everyone told him how well he looked. In the afternoons, he and Antonin Proust amused themselves visiting fashionable dressmakers and milliners, in preparation for a series of portraits of women Manet was planning, one for each season. He still adored fashion, and derived great pleasure from the fabrics – silks, velvets and furs – he planned to dress his models in. He spent an entire day watching Madame Derot the dressmaker unroll fabrics, captivated by their colours and textures, ecstatic to be back in the world of *couture*. The next day they visited Madame Virot, the milliner. When he arrived, she was leaning on the mantelpiece, resting her elbows, a Marie-Antoinette-style lace shawl draped across her shoulders setting off the pearl whiteness of her hair. 'Wow!' he told her, 'you've wonderful hair for showing off that shawl.' She noticed that he was leaning on his stick, and offered him a chair. 'Good God, woman,' he yelled at her, 'I don't need a chair, I'm not a cripple.'

Back in his apartment that evening, he was still talking animatedly about Madame Virot's fabulous creations. Then he said, 'Imagine, trying to pass me off as a *cul de jatte* (legless cripple) in front of all those women. Ah! Women . . . I met one yesterday on the Pont de l'Europe. She was walking the way only a *Parisienne* knows how to walk, but with an extra something, even more assured. I'll remember that. There are some things that will always be engraved on my mind.'

★

'What is to become of our exhibitions?' Caillebotte was asking everyone, in the New Year of 1881. He badly wanted the original group of painters to continue exhibiting together. His idea was to re-form the original group, and he told Degas that if they all exhibited together again, he would be prepared to include Gauguin and Guillaumin, but he drew the line at Raffaelli. 'If Degas wants to take part,' he told Pissarro, 'fine, but without the crowd he wants to drag along.' He was furious that Degas seemed to have ostracised Monet yet was willing to court young painters

who had no particular loyalty to the original group, or its aims. Gauguin had remarked that Sisley and Monet seemed to be churning out pictures indiscriminately; 'we can't flood the place with rowing boats and endless views of Chatou'.

Pissarro wanted everyone to continue as a united front, but he saw no point in enticing Monet and Renoir back 'as if they were the victors'. Moreover, he told Caillebotte, it was all very well to criticise Degas, but he should perhaps remember that it was Degas who 'brought us Mlle Cassatt, Forain, and *you*'.

Caillebotte, who saw himself as the new leader of the group, was in despair. Nobody seemed willing to let him organise things. Degas, who, according to Caillebotte, spent all his time in the Nouvelle Athènes, refused to drop Raffaelli. Pissarro did not want to drop Degas. Renoir, Monet, Sisley and Cézanne had all deserted. It was beginning to look as if there would be no more independent exhibitions. Eventually, Degas and Gauguin took control, and rented a space in an annexe to Nadar's old studio at 35, boulevard des Capucines, where seven years earlier the group had held its first exhibition. They now had the problem of how to get Caillebotte back, and of who would actually exhibit, since everyone was now working independently.

Degas was not, in fact, spending all his time in the Nouvelle Athènes. He was working on his mystery sculpture. His fourteen-year-old model, Marie van Goethen, daughter of a tailor and a laundress, was a *petit rat* at the Opéra, and she was posing for a strange, demanding piece, different from anything ever before attempted. Degas had first drawn Marie from the nude, standing in a dancer's fourth position, pointing one leg forward, the foot turned out, then modelled a two-thirds life-size figure in red wax, with a lead armature, paintbrushes to stiffen the arms, and metal ferals scattered through the piece. He went on working at the small maquette, tilting the head, moving the arms and clasped hands; and adjusting the pose. Once the nude maquette was as he wanted it, Marie posed another dozen times, in her dance costume. He painted over the wax, then added real ballet shoes, silk stockings, a white gauze tutu and white linen bodice, and real hair – perhaps cut from Marie's own thick, black hair, which she wore plaited down her back – which he tied with a green satin ribbon. Finally, he smeared the shoes, tights and bodice with a thin layer of hot wax, through which areas of actual fabric were left visible, leaving the hair, tutu and ribbon unsmeared. He worked quietly and painstakingly on the sculpture for several months, and was still working on it in spring 1881.

That year, both Sisley and Monet benefited from a sudden improve-

ment in Durand-Ruel's purchasing power. In 1880 he had received new backing from the Union Générale bank. This had immediately provided Sisley, now living in Moret-sur-Loing, near Fontainebleau, with a new opportunity: he had a contract with Durand-Ruel guaranteeing him a regular income in return for his entire output. Monet had also benefited. In February 1881, Durand-Ruel went to his studio in the rue Vintimille and saw a large collection of his new work. He bought 15 paintings, for a total of 4,500 francs, which he paid up front. With this new injection of funds, Monet went to Fécamp, to paint the Normandy coast. When he returned to Paris in May, Durand-Ruel bought a further 22 paintings. Monet spent the rest of the summer in Vétheuil, painting his garden. The old dream of prosperity looked as if it was about to be revived.

While Monet was in Vétheuil, Renoir was in Algeria with his brother-in-law and friends from Montmartre, the 'nomad' Lhote and amateur hypnotist Lestringuez. In Algeria they saw mysterious, exotic women and beggars in tattered purple and gold raiments, dazzling in the sunlight like the robes of the characters in *A Thousand and One Nights*. The light gave all the colours new values. 'Everything is white,' Renoir remarked – the burnous (traditional hooded cloaks), walls, mirrors, mosques, and the roads, against which the green of the orange trees and grey of the fig trees stood out. He loved the way the Arab women walked, their dress, and the fascination of their partially veiled eyes – 'clever enough to know the value of mystery'.

Like Degas in New Orleans, he was hardly able to paint, there was so much to look at. It gave him time to reflect, and at this distance he had an opportunity to collect his thoughts on the group, his decision to go on exhibiting at the Salon, and his loyalty to the other painters. From Algiers, he wrote to Durand-Ruel explaining his need for this temporary exile, assuring him of his commitment to his work, and revealing that his loyalty to his friends was a deep concern. There were hardly fifteen *amateurs*, he wrote, capable of appreciating a painting unless it appeared at the Salon, and 80,000 more who would 'not even buy a nose' from any but a Salon painter. That was the reason he had continued to send his portraits there, but he did not want his paintings categorised in people's minds, as a result. He could see no point in snubbing the Salon, though equally he had 'no desire to exaggerate its importance'. As far as he was concerned, it was simply a question of continuing to do one's best work. If he were neglecting his work for the sake of ambition, or making sacrifices that went against his beliefs, he could understand why he would be criticised, but there was no reason for anyone to think that. All he was trying to do now was to produce something good, which Durand-Ruel could sell.

The reason for his exile in the sun was to distance himself from the other painters, to 'think hard about everything'. He planned to stay another month. If Durand-Ruel could continue to be patient with him, he hoped to be able to prove that it was possible to continue to exhibit at the Salon, while still producing good work. 'Please, therefore, plead my case with my friends. My decision to send to the Salon is entirely commercial. It's just like some medicines, they may not do any good, but they can't do any harm . . . I wish you the best of health, and lots of rich *amateurs*. Please hold onto them until I get back . . .'

In part, Renoir's soul-searching was emotional. Alone with his friends in Algiers, he realised he did not want to return home to a life without Aline. He wrote to tell her he would be returning to Paris at the end of March. She was waiting for him at the station. They settled together in his studio in the rue Saint-Georges, Madame Charigot asserting her territorial rights by taking over the housekeeping. This was no particular hardship, since she was an expert in the kitchen, and Renoir, though he ate frugally, was actually something of a gourmet. She made soufflés, *blanquette de veau*, and delicious *crème caramel*. Life was good, as long as Renoir could put up with the banter. 'So, you don't want any more veal? Perhaps you'll have a little *pâté de foie gras*? Dying of hunger, and he wants *pâté de foie gras*.' Sometimes, he would get up from the table to sketch out an idea. 'So that's how a gentleman behaves!' Aline would point silently to the door, and the old lady would take her plate and finish eating by the kitchen stove. Later she would produce some placatory *marrons glacés*. 'If I'd been really unscrupulous,' said Renoir, 'I could have had *marrons glacés* every day.'

In the autumn he went to Italy, starting in Venice and travelling south to Rome, Naples and Capri. He had suddenly been seized by a feverish desire to see the Raphaels, he wrote to Marguerite Charpentier from Venice, on his way to Rome. 'Now I'll be able to say squarely, "Oh yes, sir, I've seen the Raphaels" . . . A man who has seen the Raphaels! *Mince de bate peinture* [fabulous stuff].' To his friend Charles Deudon he wrote, 'I want to see the Raphaels, oui, Monsieur, les-Ra, les-pha, les-el. After that, anyone who's not satisfied with me can . . . I bet they'll say I've been influenced by them!' By 21 November, having realised his ambition, he was in Naples writing to Durand-Ruel, 'I'm like a school child with a blank page waiting to be filled up and paf! A credit. I'm still trying to get credits, and I'm forty. I really have seen the Raphaels in Rome. Yes, they certainly were fine, and I should have done it earlier.'

But the problem of overkill presented itself again. 'The trouble with Italy is that it's too beautiful. Why bother to paint, when there's so much

pleasure to be had from looking around you? . . . To resist such beauty and not be consumed by it you've really got to know what you're doing.' The trip to Italy fascinated him, but he was searching for a new direction in his own work, which the trip was not helping him to find. The Raphaels were so full of learning and wisdom, he told Durand-Ruel – 'unlike me, he was not looking for the impossible'. Degas thought the opposite. In his view, Italy ruined Renoir as a painter, since it filled his head with classical ideas and stopped him from following his own instincts. For the time being, no nearer to understanding what he was searching for, Renoir continued with his portraiture, regularly sending his work to the Salon.

The Salon had continued to relax its restrictions, and in 1881 it was finally released from the exclusive control of the Ministry of Fine Arts and placed under the government of the Société des Artistes Françaises. Artists whose work was accepted were now eligible to vote members on to the jury. For Manet, this was a major breakthrough, since it meant that he might finally be awarded the *Légion d'honneur*. This had already been mooted on earlier occasions and dismissed out of hand, but more of Manet's supporters were now eligible to vote. In the 1881 elections, he finally earned the 17 votes he needed to become HC (*Hors Concours*), which gave him the undisputed right to exhibit annually. He was also awarded a second-class medal for his *Portrait of Henri Rochefort*. At the Salon to receive his award, Manet was limping noticeably, but he stopped to thank each of the 17 voters in turn.

The group exhibition, organised largely by Degas and Gaugin, opened on 2 April. This year, it was cryptically entitled *6e Exposition de Peinture par . . .*, and included works by the new generation of painters: Gauguin, Forain, Rouart, Tillot, Vidal, Vignon, Zandomeneghi, Raffaelli. Gauguin showed two sculptures and seven paintings, including *Nude*, a portrait he had painted the previous year of a girl sewing. This was a departure from the work he had been doing so far, delicate landscapes in cool colours, evidently influenced by Pissarro. Though relatively traditional compared with Gauguin's later work, the summarily modelled forms of the nude figure, the ethnic rug and mandolin hung on the rough stone wall, and one or two daubs of hot blue and yellow give the painting a feeling of freedom and modernity. Huysmans singled it out for review, commenting that 'Here is a girl of our time, who doesn't pose for an audience, who is neither lascivious nor affected, who is simply concerned with mending her clothes.'

Raffaelli showed more paintings than anyone else – one of the reasons why he became a bone of contention within the group. He exhibited *Les*

*Déclassés* (later entitled *Les Buveurs d'absinthe*), a painting, reminiscent of Manet's early work, of two drinkers in shabby top hats, battered boots and overcoats, seated at a table pushed against the wall of a rough-looking country bar. Its reception undoubtedly served to irritate his dissenters within the group further. The work was reviewed by Wolff on 10 April in the *Figaro*. 'Like Millet he is the poet of the humble. What the great master did for the fields, Raffaelli begins to do for the modest people of Paris. He shows them as they are, more often than not stupefied by life's hardships.' Of the original exhibitors, only Degas, Berthe Morisot and Pissarro remained. The glass case was on show again, still empty. But half-way through the exhibition, the dancer appeared.

The *petite danseuse* took the Paris art world by storm. The sculpture was arresting, astounding, disturbing. No one could fail to detect the power of this extraordinary, semi-living work, eerily midway between a large doll and a petite, living child, hips thrust forward, leg and ankle strained into position, head back. *Paris-Journal* reviewed the show, and reported that there were groups of 'male and female nihilists, fainting with rapture' before the glass case. The painter Jacques-Emile Blanche noticed that among them was Whistler, 'wielding a painter's bamboo mahlstick . . .; emitting piercing cries; gesticulating before the glass case that contained the figurine'. In the *Gazette des Beaux-Arts*, Paul Mantz recognised the naturalist power of the figure, and saw that Degas had picked up on the disturbing, lifelike vulnerability of the *petit rat*; the bourgeois audience 'stand stupefied for a moment, and you can almost hear fathers shouting, "Heaven forbid that my daughter should ever become a dancer." ' Mary Cassatt brought Louisine Elder to see it. She remarked that the soul of an ancient Egyptian seemed to have entered into the body of a little dancer from Montmartre.

This third opportunity for Cassatt to exhibit her work effectively launched her onto the Parisian art scene and established her reputation. The press paid particular attention to her portraits of Lydia, in which they saw delicate, nuanced pinks, subtle reflections; and to her unusual talent for painting children and babies. Huysmans particularly relished these. 'Oh, my Lord! Those babies! How those portraits have made my flesh creep, time and time again . . . For the first time, . . . likenesses of enchanting tots in calm, bourgeois scenes, painted with an utterly charming, delicate tenderness.' Cassatt depicted babies and children in the poses they actually strike: sleepily curled and clinging to their mothers, arranged in a jostling huddle; lying sulkily in adult armchairs. The Cassatts were delighted by the reactions of the press, Robert announcing to Aleck that 'Mame's success is certainly more marked now than at any time

previous.' She seemed pleased not so much by the attention of the press as by the compliments paid by her fellow artists. 'She has sold all her pictures or can sell them if she chooses.'

Mary Cassatt was also beginning to establish herself as a collector, purchasing pictures on behalf of her brother Aleck. 'When you get these pictures,' she told him, 'you will probably be the only person in Philadelphia who owns specimens . . . of the masters.' Louisine Elder already had a Degas (the one she had purchased with Mary in 1875) and a Pissarro; but these, and Aleck's pictures, were so far the only examples of impressionism to reach America – 'if exhibited at any of your fine art shows they would be sure to attract attention'. Mary bought a Pissarro, a Monet seascape, and commissioned a painting from Degas, though this caused another rift between them when, despite their friendship, he kept her waiting for the picture, then refused to sell directly to her, insisting she purchase through a dealer. When the painting finally reached the New York Customs House, the bill had been made out at double the cost, to hide the duty paid by the dealer and thereby double his profits. 'I hope it will be a lesson to her,' remarked Katherine.

The Cassatts (this time without Aleck, Lois and children) spent the summer back in the Côte du Coeur Volant, keen to get out of Paris, which was still covered in plaster dust, with new houses going up, sewers being installed and paving being laid. They were considering a move from Pigalle to the vicinity of the parc Monceau, but the word on the new houses being built there was that they were best avoided. Katherine had asked around and everyone, including the doctor, had 'held up their hands in horror at the idea of our becoming *essuyeuses de plâtre*' [soaked in (damp) plaster], as they call the first lodgers in new houses.'

This time they did not return to the house called the Coeur Volant. As Katherine told Aleck, 'we cannot rent the place . . . because it is furnished and the landlady is such a screw that I would be afraid to do anything with the furniture'. After 'a pack of troubles', which drove Mary nearly to her wits' end, they rented another house, also furnished, at the top of the road near the entrance to the château. From here they had an even better view of the aqueduct, news which Robert passed on to the family in Philadelphia, with a special message for his grandson: 'Tell Robbie, his aqueduct is all right yet and that we are going to live this summer nearer to it than we did last summer and that we shall never look at it without thinking of him and how much he admired it.'

The fear of damp plaster may have been an expatriate alarm, since Berthe and Eugène, hardened Parisians, were apparently oblivious to its dangers. They were having a large house built at 40, rue de Villejust (now

rue Paul Valéry), the long, sinuous road leading from the avenue d'Eylau down to the Bois de Boulogne. Berthe's maternal grandfather had died in December 1880, and the Morisots' family house in the rue Franklin was to be sold. While they waited to realise the assets from the sale, they took out a loan to build their house in the quieter, more secluded street. Berthe had a hand in designing the huge, seven-storey building which had large rooms, a tiered roof and two large entrances, one each side of a broad, marbled corridor, with plenty of room to wheel a baby carriage in and out. While the new house was being built, they rented a house near the river at Bougival, where Berthe painted in the garden, with two-and-a-half-year-old Julie for company. 'She likes the street more than anything in the world' (like her Uncle Edouard), Berthe told her friends, and 'goes up to all the children in Bougival . . . From every door we hear, "Hello, Mlle Julie." When she's asked her name, she answers very politely, "Bibi Manet." ' Though she adored Julie, Berthe was preoccupied. Some days, she complained that she felt lonely and old. (In January 1881 she was forty.) Only her work energised her. 'The love of art . . . the habit of any work, . . . reconciles us to our lined faces and white hair,' she told a friend. But she felt obscurely bereft – 'I have no friends left, of either sex . . .'

Manet was in Versailles, attempting a rest cure. Dr Siredey was now advising against too many treatments, and especially against too many drugs. Manet had initially wanted to spend the summer at the family home in Gennevilliers, but the doctor had advised against proximity to the river, which he considered too damp. A friend (Marcel Bernstein) offered him the loan of his country house in Versailles, at 20, avenue Villeneuve-L'Etang. Manet agreed, attracted by the idea of painting Marie Antoinette's vast park. But it turned out to be an unfortunate choice. He found the walk from the house to the park too exhausting, and spent most of the summer in Bernstein's 'most horrible of gardens', sitting at his easel in his slippers, trying to work. He was frustrated, depressed and in increasing pain.

<center>★</center>

In the Monet/Hoschedé household, there was trying news for Hoschedé, still moving haplessly between Paris and Vétheuil. The landlady in Vétheuil suddenly demanded payment of all outstanding rent (eighteen months' worth), and refused to extend the lease beyond its due date of expiry, 1 October. Monet decided it was time to move. When Hoschedé saw that Alice planned to go too, he began to plead with her for a reconciliation. He found a house for rent, and announced that he wanted her to live with him. Alice called his bluff. 'How can you say I don't want

to come and live with you, when I've actually decided to come back to Paris in October. Rent the house you have found, move into it, and prepare for our return in October.' While she was on the subject, she also wanted to know why he was suddenly so worried about her living with Monet in Vétheuil. He had seemed happy enough before. In the past, his only reaction had been to spend even more time in Paris. Whose fault was that? 'Anyway, your behaviour towards M. Monet creates a very strange and completely unexpected situation.' She added 'a thousand sad thoughts'.

All that summer, Hoschedé and Monet avoided each other, Hoschedé staying away from Vétheuil whenever he knew Monet was there. Not wanting any direct contact with the painter, Hoschedé now asked Alice to deal with their accounts. It emerged that by late July, Hoschedé (still responsible for the household, though not for the personal expenses of Monet and his children) technically owed Monet over 2,000 francs. He paid what he could, but was unable to produce the full amount. When Jacques Hoschedé was confirmed, on 28 August, Monet made himself scarce, and went off to paint in Trouville and Saint-Adresse. With Durand-Ruel's renewed interest in his work, he had plenty to get on with. (In 1881, he earned a total of 20,400 francs – his highest earnings since the halcyon Argenteuil year of 1873.)

On 18 November, Michel Monet was baptised. Since Monet was strictly atheist, this indicated the degree to which Alice now controlled the decisions. At her instigation, Monet continued to draw up accounts for Hoschedé. Unable to pay his dues, Hoschedé was hardly in a position to insist on rehousing his wife in Paris, but in trying to persuade her to join him, he was asking her to make a significant, indeed life-changing decision. For the time being, the entire household moved to a borrowed house in the village, while Monet looked for a new place to rent. When he found a house for rent in Poissy, a small town between Paris and Mantes, Alice was forced to decide. The circumstances of her move to Vétheuil, ostensibly as a loyal friend, nursing Camille and taking care of Monet's two little boys, had been ambiguous. But – as it had finally dawned on even Hoschedé himself – the decision to move in with Monet as his lover, especially as a married woman and a devout Catholic, was another matter, constituting flagrant desertion of her husband. Hoschedé, in Paris, waited with a sinking heart for her to make up her mind.

★

Manet returned to Paris in November, to find that word had finally got out: the rumour was that he was seriously ill. He was determined,

however, to prove everyone wrong. Making a joke of his bad foot, he was soon back in the Nouvelle Athènes, Tortini's and the Café de Bade. At home he was moody and silent, with distressing mood swings. Being charming in public was exhausting, and at home, Suzanne and his mother paid the price. He went to the rue Villejust, hoping to find Berthe but discovering instead that the new house was still under scaffolding. He wrote to her in Bougival, admitting that 'this year is not ending very well for me as far as my health's concerned'. But he was now seeing more than one doctor, and one of them, at least, reassured him that there was room for hope.

He was working on another hugely ambitious painting. One evening in the *Folies Bergère* he had been chatting to the barmaid, Suzon, and looking at the elaborate layout of the place, with its mezzanine levels, complex lighting and mirror reflections, and brilliant, dazzling chandeliers. Suzon, young, blonde, aloof, in her black, *décolleté* dress, seemed to cast a spell on all her customers. Manet began to think out a new idea, with Suzon as the centrepiece. Since he could not paint her *in situ*, amidst all the bustle and noise, she came to his studio for sittings, and he began a complex new work of ingenious and confounding conception. Viewers have long been puzzled by the disparity between the front view of Suzon, surrounded by her glittering array of bottles, and her back view in the mirror, which does not appear to reflect her. But the image is not static. It *rotates* around the girl as she stands, her mind clearly elsewhere, amidst her hypnotic surroundings, the chandelier above her a mist of crystal as it too seems to circulate, the whole scene almost hallucinatory. In the receding plane, a glimpse of ancient ruins makes a kind of back-drop, or running symbol, of the art of the classical past, which Manet had spent much of his career remodelling and re-fashioning. The history of art, from the ancient past to the present moment, swims before the viewer's eyes, as the images seem to advance and recede, a muddle of shifting perspectives. At the still centre of this hypnotically turning world is Suzon: youthful, fleshy, all too solid, her expression remote and sad.

While Manet worked on the picture, Méry Laurent came every day to see him. He was still working on his series of paintings of the four seasons, and Méry was posing for Autumn. To sit for him she had ordered a special pelisse from Worth. Manet was seduced. 'What a pelisse! It's tawny brown with an old gold lining – staggering. It will make a wonderful background for some things I'm thinking of doing. Promise that when it's worn out you'll give it to me,' he begged her. Méry promised.

On 14 November 1881, Antonin Proust was appointed Minister of Fine Arts in Gambetta's newly formed government. Manet was now more

or less certain to get his *Légion d'honneur*. What on earth did he want it for, anyway? asked Degas. 'My dear chap,' said Manet, 'if these things didn't exist, I'd hardly go to the trouble to invent them, but since they do, why not get everything you can, if it's your due. It's just another stage in your career. If I haven't been decorated so far, it's through no fault of my own, and if I get the chance, I'll take it. I'll do everything I can to make it possible.' Of course, replied Degas. 'You don't have to convince *me* what a bourgeois you are.' In December, when Gambetta presented the new Honours list for signature, there were protests. 'Oh no, not Manet! Not on your life!' said President Grévy. As a minister, Gambetta reminded him, Proust was entitled to award decorations within his own department.

On 28 December in Capri, Renoir, still on his travels, picked up a copy of the *Petit Journal*, where he learned the news of Manet's nomination. He immediately sent New Year greetings, saying that as soon as he was back in Paris he hoped to be able to greet the most loved painter in France, finally honoured with the recognition he deserved. 'You have fought for it cheerfully, without a grudge against a soul, like a true Gaulois; and I love you for all that cheerfulness in the face of injustice. Here I am far away, but with not much news. When the sea is rough, there are no newspapers, and I can't imagine by what circuitous route the *Petit Journal* wends its way to Capri, where I am the only French person. Until soon, *mille amitiés, et une longue santé* . . .'

The Honours list was signed, and Manet received his *Légion d'honneur*. By the end of the year, he needed his stick to get from his sofa to his easel. Nieuwerkerke (Napoleon III's former superintendent of the Académie des Beaux-Arts) asked a mutual friend to pass Manet his congratulations. 'When you write to him,' said Manet, 'tell him I am touched that he remembers me, but that he could have decorated me himself. He would have made my fortune, and now I'll never have those twenty years again.'

# THE GROUP DIVIDES

*'The fools! They've never stopped telling me I'm inconsistent. They couldn't have said anything more flattering.'*
— Edouard Manet

IN JANUARY 1882, THE GOVERNMENT was disbanded. Someone had taken a shot at Gambetta in what looked like a *coup d'état*, as a result of which the entire Cabinet resigned. Gambetta, aged only forty-four, appeared to recover from his bullet wound, but a few months later he died, apparently of a digestive disorder (some said, from lead poisoning caused by the bullet). After only seventy-seven days in office, Antonin Proust had to relinquish his post as Minister of Fine Arts. At least he had managed to secure Manet his *Légion d'honneur*. The day when justice would finally be done was on hand, Proust told him. 'Oh, I know all about justice being done one day,' replied Manet. 'It means you begin to live only after you're dead. I know all about that kind of justice.'

The change of government, and the resulting financial precariousness, had an immediate impact on painters and dealers. When news broke (in February) of the collapse of the Union Générale Bank, Durand-Ruel was faced yet again with the problem of repaying enormous loans. Once again, it looked as if his regular payments to artists on account would have to be suspended. In a desperate attempt to do something constructive, he decided to organise a seventh impressionist exhibition. In the main, the painters were anxious to do anything possible to support him, though the proposal failed to fill Monet with excitement; he simply saw it as another opportunity for everyone to refuel all their old disputes. But he was dependent on Durand-Ruel. Renoir also still owed him paintings. On his way back from Italy he had been taken ill, and stopped off in Provence to recover. When his illness dragged on he went to L'Estaque to get some sea air. He contacted Durand-Ruel from there, describing the beauty of the place, the mild sun and windless days, and explaining that he wished

to stay longer, in the hope of producing some paintings. He ran into Cézanne, and they decided to work together, but he was so unwell that the idea never came to fruition. Instead, he gave in and let Madame Cézanne nurture him back to health with her ragout of cod – 'the ambrosia of the gods,' he told Victor Chocquet. 'I should eat this and die . . .' When Cézanne returned to Paris in March, Renoir was still convalescing in Provence. Only then did news reach him of Durand-Ruel's latest setback. Renoir wrote immediately, offering to do anything possible to support him. He sent twenty-five pictures for the exhibition, including *Luncheon of the Boating Party*.

Monet was in Poissy with Alice and the children, where they were attempting to settle into their house – the Villa Saint-Louis. It was a great improvement on the house in Vétheuil, being much bigger, with a pleasant aspect across the boulevard de la Seine, lined by limes and with a view of the river. Monet, however, was uninspired. He was still anxious about Alice. Though she had followed him to Poissy, he realised the move did not constitute a guarantee of her intentions. It would not be long before their scandal was out in the open, and Monet was worried about how she would react. One concern was her daughter Marthe, who was devoted to her father and set against her mother's liaison with Monet. Hoschedé, for the time being, seemed to be lying low in Paris, not daring to visit his wife while Monet was around. But he was still Alice's husband, and she had given no indication that she had any intention of formally dissolving their marriage. Telling her he thought she needed space to think things over, Monet took off for Dieppe.

He arrived in superb sunshine, checked into the hôtel Victoria, and immediately set off, in thick socks and stout walking boots, to explore the cliffs. By the following day, he was already bored and gloomy. He was too close to the centre of town, the cliffs were no match for those at Fécamp, and he could not find anything he wanted to paint. He walked right across Dieppe, away from the port, across the cliffs behind the castle, but still found nothing to fire him with enthusiasm. He spent his evenings in cafés or alone in his room until he happened upon a local painter willing to lend his studio. He set himself up there and tried to paint, but his heart was not in it. From Dieppe, he kept up to date with Durand-Ruel's plans, announcing that if 'certain persons' were to be involved in the exhibition, he wanted nothing to do with it. As usual, Raffaelli seemed to be the major bone of contention. Gauguin had resigned, announcing that he was not prepared to be made a fool of by 'M. Raffaelli and company'. Caillebotte and Pissarro assured Monet that Degas had definitely pulled out – hardly, replied Monet, in itself a reason to get excited. Durand-Ruel

began to accuse Monet of trying to undermine the whole enterprise, whereupon Monet somehow got the (false) impression that Caillebotte had been excluded. The one thing Monet appeared to have failed to get hold of was the news of Durand-Ruel's financial crisis, though the newspapers were full of the story. Monet continued to harass Durand-Ruel for money, while he hedged his bets *vis-à-vis* the exhibition by telling everyone he would do nothing unless Renoir (whose latest views he was unaware of) was involved.

Having finished with Dieppe, he moved on to the small fishing village of Pourville, where the water is pale blue-green, with low, grassy cliffs and a flotilla of small sailing boats making snatches of white on the water. The scene had little more to recommend it than Dieppe, but he found a hotel/restaurant where the proprietors made a great deal of fuss over him, and the rate was only six francs a day. He was soon happily settled there, walking out every day to paint the seascape and cliffs. While he was enjoying the bracing climate and the opportunity to paint in comfort, Alice was discovering she hated Poissy. The usual difficulties were getting her down: the children always seemed to be ill with colds, she disliked being on her own with them; and she hadn't sufficient resources to look after them properly. Monet wrote to her daily '. . . if only you knew how I hate seeing you suffer like this . . .' For a moment, he told her, he had thought about going straight back to Poissy, but the most important thing, for the time being, was that he get some work done. Pourville was conducive to this – he could not be closer to the sea, he was actually painting on the shingle – and he was sorry he had not gone there earlier, instead of wasting time in Dieppe.

When Alice continued to put pressure on him, he contacted Durand-Ruel to ask for help. Seizing the opportunity, Durand-Ruel made his financial position clear and asked him to settle on a list of his works to be shown at the exhibition. Monet sent a list, but insisted that he would exhibit only if both Caillebotte and Renoir took part. He added that a painting of his belonging to Caillebotte, 'very fine, of red chrysanthemums', might be lent for the exhibition, and he promised to bring back some exciting work from Pourville. He signed off with a reminder that he was still facing 'all the usual obligations', and requested 1,000 francs.

Despite this show of support, Caillebotte decided he could no longer finance Monet's studio in the rue Vintimille, so in April Monet travelled to Paris to make arrangements to move all his canvases out. He took twenty-three paintings to Durand-Ruel who, despite his own difficulties, bought the lot for 10,000 francs. Monet then went straight back to Pourville to paint more seascapes, seeing that they were clearly in demand.

He also began looking for a house where the family could spend the summer. While he was away, Alice summoned Hoschedé to Poissy for a discussion about his outstanding debts. He failed to appear.

Durand-Ruel's crisis was potentially disastrous for everyone, including Sisley, whose support from the dealer, renewed less than two years previously, would now again have to be suspended. Up until this point Durand-Ruel had seemed, directly or indirectly, to be supporting most of the group, including Degas, who was staunchly determined to have nothing to do with the planned exhibition. Degas's own financial problems were far from resolved, and he had had to move again. He left his apartment in the house in the rue Frochot where he had enjoyed his view of an acacia tree, and moved to a small apartment at 21, rue Pigalle, at the foot of the *Butte* de Montmartre. (This move, effectively from Pigalle to Montmartre, meant a significant drop in rent.) Sabine, his matronly housekeeper, went with him. He gave a house-warming party, describing his new home, on the invitations, as 'the handsomest third-floor flat in the neighbourhood'. He was at least able to keep his studio in Montmartre, at 19bis, rue Fontaine-Saint-Georges. Increasingly, he relied on the wealthy friends he had kept from his schooldays for entertainment. He received dinner invitations several times a week from Henri Rouart at La Queue en Brie, Paul Valpinçon at Menil-Hubert, near Argentan in Normandy and Ludovic Halévy, whom he also visited frequently in Paris, all of whom had wives and families and were used to entertaining in style. Degas overcame his dread of the countryside to visit them in their villas, though his stays tended to be short, as there were limits to his tolerance of country-house small talk, piquet and billiards. He was always relieved to get back to his work, 'the one blessing that may be had for the asking'. Though he still had purchasers, his relatively economical way of life nevertheless had to be subsidised, and in 1882 he continued to rely on Durand-Ruel, who in theory retained exclusive rights to everything Degas produced. In previous years Durand-Ruel had advanced regular funds almost like a banker. Now that he had no funds to advance, Degas gave his work to other dealers. Even his precarious existence could not persuade him to join in the 1882 impressionist exhibition. All attempts to entice him failed. The other painters' treatment of Raffaelli, combined with the previous year's row with Caillebotte, had been the last straw. Mary Cassatt loyally defected with Degas.

Pissarro, in Pontoise, was also affected by Durand-Ruel's problems though, like Renoir, he was as concerned for the dealer as for himself. He was more than willing to be involved in the exhibition, especially since he had begun to be irritated by Gauguin, whose decision to desert the group

he saw as a piece of self-posturing arrogance. It was gradually emerging that Gauguin and Pissarro, once apparently compatible, were actually very different in temperament. Concerned about the emerging divisions within the group, Pissarro and Sisley went to see Manet, who told Berthe, 'these gentlemen don't appear to get on together, . . . Gauguin is behaving like a dictator.' He warned her that business was bad: 'everyone is penniless because of the recent financial events, and painting is feeling the effects'. After all these years, he was almost on the point of being persuaded to join the group himself. He hesitated for a long time, and after finally deciding against it, Eugène thought he bitterly regretted his decision. But *Spring* (the first of his series of portraits of the seasons, each modelled by a woman) and *A Bar at the Folies Bergère* were being shown at the Salon where, for the first time, he was exhibiting with the letters H.C. (*Hors Concours*) after his name. Showing his work in the group exhibition would have been tantamount to implying that he had accepted the accolade of H.C. only to rebuff it.

Monet was eventually persuaded to exhibit. Caillebotte, who had initially tried to organise the show, gave way completely and let Durand-Ruel take over. Using all his powers of diplomacy, Durand-Ruel gradually managed to assemble a group that consisted of Monet, Renoir, Pissarro, Sisley, Caillebotte, Berthe Morisot, Cézanne's old friend Guillaumin, who had been exhibiting with them since 1874, newcomer Charles Vignon – one of Degas's protégés – and Gauguin, who was persuaded to return by Pissarro and gradually readmitted by the others.

The premises Durand-Ruel found for the exhibition were, somewhat ironically, at 251, rue Saint-Honoré, in the Salle des Panoramas, an enormous hall constructed to commemorate the Battle of Reichshoffen, the upper walls of which were decorated with valuable Gobelin tapestries. Everyone gathered to hang the paintings, Pissarro grumbling about the space, with all that 'official red'. Berthe, who had been in Nice for the winter, stayed away to look after Julie, who had severe bronchitis. So Eugène made the journey overnight from Nice, arriving in Paris at 11.15 in the morning after a thirteen-minute stop for hot chocolate at Larouche. He went straight to the Salle des Panoramas to assure everyone that Berthe's paintings were on their way, then back to the Gare Saint-Lazare, where he took another train to Bougival, only to find that he had no keys to their house. After hiring a locksmith to break in, he collected all Berthe's finished paintings of Nice and all her pastels, then made straight back to Paris to get them framed, in a torrent of driving rain. While the pictures were being framed, he visited Manet, to congratulate him on his decoration. The next day, at eight in the morning, Eugène was back in

the Salle des Panoramas. It was looking good, he reassured Berthe in Nice, especially Renoir's *Luncheon of the Boating Party*, though his paintings of Venice were 'hideous, real failures'. Manet came over to approve Eugène's selection of Berthe's work, and the exhibition was ready to open.

*A Bar at the Folies Bergère* was already on show at the Salon. Wolff reviewed it in the *Figaro*, sniping that in years to come, Manet would be admired 'more for what he attempted than for what he achieved'. In Nice, Berthe's maid accidentally spilled a whole inkpot over the newspaper, so Wolff's article, said Berthe, got what it deserved. Manet wrote to Wolff, 'I have not given up hope that you may one day write the splendid article I've been looking forward to for so long, and that you are quite capable of doing when you want to – but if possible, I would prefer it to be in my lifetime – and I must warn you that I'm getting on in my career. Meanwhile, thank you for yesterday's piece . . .'

The seventh impressionist exhibition, despite all the problems with its planning, was the most coherent and most successful to date. The venue even seemed to lend added cachet, and the rue Saint-Honore was lined with carriages, as the *beau monde* queued to see the show. Critical reception was as mixed as ever. Wolff complimented Degas on his defection. *Le Soleil*'s reviewer singled out one of Monet's paintings of the sunset at Lavacourt – 'a slice of tomato stuck onto the sky'. *L'Evénement* focused on the group's reputation for naturalism, sneering that it was fortunate that the artists had chosen painting as their vocation, rather than a career on the railways. This year's in-joke was that the painters were obviously all colour blind (a myth that stuck to Monet, and still persists today). Sisley and Pissarro seemed to come off best, though *Paris-Journal* praised Monet's seascapes and his 'extraordinary power of illusion'. Durand-Ruel's biggest rival, Portier, went to the exhibition, where he completely changed his mind about Berthe Morisot, deciding that if the work shown here was anything to go by, he should certainly be able to sell more of it.

News had reached Berthe of Mary Cassatt's defection. Berthe was intrigued, and asked Eugène to find out why Mary had backed out. Mary remained as good as her word, refusing to exhibit out of solidarity with Degas, but she went to see the show. She was friendly with Eugène, and asked if she could paint some portraits of Berthe and Julie. Family life for the Cassatts was under strain. Lydia's condition seemed to be worsening, and Katherine was suffering problems with her heart. Both were unwell and in pain, in need of the care they were used to giving each other, and reliant on Mary until the doctors recommended a warmer climate. They

went to Pau, in the South of France, where Katherine improved, but Lydia was rapidly deteriorating. In the past, her attacks had been temporary and she had not suffered a serious one for a year and a half. But she was now in constant pain, reliant on arsenic, morphine and other dreadful nineteenth-century remedies (including 'the blood of animals, drunk fresh at the abattoir').

Manet and Suzanne were in Rueil, just west of Paris, a few kilometres from Chatou. In this small village, clustered around its squares – place de la Mairie, place de l'Eglise – he was once again attempting to rest, spending the summer in another borrowed house, this time at 18, rue du Château. The house was large but inconvenient, with blue shutters and a pretentious façade decorated with pediments and columns, set in a modest garden. Manet sat in the garden, trapped like a bear in a cage. He painted the house, the shutters open, looking resoundingly empty, with slightly spooky shadows. His painting gives no sense of the smallness of the garden or of its location within a narrow street. The rue du Château, despite its imposing name, was a narrow, cobbled lane curving directly away from the place de l'Eglise, with houses on either side, no sign of a château, and no proximity to the river. The short walk along the lane to the place de l'Eglise led only to the church. Just around the corner, on the main road to Sèvres, was the hospital, ominously close. Marooned and cramped, with all the threads of his busy life severed, Manet was lonely and frustrated, his only consolation the nearness of Berthe, Eugène and three-and-a-half-year-old Julie at their summer house in Bougival, and regular visits from Léon. Manet painted Julie in the garden of the house in Rueil, in her summer dress and bonnet, perched on a watering-can, her small, broad face set in a frown.

On 8 July, L'Evénement broke the news of Manet's ill health. He wrote immediately to the paper, insisting he had merely sprained his foot, but no one was fooled. The depressing, dull summer did nothing to raise his spirits. He was still writing bravely to his closest friends – perhaps, he told Méry Laurent, 'the new moon will bring more sunshine' – but he was very tired. In Paris, before he left, he had started a rather sombre portrait of a woman in riding habit, L'Amazone. But in Rueil he did very little painting in oils. That summer, his most ravishing works were his still lifes: he painted plums and mirabelles in watercolour, with matt earthy skins; Two Roses on a Tablecloth, their petals battered and creamy, strewn on the table like wounded soldiers; and a basket of vivid, luscious strawberries, mouth-wateringly red, glutinous and tactile. While his paintings of people were becoming haunting and remote, his still lifes seemed to be ever more vibrant.

Late summer brought rain and wind, 'not exactly calculated to make the countryside attractive, even to an invalid', he grumbled to his friends in Paris. He was still begging everyone for news. 'You say you have heaps of things to tell me,' he complained to Méry, so why didn't she do so? He wanted it now, while he was still captive. As usual, he assured everyone the rest had done him good, and he was continuing to improve, but he was aware that the prognosis was not good. On 30 September he wrote his will, establishing Suzanne as his universal legatee and making clear provision for Léon: 'In her last will, she will leave everything I have left her to Léon Koella, known as Leenhoff, who has given me the most devoted care.' This was significant, since in French law an estate passes unquestionably to children, legitimate or illegitimate. Manet endorsed this by adding, 'I believe that my brothers will find these arrangements perfectly natural.' Beneath his signature, he added a further two, unambiguous lines: 'It is clearly understood that Suzanne Leenhoff, my wife, will leave in her will to Léon Koella, known as Leenhoff, the fortune I have left her.'

In October he returned to Paris, still determined to work. He began his paintings for the following year's Salon, working compulsively, with much grumbling and complaining. *L'Amazone* was driving him mad with frustration; he lay cursing and fuming on the sofa. It was torture to finally have been honoured, and now be unable to work. Antonin Proust visited him in the evenings, and Manet told him he wanted to paint a crucifixion. He said that all the time he had been working on Proust's portrait, painting him in frock-coat and top hat, with a rose in his buttonhole, he had been imagining him on his way to visit Mary Magdalene. 'Christ on the cross – what a symbol!' – a symbol of 'love surpassed by sorrow, which lies at the root of the human condition, the main symbol of human poetry . . . but that's enough of that, I'm getting morbid. It's Siredey's fault, doctors always remind me of undertakers. Though I must say, I feel a lot better this evening . . .' He had begun to worry about what would become of his work in the future. 'I beg you,' he told Proust, 'if I die, don't let me go piecemeal into the public collections, my work would not be fairly judged. I want to get in complete or not at all . . . Please, please promise me one thing, never let my things go into a museum piecemeal.' For the first time, he admitted that the critics' persistent insults had deeply hurt him – 'no one knows what it feels like to be constantly insulted. It sickens and destroys you . . . The fools! They've never stopped telling me I'm inconsistent: they couldn't have said anything more flattering.'

In the daytime, he forced himself with difficulty from his couch to his easel. Everyone, even strangers, began to send him flowers. Méry sent her

maid, Eliza, with a fresh bunch every day. 'Take care, Monsieur Manet,' Eliza told him, 'don't catch cold, you must look after yourself.' He was touched, and promised to paint her portrait. To his closest friends he admitted to hiding himself away 'like a sick cat'. He found it harder and harder to hide his despair, lashing out even at his mother, telling her, 'You shouldn't bring children into the world if they're going to end up like this.' Still he persisted in going to his studio every day, where sometimes he simply lay on his couch for hours at a time. With each day that passed he was in increasing pain, and becoming more gravely ill.

<p style="text-align:center">★</p>

Lydia Cassatt died in her sleep, aged forty-five, on 7 November 1882, a few days after the family returned to Paris from Louveciennes. Aleck and Lois arrived, as planned, three weeks later, having received the news of her death the day before they left Pennsylvania. Though they all knew how fragile she was, nobody had really expected Lydia to die. The whole family was devastated. Mary was deeply shocked. She had been very close to Lydia, and found it impossible to imagine the rest of her life without her. She had not been working properly since the previous spring, and now hardly had the heart to begin painting again. Her friend Louisine Elder returned to Paris at the end of the year. She was making preparations for her marriage to Harry Havemeyer, and this time in Paris with Mary was to be the last they would enjoy together as single women. While there, Louisine took the opportunity to penetrate the Parisian art scene even further, purchasing works by Degas, Pissarro, Monet and Whistler, as well as Cassatt's *Self Portrait*. (A decade later, Mary Cassatt and the Havemeyers became a team of collectors unrivalled in the history of American patronage, crucially instrumental in introducing impressionism to America.)

Mary also distracted herself by painting portraits of her nieces and nephews, who stayed behind at 13, avenue Trudaine with their aunt and grandparents while their parents went to London to meet Whistler, whom Lois had chosen to paint her portrait. Whistler was by now the talk of both cities, and Lucien Pissarro, working in London for a music publisher (Julie had got her way – though the pay was in theatre tickets), had been to his studio, the height of *chic*. 'It is completely white with lemon yellow borders, and yellow velvet drapery with his butterfly embroidered in a corner. The chairs are yellow with white straw seats. There is a yellow Indian mat on the floor, and some kind of yellow dandelions in yellow earthenware vases. The attendant is dressed in white and yellow.' Lois was expecting great things, and had set her heart on Whistler, ignoring all

Mary's attempts to persuade her to go to Renoir instead. Mary turned out to be right: Lois was most disappointed by Whistler's indifference to the choice of elegant costumes she brought him. He painted her in her riding habit, looking chaste, stern and somewhat chinless. But all the Cassatts agreed that a portrait by Whistler, even posed in a riding habit, had to be a good investment.

At the end of April, Aleck, Lois and the younger children sailed for home, leaving fourteen-year-old Eddie in Paris to finish his school year at the Ecole Monge. His schooling and his riding lessons provided further diversions for Mary. Nevertheless, when spring came she was still depressed. 'Mame has got to work again in her studio, but is not in good spirits at all,' Robert told Aleck in Pennsylvania: '– one of her gloomy spells – all artists I believe are subject to them – hasn't put the finishing touches to your portrait yet . . .' Aleck had gone back to Pennsylvania without his portrait, but he did take a small collection of Monets, assured by all the family that he was making a wise investment. Monet's seascapes were becoming popular, and on Mary's advice, the Cassatts exchanged their scene of Trouville for one. Katherine described it to Aleck: 'one of those which it would take an artist to appreciate, or maybe a sailor. It is a boat tossing on a great wave tipped with foam – the contrast of the white foam and the very dark blue of the water is tremendous.'

Like many people, the Cassatts were keeping a careful eye on their investments. The political climate remained insecure, and after the collapse of the Union Générale bank the stock market had fallen sharply. Durand-Ruel was still making payments to the impressionists (including Sisley, who throughout 1882 had continued to send him paintings in return for modest sums), but everyone knew that his support could no longer be taken for granted. Pissarro had begun to look for a cheaper house, aware that things were not likely to improve and anxious that he could no longer afford the rent. With the birth, in 1881, of Jeanne ('Cocotte'), he now had five children to support, and he was beginning to realise he would probably have to leave Pontoise altogether. 'I really regret it,' he told Monet. 'I always felt Pontoise suited me in every respect.' He began to look around at other villages. For some months, Durand-Ruel had been talking about holding some separate shows of individual artists, still a very modern idea. At first, none of the painters was keen, since the critics never took these seriously, regarding them as exclusively commercial ventures. At the same time, nobody was in the mood to press for another group exhibition. By spring 1883, Durand-Ruel had managed to persuade four of the group to exhibit independently, and was in the throes of organising four shows, for

Monet, Renoir, Pissarro and Sisley, in March, April, May and June respectively.

★

Monet had been in Normandy. He stayed there from 31 January to 21 February painting the steep cliffs at Etretat, on the south side of the estuary just north of Le Havre, where they jut out into the sea in a strange formation, like an elephant dipping its trunk into the water. The light reflects on the water, which seems to change colour continually, and the tides can turn quickly, almost without warning. In winter, Monet found the place deserted but for the fishermen spreading their nets across the beach. He worked undisturbed, spending evenings in his room at the hôtel Blanquet (which advertised itself as 'The Artists' Rendez-Vous) writing home to Alice, who had still not decided what to do. Her problem was her husband, who just could not accept the idea of losing his wife. She would have to face up to him, Monet told her – organise a proper meeting with him and get things resolved, since the longer she left it, the harder it would be. 'As far as I'm concerned,' he assured her, 'you need have no fears, I think of you constantly, you can be sure of my love, be brave . . .' But this show of confidence hid the fact that Monet himself felt far from secure. It suddenly seemed possible that after all this time, he might actually lose Alice. He was so preoccupied that he forgot her thirty-ninth birthday, on 19 February. He dashed off a telegram – 'you know dates are not my forte' – which he followed up with a long letter.

'I've been in such a state,' he wrote, 'that I'm completely overwhelmed by it . . . I feel very strongly that I love you more than you imagine, more than I thought possible. You have no idea what I've been through . . ., how desperate I've been to hear from you.' Alice sent him a four-line telegram, asking him to come straight away. The telegram terrified him; he assumed it meant that she had made her decision. 'I have read and re-read each line 20 times over,' he replied, 'my eyes are swimming with tears; can it really be true? Must I really get used to the idea of living without you?' He was aware that nothing would dissuade her if she had made up her mind to return to her husband, and whatever the text of the telegram was, it plunged him into despair. 'I am so very, very sad. Nothing means anything to me any more. I couldn't care less if my paintings are good or bad . . . Those four lines were a terrible blow to me, I am devastated . . . You tell me to come right away; do you mean you want to leave me immediately? What in Heaven's name have people been saying to you, for you suddenly to be so sure?' On 21 February he left Etretat, arriving back in Poissy that afternoon. Hoschedé had been and

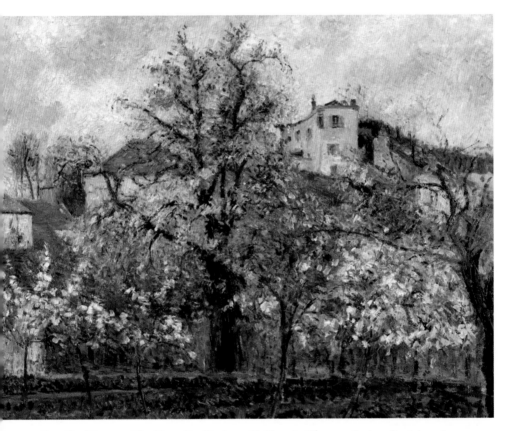

13. Camille Pissarro, *The Vegetable Garden with Trees in Blossom, Spring, Pontoise*, 1877

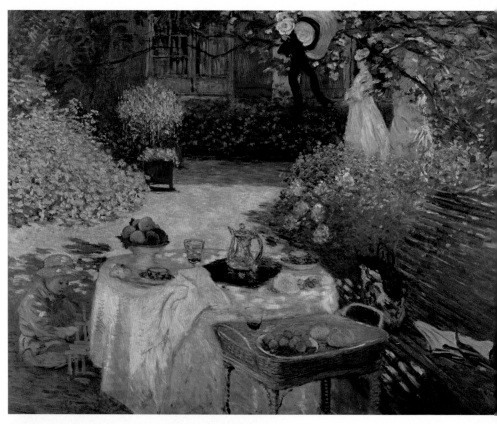

14. Claude Monet, *The Lunch*
*Monet's Garden at Argenteuil*, c. 1

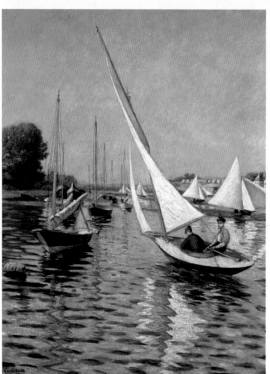

15 Gustave Caillebotte,
*Regatta at Argenteuil*, 1893

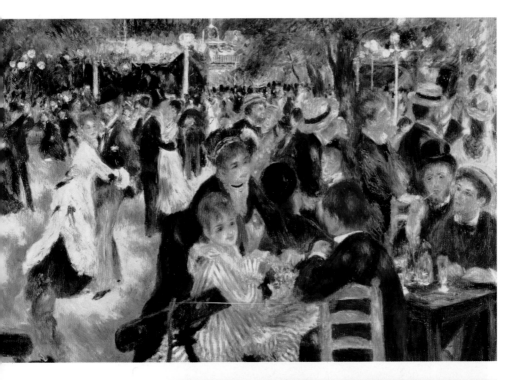

. Auguste Renoir, *Ball at*
*Moulin de la Galette*, 1876

17. Auguste Renoir,
*The Swing*, 1876

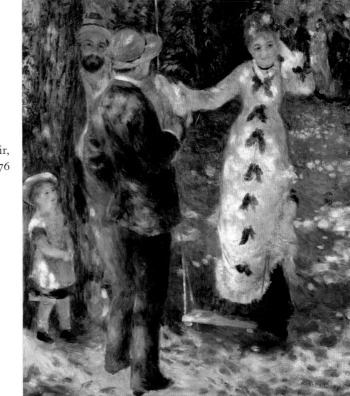

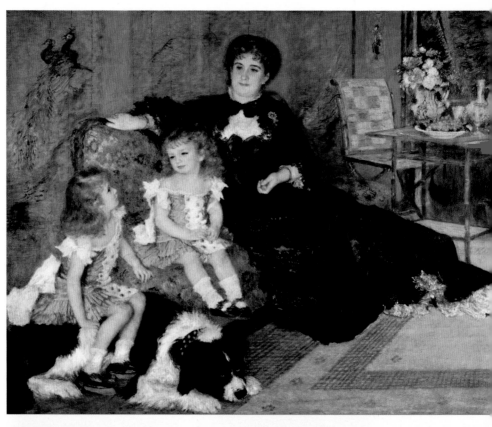

FACING PAGE
18. Auguste Renoir, *Madame Charpentier and her Children*, 1878

19. Mary Stevenson Cassatt, *Little Girl in a Blue Armchair*, 1878

20. Auguste Renoir, *Luncheon of the Boating Party*, 1881

21. Gustave Caillebotte, *Study for 'The Floor Strippers'*, 1875

22. Claude Monet, *The Rue Montorgueil, Paris,*
*Celebration of June 30, 1878,* 1878

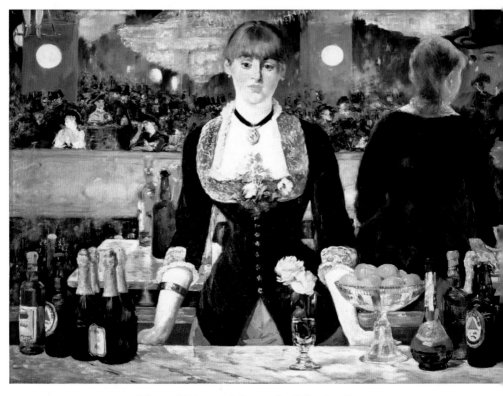

23. Edouard Manet, *A Bar at the Folies-Bergère*, 1881–82

gone. If any decision had been taken in Monet's absence, there was no evidence of it for the time being. Alice remained at Poissy, perhaps reassured by the declarations of love and devotion she had managed to elicit.

Before this, Durand-Ruel had been in touch, with a reminder that Monet's one-man exhibition was scheduled for March. He had opened a new gallery, at 9, boulevard de la Madeleine; Monet's would be one of his first shows there. He was afraid there would be no new work to show, Monet told him. He had been trying to paint, but had been in such a state of anxiety over Alice that he had not been able to finish anything. To Alice, he complained that her telegram had paralysed him at a time when he already had problems. In the few days before he left Etretat the weather had broken, bringing rain and terrible storms. He had spent his last few days in his hotel room, writing letters to collectors, inviting them to his exhibition. When it opened on 1 March, the show consisted mainly of landscapes of Pourville and Varengeville; there were no Etretat pictures at all. Pissarro was there, and told Lucien it was a great success, but it certainly was not at first. For a while, it went unnoticed by both public and press: a 'catastrophe', concluded Monet, a 'fiasco'. He blamed Durand-Ruel for failing to light it appropriately, organise it properly, or bring it to the attention of the press.

Six days after the show opened, he was already writing from Poissy to ask Durand-Ruel to send him some funds, '*straight away* as I am in a very embarrassing financial position and cannot wait'. He took the opportunity to make Durand-Ruel aware of the full extent of his lack of confidence in him. He had no desire to go to Paris to see the show – why would he wish to be confronted by the extent of his own failure? He did not see things the way Durand-Ruel did, and had no doubt that this exhibition was 'a step in the wrong direction'. It was all very well relying on 'people of taste' to appreciate the show, but they would wait an eternity. No doubt, others would benefit from this show, since future exhibitions would have the advantage of Durand-Ruel's having 'learnt from the experiment made at my expense'. What was really upsetting him was the public's apparent indifference: even being attacked was a measure of worth, whereas being ignored like this seemed to him intolerable. Durand-Ruel should rest assured that Monet really could not care less what 'so called art critics' thought, they were all as stupid as one another. But 'I know my worth.'

His outburst was hasty. Soon afterwards, four major reviews of the exhibition appeared, in the *Gaulois*, *La Justice*, the *Courier de l'art* and the *Journal des artistes*, all favourable. Philippe Burty, at Monet's instigation, wrote a long, laudatory piece in *La République française*, which appeared on

26 March. (Monet's letter thanking him – presumably sent to him first – was dated 25 March.)

In fact, Monet's most pressing problem was that he and his *ménage* had to be out of their Poissy house by 15 April, and he wanted their next home to be permanent. He wanted to settle, and he needed to secure Alice. In a search for somewhere new to live, he took the train as far as the small, medieval village of Vernon, set in a valley surrounded by cornfields and poppy fields, with hillsides stretching away into the distance. At Vernon he got off the train and walked right across the fields, off the beaten track until, two kilometres from Vernon, he found a tiny hamlet consisting of one main street and a few country houses, including a long, low house with pink walls. Set in a scrubby garden, the house – two storeys and an attic – faced away from the road, towards the river. When he discovered that it was available for rent, he looked no further. On 29 April, from Poissy, he sent Durand-Ruel the news that he was about to move to Giverny.

Alice and her children moved with him. However, she was still very far from offering Monet any assurances. Discreetly, she wanted Hoschedé to go on providing for their children and to pay off the outstanding debts from Vétheuil. She told him she could no longer ask anything of Monet as she already owed him so much money – a complete fiction, intended to keep up appearances. She had more inconclusive talks with Hoschedé later that year, which produced only 'nonsense on both sides'. She ordered him to reflect calmly, put his thoughts down in black and white, and she would reflect at length on her reply. Still nothing was decided. (In fact, the situation remained ambiguous for the next ten years, until after Hoschedé's death from gout in 1891. Monet and Alice finally married in Giverny on 16 July 1892, four days before the wedding of her daughter Suzanne to the American painter Theodore Butler.) Meanwhile, in April 1882 Monet notified Durand-Ruel, 'I am setting off . . . this morning with some of my children. We are so short of money, however, that Madame Hoschedé will have to stay here, even though she has to be out of the house by ten o'clock tomorrow at the latest. So I am writing to ask you if you can provide the carrier with one or two hundred francs, whatever you can manage, . . . as we won't have a *sou* when we get there. I'm depending on you . . .'

★

Fully preoccupied by his move and his financial worries, Monet had heard no news of Manet, who by spring 1883 had been bedridden for several weeks. He was sitting up in bed, painting flowers – the gifts of his visitors

– in glass vases, pinks, roses and clematis in water, which combined the limpid delicacy of Vermeer's paintings of stems in water with his own unmistakable thick, creamy brush strokes. Méry brought him lilacs, and he painted them in water, a subtle blur of surfaces reflecting the light caught in the petals, with strong, dark, contrasting backgrounds. These were his last masterpieces, fragile impressions of refracted colour and light; gentle interpretations of the impact of mass on water. On 1 March he painted a glass vase of roses (*Roses in a Glass Vase*), one rose smashed down, its petals crushed on the ground beside the vase, the flowers barely discernible as roses, the water smudged, the contours of the vase awkwardly finished. This was his last oil painting. Three weeks later, at Easter, Méry's maid Eliza arrived, bringing an Easter egg full of sweets, and he remembered his promise. His simple pastel sketch of Eliza was his final work.

By early April, the news had already begun to spread. 'Manet is dying,' Degas told the sculptor Bartholomé. 'Manet is on his death-bed,' reported *L'Illustration* on 7 March. Pissarro was in Paris, preparing for his exhibition at Durand-Ruel's. 'Our poor Manet is desperately ill,' he wrote to Lucien in London, 'we are losing a great painter, and a man of great charm.' All the doctors were fighting for the honour of attending him. Someone sent for Dr Gachet. 'When I'm better,' said Manet, 'bring your children along, I'll do a pastel portrait of them.'

Antonin Proust visited, and found him lying with the sweets from Eliza's Easter egg arranged where he could see them. He was calm, but waiting anxiously for a visit from his doctors. During the night, his left foot turned black. His close friends and family knew that he was in excruciating pain. Léon went to fetch Dr Siredey, who diagnosed gangrene. On 18 April, Dr Siredey informed Manet that he had no choice but to amputate. 'Well,' said Manet, 'if there's no other way of getting me out of this, take off the leg, and let's have done with it.'

On 19 April, Proust visited him early in the morning. Manet asked about the Salon, which was about to open, wanting to know if there was going to be anything interesting there. Then Proust left, and at ten o'clock Manet was carried to a large table in his own drawing room. In the presence of two medical students and one of his brothers, he was given chloroform and the operation was performed, by three doctors, including Dr Siredey. The *Figaro* reported every last detail, including the state of the amputated leg, which was in such decay that the toenails came off on contact. According to the press, Manet had suffered no pain, and was giving no cause for concern.

For ten days he lay in a fever, with the few people allowed to see him

(Suzanne, Léon, his brothers, Berthe, Mallarmé) at his bedside. In his delirium, it was impossible to tell whether he knew they were there. People started to gather in the street, Léon doing his best to field increasing numbers of callers. On 29 April, Manet seemed to be sinking. The abbé Hurel called, with a message from the Archbishop of Paris, who had offered to administer the last sacrament himself. 'If my godfather shows signs of wanting the last sacrament,' Léon told him, 'you can count on me to let you know at once. But I have no intention of suggesting it.' All that day and the next, Manet was in atrocious suffering. He died, in Léon's arms, at seven o'clock on the evening of 30 April, aged fifty. 'His agony was horrible,' Berthe told Edma, 'death in one of its most appalling forms, that I once again witnessed at very close range. If you add to these almost physical emotions my old bond of friendship with Edouard, an entire past of youth and work suddenly ending, you will know that I am devastated.'

At that same hour, seven o'clock on Monday, 30 April, the Palais de l'Industrie was crowded with people attending the private view of the Salon. Suddenly, a kind of chill went through the rooms. Someone had arrived with the news that Manet was dead. A deep silence fell, and slowly, one by one, the men took off their hats.

<p style="text-align:center">★</p>

The following day in Giverny, some of the packing cases were still unopened when Monet and Alice received the news. Monet had been chosen as one of the pall-bearers. He telegrammed a tailor in the rue des Capucines with an urgent order for a suit, then on 3 May took an early train to Paris. Arriving at nine o'clock, he first took the opportunity to rush straight to Durand-Ruel's gallery to pick up some money before dashing to collect his suit, then hastening to the church of Saint-Louis-d'Antin, in the Batignolles, to join the other pall-bearers, Antonin Proust, Théodore Duret, Fantin-Latour, Alfred Stevens, Philippe Burty and Zola. A huge crowd was already gathering in silence, lining the streets. Eugène, Gustave and Jules de Jouy led the mourners; Degas, Renoir, Pissarro and Puvis de Chavannes were among those following the coffin. The streets were crowded with people wanting to pay their last respects. All Montmartre seemed to be there. Manet's friend Jules-Camille de Polignac described the scene. On an otherwise ordinary day, with no sun, just fine clouds spread out grey across the pale sky, the hearse passed shop girls out buying their lunch, servants rushing across the road in their white aprons. It made a splash of bright colour, heaped with lilacs, violets, forget-me-nots, pansies and roses, and a heady scent of flowers. Behind, the crowd

followed, a long ribbon of mourning. Five hundred people marched slowly through the streets. The hearse stopped at the portal of the church of Saint-Louis-d'Antin where, in front of the high altar, radiantly lit, a catafalque had been erected. The whole church was hung with black drapery bearing the initial M. The coffin entered, laden with wreaths and heaped with flowers, and the choirs began to sing, followed by the solemn offices of the dead.

At the door of the church, where most of the crowd still stood, groups of people were huddled, talking. Polignac heard one remark, 'Well, it was a waste of time butchering him.' The hearse now resumed its slow march, through the boulevard Haussmann, the rue La Boetie and the rue Marbeuf, as far as the Trocadero, on its way to the cemetery at Passy. The sky there seemed to have been washed. In a sudden gap in the clouds, a streak of light unfolded, irradiating the young leaves of a row of trees. After the solemnity of the church, the cemetery seemed fresh and simple, spring-like; and someone, forgetting himself, burst out, 'It's nice here!' The procession passed two square lawns bordered with small, white flowers. As the mourners proceeded, the whole cemetery came into view, a simple, pretty place, bordered with flowers, beneath the soft, grey sky.

★

Méry Laurent, 'tall, beautiful, arresting, like a tea rose,' took the first spring lilacs to Manet's grave. The expressions of sympathy were 'intense and universal,' Berthe told Edma: his warmth, intellectual charm and 'something indefinable' had made him a compelling friend. He had left his studio full of paintings, which she and Eugène began to organise with a view to auctioning them.

Manet's death had an immediate impact on the morale of the group. Though he had never exhibited with them, his loss drew attention to the extent to which, in some curious way – just as the critics had assumed – he had led the group, with his advice, financial help and inspiring example. Always at the centre of things, always *au fait* with developments, he seemed to have been everybody's loyal friend. It was as if a light had gone out. Without Manet, there was somehow no yardstick; nothing to live up to. After his death, the individual members of the group began to move in new directions.

In January 1884, a major retrospective of his work was held at the Ecole des Beaux-Arts, organised by a committee of fourteen that included Berthe and Eugène, Antonin Proust, Zola, Alfred Stevens, Durand-Ruel and Georges Petit. At the opening, Stevens and Puvis de Chavannes agreed that they had seen no greater work since Ingres. The presence of

Antonin Proust, as former Minister of the Arts, lent solemnity to the occasion. At the close of the exhibition a terrific storm began to brew, and people rushed from the Ecole in a teeming torrent, dodging falling slates as chimneys rattled.

<div align="center">★</div>

Monet returned to Giverny straight after the funeral. The house he and Alice had rented, the long, low pink building with roughcast walls, sat in almost two and a half acres of scrubby orchard and garden, surrounded by hills. At the foot of the garden ran the small railway connecting Vernon and the nearby medieval village of Gasny. The house, set with its back to the lane that wound through Giverny, was reached by a simple path, bordered with pine trees and sheltered by trellises covered with roses. The garden was a vast, walled space, partly ornamented with boxwood. There were two stiff flowerbeds running parallel to a broad alley bordered with spruce and cypress. (Giverny as we now know it, with its ravishing array of flowers and Japanese water garden, subject of the series of Water Lilies, was still a thing of the future.) Monet and Alice immediately removed the box, which they both hated, and began an argument – lasting two decades – about the spruce and cypresses. Beyond the garden lay waterlogged meadows surrounded by willow and poplar trees, with poppy fields continuing into the distance. Caillebotte was called in to give his opinion of the garden. He sailed down the River Epte on his yacht, the Casse-Museau, and Monet joined him at the lock and spent several days painting with him on the river, while Alice and her wraith-like daughters, dressed identically (as was the fashion) supervised the organisation of the house.

Monet was already an object of fascination in Giverny. The locals watched as he strode around the village giving orders in his clear, ringing voice. His prospects looked good, now that Durand-Ruel's rival, Georges Petit, was keen to build a stock of his work; Petit had just purchased forty of his pictures from Durand-Ruel. Monet was having a shed built on the riverbank, to shelter his boats and store his easels and canvases; in the meantime he moved his paintings into the barn and moored his boats on a small island nearby, where the Epte joins the Seine. He and his two little boys tied their boats to the thick trunks of the willow trees by the river, and made their way back to the house at dusk to the sound of the steamboats towing the Seine barges through the night.

# FINAL YEARS

Paul Durand-Ruel

# THE IMPRESSIONISTS
# IN NEW YORK

*. . . a pile of unsung treasures . . .*

O N 13 MARCH 1886, PAUL DURAND-RUEL and his young son
Charles were travelling through the streets of Paris, on their
way to the Gare Saint-Lazare. In the two decades since Paul had
inherited his father's business, Paris had been transformed. Durand-Ruel's
daily journey from his Clichy apartment in the rue de Rome to his
two Pigalle galleries took him along the wide, tree-lined boulevard
Haussmann itself. By 1890, Baron Haussmann would be saying of his
newly created capital of Europe, 'these days, it's fashionable to admire old
Paris, which people only know about from books'. Some areas of Paris
had hardly changed: the poor still lived in the shacks of Montmartre or the
shanties of Belleville; there were still cholera, typhoid, deaths in childbirth
and infant mortality. But to the uninitiated, those problems were now
hidden from view. Paris had a new image: the new Republic was
streamlined and stylish, the epitome of healthy living and good taste.
Haussmann's Paris was architecturally modern, stratified by wealth,
quintessentially urban and, above all, commercially prosperous.

The art market, however, was still in trouble. For the past two years,
Durand-Ruel's fortunes had seemed to fall deeper and deeper into
jeopardy. He had debts of a million gold francs. There seemed no prospect
of his ever resuming his former role of 'banker' to the impressionists.
Monet was talking about moving to Georges Petit; Pissarro had begun to
realise he would be forced to break his exclusivity agreement with
Durand-Ruel. In 1884 Durand-Ruel was falsely accused of dealing in a
fake Daubigny, and had to put all his energies into defending his case. He
told Pissarro that he wished he could just walk off into the desert and
disappear. In 1885, he published an open letter in *L'Evénement,* defending

himself against ever more hostile criticism. He reminded his public that the popularity of the Barbizon painters, originally so misunderstood, was entirely due to his efforts. In promoting the impressionists, he was simply looking among the next generation of painters for those who would become *maîtres* in their turn. He continued to believe that these painters were '*très originaux et très savants*. I consider that the works of Degas, Puvis, Monet, Renoir, Pissarro and Sisley are worthy of appearing in the greatest collections.'

'Durand-Ruel was a missionary,' Renoir later told his son Jean. 'It is lucky for us that his religion was painting . . . In 1885 he almost went under, and the rest of us with him.' Though he was a respectable bourgeois, an ardent royalist and a practising Catholic, Durand-Ruel was willing to take a gamble. Since 1865, when he inherited his business, he had been directly supporting radical artists and attempting to sell their work to the wealthy set of Americans in Paris. Neither strategy had brought him success. But in 1885, his networking paid off. He received an invitation from James Sutton, President of the American Art Association in New York, to mount an exhibition in the Association's rooms. Durand-Ruel accepted without hesitation. By March 1886, he was on his way to New York.

The journey took Paul and Charles Durand-Ruel five days. They began at the Gare Saint-Lazare, and travelled through the *banlieues* of the Seine, the rattling, whistling steam train billowing out great clouds of grey and black smoke. They journeyed through the country villages, sparkling with blossom, which the impressionists had painted in all weathers, passing strings of washing like tattered flags lining the gardens of the newly built country villas or splayed out along the riverbank like the fluttering wings of great white birds. The pale, washed skies of the countryside west of Paris flashed past them as the train bypassed the loop of the Seine around which were huddled the villages – Chatou, Bougival, Louveciennes, Marly, Gennevilliers, Argenteuil – loved, lived in and celebrated by the painters for more than twenty years.

During the past three years, since Manet's death, the group had to some extent continued to disperse. Times were changing, and the impressionists had begun to look further afield for ideas. None of Durand-Ruel's 1884 one-man shows had been a success, despite the good press reactions to Monet's. Sisley and Pissarro were increasingly despondent. When Pissarro returned to Osny after seeing his exhibition in Paris, Julie went to the show, leaving Pissarro with the children, who sat at the kitchen table drawing pictures of dreadful massacres and headless warriors in their notebooks. Julie, in Paris, worryingly scanned the newspapers for notices

– 'tell her to ignore them', Pissarro wrote helplessly to Lucien. She returned unenlightened as to the mysteries of how dealers made money out of art. Her son Georges's drawings now showed her physically attacking Pissarro.

In 1884 the Pissarros moved to Eragny, on the River Epte, on the main route between Paris and Dieppe, a tiny, rural place. Pissarro had discovered the perfect house, with a small garden with acacias and weeping willows. There was even a yard with a rabbit run, henhouse and pigeon-cot. When he discovered it, after much searching, he told Lucien he had found 'a garden of Eden'. Lucien was painting in Paris, where he had met two young painters fired up with new ideas about the science of colour. He introduced Paul Signac and Paul Seurat to his father, and Pissarro began to incorporate these new *pointilliste* techniques into his own work.

Cézanne was in Aix with Hortense, painting still lifes – apples, oranges and peaches. 'When I use paint to outline the skin of a beautiful peach,' he told friends, 'or the melancholy of an old apple, I catch a glimpse, in their reflections, of . . . their love of the sun; their memories of dew and freshness.' He explained these feelings by saying he wished to become 'classical again, through nature.'

In these years, Monet, having settled Alice and the children in Giverny, had been painting in the South of France and in Italy, where the colours of Bordighera dazzled him, especially an 'extraordinary, untranslatable pink'. In December 1883 he had travelled with Renoir to the Mediterranean, exploring the mountain roads of Cagnes, and journeying on to Italy, where they were both ravished by the dark light which made the olive trees misty grey. They discovered Bordighera together, and in the New Year of 1884 Monet returned there alone, wanting to work without interruption. Back in Giverny, he still yearned for the sea. In 1886 he was in Brittany, at Belle-Ile-en Mer, just opposite the Morbihan coast, painting the *Pyramides* – the great, pointed cliffs which jut straight up from the middle of the ocean.

In Paris that year, the remaining members of the original group were about to mount an exhibition in the Restaurant de la Maison Dorée, famous for its massive gilded cast iron balcony and clientele of publishers, theatrical people and literati. Just across the street, in the boulevard des Italiens, was the Café Tortini, one of Manet's old haunts, famous for its apéritifs, outdoor terrace, three-stepped perron, and clientele of elegant boulevardiers. This would effectively be the eighth and last exhibition organised by the impressionists themselves. Of the usual group, only four – Degas, Pissarro, Mary Cassatt and Berthe Morisot – participated. With the exception of Mary Cassatt, the painters of Paris had no comprehension

of what Durand-Ruel was attempting to achieve by exhibiting in New York. When Monet got word of Durand-Ruel's plans, he was furious. If Durand-Ruel had so many paintings to exhibit, why on earth didn't he simply show them in his own country? He, Monet, had been complaining for months that the few paintings Durand-Ruel did purchase were simply hidden away. 'What's the use of our painting pictures if the public never gets to see them?' Taking them to America seemed to him tantamount to removing them completely from the public eye. 'If you take them away to America,' he complained, 'it's me who's going to be losing out over here.' To most Parisians in the 1880s, life on the other side of the Atlantic was another world.

★

Paul and Charles Durand-Ruel arrived in New York on 18 March 1886. They made their way by horse and cart along Madison Avenue to the American Art Association's well-known galleries on the south side of Madison Square, described in gallery publicity as 'the finest and best adapted for the purposes to be found in America'. Arguing that the Association's purposes were primarily educational (as opposed to commercial), Durand-Ruel had negotiated his way through customs and succeeded in getting forty-three cases of 300 paintings into America duty-free, as temporary imports. This, at a time when the high tariff on imported works of art was a major, and prohibitive, concern among American collectors, was no mean feat. James Sutton supported him and the Association agreed to cover all the exhibition costs – shipping, insurance and publicity – against commission on any works sold. For three weeks, before the exhibition opened on 10 April, Paul and Charles (the *génie des affaires*, according to his father) supervised the hanging of 300 pictures by the French impressionists, valued at $81,799.

On 10 April, collectors, dealers and an intrigued American public arrived in Madison Square. The catalogue – listing the works shown, followed by extracts from earlier French reviews – was entitled simply, *Works in Oil and Pastel by the Impressionists of Paris*. For the first time, an American audience saw the works of the impressionists: all members of the original group excluding Cézanne, and including one woman, Berthe Morisot. The exhibition, which spanned five large rooms (Galleries A to E), included fifteen works by Sisley; seventeen by Manet; twenty-three by Degas; thirty-eight by Renoir; forty-two by Pissarro and forty-eight by Monet. Viewers could little have suspected the extent to which every picture told a story. But unlike Parisian audiences twenty years earlier, the New York viewers were not here to laugh or sneer. They looked with

discernment and with open minds at works of art that were unusual, even perhaps rebellious. They saw pictures painted with talent and passion. The *New York Tribune* praised works of beauty surpassing anything by Rousseau or Corot. There was none of the ferocious uproar the impressionists had initially aroused in their own country. The luxurious rooms in Madison Square were quiet, as viewers looked thoughtfully at paintings and pastels which represented two and a half decades of dedication and struggle. Among them was Edouard Manet's *Boy With Sword* (*c.* 1860–1), which Durand-Ruel had first purchased in 1872. Léon, aged about eight or nine, holds an enormous, heavy sword, its strap reaching from his waist to beneath his shins. He holds the sword tight, his elegant posture compromised only by the weight of the thing, his fingers pink from the effort of posing with it. Under the spell of Vélazquez, Manet, the charismatic *boulevardier* without whom the impressionists, different though their concerns were from his, could not have survived as a group, was here immortalising the young son for whose sake he kept silence all his life. Léon's feet, like his father's, are elegant and eloquent in laced ankle boots; the trusting face, pale, with blue eyes and small mouth, like his mother's, is open and serious. He is doing his job as a model with poise and concentration, his face, brightly lit, raised unsmiling to meet the gaze of the artist, his father.

Also in Gallery A was Manet's *Le Buveur de l'absinthe*, the painting rejected two decades earlier by the Salon, when it had sparked rumours that the artist of such dissolute subjects must himself be a greasy-haired, good-for-nothing bohemian. When journalists had tracked him down, they had discovered him in a lavish studio in which the rich and famous, in top hats, Worth dresses and hats decorated with feathers and flowers, had gathered to watch the artist at work. *Le Buveur de l'absinthe* now hung in New York, alongside the painting which had reinstated Manet's Salon reputation: *Le Balcon*, in which Berthe Morisot appeared, dark and mysterious, a quintessentially modern *femme fatale*. In the same room hung Manet's portraits of Faure and Rochefort; and one of the finest examples of his still life painting, *The Salmon*, catalogued as *Nature morte* (c. 1868–69). This was the work he had referred to twenty years earlier, as he enthusiastically gave the young Eva Gonzales her lesson in still life painting. Arranged on a white cloth, with lemons modelled in quick, bright daubs of acid yellow, the scales of the salmon are little silver pearls against tactile pink flesh, newly carved. In Gallery E was *Lola de Valence*, his early portrait of the Spanish prima ballerina. In the catalogue of the American Art Association exhibition it was mistakenly attributed – in an ironic, unintentional reminder of the early days of Impressionism – to Monet.

Berthe Morisot's works included *Peasant Hanging the Washing*, one of her early paintings of the *banlieues* of Paris, souvenir of a particular aspect and phase of Haussmann's massive project to redesign the city. It depicts the small, enclosed gardens of the newly built villas of Chatou, Bougival and Gennevilliers, as people began to make their lives outside the capital, planting vegetables in their gardens and hanging out their laundry to dry in the summer breeze.

In the two and a half years since Manet's death in 1883, Berthe had been struggling to come to terms with her grief. She distracted herself by organising children's parties for Julie in her smart new home in the rue Villejust, where she also began to give dinners for painters and writers including Mallarmé, Degas, Renoir and Monet. With Eugène, she tended Edouard Manet's grave; and they bought a plot beside it so that eventually Eugène might be buried alongside his brother. When Edouard Manet died, something died in her too; she told Edma she was devastated; his charm had been such that she had somehow imagined him immortal. She remained loyal to the cause of the impressionists, and by 1886 was one of three remaining members of the original group. While they exhibited in Paris for the last time as a group, Durand-Ruel, in New York, was exhibiting six of her works. She appeared in the catalogue as Berthe Morizot. Her works (in Gallery C) included *In the Garden*, one of the gentle, sunlit portrayals of her garden at Bougival, its long grass and lush foliage evoked in her distinctive, loosely applied diagonal brush strokes, and *Marine View*, a souvenir of the scene of her betrothal to Eugène Manet.

Edgar Degas's *Danseuse* (in many variants) hung throughout the American Art Association's rooms: his paintings of dancers alone and in groups, in the wings and on stage, included *Chorus d'opéra* and *Behind the Wings*. Again and again, from his vantage point in the wings of the Paris Opéra, Degas had painted the *petits rats*, in a flickering haze of pink and red gauze, as they appeared on stage by gaslight, their young bodies primed and stretched, shimmering in moving particles of colour. The painter, tantalised at an early age by his exotic mother with ruffled skirts and a rose in her belt, had shown rigorous determination in his efforts to bring alive in paint something ephemeral in women. During his early trip to New Orleans he had seen in the women of the deep South a primal quality, which influenced his work from then onwards. The hot colours had made him yearn to return to the coolness of the laundresses whom he painted without sentiment, capturing the musculature of their arms and shoulders as they worked their heavy steam irons across swathes of resistant fabric. The New York public also saw *Washerwomen*, an example

of his depictions of the working women for whom he had felt such nostalgia.

Degas's was a strange, solitary life, as he moved uncomplainingly to successively smaller apartments until, in 21, rue Pigalle (where he lived from the mid-1880s onwards) he was reduced to using his studio as his dressing room: the dusty attic the models posed in was hung with his own dressing gowns and other clothes. 'Your studio is so peculiar,' commented Ludovic Halévy's wife Louise when she visited him, troubled by the muddle of his domestic space. 'Do remove your dressing-room from your picture gallery. It spoils the whole thing.' 'Oh, it doesn't worry me,' replied Degas. 'It's convenient where it is . . . I tell myself, "this is the life of a worker."' The years leading up to the exhibition in New York had been desolate ones for him. As he approached fifty, he began to seriously regret his lack of family, acutely aware of his increasing loneliness. Ageing made him feel somehow inauthentic. 'Even this heart of mine has something artificial,' he complained to Bartholomé. 'The dancers have sewn it into a pink satin bag, slightly faded pink satin, like their ballet shoes.' He began to write poetry, complaining to Stéphane Mallarmé that he could not understand his difficulties with sonnets, since he was not short of ideas. 'But Degas,' replied Mallarmé, 'you do not write poetry with ideas, you write it with words.' Degas's third sonnet was dedicated to Mary Cassatt, the fellow artist who had raised his spirits, despite all his personal difficulties, and renewed his creative energy. In Gallery B of the Art Association's rooms hung *Visit to the Museum*, his wittiest and most affectionate testimony to her.

None of Cassatt's own works were exhibited in New York – or at least, if they were, they did not appear in the catalogue. In the three years following Lydia's death, Mary had found it difficult to concentrate on her painting. She distracted herself with domestic tasks, and in spring 1885 was busy appointing a Parisian maid for her sister-in-law Lois, and with assembling Lois's spring wardrobe. In May, Lois's maid was finally packed off to Le Havre, where she boarded the *Normandie* bound for Pennsylvania accompanied by a hat box containing a concoction the height of which was 'mild for Paris' and a large trunk of newly tailored *couture*. Mary now threw herself with relief into the organisation of the exhibition at the Restaurant de la Maison Dorée.

For the eighth and last time, the public came to laugh and jeer, particularly at Degas's recent paintings of women in tubs, twisted into contortions as they performed their ablutions, which the critics found shocking and awesome. Alfred Stevens could hardly believe his eyes. He dashed through the turnstile throwing gold coins at it, too impatient to

wait for his change, as he ushered people excitedly through to see the impressionists' scandalous new work. George Moore went into the room devoted to the pointillistes (Seurat, Signac and Lucien Pissarro) and found at least ten pictures of yachts in full sail, 'all unrelieved by any attempt at atmospheric effect, all painted in a series of little dots!'

In New York, Durand-Ruel's American audience were also seeing work by the young pointillistes, as well as paintings by the venerable 'father' of impressionism, and fourth remaining member of the original group, Camille Pissarro (now in his fifty-fifth year). Among his works on display at the American Art Association were *Country Woman in the Field*; *Potato Gatherers*; *Peasants at Work*, and *Route de Pontoise*. Until he discovered Eragny, Pontoise was the place Pissarro loved best: the small, medieval town on the banks of the Oise with working windmills, orchards sparkling with blossom in springtime and hillside terraces rich with tangled foliage, dotted here and there with distinctive red roofs. For the Portuguese Jew from the West Indies, brought up under the blazing sun, the pale, watery, changeable skies of the Seine-et-Oise were endlessly fascinating. To the end of his days a committed socialist, determined to live by his own labours and to survive on the fruits of the land, he was endlessly mocked for his subtle, imaginative interpretations of colour, shifting perspectives and cropped glimpses of the landscapes he loved. Loyal husband to the volatile Julie and a devoted father, he had also rescued Cézanne from despair, endeavoured to help Gauguin, and encouraged his son Lucien to paint despite his mother's desperate exhortations that he go out and earn an honest wage. Now, in 1886, he was learning new techniques from the younger generation. In Paris, he could still be found sitting in a corner of the Nouvelle Athènes, talking and listening to the new generation of painters.

Some of Pissarro's more recent work was also on show, including *View of Rouen*. In summer 1883 he had gone there to work, lodging with his old friend Murer, who had opened a hotel there (where he exhibited his impressionist collection daily between ten and six, 'free of charge'). They were joined by Gauguin, who asked the Pissarros not to consider moving there, for if they did so Pissarro would be sure to corner the market. Julie was incredulous. 'What is this Gauguin to us that we have to stay away from Rouen because he's there?' Pissarro had remained friends with Gauguin despite his dawning realisation that they were not really temperamentally compatible, but he was unimpressed by this show of disloyalty. 'At last,' he admitted to Lucien, 'I realise my poor friend Gauguin is . . . more naïve than I thought.' In October Monet had arrived, with Durand-Ruel. They took Pissarro off to Canteleu, a village

high on a hill near Deville, where they visited Monet's brother Léon. 'We saw the most wonderful landscapes a painter could possibly dream of,' Pissarro told Lucien: 'a view of Rouen in the distance, with a section of the Seine, as smooth as a mirror . . . quite magical.' When Monet and Durand-Ruel left, Pissarro went off by himself along the coast, painting the cliffs at Petit-Dalles. He returned full of ideas, and with a new serenity.

Of all the young painters this honest and generous man had helped and encouraged, perhaps the most notable was Paul Cézanne, whose style Pissarro had transformed, enabling Cézanne to conquer his inner demons and to take his subjects from the world around him. But Cézanne, who had struggled in vain for recognition, also evidently went unrepresented in New York. If you go to Auvers today, where Cézanne lived and painted with Pissarro close by, you can see the church Van Gogh painted, and Dr Gachet's house. The House of the Hanged Man is still standing, and you can recognise it from Cézanne's painting, but nothing survives from Cézanne's domestic life here. His old friend Guillaumin was represented in the American Art Association exhibition by a number of landscapes, as were newcomers Paul Signac and Paul Seurat, whose *Sunday Afternoon on the Island of Grande Jatte* hung in Gallery C. But of Cézanne there was apparently no trace. His reputation was yet to be made, when in Paris in the 1890s he was 'discovered' by Ambroise Vollard, a young dealer who had begun to buy works by Renoir and Degas.

Gustave Caillebotte was represented in New York by a number of works, including *Portrait of a Gentleman, The Rowers,* and *The Floor Strippers* (1876). That exemplary demonstration of his skill served to introduce the American public to the vastly underrated talents of this superlative draughtsman in paint. For more than a decade he had supported the impressionists' ventures, putting up money for exhibitions and paying their bills (especially Monet's) time and time again. His paintings of his brother's piano, of furniture and floorboards show a deep understanding of the texture and rhythms of wood, with which he lived closely as a yachtsman and boatbuilder. The variations in surface, its absorbency, the way it catches the light, and the comparison between its rhythms and the contrasting stillness of concrete and stone, the dryness of tapestries and silks, are evidenced in many of Caillebotte's works. A shy, retiring, restrained man, he appeared to retreat increasingly into his private life. His disputes with Degas finally wore away his patience and he gradually ceased exhibiting with the group.

He continued to paint the Petit Bras at Argenteuil, the secluded reach where the arm of the river encircled a small island where boats were

moored, where he and Monet had first met, endlessly fascinated by the changing reflections of light on water. Still essentially engaged with the struggles of *plein-air* painting, he went on painting the yachts, their sails sheafs of white against the river's reflections; and the changing landscape of steel constructions against the sky. In his garden at Petit-Gennevilliers he painted flowers in vibrant reds and pinks, and Charlotte in her straw hat, tending roses with her little dog at her feet. Charlotte never played a part in his Parisian social life, but he introduced her to Renoir and Aline, who visited them at Petit-Gennevilliers. Aline and Charlotte were very fond of each other. Renoir later told his son Jean, 'she amused Aline by the languid way in which she voiced her disappointments in a tone of comic resignation: "We had very poor seats for the opening of *The Power of Darkness*. Fortunately the play bored us to death".'

Among the thirty-eight paintings by Auguste Renoir on show at the American Art Association was *Portrait de Mlle Savaray*, his ravishing portrait of the actress who modelled for him in Montmartre. The American audiences also saw *A Box at the Opéra*, his painting of a girl in a blue dress, expectantly watching the stage, and *Au Cirque*, his depiction of the troupe which came to perform in Montmartre. The vibrant colours and dappled sunlight, gaudy dresses and glimpses of trees in full leaf celebrated in that painting revealed nothing of the abject, rundown poverty behind the scenes. But the joy and cheerfulness of the people of Montmartre were some of Renoir's greatest subjects. The Moulin and the Cirque Fernando (also immortalised by Degas) would always remind him of the blazing summer of 1876, and of his daily walks down the hill from his lodgings in the rue Cortot (now the Musée Montmartre) with his friend Georges Rivière, lugging the huge canvas between them.

In 1885, when Renoir was forty-four, his first child, Pierre was born, and the new family moved from the cramped lodgings in the rue de Saint-Georges to a spacious apartment in the rue Houdon, still in Montmartre, with four rooms and a large kitchen. He painted in a nearby studio (that way, he said, the baby could cry to his heart's content). Aline had changed Renoir's life, and the birth of the baby brought him complete joy. Once Pierre was born, Aline retreated contentedly into a life of domesticity and was almost never seen in public. When Julie Manet met her some years later, she was amazed: she had met Renoir a number of times without realising Aline existed. In January 1886, Berthe Morisot paid a rare visit to Renoir's studio. She saw on his easel a red pencil and chalk drawing of a young mother nursing her child. 'As I admired it,' she recorded in her journal, 'he showed me a whole series done from the same model and with the same sort of rhythm. He is a draughtsman of the first order; it

would be interesting to show all these preparatory studies for a painting to the public, which generally imagines that the impressionists work in a very casual way. I do not think it possible to go further in the rendering of form.'

*Effect of Snow at Marly* and *Rue de Marly in Winter* were among the fifteen works exhibited in New York by Alfred Sisley – his snowscapes were masterpieces of reflected light. Given his fascination with the Machine de Marly, the *abreuvoir*, the aqueduct and other industrial forms looming high against the sky, it is tempting to wonder what he would have made of the Manhattan skyline. While his work was being exhibited in New York, Sisley was living in Moret-sur-Loing, one of the small villages bordering the forest of Fontainebleau. In the 1870s he had moved, first from Louveciennes to Marly, then to Sèvres; and had finally been forced by his straitened circumstances to come full circle, back to the place where the impressionists had first started painting in the open air. But Marly seems to have been the place he loved best. Durand-Ruel never gave up attempting to find purchasers for Sisley's work, and Caillebotte continued to buy his sketches, but by 1886 Sisley was entirely disillusioned. He had lost touch with the other painters and lived quietly with his family, painting the village streets, church and mill at Moret, fascinated by the construction of the weir, and the bridge over the Loing.

Of all the works exhibited by Durand-Ruel in America, those that received the most attention were the forty-eight works by Claude Monet, including *The Setting Sun*. His *Impression: Sunrise* had shocked Paris when it was first exhibited there in 1874. That painting had introduced experimental talent and artistic originality of a kind that had never been seen before. Also represented in New York were Monet's paintings catalogued as *Poppies in Bloom*, of the poppy fields of Vétheuil and earlier of Argenteuil, in which Camille and six-year-old Jean seem to emerge from a haze of sheer, rhythmical red. This audience was too early to see Monet's *Water Lilies* (which he began more than ten years later, in 1899), but they saw his paintings of the Petit Bras at Argenteuil (catalogued as *The Seine at Argenteuil*), depicting shimmering light on the waters of the Seine, its surfaces in constant motion. Also there were some of his recent landscapes, including those of Pourville, Bordighera and Giverny, and *Vue de Vétheuil*, in which blues, mauves and oranges create complex depictions of colour which are almost abstractions. In summer 1886, while Durand-Ruel was in New York, Monet was still in Belle-Ile-en-Mer, a terrible, sinister place, he told Alice, but very beautiful – 'it seduced me from the moment I arrived'. The sea there was 'an unheard-of colour' – deep,

turbulent ripples of purple, turquoise and blue, which drew down reflections of red from the sky. He had already decided that if he produced six good paintings as a result of this trip, Durand-Ruel would be entitled to only three.

<div align="center">★</div>

The New York press continued to take an interest in the show. Reviews went on appearing: they were varied, uneven but thoughtful. The *Sun* reviewer thought that on the evidence of these works, Degas painted badly; but that he also clearly had the capacity to paint well. The *Express* announced that Renoir painted like a bad pupil; the *New York Mail* compared him with Leonardo. On the whole, the American public remained engaged and curious. Sales, though not sufficiently dramatic to immediately reverse Durand-Ruel's fortunes (let alone those of the painters) were sufficiently encouraging to raise the hackles of conservative collectors who started to become uneasy about the unexpected attention Durand-Ruel was receiving. They began to lobby for the imposition of a tax of 30 per cent tax on all foreign paintings. To avoid these duties, on 25 May James Sutton and Durand-Ruel moved the exhibition to the vast, newly refurbished galleries of the National Academy of Design, at the corner of 23rd Street, between Madison and Park Avenues. Though still under the auspices of the American Art Association, just across the street, its credentials, unlike those of the Art Association, were indisputably educational, which meant that the exhibition would be exempt from commercial taxes. It was an auspicious venue: the vast, pale building with its Venetian Gothic façade was an eye-catching example of modern architecture. It had also begun to transform the marketing of contemporary American art in New York, since the Academy now hosted evening receptions, where artists could entertain friends, clients and potential purchasers. There, with twenty-one additional impressionist paintings, lent principally by Alexander Cassatt, Durand-Ruel exhibited for another month, and sold some $18,000 worth of pictures. The additional paintings included *Répétition de Danse*, the painting Louisine Elder (now Mrs Henry Havemeyer) had been persuaded by Mary Cassatt to buy when the two young women first discovered Degas's work in Durand-Ruel's gallery in Pigalle.

Henry Havemeyer also lent pictures for the continuation of the show. The day after it opened at the American Art Association, Louisine gave birth to her second child, so she was unable to go in person. She sent Henry to the National Academy of Design in her place and asked him, if

he saw any, to buy her a Manet. He purchased *The Salmon*, which he thought 'very fine', but told her, 'I must confess the *Boy with Sword* was too much for me.' Even in 1886, fifteen years after the painting was first exhibited, it was still difficult, as Louisine later explained, to understand 'Manet's method of modelling in light'.

★

When Durand-Ruel sent word that he was on his way back to Paris, Renoir wrote to assure him that he hoped to be the first to shake his hand. Durand-Ruel arrived back in his galleries in Pigalle encouraged by his successes. When Monet returned from Belle-Ile, Durand-Ruel went straight to Giverny, following up his visit with a written promise of 1,000 francs, and the suggestion that they should now do business on a cash basis. Monet dismissively returned the note. Almost immediately, Durand-Ruel set about organising another exhibition in Manhattan. There followed a complex and protracted tax controversy, eventually resolved only by the decision to allow him to exhibit, but not sell, in New York. To avoid paying heavy duties, any purchaser would be obliged to ship the work back to Paris; then re-ship it, if necessary back to New York. For this second exhibition, Durand-Ruel included along with the impressionists established artists such as Boudin, Courbet and Delacroix. This show received serious attention from reviewers. The *Collector* singled out Manet's *Death of Maximilian*, 'powerful and awful for its inspiring sentiment and its very desperate defiance of every tradition of painting'.

Durand-Ruel's fortune would never be assured, however, while the rule still applied that after the exhibition, all works had to be shipped back to France. It was for this reason that in 1888 he returned to New York, and opened, in an apartment at 297, Fifth Avenue, the first Durand-Ruel gallery in America. He kept his two galleries in Paris, and for the next few years travelled back and forth across the Atlantic, setting up his New York operation. Once it was established, he turned over the management to his three sons, Joseph, Charles and Georges, while he stayed in Paris and continued to run his galleries in Pigalle. Edmond de Goncourt visited his Batignolles apartment in 1892, and found him, after all his struggles, in 'a surprising home for a nineteenth-century picture dealer. A huge apartment in the rue de Rome, full of pictures by Renoir, Monet, Degas, etc., with a bedroom with a crucifix at the head of the bed, and a dining room where a table is laid for eighteen people and where each guest has before him a Pandean pipe of six wine glasses. Geffroy tells me the table of impressionist art is laid like that every day.' By the time the

impressionists made his fortune, Durand-Ruel was sixty-one. 'If I had died at sixty,' he remarked in his memoirs, 'I'd have died with crippling debts amidst a pile of unsung treasures.'

# EPILOGUE

I N THE LATE 1880S, THE Paris art scene changed completely. Newcomers established themselves: Seurat, Signac, Gauguin, Toulouse-Lautrec, Van Gogh. The *fin-de-siècle* was approaching. The impressionists lived out the rest of their lives in relative prosperity, though their artistic struggles continued.

*Caillebotte* died in 1894, aged forty-two, from a cerebral haemorrhage – the untimely death he had always dreaded. His death reactivated the impressionist controversy. His legacy included paintings by the entire group, with the exception of Cassatt and Morisot. Renoir, Mallarmé and Théodore Duret, seeing that this would exclude Morisot from ensuing museum collections, pulled strings, and her *Woman at a Ball* was purchased by the state.

*Morisot* became a widow in 1892. When Eugène died, her hair turned white overnight, and her health rapidly deteriorated. She left her home and moved with her daughter Julie to a smaller home, where she continued painting. In January 1895, Julie fell ill with flu. Nursing her, Morisot became ill herself. She died in February. When he heard the news of her death, Renoir, painting in Cagnes, downed tools and rushed to Paris. Berthe had asked that he and Mallarmé should both take care of Julie. After her death, Berthe's reputation dwindled for nearly a century, until feminist art historians rediscovered her work, now often exhibited in Paris at the Musée Marmottan, alongside Monet's.

*Sisley* never completely came to terms with the impressionists' sustained lack of public recognition. After the failure of his father's business in the early 1870s, he managed to remain cheerful to strangers, while privately succumbing to chronic depression. Once he settled, in the early 1880s, in Moret-sur-Loing, he more or less lost touch with the other impressionists. In the 1890s, Eugénie was suffering from cancer of the tongue, and he retreated from social life to take care of her. While nursing her, he discovered that he himself was suffering from cancer of the throat. On his deathbed, he called for Monet, who travelled to Moret to hear his dying

wish, that he should take over the care of Sisley's two children. Sisley died
in January 1899. Discovering his old friend's children in poverty, Monet
immediately organised a benefit auction at Georges Petit's. It was held in
May 1899, in two parts: the first for the sale of Sisley's own works, and the
second for works of the original group. The sale was a huge success,
providing Jeanne and Pierre Sisley with over 145,000 francs.

*Pissarro* achieved recognition in his lifetime, though he made nothing
of it. In 1903, he sold two paintings to the Louvre. He continued to feel
that the impressionists were 'far from being understood'. In his final year,
he experienced a huge burst of creative energy, completing fifty-seven oils
and gouaches, before his health began to fail. Convinced that Durand-
Ruel had set his prices too low, Pissarro spent his last months feeling that
he was painting just to pander to the tastes of collectors. He died in
November 1903. His son Lucien also became a successful and celebrated
painter.

*Cézanne* married Hortense in April 1886. When his father died six
months later, he inherited the Jas de Bouffan. In 1906 he was among the
celebrated crowd at the Bibliothèque Méjanes in Aix-en-Provence, for
the unveiling of a bust of Zola, who died in September 1902. When
Zola's friendship with him was publicly alluded to, he was reduced to
tears. He had broken off his friendship with Zola in 1886, when the
writer published *L'Oeuvre*, a novel about a volatile and unsuccessful
painter who many presumed to be based on Cézanne. Having coldly
acknowledged receipt of his copy of the book, he never spoke to Zola
again. When he heard the news of Zola's death, Cézanne was racked
with grief. In the final months of his own life, he told his son, 'as a painter
I am beginning to see more clearly how to work from nature . . . But I
still can't do justice to the intensity unfolding before my senses.' To
Renoir, he confided that 'it took me forty years to discover that painting
is not sculpture'. Hortense told Henri Matisse, 'you see, Cézanne never
knew what he was doing . . . Renoir and Monet, they knew their craft.'
Cézanne died in 1906.

*Degas* continued to explore new directions, though his eyesight was
deteriorating. In 1895 he bought a camera and began to take photographs
of models, dancers and friends, as well as of mirrored reflections and 'the
atmosphere of lamps or moonlight'. In 1893, at Henri Rouart's home, he
met Paul Valéry, and introduced him to Jeannie Gobillard, daughter of
Yves, Berthe Morisot's sister. In 1900 Valéry and Jeannie married, in a
joint ceremony with Julie Manet and Henri Rouart's son Ernest. By then
he had moved to 37, rue Victor Massée, where he was seen every day
strolling through the streets in top hat and cane, an ageing, partially

sighted *flâneur.* By 1897 he was looking at his drawings through a magnifying glass, and unable to read. In 1898 he exhibited paintings of dancers at Durand-Ruel's gallery in Paris. Valéry called them 'outright marvels – dancers from some other, extraordinary planet.' In 1907, his friend Ludovic Halévy's son Daniel read to him from Antonin Proust's newly published recollections of Manet. '*What a fate!,*' sighed Degas. 'To be handed over to writers!' He died ten years later, in 1917.

*Renoir,* in his forties, had three sons. Initially, he bought a house at Essoyes, in Burgundy, Aline's native home. But he had begun to suffer from creeping arthritis, which made him move every winter to the warm southern climate of Cagnes, in the mountains above Nice. He made his home there in 1903, when he discovered an old farmhouse set in an olive grove, and he lived out the rest of his days in Cagnes, painting in the warm southern light, in a studio in the garden. Aline died in 1915. In his last years, Renoir had to be lifted by servants and his sons into a sedan chair and carried to his wheelchair, his arthritic hands bandaged to prevent sores, and have his brushes placed between his fingers. He died in 1919, paralysed by arthritis. On the day he died he was still painting. He gave up his paintbrush with the words, 'I think I am beginning to understand something about it.'

*Monet* settled at Giverny, painting his haystack, poplar and cathedral series, all of which sold immediately for high prices. In 1889 he exhibited jointly with Rodin at Georges Petit's gallery. He created his garden, and in 1890 purchased his house and extended the grounds, constructing his water gardens and lily ponds, building a collection of Japanese art and converting the place into the riot of colour and beauty it has been restored to today. By 1908 he was still protesting, 'It's quite beyond my powers at my age, and yet I want to succeed in expressing what I feel.' After Hoschedé died in 1891, Monet married Alice, quietly and unexpectedly, on 16 July 1892. In 1912 he told Gustave Geffroy, 'no, I am not a great painter.' Monet died in 1926.

*Cassatt* was given two one-woman shows at Durand-Ruel's gallery, in 1891 and (a much larger show) in 1893. In 1895, Durand-Ruel organised a Cassatt exhibition in New York, where she showed fifty-eight works. Unmarried and childless, she continued to please her public with paintings and etchings of mothers and children. In her final years, like Monet and Degas, she struggled with failing sight. From 1914 to 1918 she lived in Grasse, on the Riviera, and often visited Renoir. She died in 1926.

*Durand-Ruel* established the worldwide reputations of the impressionists. His New York gallery enabled him to broaden the scope of his operation and, little by little, to overcome his financial difficulties. During the 1890s

he succeeded in augmenting not only the credibility of the impressionists, but the prices realised by their paintings. He continued to purchase their works, and those of their successors, including Lucien Pissarro, Signac and Seurat. He exhibited Gauguin in 1893; Odilon Redon in 1894; Toulouse-Lautrec in 1902. (That year, he also regained exclusive rights to Camille Pissarro's works.) Following his success in America, Durand-Ruel exhibited internationally, in London, Stockholm and Berlin. On his death, Monet, sole survivor of the original impressionist group, told Joseph Durand-Ruel, 'I can never forget everything my friends and I owe your dear father.' Paul Durand-Ruel died in 1922.

# THE IMPRESSIONIST MARKET

THE OPENING OF DURAND-RUEL'S gallery in New York marked the beginning of the impressionists' popularity in America. In Britain, impressionist works were slow to appreciate in value, despite their exposure by Durand-Ruel in London during the painters' lifetimes. The Davies sisters in Cardiff collected impressionist works, and bequeathed them to the National Museum of Wales, but in the 1920s the Tate declined the opportunity to purchase any. In America and France, however, the impressionist market steadily flourished. The galleries of the Metropolitan Museum of Art in New York, and the Louvre and Jeu de Paume in Paris began to fill up with impressionist works. In 1987, the collections of the Louvre and Jeu de Paume were collated and rehoused in the newly opened Musée d'Orsay, where impressionist works now occupy an entire floor of the museum.

It was not until the 1970s that impressionism began to make an impact in Britain. Prices began to escalate. During the 1970s, Degas's *After the Bath* sold for £141,750. Other impressionist works commanded similar prices. Sotheby's and Christie's sold works by Manet, Monet, Pissarro and Renoir. Monet: *The Wooden Bridge at Argenteuil* sold for £168,000; Renoir: *Jean Renoir Holding a Hoop*, for £194,250.

Prices escalated throughout the 1980s, and the paintings began to sell for sums beyond anyone's wildest dreams.

In February 2002, Christie's 'Impressionist and Modern Art Sale' totalled £42.1 million. The label 'impressionist' is now also loosely applied to the works of the neo-impressionists, and to those of earlier and later painters (Barbizon, Fauviste and Nabis) unconnected with the original group. Major works by the painters who formed the original group now sell for several million pounds each. In November 2005 the *Daily Telegraph* reported that buyers had spent almost £165 million at Christie's and Sotheby's main New York sales, 'Impressionists in New York'. 'Impressionists' included Picasso, Bonnard and Toulouse-Lautrec, but sales of paintings by the original group included one of Monet's

*Water Lilies* series (£7.9 million), Cézanne's *Pommes et Gateaux* (£7.9 million), Monet's *Le Pont Japonais* (£2.9 million) and Berthe Morisot's *Cache-Cache* (£2.9 million).

*Hislop's Art Sales Index 2005* includes the following:

## MANET
*Deux Poires*
£735,294   $1,317,600   €1,073,529
*Berthe Morisot* (print)
£2,000   $3,640   €3,000
*Olympia* (print)
£2,375   $3,800   €3,468

## MONET
*Route à Giverny*
£380,000   $699,200   €554,800
*La Seine à Lavacourt*
£441,176   $750,000   €644,117
*Vétheuil*
£2,450,000   $4,459,000   €3,577,000

## RENOIR
*Forêt de Marly*
£698,324   $1,250,000   €1,019,553
*Les Enfants au Bord de la Mer*
£823,529   $1,400,000   €1,202,352

## PISSARRO
*Jardin à Eragny*
£81,379   $135,090   €118,000
*Etude à Pontoise*
£156,425   $280,000   €228,381

## SISLEY
*Route de Marly-le-Roi*
£1,300,000   $2,379,000   €1,898,000
*Route à Louveciennes*
£1,400,000   $2,548,000   €2,044,000

## MORISOT
*Petite Fille Assise dans L'Herbe*

£44,693    $80,000    €65,252
*Chrysanthemums*
£100,000    $184,000    €146,000

## CASSATT
*Lydia Reading* (works on paper)
£7,821    $14,000    €11,419
*Fitting* (print)
£695,068    $110,616    €95,000

## CÉZANNE
*Nature Morte, Pommes et Poires*
£4,588,235    $7,800,000    €6,698,823

## CAILLEBOTTE
*Voiliers sur la Seine à Argenteuil*
£735,294    $1,250,000    €1,073,529

## DEGAS
*Little Dancer of Fourteen Years* (sculpture)
£4,500,000    $8,190,000    €6,570,000
*Danseuse, Vue de Profil* (works on paper)
£100,000    $182,000    €146,000
*Chevaux de Courses* (paintings)
£3,700,000    $6,734,000    €5,402,000

## BAZILLE
*Pots de Fleurs*
£2,653,631    $4,750,000    €3,874,301

# ACKNOWLEDGEMENTS

Warm thanks for helping to make this book possible and for invaluable ongoing advice and support, to Gill Coleridge and Lucy Luck of Rogers, Coleridge and White, Alison Samuel and Jenny Uglow of Chatto & Windus, Terry Karten of HarperCollins, New York, Melanie Jackson of Melanie Jackson Agency, New York, and to my copy-editor and friend Beth Humphries. Grateful thanks to Rosemary Evison of the National Portrait Gallery, London, and to Beth McIntyre of the National Museum, Wales, for archival assistance, also to Monsieur Christophe Duvivier, Directeur des Musées de Pontoise for generous help with Julie Pissarro's letters, and to Marshall Price, Assistant Curator of the National Academy of Design, New York, for supplying information on the first Impressionist Exhibition in New York. I also benefited greatly from visits to the Musée d'Auvers, Musée Fournaise, Chatou, Musée de la Grenouillère, Croissy-sur-Seine, Musée Eugene Boudin, Honfleur, Musée de l'Ancien Havre, Musée Malraux, Le Havre, Musée de Marly, Marly-le-Roi, Musée Camille Pissarro, Pontoise, Musée Carnavalet, Paris, and the Documents Orsay, Musée d'Orsay, Paris. Louise Murphy gave inimitable and untiring help in Paris and the banlieues and in Trouville and Honfleur, as did Steve Ward in our visits to Chatou and Le Havre. Special thanks to Terence Blacker for inspiring comments, especially on the penultimate draft. I was in grateful receipt of generous support from the Author's Foundation, via the Society of Authors.

# NOTES

Throughout the notes section, where translations from the French are quoted and acknowledged, the exact words of the translation have sometimes been adjusted by the author in the interests of consistency of narrative tone

## PART ONE: The Birth of Impressionism

### 1: Napoleon III's Paris

p. 5     'The Seine' ] Claude Monet, quoted in Karin Sagner-Duchting, *Claude Monet: A Feast for the Eyes* (Cologne: Taschen, 1998), p. 9.

p. 5     'Le Havre, Rouen and Paris' ] Napoleon III, quoted in Pascal Bonafoux, *Au Fil de la Seine* (Paris: Editions de Chène, 1998), p. 1.

p. 5     'a dormant flotilla' ] Emile Zola, *The Masterpiece*, translated from the French, *L'Oeuvre* by Thomas Walton, trans. revised, Roger Pearson (Oxford World's Classics, 1999), p. 4.

p. 6     'nothing but a vast ruin' ] Willet Weeks, *The Man Who Made Paris: The Illustrated Biography of Georges-Eugène Haussmann* (London: London House, 1999), pp. 11–30.

p. 7     'In sumptuous studios, in wretched garrets' ] John Milner, *The Studios of Paris: The Capital of Art in the Late Nineteenth Century* (New Haven and London: Yale University Press, 1988), p. 46.

p. 9     'lying on boards, hands and mouths still dripping' ] *Constable to Delacroix* (exhibition leaflet), London: Tate Britain, February 2003. Théodore Géricault (1791–1824): *The Raft of the Medusa* (1859–60).

p. 11     'we tip it in just before you arrive' ] *Un Siècle de bains de mer dans l'estuaire de la Seine, 1830–1930*, Musée Eugène Boudin, Honfleur, 28 juin–6 octobre, 2003. The cartoon caption reads, 'Est-ce que l'eau de la mer est salée comme ca toute l'année?'

'Oh! Non, ce n'est que trois jours avant que les Parisiens doivent venir que nous la salons!'

p. 11 The shops advertised '10,000 novelties' ] Nineteenth-century photograph of the rue de Paris, Le Havre. Musée de l'Ancien Havre, Le Havre, 2003.

p. 11 'Had I carried on' ] Claude Monet, quoted in Sagner-Duchting, *Claude Monet: A Feast for the Eyes*, p. 10.

p. 13 'Draw from nature during your holidays' ] Ralph E. Shikes and Paula Harper, *Pissarro: His Life and Work* (London, Melbourne and New York: Quartet, 1980), p. 21.

p. 14 'You are surrounded by people' ] Julie Pissarro, *Quatorze Lettres de Julie Pissarro*, Preface d'Edda Maillet (Pontoise: L'Arbre et Les Amis de Camille Pissarro, 1984), unpaginated; Julie Pissarro to 'Cher Monsieur'. (When writing to Pissarro Julie signed her letters, 'ta femme aff Julie', or 'ta f. Julie'. When writing to others, even friends, she signed herself, 'F. Pissarro' – i.e. wife of Pissarro.)

p. 15 'the strange Provencal' ] John Rewald, *Cézanne: A Biography* (The Netherlands: Harry N. Abrams, 1986), p. 38.

p. 16 'What do you consider' ] *Mes Confidences* (c. 1866–9), Bibliothèque Nationale, Paris; reprinted in Adrien Chappuis (ed.), *Cézanne: Catalogue raisonnée* (London: Thames & Hudson, 1973), extracted in Richard Kendall (ed.), *Cézanne by Himself* (London, New York, Sydney and Toronto: Guild Publishing, 1990), pp. 31–3.

p. 16 'Find out about the entrance exam' ] Ibid., p. 23.

p. 17 'I thought when I left Aix' ] Paul Cézanne, quoted in Rewald, *Cézanne: A Biography*, p. 29.

p. 17 'all tastes, all styles' ] Paul Cézanne, quoted in John Rewald, *The Ordeal of Paul Cézanne*, trans. Margaret H. Liebman (London: Phoenix House, 1950), p. 19 [published in the US under the title *Paul Cézanne*].

p. 17 'the sluts are always watching you' ] Paul Cézanne, quoted in Jean Renoir, *Renoir, My Father*, trans. Randolph and Dorothy Weaver (London: Collins, 1962; 1st published, 1958), p. 106.

p. 18 'The banker Cézanne' ] Paul Cézanne, quoted in Rewald, *Cézanne: A Biography*, p. 34.

## 2: The Circle Widens

p. 20 'just remember this' ] Charles Gleyre, quoted in Richard Shone,

*Sisley* (London: Phaidon, 1999; 1st published, 1992), p. 22.

p. 20 'But I don't want to lose my students from the faubourg Saint-Germain' ] Jean Renoir, *Renoir, My Father* (London: Collins, 1962; 1st published, 1958), p. 103.

p. 20 'surrounded by rolls of cloth' ] Auguste Renoir, quoted in Jean Renoir, *Renoir, My Father*, trans. Randolph and Dorothy Weaver (London: Collins, 1962; 1st published, 1958), pp. 27; 102–3; 191.

p. 20 'you always have to be ready to start out' ] Jean Renoir, *Renoir, My Father*, p. 191.

p. 21 'it was with Gleyre that I really learned to paint' ] Auguste Renoir, quoted in Ambroise Vollard, *En Ecoutant Cézanne, Degas, Renoir* (Paris: Bernard Grasset, 2003; 1st published, 1938), p. 214. Compare the attribution in Jean Renoir, *Renoir, My Father*, p. 99: 'a second-rate schoolmaster but a good man'.

p. 21 'Young man' ] Ibid., p. 100.

p. 22 Alfred Sisley ] Sisley was introduced to Gleyre by Frédéric Bazille. See Mary Anne Stevens (ed.), *Sisley* (New Haven and London: Yale University Press, 1992), *Chronology*.

p. 22 'exceedingly well bred' ] Auguste Renoir, quoted in Jean Renoir, *Renoir, My Father*, p. 110.

p. 22 not so much abject as genteel ] Shone, *Sisley*, p. 110. Shone also records, however, that when Sisley's father died in 1879, he left 'almost nothing'. Richard Shone, *Sisley* (London: Phaidon, 1994; first published, 1979), p. 12.

p. 22 'the sort . . . who'd have a valet' ] Jean Renoir, *Renoir, My Father*, p. 96.

p. 23 'A born lord' ] Auguste Renoir, quoted in Jean Renoir, *Renoir, My Father*, p. 103.

p. 23 Pissarro . . . introduced him to Monet, Renoir and Bazille ] Ralph E. Shikes and Paula Harper, *Pissarro: His Life and Work* (London, Melbourne and New York: Quartet, 1980), p. 61: 'Pissarro met the members of the Gleyre group through Monet, . . . in 1863, when Bazille was sharing a studio with Renoir.' Other sources (e.g. *Renoir, My Father*) give the studio as shared by Monet and Renoir. Soon afterwards (in 1864) Bazille took a studio which he shared with Monet and Renoir at various times. Accommodation arrangements varied, since Bazille was in the habit of giving the other painters shelter. It seems certain, however, that the group of friends all met in 1863.

p. 23 'If you like it, you can have it' ] Ibid., pp. 105–7.

p. 24     'a great difference' ] Frédéric Bazille, quoted in Patrice Marandel, François Daulte et al., *Frédéric Bazille and Early Impressionism* (Chicago: The Art Institute of Chicago, 1978), p. 153.

p. 24     'The big classic compositions are finished' ] Frédéric Bazille, quoted in Jean Renoir, *Renoir, My Father*, p. 96.

p. 25     'Certain parts of the forest are truly wonderful' ] Marandel, Daulte et al. *Frédéric Bazille and Early Impressionism*, p. 155.

p. 26     'Good, good' ] Diaz, quoted ibid., pp. 69–70.

p. 26     exotic seventeen-year-old called Lise ] Not to be confused with Lisa, Renoir's sister.

p. 26     'I would find him charming a young lady' ] Auguste Renoir, quoted in Jean Renoir, *Renoir, My Father*, p. 109; also Richard Shone, *Sisley* (1999), p. 39. Jean Renoir thinks the couple in Renoir's *The Engaged Couple* are Sisley and Marie-Eugénie; Shone believes it depicts Sisley posing with Lise Tréhot.

p. 27     'too-handsome Nieuwerkerke' ] Lewis Galantiere (ed.), *The Goncourt Journals, 1851–1870* (London, Toronto, Melbourne and Sydney: Cassell, 1937), p. 349.

p. 27     'The Emperor's Salon' ] See Henri Perruchot, *Manet*, trans. Humphrey Hare (London: Perpetua, 1962; 1st published, Paris, 1959), p. 107. (John Richardson argues, on the other hand, that Napoleon's decision to hold the Salon des Refusés was 'more out of a desire to prove the Salon jury right than out of any desire to display his own liberal feelings'. John Richardson, *Edouard Manet: Paintings and Drawings* (London: Phaidon, 1958), p. 21.)

p. 28     'the sharp and irritating colours' ] Letter from 'Un Bourgeois de Paris' (allegedly, Delacroix though actually Jules Claretie) in *Gazette de France*, May 1863. Quoted in Margaret Shennan, *Berthe Morisot: The First Lady of Impressionism* (Stroud: Sutton Books, 2000; 1st published, 1996), p. 50.

p. 28     the men were modelled by Manet's younger brothers ] Both Eugène and Gustave modelled, alternatively or successively, for the figure facing Victorine; the bearded figure was Suzanne's brother, Ferdinand Leenhoff.

p. 31     distinctive, cracked voice ] Robert Baldick (ed.), *Pages from the Goncourt Journal* (Oxford: Oxford University Press, 1962), p. 206.

p. 31     'the spitfire' ] Jean-Baptiste Faure, published in Louis Hourticq, *Manet*, extracted in Pierre Courthion and Pierre Caller (eds.),

*Portrait of Manet by Himself and His Contemporaries* (London: Cassell, 1960; 1st published, 1953), p. 86.

p. 31   'Don Manet y Courbetos y Zurbaran de las Batignolas' ] Roy McMullen, *Degas, His Life, Times, and Work* (London: Secker & Warburg, 1985), p. 126.

p. 32   Victorine Meurent . . . the Law Courts ] – the popular view. Perruchot believes, however, that Manet met Victorine in the neighbourhood of the rue Maître-Albert, where an artisan did the biting of plates for Manet's etchings. Perruchot, *Manet*, p. 96.

p. 32   'they'd prefer me to do a nude' ] Antonin Proust, quoting Manet, in Françoise Cachin, *Manet*, translated by Emily Read (London: Barrie & Jenkins, 1991) p. 16. Theodore Duret, in *Manet and the French Impressionists*, trans. J. E. Crawford Flitch (New York: Books for Libraries Press, 1971; 1st published, 1910), p. 34, gives the source of the painting as Giorgione, *Concert* [sometimes entitled *Pastoral Symphony*]. Cf. Cachin, *Manet*, p. 17: 'In fact Manet was referring to a painting by Raphael, reproduced as an engraving by Marc-Antoine.'

## 3: Café Life

p. 33   'pinkish and bluish draperies' ] Edgar Degas, extract from Notebooks 22 & 23, quoted in Richard Kendall (ed.), *Degas by Himself: Drawings, Prints, Paintings, Writings* (London: MacDonald Orbis, 1989; 1st published, 1987), p. 37.

p. 34   A real Creole belle ] See Roy McMullen, *Degas: His Life, Times, and Work* (London: Secker & Warburg, 1985), pp. 1–18.

p. 34   'anyone would think' ] Theodore Reff, *The Notebooks of Edgar Degas: A Catalogue of the Thirty-Eight Notebooks in the Bibliothèque Nationale and Other Collections*, I (Oxford: Clarendon Press, 1976), p. 32.

p. 34   'no art was less spontaneous than mine' ] Edgar Degas, quoted in Kendall (ed.), *Degas by Himself*, p. 311.

p. 35   'never had a nose like that' ] Ambroise Vollard, *En Ecoutant Cézanne, Degas, Renoir* (Paris: Bernard Grasset, 2003; 1st published, 1938), p. 149.

p. 35   'Get out, you miserable creature!' ] See McMullen, *Degas: His Life, Times, and Work*, pp. 268–9.

p. 35   'that's a nice painting, dear' ] Vollard, *En Ecoutant Cézanne, Degas, Renoir*, p. 172.

p. 35    'Good Lord, Madame, I wish I had the choice' ] Daniel Halévy, *My Friend Degas*, trans. and ed. Mina Curtiss (London: Rupert Hart-Davis, 1966), p. 47.

p. 35    'The artist must live apart' ] Edgar Degas, quoted in Kendall (ed.), *Degas by Himself*, p. 311.

p. 35    'I'd rather keep a hundred sheep' ] Vollard, *En Ecoutant Cézanne, Degas, Renoir*, p. 149:
*Sans chien et sans houlette*
*J'aimerais mieux garder cent moutons dans un pré*
*Qu'une fillette*
*Dont le cœur a parle*

p. 35    the first version of *Le Déjeuner sur l'herbe* ] See Henri Perruchot, *Manet*, trans. Humphrey Hare (London: Perpetua, 1962; 1st published, Paris, 1959), p. 112.

p. 36    'It always hurts me' ] Frédéric Bazille, quoted in Patrice Marandel, François Daulte et al. (ex. cat.), *Frédéric Bazille and Early Impressionism* (Chicago: The Art Institute of Chicago, 1978), p. 159.

p. 36    'he'll be bringing his *wife*' ] Charles Baudelaire, quoted in Perruchot, *Manet*, p. 118. See Charles Baudelaire, *Correspondance*, II, texte établi, présenté et annoté par Claude Pichois avec la collaboration de Jean Ziegler (Paris: Gallimard, 1973; 1st published, 1966), p. 323: 'Manet Vient de m'annoncer, la nouvelle la plus inattendue. Il part ce soir pour la Hollande d'où il ramenera *sa femme*.'

p. 36    'Koella, Léon Edouard' ] Ibid., pp. 57; 118–19 : 'The child was born on 29 January 1852. Manet merely gave him a Christian name; and an imaginary father was invented. The child was registered under the name of "Koella, Léon Edouard, son of Koella and Suzanne Leenhoff."' Perruchot adds, 'Various attempts have been made to deny that Léon Edouard Koella was Manet's son. They are absurd in view of the established facts' (Source: unpublished notes by Léon Koella and by Manet's mother, Paris: Bibliothèque Nationale, Cabinet des Estampes).

p. 37    a family rumour ] Léon's parentage is discussed at length in Nancy Locke, *Manet and the Family Romance* (Princeton and Oxford: Princeton University Press, 2001). Margaret Shennan, in *Berthe Morisot: The First Lady of Impressionism* (Stroud: Sutton Books, 2000), p. 306 (note 41), speculates on family rumour: a 'distinguished relation by marriage revealed that Judge Manet was Léon's true father'.

p. 37    'You may be interested' ] Frédéric Bazille, quoted in Marandel, Daulte et al., *Frédéric Bazille and Early Impressionism*, p. 162.

p. 38    'This country is paradise' ] Ibid., p. 166.

p. 39    'This Lequet restaurant was my only creditor' ] Ibid., p. 167.

p. 39    'make the Institut blush with rage and despair' ] Paul Cézanne, quoted in Richard Kendall (ed.), *Cézanne by Himself: Drawings, Paintings, Writings* (London, New York, Sydney and Toronto: MacDonald Orbis, 1990; 1st published, 1988), p. 27.

p. 40    'terrible portrait of the Emperor' ] Frédéric Bazille, quoted in Marandel, Daulte et al., *Frédéric Bazille and Early Impressionism*, p. 168.

p. 40    some 5,000 registered prostitutes . . . ] See Perruchot, *Manet*, p. 135.

p. 40    'disquieting significance' ] Ibid.

p. 41    'A vile Odalisque with a yellow belly' ] Alan Krell, *Manet and the Painters of Contemporary Life* (London: Thames & Hudson, 1996), p. 56.

p. 41    Velázquez on the canvas ] Firmin Javel, in *L'Evénement*, 2 May, 1883, quoted in Pierre Courthion and Pierre Cailler (eds.), *Portrait of Manet by Himself and His Contemporaries* (London: Cassell, 1960; 1st published, 1953), p. 86.

p. 41    'Do you think you're the first' ] Charles Baudelaire, *Correspondances*, II, pp.496–7. 'Croyez-vous que vous soyez le premier homme placé dans ce cas? Avez-vous plus de génie que Chateaubriand et que Wagner? On s'est bien moqué d'eux cependant? Ils n'en sont pas morts . . .'

p. 41    'Who is this Monet . . . ?' ] C.P. Weekes, *Camille: A Study of Claude Monet* (London: Sidgwick & Jackson, 1962; 1st published, New York, 1960, as *Invincible Monet*), p. 79.

p. 41    'like the Messiah' ] Frédéric Bazille, quoted in Marandel, Daulte et al., *Frédéric Bazille and Early Impressionism*, pp. 169–72.

p. 42    'I am 300 francs short' ] Ibid., p. 170.

p. 43    'it's practically an *infirmerie* ] Ibid., p. 173.

p. 44    'Dear Mother . . . I am very sorry' ] Ibid., p. 172.

p. 44    'boring beyond measure' ] Paul Cézanne, quoted in Kendall (ed.), *Cézanne by Himself*, p. 29.

p. 44    'What he asks' ] See Jack Lindsay, *Cézanne: His Life and Art* (London: Evelyn, Adams & Mackay, 1969), p. 106.

p. 45    'that window onto nature' ] Emile Zola, quoted in Karin Sagner-Duchting, *Claude Monet: A Feast for the Eyes* (Cologne etc.: Taschen, 1998), p. 31.

p. 45    'Monet or Manet?' ] Weekes, *Camille*, p. 76.

p. 45    'All these *reflets d'eaux* are making my eyes hurt' ] Edgar Degas, quoted in Vollard, *En Ecoutant Degas, Renoir, Cézanne*, p. 161.

p. 45    'powerfully treated' ] Edouard Manet, quoted in John Rewald, *Cézanne: A Biography* (Harry N. Abrams, 1986), pp. 56–7.

p. 46    'a simple bit of road' ] See Ralph E. Shikes and Paula Harper, *Pissarro: His Life and Work* (London, Melbourne and New York: Quartet, 1980), p. 70.

p. 46    'I expect he'll be rejected for another ten years' ] Emile Zola, quoted ibid., pp. 62–4.

## 4: Modelling

p. 48    The *Exposition Universelle* (1867) ] The exhibition is described in detail in Alistair Horne, *The Fall of Paris: The Siege and the Commune, 1870–71* (London: The Reprint Society, 1967), pp. 3–13.

p. 49    'If I were a few years younger' ] Frédéric Bazille, quoted in Patrice Marandel, François Daulte et al. (ex. cat.), *Frédéric Bazille and Early Impressionism* (Chicago: The Art Institute of Chicago, 1978), p. 175.

p. 50    'His family is incredibly stingy with him' ] Ibid.

p. 51    'Then you should have proposed to her' ] Edouard Manet, quoted in Denis Rouart (ed.), newly introduced and edited by Kathleen Adler and Tamar Garb, *The Correspondence of Berthe Morisot, with her Family and Friends* (London: Camden Press, 1986), p. 26.

p. 53    'ornaments for or by women' ] From Degas's Notebooks, quoted in Richard Kendall (ed.), *Degas by Himself: Drawings, Prints, Paintings, Writings* (London: MacDonald Orbis, 1989; 1st published, 1987), p. 37.

p. 53    'sow the seeds of discord' ] Edouard Manet, quoted in Pierre Courthion and Pierre Cailler (eds), *Portrait of Manet by Himself and His Contemporaries* (London: Cassell, 1960; 1st published, 1953), (letter from Manet to Fantin-Latour, 26 August 1868).

p. 54    'All these people may be very amusing' ] Cornélie Morisot, quoted in Rouart (ed.) with Adler and Garb, *The Correspondence of Berthe Morisot*, pp. 33–4.

p. 54    'He begged me to go straight up' ] Berthe Morisot, quoted ibid., pp. 35–6.

p. 55    'I am more strange than ugly' ] Berthe Morisot, ibid., p. 36.

p. 55     'He has tried' ] Ibid., p. 37.

p. 56     'this work you're mourning' ] Berthe Morisot, quoted in Roy
          McMullen, *Degas: His Life, Times and Work* (London: Secker &
          Warburg, 1985), p. 166.

p. 56     Emmanuel Gonzales ] A prolific writer of popular novels and
          successful serials, who from 1863 was President of the *Société des
          Gens de Lettres*, and one of the best-known men in Paris. He was
          descended from a Spanish family ennobled by Charles V (one of
          the dozen Spanish families in the Principality of Monaco).
          Henri Perruchot, *Manet*, trans. Humphrey Hare (London:
          Perpetua, 1962; 1st published, Paris, 1959), pp. 167–8.

p. 56     'Get it down quickly' ] Edouard Manet, quoted in Juliet
          Wilson-Bareau (ed.), *Manet by Himself* (London: Little, Brown,
          2000; 1st published, 1991), p. 52, recorded by Philippe Burty.

p. 57     'he has forgotten about you' ] Cornélie Morisot, quoted Rouart
          (ed.), newly introduced and edited by Adler and Garb, *The
          Correspondence of Berthe Morisot*, p. 43.

p. 57     'I'm so sad' ] Berthe Morisot, quoted ibid., p. 46.

p. 58     2, rue de la Vallée ] Daniel Wildenstein, *Monet, Or the Triumph
          of Impressionism* (Cologne: Taschen and The Wildenstein
          Institute, 1999), p. 78. The exact address is given in Julian More,
          *Impressionist Paris: The Essential Guide to the City of Light*
          (London: Pavilion, 1998), p. 72

p. 58     9, place Ernest Dreux ] The artisans' cottages, including number
          9, are still standing; the Renoirs' is marked by a plaque.

p. 59     La Grenouillère ] Croissy-sur-Seine, Musée de la Grenouillère
          ] See also *Tous au Bain! Plaisirs aquatiques au XIX siècle*, Preface
          par Jean-Louis Ayme (Croissy-sur-Seine: Musée de la
          Grenouillière), p. 22: *Bibliographie*.

p. 59     'brilliant, witty and amusing' ] Jean Renoir, *Renoir, My Father*
          (London: Collins, 1962, 1st published, 1958), p. 187.

p. 60     singing as they handed down the ladies ] Guy de Maupassant,
          'La Femme de Paul', in *Contes divers, 1875–1880*, imaginé et
          dirigé par Dominique Fremy (Paris: Editions Robert Laffont,
          2000), pp. 225–38.

p. 61     '*tendresse exquise*' ] Emile Zola, *Dossier préparatoire: fiche de
          Christine*, Paris: Bibliothèque Nationale.

p. 61     'far more animated and volatile than his paintings suggest' ]
          Gerstl Mack, *Paul Cézanne* (London: Cape, n.d.), pp. 169–73;
          Jack Lindsay, *Cézanne: His Life and Art* (London: Evelyn, Adams
          & Mackay, 1969), pp. 130–1; Laurence Hanson, *Mountain of*

*Victory: A Biography of Paul Cézanne* (London: Secker & Warburg, 1960), pp. 89–90.

p. 62    slumbering peacefully ] Emile Zola, *The Masterpiece* (translated by Thomas Walton, translation revised and introduced by Roger Pearson, *L'Oeuvre*) (Oxford: Oxford World's Classics, 1999), pp. 3–27.

p. 62    'once started, nothing could stop him' ] Berthe Morisot, quoted in Rouart (ed.) newly introduced and edited by Adler and Garb, *The Correspondence of Berthe Morisot*, p. 48.

p. 63    a large painting of his studio ] Frédéric Bazille: *The Studio in the rue de la Condamine*, 1870; Henri Fantin-Latour: *A Studio in the Batignolles*, 1870.

p. 64    'It is really too ridiculous' ] Frédéric Bazille, quoted in Marandel, Daulte et al., *Frédéric Bazille and Early Impressionism*, pp. 179–80.

p. 64    Paul Durand-Ruel ] Durand-Ruel's memoirs are described in Lionello Venturi, *Les Archives de l'impressionisme, I*, pp. 10–12 and quoted in *II*, pp. 143–220 (Paris and New York: Editions Durand-Ruel, 1939) see II, p. 169.

## PART TWO: War

## 5: The Siege

p. 67    'I've no intention of being killed' ] Frédéric Bazille, quoted in Jean-Michel Puydebat (ed.), *Les Impressionistes autour de Paris: tableau de banlieu avec peintres* (ParisAuvers: SEM Château d'Auvers, 1993), p. 16.

p. 67    'No one ever fell out with Manet for long' ] Ambroise Vollard, *En Ecoutant Cézanne, Degas, Renoir* (Paris: Grasset, 2003; 1st published, 1938), pp. 179–80.

p. 67    On the beach ] Claude Monet: *The Beach at Trouville*, 1870.

p. 70    'If the fellow replacing me had been killed' ] Jean Renoir, *Renoir, My Father* (London: Collins, 1962; 1st published, 1958), p. 123.

p. 70    'What is your profession?' ] Ibid., pp. 122–4.

p. 71    'he could see himself galloping' ] Ibid., p. 123.

p. 71    'Montpellier connections' ] Commander Lejosne 'went through fire and water to have me sent to Constantinople': Frédéric Bazille, quoted in J. P. Marandel, F. Daulte et al. (exh.cat.), *Frédéric Bazille and Early Impressionism* (The Art Institute of

Chicago, 1978), pp. 183–8.

p. 71  the Imperial Guard ] The Imperial Guard is described in Michael Howard, *The Franco-Prussian War: The German Invasion of France, 1870–1871* (London: Rupert Hart-Davis, 1971), p. 66.

p. 72  'He would drive an entire regiment mad' ] Cornélie Morisot, quoted in Denis Rouart (ed., newly introduced and edited by Kathleen Adler and Tamar Garb), *The Correspondence of Berthe Morisot with her Family and Friends* (London: Camden Press, 1986), pp. 54–6.

p. 72  'The stories the Manet brothers tell us' ] Ibid., p. 55.

p. 72  a portrait he wryly entitled *Repose* ] Edouard Manet: *Repose, Portrait of Berthe Morisot*, 1870.

p. 73  witnessed both Yves's and Edma's marriages ] Anne Higonnet, *Berthe Morisot: A Biography* (London: Collins, 1990), p. 70.

p. 74  'Down with the Empire! *Dé-ché-ance!*' ] Robert Baldick (ed.), *Pages from the Goncourt Journal* (Oxford: Oxford University Press, 1962), p. 54.

p. 75  'a filthy, greasy lot' ] Frédéric Bazille, quoted in Marandel, Daulte et al., *Frédéric Bazille and Early Impressionism*, p. 185.

p. 75  'the red earth bleeds' ] Emile Zola, quoted in Jack Lindsay, *Cézanne: His Life and Art* (London: Evelyn, Adams & Mackay, 1969), p. 142.

p. 75  'I think we poor Parisians' ] Edouard Manet, quoted in Juliet Wilson-Bareau (ed.), *Manet by Himself* (London: Little, Brown, 2000; 1st published, 1991), pp. 55–7.

p. 76  'Why haven't I had a telegram' ] Ibid., p. 55.

p. 76  'If there were any risk of fire' ] Ibid.

p. 76  Paris was a line of yellow ramparts ] See Baldick (ed.), *Pages from the Goncourt Journals*, p. 173.

p. 76  'We've reached the decisive moment' ] Edouard Manet, quoted in Wilson-Bareau, *Manet by Himself*, p. 57.

p. 77  'Everyone is furious' ] Ibid.

p. 77  'like a shoal of injured whales' ] See Alistair Horne, *The Fall of Paris: The Siege and the Commune, 1870–71* (London: The Reprint Society, 1967), pp. 121–31.

p. 77  'Paris is now a huge camp' ] Edouard Manet, quoted in Juliet Wilson-Bareau, *Manet by Himself*, p. 58.

p. 78  'I spent a long time' ] Ibid., p. 59.

p. 78  'You are not French' ] Rachel Pissarro, quoted in Ralph E. Shikes and Paula Harper, *Pissarro: His Life and Work* (London, Melbourne and New York: Quartet, 1980), p. 87.

p. 79     'The Armistice has just been rejected' ] Edouard Manet, quoted in Wilson-Barreau (ed.), *Manet by Himself*, p. 60.

p. 80     'I long for the day' ] Ibid., p. 61.

p. 80     'The queue for rat meat' ] Cham (pseudonym of Amadee Charles Henri, Count of Noe), *The Queue for Rats' Meat*, December 1870. Victoria and Albert Museum, London.

p. 80     'I don't feel like seeing anyone' ] Edouard Manet, quoted in Wilson-Bareau (ed.), *Manet by Himself*, p. 61.

p. 80     'News like this' ] Frédéric Bazille, quoted in Marandel, Daulte et al., *Frédéric Bazille and Early Impressionism*, pp. 187–8.

p. 80     'like biscuits' ] Horne, *The Fall of Paris*, p. 174 (quoting eyewitness Tommy Bowles).

p. 81     'terrible din . . . shells flying' ] Edouard Manet, quoted in Wilson-Bareau (ed.), *Manet by Himself*, p. 62.

p. 82     'Look! Wooden shoes!' ] W.S. Meadmore, *Lucien Pissarro: un coeur simple* (London: Constable, 1962), p. 23.

p. 82     'Your friend Monet' ] Paul Durand-Ruel, quoted in Ralph E. Shikes and Paula Harper, *Pissarro: His Life and Work* (London, Melbourne and New York: Quartet, 1980), p. 91. Lionello Venturi, *Les Archives de l'impressionisme* (Paris and New York: Editions Durand-Ruel, 1939), II, p. 179.

p. 83     'Although I hate being under Military Command' ] Edouard Manet, quoted in Wilson-Bareau (ed.), *Manet by Himself*, p. 64.

p. 83     'I'll come and fetch you' ] Ibid.

p. 83     Beaune-la-Rolande ] For details of the battle see Howard, *The Franco-Prussian War*, pp. 299–310. Sources vary as to the exact date of Bazille's death. Juliet Wilson-Bareau, *Manet by Himself*, p. 65 (quoting letter from Edouard Manet to Emile Zola, 9 February 1871) gives 28 November. Marandel, Daulte et al,. *Frédéric Bazille and Early Impressionism*, p. 29 dates it 20 November. Bazille was twenty-nine.

p. 83     'romantically, galloping over a Delacroix battlefield' ] Jean Renoir, *Renoir, My Father*, p. 124.

## 6: The Paris Commune

p. 84     'doddering old fools' Edouard Manet, quoted in Juliet Wilson-Bareau (ed.), *Manet by Himself* (London: Little, Brown 2000; 1st published, 1991), p. 160.

p. 84     substantial foreign contributions and loans ] See *Paris under Siege: A journal of the events of 1870–1871, kept by contemporaries and*

*translated and presented by Joanna Richardson* (London: The Folio Society, 1982), pp. 111, 127 – eg. 'a highly successful Lord Mayor's Fund having been established in London in order to relieve the necessities of the famished Parisians' – Ernest A. Vizetelly, February 1871.

p. 84        contributions from his populace ] See *Cassell's History of the War between France and Germany, 1870–1871, Vol II* intro. by Edmund Ollier (London: Cassell, n.d.), p. 533: 'The French peasant or small farmer is thrifty; he saves or stores away as much money as he can spare for the necessities of life; and nothing brings out these secret hoards like a popular loan . . . the long-cherished stores came out from cupboards from drawers, from chests, from chimney-nooks, from old stockings, and from the very earth.'

p. 85        'The policy, strategy, administration' ] Stewart Edwards (ed.) *The Communards of Paris, 1871* (London: Thames & Hudson, 1973), pp. 18–20.

p. 85        'the ruin, the invasion and the dismemberment of France' ] Fenton Bresler, *Napoleon III: A Life* (London: HarperCollins, 1999), p. 387.

p. 85        'this dreadful war' ] Edouard Manet, quoted in Wilson-Bareau (ed.), *Manet by Himself*, p. 160.

p. 86        'Closed for national mourning' ] Roy McMullen, *Degas: His Life, Times, and Work* (London: Secker & Warburg, 1985), p. 194.

p. 86        'your blankets, suits, shoes' ] Ralph E. Shikes and Paula Harper, *Pissarro: His Life and Work* (London, Melbourne and New York: Quartet, 1980), p. 94. Sisley also lost practically all his early output (Richard Shone, *Sisley*, London: Phaidon, 1999; 1st published, 1992), p. 46.

## 7: 'The Week of Blood'

p. 88        'We're living in a miserable country' ] Edouard Manet, quoted in Juliet Wilson-Bareau (ed.), *Manet by Himself* (London: Little, Brown, 2000; 1st published, 1991), pp. 160–1.

p. 88        'Paris does not want to be tricked out of its republic' ] Cornélie Morisot, quoted in Denis Rouart (ed.), newly introduced and edited by Kathleen Adler and Tamar Garb, *The Correspondence of Berthe Morisot, with her Family and Friends* (London: Camden Press, 1986), p. 63.

p. 89        'there were now two governments in France' ] John Milner,

*Art, War and Revolution in France, 1870–1871: Myth, Reportage and Reality* (New Haven and London: Yale University Press, 2000), p. 145.

p. 89     'he could think of nothing but the Vendôme Column' ] Jean Renoir, *Renoir, My Father* (London: Collins, 1962; 1st published, 1958), p. 125.

p. 89     'Edma has picked a fine time to ask for her painting materials!' Cornélie Morisot, in Rouart (ed.), newly introduced and edited by Adler and Garb, *The Correspondence of Berthe Morisot*, p. 67.

p. 90     'the great, tragic, booming notes' ] Robert Baldick (ed.), *Pages from the Goncourt Journal* (Oxford: Oxford University Press, 1962), pp. 205–6

p. 90     ''Paris is on fire!' Cornélie Morisot, quoted in Rouart (ed.), newly introduced and edited by Adler and Garb, *The Correspondence of Berthe Morisot*, pp. 70–2.

p. 90     'a perpetual reminder' ] Ibid., p. 73.

p. 91     'It's frightful' ] Claude Monet, quoted in Michael Howard, *The Impressionists by Themselves: More than Twenty Artists, Their Works, and their Words* (New York: Smithmark; London: Conran Octopus, 1991), p. 49.

p. 91     'Citizen Renoir' ] Jean Renoir, *Renoir, My Father*, pp. 119–20.

p. 92     'It's unbelievable' ] Cornélie Morisot, quoted in Rouart (newly introduced and edited by Adler & Garb), *The Correspondence of Berthe Morisot*, p. 73

p. 92     'unable to say anything' ] Ibid., pp. 79–82.

p. 93     'low and dirty tasks' ] Ralph E. Shikes and Paula Harper, *Pissarro: His Life and Work* (London, Melbourne and New York: Quartet, 1980), pp. 93–5.

p. 93     'Out of sheer boredom' ] Berthe Morisot, quoted in Rouart (ed.), newly introduced and edited by Adler and Garb), *The Correspondence of Berthe Morisot*, pp. 82–3.

p. 93     'The composition looks like one of Manet's' ] Ibid., p. 82.

p. 93     'They tell me' ] Edgar Degas, quoted in Richard Kendall (ed.), *Degas by Himself: Drawings, Prints, Paintings, Writings* (London: MacDonald Orbis, 1989; 1st published, 1987), p. 100.

p. 94     'Are they really sincere?' ] Cornélie Morisot, quoted in Rouart (ed.), newly introduced and edited by Adler and Garb, *The Correspondence of Berthe Morisot*, pp. 83–4.

p. 94     'We must consider' ] Ibid., p. 76.

p. 94     'They were madmen' ] Jean Renoir, *Renoir, My Father*, p. 125.

p. 94     'like an actor' ] Roy McMullen, *Degas: His Life, Times, and*

*Work* (London: Secker & Warburg, 1985), p. 200.

p. 94     'that pure-hearted, gentle knight' ] Jean Renoir, *Renoir, My Father*, p. 125.

PART THREE: Formations

## 8: Recovery

p. 97     the fashionable crowds as they crossed the Pont Neuf ] Renoir: *Pont Neuf*, 1872.

p. 97     'a block of private carriages' ] Robert Baldick (ed.), *Pages from the Goncourt Journals* (Oxford: Oxford University Press, 1962), p. 197, 15 January 1872.

p. 98     'the golden age of the middle man' ] Jean Renoir, *Renoir, My Father* (London: Collins, 1962; 1st published, 1958), p. 122.

p. 98     'the alternative Salon' ] Roy McMullen, *Degas: His Life, Times, and Work* (London: Secker & Warburg, 1985), p. 207.

p. 98     'Do you know of a painter . . . ?' ] Edouard Manet, quoted in Juliet Wilson-Bareau (ed.), *Manet by Himself* (London: Little, Brown, 2000; 1st published, 1991), p. 162.

p. 99     rented in the name of 'Monnet' ] Daniel Wildenstein, *Monet, Or the Triumph of Impressionism* (Cologne: Taschen and The Wildenstein Institute, 1999), p. 92.

p. 100    the large horse-chestnut tree ] The house rented by Monet no longer exists, and a main road now runs between the site and the river. On the site is a block of tenement flats. But amidst a scrubby patch of grass, a chestnut tree still stands.

p. 103    'I thought she was you' ] Edouard Manet, quoted in Henri Perruchot, *Manet*, trans. Humphrey Hare (London: Perpetua, 1962; 1st published, Paris, 1959), pp. 215–16.

p. 103    'You can deduce everything' ] Edouard Manet, recorded by Thadée Natanson, cited in Margaret Shennan, *Berthe Morisot: The First Lady of Impressionism* (London: Sutton Books, 2000; 1st published, 1996), p. 136.

p. 104    The *mode sensible* ] Paul Valéry: 'Berthe Morisot', *Oeuvres, II* (Paris: Gallimard, 5th edition, 1960), pp. 1304–6.

p. 104    'sensual and *spirituel* transformation' ] Paul Valéry: 'Triomphe de Manet', ibid., pp. 1326–33.

p. 104    'willful eccentric' ] Anne Higonnet, *Berthe Morisot: A Biography* (London: Collins, 1990), p. 80.

p. 105    'to make of that monster something slender and interesting' ] Cornélie Morisot, quoted ibid., p. 84.

p. 105    'having wanted to think things over' ] Ibid., p. 85.

p. 106    'I do not like this place' ] Berthe Morisot, quoted in Denis Rouart (ed.), newly introduced and edited by Kathleen Adler and Tamar Garb, *The Correspondence of Berthe Morisot, with her Family and Friends* (London: Camden Press, 1986), p. 87.

p. 106    'I pity you' ] Pierre Puvis de Chavannes, quoted ibid., p. 87.

p. 107    'in such a bad mood that I don't know how they'll get there' ] Berthe Morisot, quoted ibid., p. 88.

p. 107    'a clatter to raise the dead' ] Jack Lindsay, *Cézanne: His Life and Art* (London: Evelyn, Adams & Mackay, 1969), p. 149.

p. 108    'Gachet believed it absolutely' ] Ralph E. Shikes and Paula Harper, *Pissarro: His Life and Work* (London, Melbourne & New York: Quartet, 1980), pp. 118–19

p. 108    'large, black eyes, which rolled in their sockets' ] Ibid., p. 116.

p. 108    'I take up Lucien's pen' ] Paul Cézanne and Lucien Pissarro, ibid., p. 116.

p. 109    Dr Gachet's house ] The house is still standing, on the main road through the village of Auvers, with his drawings on display in the house, and his orange table visible in Van Gogh's portrait (mentioned above) preserved beneath Perspex in the garden.

p. 110    'Lighten your palette' ] Jack Lindsay, *Cézanne: His Life and Art*, pp. 154–5.

p. 111    '*distraite* and far-away look' ] Paul Valéry: 'Triomphe de Manet', in *Oeuvres, II*, p. 1332.

p. 111    'almost too vast' ] Paul Valéry, 'Berthe Morisot', ibid., p. 1303.

p. 111    'I am keen to earn some money' ] Berthe Morisot, quoted in Rouart (ed.), newly introduced and edited by Adler and Garb, pp. 89–90

p. 112    'turkey buzzard' ] McMullen, *Degas: His Life, Times, and Work*, p. 231

p. 112    'delightful bachelor's apartment' ] René De Gas, quoted ibid.

p. 112    'that fellow Whistler has really hit on something' ] Edgar Degas, quoted ibid., p. 232.

p. 112    'a marvellous invention' ] Edgar Degas, quoted in Richard Kendall (ed.), *Degas by Himself: Drawings, Prints, Paintings, Writings* (London: MacDonald Orbis, 1989; 1st published, 1987), p. 90.

p. 113    inscrutably aged 'twelve to fifteen months' ] Ibid., p. 91.

p. 113    'How do you suppose a rascal like that' ] Edgar Degas, quoted

in Ambroise Vollard, *En Ecoutant Cézanne, Degas, Renoir* (Paris: Bernard Grasset, 2003; 1st published, 1938), p. 163.

p. 113    'a good woman. A few children of my own' ] Edgar Degas, quoted in Kendall (ed.), *Degas by Himself*, p. 95.

p. 114    'villas with columns in different styles . . . the negresses of all shades' ] Ibid., p. 92-3. This and the quotations from Degas which follow are taken from *Degas by Himself* pp. 93–5 and from Roy McMullen, *Degas: His Life, Times, and Work*, p. 235. Kendall and McMullen extract from and loosely translate the same letters.

p. 114    '*Ohé! Auguste . . .*' ] McMullen, *Degas: His Life, Times, and Work*, p. 235.

## 9: The Group Charter

p. 116    'the white nose of a block of buildings' ] George Moore, *Reminiscences of the Impressionist Painters* (Dublin: The Tower Press Booklets, no. 3, Maunsel, 1906), pp. 11–13.

p. 116    'The glass door . . . grated upon the sanded floor' ] Ibid., pp. 13–24.

p. 116    'I've got it!' ] Edgar Degas, quoted ibid., pp. 30–1.

p. 118    'Since you are seeing her' ] See Henri Perruchot, *Manet*, trans. Humphrey Hare (London: Perpetua, 1962; 1st published, Paris, 1959), p. 201.

p. 118    'Why don't you stay with me?' ] Edouard Manet, quoted ibid., p. 200.

p. 119    'had such a realist scope' ] Edgar Degas, quoted in Anne Higonnet, *Berthe Morisot: A Biography* (London: Collins, 1990), p. 108.

p. 119    'Unfortunately you don't have the heavy artillery' ] Pierre Puvis de Chavannes, quoted ibid., pp. 109–10

p. 119    'A group of painters assembled in my house' ] Richard Kendall (ed.), *Monet by Himself: Paintings, Drawings, Pastels, Letters* (London, New York, Sydney and Toronto: MacDonald Orbis, 1990; 1st published, 1989), p. 28. See also Daniel Wildenstein, *Monet, Or The Triumph of Impressionism* (Cologne: Taschen and The Wildenstein Institute, 1999), p. 104.

p. 120    'One step more' ] Gustave Geffroy, quoted in Ralph E. Shikes and Paula Harper, *Pissarro: His Life and Work* (London, Melbourne and New York: Quartet, 1980), pp. 103–6.

p. 121    'He forgot all about Argenteuil and geography' ] Paul Mantz, in *Le Temps*, 1884.

p. 121    'Behind the figures' ] Jean Rousseau, in the *Figaro*, 2 May 1875. Quoted in Pierre Courthion and Pierre Cailler (eds), *Portrait of Manet by Himself and his Contemporaries* (London: Cassell, 1960; 1st published, 1953), pp. 174, 226.

p. 122    'like a housemaid in a theatrical comedy' ] Roy McMullen, *Degas: His Life, Times, and Work* (London: Secker & Warburg, 1985), p. 239.

p. 122    'He conjures up before you' ] Robert Baldick (ed.), *Pages from the Goncourt Journals* (Oxford: Oxford University Press, 1962), p. 206 (13 February 1874: visit to Degas at 77, rue Blanche).

p. 122    'tenebrous and glimmering' ] McMullen, *Degas: His Life, Times, and Work*, pp. 223–4.

p. 124    'A blond light' ] Armand Silvestre, 'Galerie Durand-Ruel, Recueil d'Estampes Gravées à l'Eau-Forte', in Denys Riout (ed.), *Les Ecrivains devant l'impressionisme* (Paris: Macula, 1989), pp. 36–9.

p. 124    'you will be seen by fifty dealers' ] Theodore Duret, quoted in Shikes and Harper, *Pissarro: His Life and Work*, p. 108.

p. 125    a painting he had made from a hotel window ] Claude Monet: *Impression: Sunrise*, 1873. Paris, Musée Marmottan. This is the first painting in which Monet depicted the sun as an orange disc, with reflections in rough, summary marks. He used the idea again in other paintings, including *Impression: Sunset*. The original painting, *Impression: Sunrise*, has never left Paris.

p. 125    'What, get myself mixed up' ] Edouard Manet, quoted in Laurence Hanson, *Mountain of Victory: A Biography of Paul Cézanne* (London: Secker & Warburg, 1960), p. 109.

p. 125    fragile child, with long, thin limbs ] See her portrait: Camille Pissarro: *Portrait of Jeanne (Minette) Holding a Fan, c. 1873.*

p. 126    By the time it closed, 3,500 people had visited ] Roy McMullen, in *Degas: His Life, Times, and Work*, p. 247, compares the figure with the roughly 450,000 visitors to the Salon in spring 1874.

p. 127    'neither tiresome nor banal' ] Jules-Antoine Castagnary, *Le Siècle*, 29 April 1874, p. 3, in Riout (ed.), *Les Ecrivains devant l'impressionisme*, pp. 52–8.

p. 127    'What are we supposed to do' ] Renoir said this often, including to Mary Cassatt, who challenged him, 'Your technique is too simple.' He replied, 'Don't worry. Complicated theories can always be thought up afterwards.' Jean Renoir, *Renoir, My Father* (London: Collins, 1962; 1st published, 1958), p. 227.

p. 128    'What a pity' ] Louis Leroy, 'L'Exposition des impressionistes',

*Le Charivari*, 25 April, 1874.

p. 130   'they ignored me' ] Jean Renoir, *Renoir, My Father*, p. 155.

p. 131   'I do enjoy being with you' ] Paul Cézanne, quoted in Hanson, *Mountain of Victory*, p. 114

p. 131   'patience is the mother of genius' ] Gerstle Mack, *Paul Cézanne* (London: Jonathan Cape, n.d.), p. 197.

p. 132   a cheaper, one-storey house ] Monet simply moved further up the street, to a 'pink house with green shutters' at the top of the rue Saint-Denis, directly opposite the station. Daniel Wildenstein, *Monet, Or the Triumph of Impressionism* (Cologne: Taschen and The Wildenstein Institute, 1999), p. 111.

p. 132   'Who's your friend?' ] Edouard Manet, quoted in Michael Howard (ed.), *The Impressionists by Themselves, More than Twenty Artists, their Works and their Words* (New York: Smithmark; London: Conran Octopus, 1991), p. 102.

p. 132   'Madame, the kind welcome' ] Joseph Guichard, quoted in Higonnet, *Berthe Morisot: A Biography*, pp. 112–13.

p. 133   'filled with liquid flame' ] Ibid., p. 117.

p. 133   the match-making potential of the *bord de mer* ] On 11 September 1886, *L'Univers illustré* ran a picture of the railway station with the caption, 'Aux bains de mer – le train des maris.' Honfleur: Musée Eugène Boudin.

p. 134   dansez, et faites le phoque ou la grenouille ] 'Comment prendre le bain', in Jean-Louis Ayme, *Tous au Bain! Plaisirs aquatiques au XIX siècle* (Croissy-sur-Seine: Musée de la Grenouillère, 2002), p. 17.

p. 134   'Madame Pontillon's triumph is her bathing suit' ] Madame Auguste Manet, quoted by Eugène Manet, in Denis Rouart (ed.), newly introduced and edited by Kathleen Adler and Tamar Garb, *The Correspondence of Berthe Morisot, with her Family and Friends* (London: Camden Press, 1986), p. 94.

p. 134   'I doff my hat' ] Eugène Manet, quoted ibid., p. 93.

p. 135   back in his studio six weeks later ] Higonnet, *Berthe Morisot: A Biography*, p. 118: 'Family tradition holds that Eugène Manet made one last portrait of Morisot after her engagement or shortly after her marriage.' Cf. A. Tabarant, in *Manet et ses Oeuvres* (Paris: Gallimard, 5th edition, 1947), p. 199, who notes that though *Berthe Morisot à l'Eventail*, painted at the time of her marriage in December 1844, has always been regarded as Manet's last painting of her, six weeks later she was back in his studio posing for *Berthe Morisot au chapeau à plume* (also called

*Tête de jeune femme*). Tabarant also notes that on the question of how long Berthe continued to model for Manet the documents reveal nothing but uncertainty.

PART FOUR: Dancing at the Moulin de la Galette

### 10: Dealers and Salesrooms

p. 140   'achieving with their palettes' ] Phillipe Burty (untitled) in the catalogue of sale, on 24 March 1875, of *Paintings and Watercolours by Claude Monet, Berthe Morisot, A. Renoir, A. Sisley,* pp. iii–vi, in Denys Riout (ed.), *Les Ecrivains devant l'impressionisme* (Paris: Macula, 1989), pp. 47–9.

p. 140   'You may not appreciate' ] Edouard Manet, quoted in Margaret Shennan, *Berthe Morisot: The First Lady of Impressionism* (Stroud: Sutton Books, 2000; 1st published, 1996), p. 173. Some sources date this later.

p. 140   'All these pictures' ] Albert Wolff, *Figaro*, 23 March, 1875, quoted ibid.

p. 141   'purple-coloured landscapes' ] Gyges, in *Paris-Journal*, quoted ibid.

p. 142   'Oui, Marguerite, c'est Marie-Antoinette' ] François Fosca, *Renoir: L'Homme et son oeuvre* (Paris: Editions Aimery Somogy, 1985; 1st published, 1961), p. 112.

p. 142   'retired colonel turned wine-merchant' ] Edgar Degas, quoted in Georges Rivière, *Renoir et ses amis* (Paris: H. Floury, 1921), p. 168.

p. 142   'My dear, I bet you don't remember me' ] Fosca, *Renoir: L'Homme et son oeuvre*, p. 115.

p. 143   'very democratic,' remarked Gambetta ] Jean Renoir, *Renoir, My Father,* (London: Collins, 1962; 1st published, 1958), pp. 128–9.

p. 143   a vivacious redhead ] See portraits by Louise Abbema: *Jeanne Samaray, 1857–1890* (Paris: Musée Carnavalet); Auguste Renoir: *Portrait de Jeanne Samaray,* 1877.

p. 143   a real Renoir ] Jean Renoir, *Renoir, My Father,* p. 172.

p. 143   'Jeanne admires you so much' ] Ibid., p. 173.

p. 143   'not the marrying kind' ] ibid., p. 174.

p. 144   'When I think, . . .' ] Victor Chocquet, quoted in Daniel Wildenstein, *Monet, Or the Triumph of Impressionism* (Cologne: Taschen and The Wildenstein Institute, 1999), p. 117.

p. 144    'the portrait of one madman by another' ] Auguste Renoir
          quoted in Michael Howard (ed.), *The Impressionists by
          Themselves: More than Twenty Artists, their Works, and their Words*
          (London: Conran Octopus, 1991), p. 197.

p. 144    'It should look great' ] Victor Chocquet quoted in Ambroise
          Vollard, *En Ecoutant Cézanne, Degas, Renoir* (Paris: Bernard
          Grasset, 2003; 1st published, 1938), p. 260.

p. 144    Guillaumin . . . night-shift job ] Employed in the services of the
          Voirie de la Ville de Paris, Guillaumin was Vidangeur de fosses
          d'aisances durant la nuit. Chatou: Musée Fournaise.

p. 145    'a newcomer, Gustave Caillebotte' ] Georges Rivière, 'Les
          Intransigeants de la peinture', *L'Esprit moderne* (13 April 1876),
          pp. 7–8.

p. 145    Others whose purchases . . . would seem substantial ] See
          Lionello Venturi, *Les Archives de l'impressionisme, I* (Paris and
          New York: Editions Durand-Ruel, 1939), pp. 39–41 for details.

p. 146    'It's getting more and more desperate' ] Claude Monet, quoted
          in Richard Kendall (ed.), *Monet by Himself: Paintings, Drawings,
          Pastels, Letters* (London, New York, Sydney & Toronto:
          MacDonald Orbis, 1990; 1st published, 1989), p. 28.

p. 146    'What about it?' ] Edouard Manet, quoted in Juliet Wilson-
          Bareau (ed.), *Manet by Himself* (London: Little, Brown 2000; 1st
          published in 1991), p. 175.

p. 146    Camille in a scarlet Japanese kimono and peculiar blonde wig ]
          Claude Monet: *La Japonaise*, 1875.

p. 146    admitted he thought was 'rubbish' ] Karin Sagner-Duchting,
          *Claude Monet. 1840–1926: A Feast for the Eyes* (Cologne, Lisbon,
          London, New York, Paris and Tokyo: Taschen, 1998), pp. 83,
          87.

p. 146    'Never say *plein-air* to me again!' ] Edgar Degas, quoted in
          Vollard, *En Ecoutant Cézanne, Degas, Renoir*, p. 180.

p. 146    'he does cafés from nature!' ] Edouard Manet to Paul Alexis,
          quoted in Henri Loyrette, *Degas: Passion and Intellect* (London
          and New York: Thames & Hudson and Harry N. Abrams,
          1993; 1st published, Paris, 1988), p. 157.

p. 147    'You see, the air you breathe' ] Edgar Degas, quoted in Vollard,
          *En Ecoutant Cézanne, Degas, Renoir*, p. 161.

p. 147    'I have found an honest and excellent man' ] Berthe Morisot,
          quoted in Denis Rouart (ed.), newly introduced and edited by
          Kathleen Adler and Tamar Garb, *The Correspondence of Berthe
          Morisot, with her Family and Friends* (London: Camden Press,

1986), pp. 95–6.

p. 147     'an atmosphere of lofty and touching sentiment' ] Cornélie Morisot quoted ibid., p. 101.

p. 149     'we race about like lost souls' ] Berthe Morisot, quoted ibid., pp. 101–6.

p. 149     'glimpse of the dome' ] Ibid., p. 105.

p. 149     'sell it as you promised' ] Edgar Degas quoted in Richard Kendall (ed.), *Degas by Himself: Drawings, Prints, Paintings, Writings* (London: MacDonald Orbis, 1989; 1st published, 1987), p. 102.

p. 150     'I scarcely knew how to appreciate it' ] Louisine Elder quoted in Roy McMullen, *Degas: His Life, Times, and Work* (London: Secker & Warburg, 1985), p. 29.

p. 152     'If possible, come and take care of the placing' ] Edgar Degas, quoted in Rouart (ed.), newly introduced and edited by Adler and Garb, *The Correspondence of Berthe Morisot*, p. 110.

p. 153     'Heavens! What a slut' ] George Moore, quoted in Jad Adams, 'Fairy Liquid', in *The Times*, 31 January 2004, pp. 20–1 (extract from Jad Adams, *Hideous Absinthe: A History of the Devil in a Bottle*, London: I.B. Tauris, 2004).

p. 153     'the beautiful . . . is what the supernatural is to the Positivists' ] Henry James, *New York Tribune*, 13 May 1876.

p. 153     'I wish fair winds for the fleet' ] Edmond Duranty, *La Nouvelle Peinture – A propos du groupe d'artistes qui expose dans les galeries de Durand-Ruel*, Paris, E. Dentu, Librairie, 1876, 38 pp.; reprinted in Denys Riout (ed.), *Les Ecrivains devant l'impressionisme* (Paris: Macula, 1989), pp. 107–34.

p. 154     Other reviewers seemed to follow suit ] See McMullen, *Degas: His Life, Times, and Work*, pp. 252–5.

p. 154     'It's not grubbiness, it's not crudity' ] See Frederick Brown, *Zola: A Life* (London: Macmillan, 1996; 1st published New York: Farrar, Strauss & Giroux, 1995). p. 365.

p. 154     'The rue le Peletier is certainly having its troubles' ] Albert Wolff, *Le Figaro*, 3 April 1876. His review was headed 'Misfortune in the rue le Peletier.'

p. 155     Berthe herself seemed unperturbed ] Auguste Renoir, quoted in Jean Renoir, *Renoir, My Father*, p. 142: 'Berthe Morisot, "that great lady," . . . just laughed.'

p. 155     'If you read some of the Parisian newspapers' ] Berthe Morisot, quoted in Rouart (ed.), newly introduced and edited by Adler and Garb, *The Correspondence of Berthe Morisot*, p. 111.

p. 155    '*Paint the Truth, Let them Talk*' ] 'Faire Vrai, Laisser Dire.' See Wilson-Bareau (ed.), *Manet by Himself*, p. 177.

p. 156    'white in the morning, lilac during the day' ] Edouard Manet, recorded by Berthe Morisot, quoted ibid., p. 303.

p. 156    'the slating attack by 'Sieur Wolff' ] Paul Cézanne, quoted in Richard Kendall (ed.), *Cézanne by Himself: Drawings, Paintings, Writings* (London, New York, Sydney and Toronto: MacDonald Orbis, 1990; 1st published, 1988), p. 59.

p. 156    *Festival at l'Hermitage* ] Camille Pissarro: *Festival at l'Hermitage*, 1876.

p. 156    'Two little motifs from the sea' ] Paul Cézanne, quoted in Kendall (ed), *Cézanne by Himself*, pp. 59–61.

p. 156    'If the impressionist profile can help me' ] Paul Cézanne, quoted in Laurence Hanson, *Mountain of Victory: A Biography of Paul Cézanne* (London: Secker & Warburg, 1960), p. 12.

p. 157    animated by strutting turkeys with bright scarlet gizzards ] Claude Monet: *Turkeys*, 1876.

p. 157    all the appearance of a successful tycoon ] Anonymous, undated photograph, reproduced in Daniel Wildenstein, *Monet, Or the Triumph of Impressionism*, p. 120-2.

p. 157    Manet painted him . . . his daughter Marthe ] Edouard Manet: *Ernest Hoschedé and his Daughter Marthe at Montgeron*, 1876.

p. 158    'wit, intelligence in plenty' ] Daniel Wildenstein, *Monet, Or the Triumph of Impressionism*, p. 121-2.

p. 158    'astonishing questions about country things' ] Claire Joyes, *Claude Monet: Life at Giverny* (London: Thames & Hudson, 1985), p. 15.

p. 158    'jagged and mutilated' ] Emile Zola, in *L'Assommoir*, quoted in Brown, *Zola: A Life*, p. 363.

## 11: Summer in Montmartre

p. 160    a 'princely sum' ] Auguste Renoir, quoted in Karin Sagner-Duchting, *Renoir: Paris and the Belle Epoque* (Munich and New York: Prestel-Verlag, 1996), p. 47.

p. 161    *le radet* ] Ibid., p. 46.

p. 161    *SOIREES jeudi samedi fêtes MATINEES* ] Postcard/photograph, *c.* 1870, reproduced ibid., p. 45.

p. 162    'the very prototype of a provincial lawyer' ] Jean Renoir, *Renoir, My Father* (London: Collins, 1962; 1st published, 1958), pp. 107; 115; 164–5.

p. 162    from *honnête fille* to *femme entretenue* ] Georges Rivière, *Renoir et Ses Amis* (Paris: H. Floury, 1921), p. 126. The story continues as recounted by Rivière, pp. 121–52, translated and paraphrased by the author.

p. 165    'What have they done to my poor Paris!' ] Jean Renoir, *Renoir, My Father*, p. 45.

p. 166    Miss LaLa ] See Roy McMullen, *Degas: His Life, Times, and Work* (London: Secker & Warburg, 1985), pp. 318–19: 'a pretty, curved mulatto performer who was billed as 'the Black Venus' and 'the Cannon Woman' and whose feats were dependent on the astonishing strength of her teeth and jaws. In one of her numbers she hung by her legs from a flying trapeze and held in her mouth a long chain, on which a small but real cannon was ceremoniously suspended and then fired.' For further details of the geometrical complexity of the painting, see David Bomford et al., *Art in the Making: Degas* (London: National Gallery and Yale University Press, 2004), pp. 82–92.

p. 167    La Pouponnière Nouvelles Etoiles des Enfants de France ] François Fosca: *Renoir l'Homme et son Œuvre*, p. 116.

p. 167    'the ever-present light' ] Stéphane Mallarmé, 'The Impressionists and Edouard Manet', *Art Monthly Review*, 30 September 1876, in Denys Riout (ed.), *Les Ecrivains devant l'impressionisme* (Paris: Macula, 1989), pp. 88–104.

p. 167    Eugène Murer, writer, amateur painter and *pâtissier* ] His own works were bold, fauviste still lifes in dark colours, the paint applied thickly and with evident panache. Chatou: Musée Fournaise.

p. 168    'If it's all the same to you' ] Ralph E. Shikes and Paula Harper, *Pissarro: His Life and Work* (London, Melbourne & New York: Quartet, 1980), pp. 137–8.

p. 168    'The entire tribe of painters' ] Eugène Manet, quoted in Denis Rouart (ed.), newly introduced and edited by Adler and Garb, *The Correspondence of Berthe Morisot, with her Family and Friends* (London: Camden Press, 1986), p. 111.

p. 168    Cornélie Morisot . . . died, aged fifty-six ] ibid., p. 113. The date of death is given as 'October 1876'. Anne Higonnet, in *Berthe Morisot: A Biography* (London: Collins, 1990), p. 144, gives the date of death as 15 December 1876.

PART FIVE: The Atmosphere of the Boulevard

## 12: Street Life

p. 173   'Poor blind idiots!' ] Claude Monet, quoted in Jean Renoir, *Renoir, My Father* (London: Collins, 1962; 1st published, 1958), pp. 157–8. Over forty years on, Renoir recalled this incident as following the first impressionist exhibition (1874), but Daniel Wildenstein gives first lists of sales of the Gare Saint-Lazare paintings as March 1877 onwards (Wildenstein: *Monet, Or the Triumph of Impressionism*, Cologne: Taschen and The Wildenstein Institute, 1999, p. 128). Michael Howard, in *Impressionism* (London: Carlton, 1997), p. 169, notes that 'Monet obtained permission to paint inside the station in January 1877 . . . seven [works] were exhibited in the third impressionist exhibition in April 1877.'

p. 173   'I have decided to paint your station' ] Jean Renoir, *Renoir, My Father*, p. 158.

p. 175   'This exhibition *will* happen' ] Gustave Caillebotte, quoted in Michael Howard (ed.): *The Impressionists by Themselves: More than Twenty Artists, their Works, their Words* (London: Conran Octopus, 1991), p. 83

p. 175   'Can one exhibit at the Salon and with us?' ] Edgar Degas, quoted ibid., p. 84.

p. 176   Citron's portrait ] Edouard Manet: *Nana*, 1877.

p. 176   'To leave him . . .' ] Méry Laurent, quoted in Henri Perruchot, *Manet*, trans. Humphrey Hare (London: Perpetua, 1962; 1st published, Paris 1959), p. 215.

p. 177   'Immense progrès!' ] Georges Rivière: *Renoir et ses amis* (Paris: H. Floury, 1921), p. 153.

p. 177   'Where can we find more grandeur' ] Georges Rivière, *L'Impressioniste, journal d'art*, no. 2, 14 April 1877, pp. 1–6, in Denys Riout (ed.), *Les Ecrivains devant l'impressionisme* (Paris: Macula, 1989), pp. 186–201.

p. 177   Delacroix's *Jacob Wrestling with the Angel* ] Saint-Sulpice, Paris (it remains there today). Auguste Renoir: 'L'Art décoratif et contemporain', in Augustin de Butler (ed.), *Renoir: Ecrits, entretiens et lettres sur l'art* (Paris: Les Editions de l'Amateur, 2002), p. 43.

p. 178   '*L'Impressioniste!*' ] Georges Rivière, *Renoir et Ses Amis*, pp. 154–6.

p. 178   Halévy's new play, *Le Cigale* ] Ibid., p. 154. The play, a comedy in three acts, was by Meilhac and Halévy.

p. 178    reviews of the show had again been mainly hostile ] See Wildenstein, *Monet, Or the Triumph of Impressionism*, p. 129.

p. 179    'You're too late' ] Auguste Renoir, in Howard (ed.), *The Impressionists by Themselves*, p. 93.

p. 179    'What dreadful weather always raining' ] Edda Maillet et al. (eds), *Quatorze lettres de Julie Pissarro* (Pontoise: L'Arbre et les Amis de Camille Pissarro, 1984), unpaginated. 'Quel affreux temps toujours . . .'

p. 180    Monet's Gare Saint-Lazare paintings had fared better than most ] See Wildenstein, *Monet, Or the Triumph of Impressionism*, pp. 128–9.

p. 180    'Don't let anyone try to find me, or I will kill myself' ] Ernest Hoschedé, quoted in Claire Joyes, *Life at Giverny* (London: Thames & Hudson, 1985), pp. 16-17. (The exact date of his summons is not given.)

p. 181    On 16 August, Hoschedé's bankruptcy was announced ] See Wildenstein, *Monet, Or the Triumph of Impressionism*, p. 122.

p. 181    Alice gave birth to her sixth child, Jean-Pierre Hoschedé ] See Joyes, *Life at Giverny*, p. 17

p. 181    Monet never acknowledged him as his son ] See Wildenstein, *Monet, Or the Triumph of Impressionism*, p. 125.

p. 181    'his vision of the world darkened' ] Daniel Halévy, *My Friend Degas*, trans. and ed. Mina Curtiss (London: Rupert Hart-Davis, 1966), p. 23.

p. 182    'To have no clothes and own sublime objects' ] Edgar Degas, quoted ibid., p. 86.

p. 182    'He could not bear the thought' ] Ibid., pp. 22–3.

p. 182    Draw all kinds of everyday objects ] Richard Kendall (ed.), *Degas by Himself: Drawings, Prints, Paintings, Writings* (London: MacDonald Orbis, 1989; 1st published, 1987), pp. 112–13. From Theodore Reff, *The Notebooks of Edgar Degas: A Catalogue of the Thirty-Eight Notebooks in the Bibliothèque Nationale & Other Collections, I* (Oxford: Clarendon Press, 1976), nos 30 & 34.

p. 182    'pornographic' sketches ] Almost all the erotic works belong to *c.* 1875–80. See Reff, *The Notebooks of Edgar Degas*, p. 11. See also Richard Thomson, *Degas: The Nudes* (London: Thames & Hudson, 1988), pp. 94–117.

p. 183    'Oh! Women can never forgive me' ] Edgar Degas, quoted in Kendall (ed.), *Degas by Himself*, p. 299.

p. 183    a loud voice, an atrocious accent ] Auguste Renoir's view. See Jean Renoir, *Renoir, My Father* p. 227.

p. 184    'here is someone who feels as I do' ] Edgar Degas, quoted in
          Roy McMullen, *Degas: His Life, Times, and Work* (London:
          Secker & Warburg, 1985), p. 293.

p. 184    'flatten my nose against the window' ] Mary Cassatt, quoted
          ibid., p. 293.

p. 184    balancing herself on her cane ] Degas made a number of
          variants, etchings as well as paintings, including *At the Louvre:
          Mary Cassatt in the Etruscan Gallery*, 1879–80; and *At the Louvre:
          Mary Cassatt in the Picture Gallery*, 1879–80.

p. 184    'so natural and truthful' ] Mary Cassatt, quoted in Griselda
          Pollock, *Mary Cassatt: Painter of Modern Women* (London:
          Thames & Hudson, 1998), p. 131.

p. 185    'I could have married her, but I could never have made love to
          her' ] Edgar Degas, quoted in McMullen, *Degas: His Life, Times,
          and Work*, p. 298.

p. 185    'With pleasure, . . . no flowers' ] Edgar Degas, quoted in
          Ambroise Vollard, *En Ecoutant Cézanne, Degas, Renoir* (Paris:
          Bernard Grasset, 2003; 1st published, 1938), p. 144.

p. 185    sounds of thumping and yelping ] Ibid., p. 165.

p. 185    'In your kennels' ] Edgar Degas, quoted in McMullen, *Degas:
          His Life, Times, and Work*, pp. 294–5.

p. 185    'I adore the brown tones' ] Mary Cassatt, quoted in Jean
          Renoir, *Renoir, My Father*, p. 227.

p. 186    'When I first saw him' ] Mary Cassatt, quoted in Laurence
          Hanson, *Mountain of Victory: A Biography of Paul Cézanne*
          (London: Secker & Warburg, 1960), p. 174.

p. 186    'the gentlest nature possible' ] Mary Cassatt, quoted in John
          Rewald, *The Ordeal of Paul Cézanne*, trans. Margaret H.
          Liebman (London: Phoenix House, 1950), pp. 133–4.

p. 186    'Now I could work with absolute independence' ] Mary
          Cassatt, quoted in McMullen, *Degas: His Life, Times, and Work*,
          p. 293.

### 13: *La Vie Moderne*

p. 187    'There are so few of us' ] Mary Cassatt, quoted in Nancy Mowll
          Mathews, *Cassatt and her Circle: Selected Letters* (New York:
          Abbeville Press, 1984), p. 137.

p. 187    'against merchandise' ] See Ralph E. Shikes and Paula Harper,
          *Pissarro: His Life and Work* (London, Melbourne and New York:
          Quartet, 1980), p. 145.

p. 189    'already on the lookout' ] Laurence Hanson, *Mountain of Victory: A Biography of Paul Cézanne* (London: Secker & Warburg, 1960), pp. 128–9.

p. 189    'a brutish Venetian, a Tintoretto turned house-painter' ] Robert Baldick (ed.), *Pages from the Goncourt Journal* (Oxford: Oxford University Press, 1962), pp. 234–5.

p. 190    'melancholy rose from that treeless garden' ] Ibid., p. 265.

p. 190    'to perpetuate a famous name' ] Berthe Morisot, quoted in Denis Rouart (ed.), newly introduced and edited by Adler and Garb, *The Correspondence of Berthe Morisot, with her Family and Friends* (London: Camden Press, 1986), p. 115.

p. 191    'How can they ridicule people like Degas' ] Edouard Manet, quoted by Antonin Proust, 'Souvenirs', in Michael Howard (ed.), *The Impressionists by Themselves* (London: Conran Octopus, 1991), p. 87.

p. 191    'This makes Mame very uneasy' ] Robert Cassatt, quoted in Nancy Mowll Mathews (ed.), *Cassatt and her Circle: Selected Letters* (New York: Abbeville Press, 1984), p. 143.

p. 192    'I was painting modern Paris' ] Manet quoted by George Moore, in Bernard Denvir, *The Impressionists at First Hand* (London: Thames & Hudson, 1991; 1st published, 1987), p. 78.

p. 192    'That Manet' ] Edgar Degas, quoted in Richard Kendall (ed.), *Degas by Himself: Drawings, Prints, Paintings, Writings* (London: MacDonald Orbis, 1989; 1st published, 1987), p. 242 (from the Diaries of Daniel Halévy).

p. 192    'Manet painted the rue Mosnier' ] Edouard Manet: *The Rue Mosnier Decked with Flags*, 1878.

p. 192    old Gothic gables blazed with red, white and blue flags ] See Claude Monet: *The rue Saint-Denis, 30th of June 1878*, 1878.

p. 193    'Once again, . . . I don't have a penny' ] Camille Pissarro, quoted in Shikes and Harper, *Pissarro: His Life and Work*, p. 142.

p. 194    'Two weeks have gone by' ] Julie Pissarro, quoted ibid., pp. 143–4.

p. 194    'Your mother believes' ] Camille Pissarro, quoted ibid., p. 144.

p. 194    'What I have suffered you can't imagine' Ibid.

p. 195    'Art is for the rich' ] Julie Pissarro, quoted in Belinda Thomson, *Impressionism: Origins, Practice, Reception* (London: Thames & Hudson, 2000), p. 83.

p. 195    'Your son is a good lad' ] W.S. Meadmore, *Lucien Pissarro: Un Coeur simple* (London: Constable, 1962), p. 31.

p. 195    'I have set up shop' ] Claude Monet, quoted in Daniel

Wildenstein, *Monet, Or the Triumph of Impressionism* (Cologne: Taschen and The Wildenstein Institute), p. 137.

p. 196  only one proper dress between them ] Claire Joyes, *Claude Monet: Life at Giverny* (London: Thames & Hudson, 1985), p. 20.

p. 196  'It's the sight of my wife's life in danger' ] Claude Monet, quoted in Richard Kendall (ed.), *Monet by Himself: Paintings, Drawings, Pastels, Letters* (London, New York, Sydney and Toronto: MacDonald Orbis, 1990; 1st published, 1989), p. 31.

p. 197  'carrying on with that nice little maid' ] Paul Cézanne, quoted in Hanson, *Mountain of Victory*, p. 130.

p. 197  referring openly to Hortense as 'my wife' ] Ibid., pp. 132–3.

p. 197  'as flat as a paving stone' ] Berthe Morisot, quoted in Rouart (ed.), newly introduced and edited by Adler and Garb, *The Correspondence of Berthe Morisot*, p. 115.

p. 198  'My daughter is a Manet' ] Ibid. Berthe's words have not gone unremarked. Margaret Shennan comments, 'If she made no mention of Eugène in all this, it could be quite a significant omission. In her heightened emotional state, what mattered most of all to Berthe was something which came out in a Freudian slip. "My daughter is a Manet to the tips of her fingers; even at this early date she is like her uncles, she has nothing of me." ' Margaret Shennan, in *Berthe Morisot: The First Lady of Impressionism* (Stroud: Sutton Books, 2000; 1st published, 1996), p. 191.

p. 198  'caught the man's spirit with merciless accuracy' ] Henri Perruchot, *Manet*, trans. Humphrey Hare (London: Perpetua, 1962; 1st published, Paris, 1959), p. 222.

p. 198  a 'lightning' pain in the small of his back ] Ibid., p. 226.

p. 199  When the Béni-Bardeuses see me' ] Edouard Manet, quoted in Perruchot, *Manet*, p. 226.

p. 200  Marthe Bérard in her lowish collar, lace cuffs and shining patent shoes ] Auguste Renoir: *Mademoiselle Marthe Bérard*, 1879.

p. 200  at the seashore, in jauntier mood ] Auguste Renoir: *La Petite Pêcheuse (Marthe Bérard)*, 1879.

p. 201  'The most subtle of the impressionists' ] Richard Shone: *Sisley* (London: Phaidon, 1999; 1st published, 1992), p. 112.

p. 201  'I can't go on treading water like this' ] Ibid., p. 117.

p. 201  'I am absolutely sickened with and demoralised by this life' ] Claude Monet, quoted in Kendall (ed.), *Monet by Himself*, p. 29.

p. 202  'Do you invite these people to your house?' ] Edgar Degas, quoted in Shikes and Harper, *Pissarro: His Life and Work*, p. 147.

p. 202    'If there's anyone in the world' ] Gustave Caillebotte, quoted ibid., p. 148.

p. 202    'very fine and sympathetic to people in trouble' ] Camille Pissarro, quoted ibid., p. 164.

p. 203    attentively leaning forward in her chair . . . dashing in a red silk scarf ] See portrait by Jacques-Emile Blanche: *Mary Cassatt*, 1883 (Paris: Musée Carnavalet).

p. 203    'You will reclaim your place at the exposition with *éclat*' ] Mary Cassatt, quoted in Anne Higonnet, *Berthe Morisot: A Biography* (London: Collins, 1990), p. 156.

p. 203    'I'm delighted' ] Marianne Delafont, *Berthe Morisot: Reasoned Audacity*, Denis and Annie Rouart Foundatioin (Paris: Musée Marmottan, 2002), p. 100.

p. 203    Marie Bracquemond ] Marie Bracquemond, wife of Felix Bracquemond, exhibited at the impressionist exhibitions of 1879, 1880 and 1886.

p. 203    It attracted nearly 16,000 paying visitors ] Roy McMullen, *Degas: His Life, Times, and Work* (London: Secker & Warburg, 1985), p. 325.

p. 204    'to transfer the atmosphere of an artist's studio to the boulevard' ] *La Vie moderne* editorial, quoted in Bernard Denvir, *The Chronicle of Impressionism: An Intimate Diary of the Lives and World of the Great Artists* (London: Thames & Hudson, 2000; 1st published, 1993), p. 112.

p. 204    the cartoonists . . . took the opportunity to pastiche the event ] See Denvir (ed.), *The Impressionists at First Hand*, p. 121.

p. 204    'I hurried to Mlle Cassatt with your parcel' ] Edgar Degas, quoted in Shikes and Harper, *Pissarro: His Life and Work*, pp. 166–9.

p. 204    'You must practise dusting the particles' ] Ibid., p. 166.

p. 204    'Come and talk it over with me' ] Ibid., p. 169.

p. 205    'Life is largely a question of money' ] Berthe Morisot, quoted in Shennan, *Berthe Morisot*, p. 196

p. 206    'His brush moves softly' ] Jacques de Biez: 'Edouard Manet', 1884, quoted in Françoise Cachin, *Manet 1832–1883* (New York: Metropolitan Museum of New York and Harry N. Abrams, 1983), pp. 208–9

p. 206    'Just move about here and there' ] Edouard Manet, quoted in A. Tabarant, 'Manet: Histoire catalographique, 1931', in Pierre Courthion and Pierre Cailler (eds), trans. Michael Ross, *Portrait of Manet by Himself and his Contemporaries* (London: Cassell, 1960; 1st published, 1953), p. 88.

p. 206    'with three strokes, *pique, pique, pique*' ] Ibid., p. 87. In the above two quotations, the English translation is very loose. For the exact word usage (e.g. *Pique, pique, pique*) see Pierre Courthion and Pierre Cailler (eds) *Manet raconté par lui-même et par ses amis*, vol. I (Geneva: Pierre Cailler, 1953), pp. 193–4.

p. 206    'half of a smashed boiled egg' ] Edouard Manet: *Portrait of George Moore*, 1879, in Cachin, *Manet*, pp. 427–9.

p. 207    'every time it came out brighter and fresher' ] Ibid., p. 424.

p. 207    as green in complexion as if he had been drowned' ] Perruchot, *Manet*, p. 232.

p. 207    'No-one but myself knows the pressure I'm under' ] Claude Monet, quoted in Kendall (ed.), *Monet by Himself*, pp. 30–1.

p. 208    'With your permission' ] Dr De Bellio, quoted in Wildenstein, *Monet, Or the Triumph of Impressionism*, pp. 144-145.

p. 208    'For a long time' ] Claude Monet, quoted in Kendall (ed.), *Monet by Himself*, p. 31.

p. 208    'I am very sorry' ] Dr De Bellio, quoted in Wildenstein, *Monet, Or the Triumph of Impressionism*, p. 146.

p. 208    'Thanks to Alice' ] Ernest Hoschedé, quoted ibid.

p. 209    'Could you retrieve' ] Claude Monet, quoted in Kendall, *Monet by Himself*, p. 32.

p. 209    'Her death was long and horrible' ] Alice Hoschedé, quoted in Wildenstein, *Monet, Or the Triumph of Impressionism*, p. 146.

p. 209    'watching her tragic forehead' ] Recounted by Georges Clemenceau, *Claude Monet: Cinquante Ans d'Amitié* (1928), quoted in Howard, *The Impressionists by Themselves*, p. 99. Daniel Wildenstein (in *Monet, Or the Triumph of Impressionism*, p. 146) claims that the words attributed to Monet are Zola's invention. (Emile Zola, *L'Oeuvre*, 1886).

p. 209    'You, more than anyone' ] Claude Monet, quoted in Kendall, *Monet by Himself*, p. 32.

p. 210    'If we're spending at this rate in Vétheuil' ] Alice Hoschedé, quoted in Wildenstein, *Monet, Or the Triumph of Impressionism*, p. 149.

## PART SIX: Divisions

### 14: New Tensions

p. 213    'so well-bred, and so helpless' ] Jean Renoir, *Renoir, My Father* (London: Collins, 1962; 1st published, 1958), p. 192.

p. 214    'a terrifying noise, like thunder' ] Daniel Wildenstein, *Monet: Or the Triumph of Impressionism* (Cologne: Taschen and The Wildenstein Institute, 1999), p. 152.

p. 215    'If you continue like this' ] Jean Renoir, *Renoir, My Father*, pp. 192–3.

p. 215    'the pleasant sensation' ] Ibid., p. 191.

p. 215    'Don't tell your mother' ] Ibid., p. 194

p. 215    a queen among fakes ] Ibid., p. 235.

p. 215    'the sad loss of M. Claude Monet' ] Wildenstein, *Monet, or the Triumph of Impressionism*, p. 155.

p. 216    'the Caillebotte exhibition' ] Ibid., p. 159.

p. 216    Marie Bracquemond seems to have been a late decision ] Edgar Degas, in Richard Kendall (ed.), *Degas by Himself: Drawings, Prints, Paintings, Writings* (London: MacDonald Orbis, 1989; 1st published, 1987), p. 117. 'My dear Bracquemond . . . If you insist and Mme Bracquemond insists too, her name can be put on the second thousand posters during the exhibition. Let me know.'

p. 216    'I have had to give in' ] Edgar Degas, quoted in Bernard Denvir (ed.), *The Impressionists at First Hand* (London: Thames & Hudson, 1991; 1st published, 1987), p. 126.

p. 217    'Degas, who is the leader' ] Katherine Cassatt, quoted in Nancy Mowll Mathews (ed.), *Cassatt and her Circle: Selected Letters* (New York: Abbeville Press, 1984), pp. 150–1.

p. 218    'Oh! . . . I am independent' ] Mary Cassatt, quoted in Nancy Mowll Mathews, *Mary Cassatt: A Life* (New Haven and London: Yale University Press, 1998; 1st published, 1994), p. 149.

p. 218    'the truth is, I cannot abide Mary' ] Lois Cassatt, quoted ibid., p. 154.

p. 219    'the Admiral of Chatou' ] Les Amis de la Maison Fournaise, *Lieu de rencontre de peintres impressionistes* (museum leaflet), Musée Fournaise, Chatou.

p. 219    On weekdays ] Photograph: *La Maison Fournaise vers 1890: La phalanstère des canotiers selon Guy de Maupassant* (Cliché Sirot-Engel), Musée Fournaise, Chatou.

p. 220    the place still exists today ] a short walk from the station Chatou/Chailly, in the opposite direction along the riverbank from the site of the Grenouillère, and Musée de la Grenouillère (see Chapter 1 above), with which the Hôtel Fournaise, a fully operational brick-built restaurant, should not be confused.

p. 221     'I'm doing penance' ] Edouard Manet, quoted in Juliet Wilson-Bareau (ed.), *Manet by Himself* (London: Little, Brown, 2000; 1st published, 1991), p. 247.

p. 221     'living here like a shellfish' ] Ibid., p. 249.

p. 221     '*A Isabelle / cette mirabelle*' ] George Mauner (ex. cat.), *Manet: The Still-Life Paintings* (New York: Harry N. Abrams, in association with the American Federation of Arts, 2000), p. 110.

p. 221     'It wouldn't be so bad' ] Edouard Manet, quoted in Wilson-Bareau (ed.), *Manet by Himself*, p. 256.

p. 221     'He is hope incarnate' ] Ibid., p. 250.

p. 221     'It'll be easier for me' ] Pierre Courthin and Pierre Cailler (eds.), *Portrait of Manet by Himself and his Contemporaries* (London: Cassell, 1960; 1st published, 1953), pp. 96–8.

p. 222     'to reassure the lonely exiles' ] Edouard Manet, quoted in Wilson-Bareau (ed.), *Manet by Himself*, p. 253.

p. 222     'Dear little Marthe' ] Ibid., p. 257.

p. 222     Henri Rochefort ] Manet painted a number of variants, including *Portrait of Henri Rochefort*, 1881 and *The Escape of Rochefort*, 1880–1.

p. 223     'Wow! . . . you've wonderful hair' ] Recounted in Courthion and Cailler, *Portrait of Manet by Himself and his Contemporaries*, p. 97.

p. 223     'Imagine, trying to pass me off' ] Ibid., p. 98.

p. 223     'What is to become of our exhibitions?' ] Gustave Caillebotte, quoted in Michael Howard (ed.), *The Impressionists by Themselves: More than Twenty Artists, their Works, and their Words* (London: Conran Octopus, 1991), p. 168.

p. 223     'If Degas wants to take part' ] Ibid., p.169.

p. 224     'we can't flood the place with rowing boats' ] Paul Gauguin, quoted ibid., p. 171.

p. 224     'as if they were the victors' ] Camille Pissarro, quoted in Howard (ed.), *The Impressionists by Themselves*, p. 169.

p. 224     his mystery sculpture ] Edgar Degas: *Little Dancer of Fourteen Years*, 1881 (sculpture).

p. 225     'Everything is white' ] Auguste Renoir, quoted in Jean Renoir, *Renoir, My Father*, p. 211, cf. François Fosca, *Renoir: L'Homme et son oeuvre* (Paris: Editions Aimery Somogy, 1985; 1st published, 1961), p. 164. Fosca claims that Renoir was suspicious of 'mystère', and therefore attracted only by pale, never by dark flesh. The discrepancy must remain a mystery.

p. 225     'not even buy a nose' ] Auguste Renoir, quoted in Augustin de

Butler (ed.), *Renoir: Ecrits, entretiens et lettres sur l'art* (Paris: Les Editions de l'Amateur, 2002), p. 113.

p. 226     'So, you don't want any more veal?' ] Madame Charigot, quoted in Jean Renoir, *Renoir, My Father*, p. 213.

p. 226     'Now I'll be able to say squarely' ] Auguste Renoir, quoted in De Butler (ed.), *Renoir: Ecrits, entretiens et lettres sur l'Art*, p. 116.

p. 226     'I want to see the Raphaels' ] Ibid., p. 117.

p. 226     'The trouble with Italy' ] Ibid., pp. 117–18.

p. 227     'Here is a girl of our time' ] Huysmans, quoted in Bernard Denvir, *The Chronicle of Impressionism: An Intimate Diary of the Lives and World of the Great Artists* (London: Thames & Hudson, 2000; 1st published, 1993), p. 125.

p. 228     'Like Millet he is the poet of the humble' ] *Le Figaro*, 10 April 1881. Quoted in Charles S. Moffett et al., *The New Painting: Impressionism, 1874–1886* (San Francisco: The Fine Arts Museums of San Francisco, with the National Gallery of Art, Washington, 1986), p. 368.

p. 228     'male and female nihilists' ] See Roy McMullen, *Degas: His Life, Times, and Work* (London: Secker & Warburg, 1985), p. 338–9.

p. 228     'Oh, my Lord! Those babies!' ] Huysmans, quoted in Griselda Pollock, *Mary Cassatt: Painter of Modern Women* (London: Thames & Hudson, 1998), p. 185.

p. 228     'Mame's success is certainly more marked now' ] Robert Cassatt, quoted in Mowll Mathews (ed.), *Cassatt and her Circle: Selected Letters*, pp. 160–1.

p. 229     'When you get these pictures' ] Mary Cassatt, quoted ibid., p. 161.

p. 229     'I hope it will be a lesson to her' ] Katherine Cassatt, quoted ibid., p. 162.

p. 229     'held up their hands' ] Ibid., p. 155.

p. 229     'we cannot rent the place' Ibid.

p. 229     'Tell Robbie, his aqueduct is all right yet' ] Robert Cassatt, quoted ibid., p. 161.

p. 230     'She likes the street' ] Berthe Morisot, quoted in Denis Rouart (ed.), newly introduced and edited by Kathleen Adler and Tamar Garb, *The Correspondence of Berthe Morisot, with her Family and her Friends* (London: Camden Press, 1986), p. 116.

p. 230     'The love of art' ] Ibid., p. 117.

p. 230     'most horrible of gardens' ] Edouard Manet, quoted in Henri Perruchot, *Manet*, trans. Humphrey Hare (London: Perpetua, 1962; 1st published, Paris, 1959), pp. 241–2.

p. 230    'How can you say' ] Alice Hoschedé, quoted in Wildenstein, *Monet: Or the Triumph of Impressionism*, p. 169.

p. 232    'this year is not ending very well' ] Edouard Manet, quoted in Wilson–Bareau (ed.), *Manet by Himself*, p. 264

p. 232    'What a pelisse!' ] Edouard Manet, quoted in Perruchot, *Manet*, pp. 243–4.

p. 233    'My dear chap' ] Edouard Manet, quoted ibid., p. 244.

p. 233    'Oh no, not Manet!' ] See Courthion and Cailler, *Portrait of Manet by Himself and his Contemporaries*, p. 94.

p. 233    'You have fought' ] Butler (ed.), *Renoir: Ecrits, entretiens et lettres sur l'art*, p. 119.

p. 233    'When you write to him' ] Edouard Manet, quoted in Henri Perruchot, *Manet*, p. 245.

## 15: The Group Divides

p. 234    'Oh, I know all about justice' ] Edouard Manet, quoted in Henri Perruchot, *Manet,* trans. Humphrey Hare (London: Perpetua, 1962; 1st published, Paris, 1959), p. 245.

p. 235    'the ambrosia of the gods' ] Paul Cézanne, quoted in John Rewald, *The Ordeal of Paul Cézanne*, trans. Margaret H. Liebman (London: Phoenix House, 1950), p. 107.

p. 236    'if only you knew' ] Claude Monet, quoted in Richard Kendall (ed.), *Monet by Himself: Paintings, Drawings, Pastels, Letters* (MacDonald Orbis, 1990; 1st published, 1989), p. 100.

p. 236    'very fine, of red chrysanthemums' ] Ibid., p. 101.

p. 237    'the handsomest third-floor flat in the neighbourhood' ] Edgar Degas, quoted in Roy McMullen, *Degas: His Life, Times, and Work* (London: Secker & Warburg, 1985), p. 373.

p. 237    'the one blessing that may be had for the asking' ] Edgar Degas, quoted in Richard Kendall (ed.), *Degas By Himself: Drawings, Prints, Paintings, Writings* (London: MacDonald Orbis, 1989; 1st published, 1987), p. 118.

p. 238    'these gentlemen don't appear to get on together' ] Edouard Manet, quoted in Juliet Wilson-Bareau (ed.), *Manet by Himself* (London: Little, Brown, 2000; 1st published, 1991), p. 264.

p. 238    all that 'official red' ] John Rewald (ed.), *Camille Pissarro: Letters to his Son Lucien* (New York: Pantheon, 1943), p. 28.

p. 239    'hideous, real failures' ] Eugène Manet, quoted in Denis Rouart (ed.), newly introduced by Kathleen Adler and Tamar Garb), *The Correspondence of Berthe Morisot, with her Family and Friends*

(London: Camden Press, 1986), p. 120.

p. 239    'more for what he attempted than for what he achieved' ] Albert Wolff, quoted in Perruchot, *Manet*, p. 246.

p. 239    'I have not given up hope' ] Edouard Manet, quoted in Wilson-Bareau (ed.), *Manet by Himself*, p. 265.

p. 239    'a slice of tomato stuck onto the sky' ] See Daniel Wildenstein, *Monet: Or the Triumph of Impressionism* (Cologne: Taschen and The Wildenstein Institute, 1999), p. 178.

p. 239    'extraordinary power of illusion' ] Ibid.

p. 240    'the blood of animals' ] Nancy Mowll Mathews, *Mary Cassatt: A Life* (New Haven and London: Yale University Press, 1998; 1st published, 1994), p. 162.

p. 240    18, rue du Château ] Edouard Manet: *The House at Rueil*, 1882.

p. 240    perched on a watering-can ] Edouard Manet: *Julie Manet with a Watering Can at Rueil*, 1882.

p. 240    'the new moon will bring more sunshine' ] Edouard Manet, quoted in Wilson–Bareau (ed.), *Manet by Himself*, p. 266.

p. 241    'You say you have heaps of things' ] Ibid.

p. 241    'In her last will' ] Manet's will is extracted ibid., p. 267; and quoted in full in Denis Rouart and Daniel Wildenstein, *Edouard Manet: Catalogue raisonné, Tome 1, Peintures* (Lausanne and Paris: La Bibliothèque des Arts, 1975), p. 25.

p. 241    'Christ on the cross' ] Edouard Manet, quoted in Wilson–Bareau (ed.), *Manet by Himself*, p. 247.

p. 241    'I beg you' ] Ibid.

p. 241    'The fools!' ] Edouard Manet, recorded by Antonin Proust, quoted ibid., p. 304.

p. 242    'Take care, Monsieur Manet' ] Perruchot, *Manet*, pp. 248–9.

p. 242    'completely white with lemon yellow borders' ] Lucien Pissarro, in Rewald (ed.), *Camille Pissarro: Letters to his Son Lucien*, pp. 22–3.

p. 243    'Mame has got to work again' ] Robert Cassatt, quoted in Mowll Mathews, *Cassatt and her Circle: Selected Letters* (New York: Abbeville Press, 1984), p. 166.

p. 243    'one of those which' ] Katherine Cassatt, quoted ibid., p. 175.

p. 243    The birth . . . of Jeanne ('Cocotte') ] Jeanne (Cocotte) Pissarro, born in 1881, was named after her deceased sister, Jeanne (Minette) Pissarro, 1865–1984.

p. 243    'I really regret it' ] Camille Pissarro, quoted in Charles S. Moffett et al. (eds) (ex. cat.), *Impressionists in Winter: effet de neige* (London: Philip Wilson and Washington, DC / The Philips

Collection, 1998, p. 162.

p. 244    like an elephant dipping its trunk into the water ] Guy de Maupassant's metaphor, in 'Une Vie', collected in *Contes et nouvelles 1875–1884* (Paris: Robert Laffont, 1988), pp. 693–852.

p. 244    'As far as I'm concerned' ] Claude Monet, quoted in Wildenstein, *Monet, Or the Triumph of Impressionism*, p. 185.

p. 244    'I've been in such a state . . .' Kendall (ed.), *Monet by Himself*, p. 105.

p. 244    I am so very, very sad' ] Claude Monet, quoted ibid., p. 105.

p. 245    'a catastrophe . . . a fiasco' ] Wildenstein, *Monet, Or the Triumph of Impressionism*, p. 186.

p. 245    '*straight away*' ] Kendall (ed.), *Monet by Himself*, p. 105.

p. 245    four major reviews ] See Wildenstein, *Monet, Or the Triumph of Impressionism*, pp. 186–7.

p. 246    'nonsense on both sides' ] Ibid., p. 182.

p. 246    Hoschedé's death ] Ibid., p. 279. By a strange coincidence, Hoschedé died (on 19 March 1891) at the address Monet was born at, 45, rue Lafitte (though because the street was later renumbered, not in the same building).

p. 246    'I am setting off . . . this morning' ] Claude Monet, Kendall (ed.), *Monet by Himself*, p. 106.

p. 247    'Manet is dying' . . . 'Manet is on his death-bed' . . . 'Our poor Manet is . . . ill' ] See Perruchot, *Manet*, p. 251.

p. 247    'When I'm better' ] Edouard Manet, quoted ibid., p. 251

p. 247    'Well, . . . if there's no other way' ] Ibid.

p. 247    The *Figaro* reported every last detail ] See Pierre Courthion and Pierre Cailler (eds.), *Portrait of Manet by Himself and his Contemporaries* (London: Cassell, 1960; 1st published, 1953), p. 102. (*Figaro*, 20 April 1883). See also Deborah Hayden, *Pox: Genius, Madness, and the Mysteries of Syphilis* (New York, Basic Books, 2004; 1st published, 2003), p. 310: 'On 14 August his leg turned black. Five days later it was amputated in the drawing room of his house, and in the general confusion thrown into the fireplace.'

p. 248    'His agony was horrible' ] Berthe Morisot, quoted in Rouart (ed.), newly introduced and edited by Adler and Garb, *The Correspondence of Berthe Morisot*, p. 131.

p. 248    Jules-Camille de Polignac described the scene ] Quoted in Courthion and Cailler, *Portrait of Manet by Himself and his Contemporaries*, pp. 103–6.

p. 249    'tall, beautiful, arresting, like a tea rose' ] Ibid., p. 101.

p. 249    'intense and universal' ] Berthe Morisot, quoted in Rouart (ed.), newly introduced and edited by Adler and Garb, *The Correspondence of Berthe Morisot*, p. 131.

PART SEVEN: Final Years

### 16: The Impressionists in New York

p. 253    his young son Charles ] Lionello Venturi, *Les Archives de l'Impressionisme, II* (Paris and New York: Editions Durand-Ruel, 1939), p. 215. Paul Durand-Ruel outlived his second son. Charles's life was cut tragically short on 18 September 1892. Their successor Charles Durand-Ruel is the grandson of Paul Durand-Ruel.

p. 253    'these days, it's fashionable' ] Baron Haussmann, quoted in Patrice Higonnet, *Paris: Capital of the World* (Cambridge, Mass.: Harvard University Press, 2002), p. 86.

p. 253    just walk off into the desert ] Paul Durand-Ruel, quoted in Lionello Venturi, *Les Archives de l'impressionisme, I*, p. 70.

p. 253    'those who will become *maîtres* in their turn' ] Ibid., pp. 72–3.

p. 253    '*très originaux et très savants*' ] Ibid.

p. 254    'Durand-Ruel was a missionary' ] Auguste Renoir, quoted in Jean Renoir, *Renoir, My Father* (London: Collins, 1962; 1st published, 1958), p. 225.

p. 254    fluttering wings of great white birds ] Gustave Caillebotte: *Laundry Drying*, 1892.

p. 254    dreadful massacres and headless warriors ] Shikes and Harper, *Pissarro: His Life and Work* (London, Melbourne and New York: Quartet, 1980), pp. 197–8.

p. 255    'tell her to ignore them' ] John Rewald (ed.), *Camille Pissarro: Letters to his Son Lucien* (New York: Pantheon, 1943), p. 30.

p. 255    'When I use paint' ] Paul Cézanne, quoted in John Rewald, *The Ordeal of Paul Cézanne*, trans. Margaret H. Liebman (London: Phoenix House, 1950), p. 108.

p. 255    'extraordinary, untranslatable pink' ] Claude Monet, quoted in Richard Kendall (ed.), *Monet by Himself: Paintings, Drawings, Pastels, Letters* (London, New York, Sydney and Toronto: MacDonald Orbis, 1990; 1st published, 1989), p. 110.

p. 256    'What's the use of our painting' ] Ibid., p. 116.

p. 256    The exhibition, which spanned five large rooms ] American Art

Galleries, *Works in Oil and Pastel by the Impressionists of Paris*, MDCCCLXXXVI (ex. cat.), New York: National Academy N620, A5, Box 1.

p. 259 'Your studio is so peculiar' ] From the Diaries of Daniel Halévy, in Richard Kendall (ed.), *Degas by Himself: Drawings, Prints, Paintings, Writings* (London: MacDonald Orbis, 1989; 1st published, 1987), p. 214.

p. 259 'The dancers have sewn it' ] Edgar Degas, quoted ibid., p. 209.

p. 259 'you do not write poetry with ideas' ] Stéphane Mallarmé, quoted in Roy McMullen, *Degas: His Life, Times, and Work* (London: Secker & Warburg), p. 405.

p. 259 Degas's third sonnet ] See Paul-André Lemoisne (ed.), *Degas et Son Oeuvre, I* (New York and London: Garland, 1984), pp. 203–12.

p. 259 'mild for Paris' ] Mary Cassatt, quoted in Nancy Mowll Mathews (ed.), *Cassatt and her Circle: Selected Letters* (New York: Abbeville Press, 1984), p. 194.

p. 260 'all unrelieved by any attempt' ] George Moore, quoted in Kathleen Adler, *Camille Pissarro: A Biography* (London: Batsford, 1978), p. 106.

p. 260 Murer, who had opened a hotel ] Rewald (ed.), *Camille Pissarro: Letters to his Son Lucien*, pp. 42–3.

p. 260 'What is this Gauguin to us' ] Julie Pissarro, quoted in W.S. Meadmore, *Lucien Pissarro: un coeur simple* (London: Constable, 1962), p. 38.

p. 260 'I realised my poor friend Gauguin' ] Rewald (ed.), *Camille Pissarro: Letters to his Son Lucien*, p. 48.

p. 261 'We saw the most wonderful landscapes' ] Ibid., p. 43.

p. 262 'she amused Aline' ] Auguste Renoir, quoted in Jean Renoir, *Renoir, My Father*, p. 237.

p. 262 'As I admired it' ] Denis Rouart (ed.), *The Correspondence of Berthe Morisot, with her Family and Friends* (newly introduced by Kathleen Adler and Tamar Garb), p. 145.

p. 264 'it seduced me' ] Claude Monet, quoted in Kendall (ed.), *Monet by Himself* (London: MacDonald, 1990; 1st published, 1989), pp. 118–22.

p. 264 Reviews went on appearing ] See Lionello Venturi, *Les Archives de l'impressionisme, I* (Paris and New York: Editions Durand-Ruel, 1939), p. 78. National Academy of Design, *Special Exhibition: Works in Oil and Pastel by the Impressionists of Paris*, MDCCCLXXXVI (ex. cat.), New York: National Arts Club Library.

p. 265    'I must confess the *Boy with the Sword*' ] Henry Havemeyer, quoted in Frances Weitzenhoffer, *The Havemeyers: Impressionism Comes to America* (New York: Harry N. Abrams, 1986), p. 44.

p. 265    'a surprising home' ] Robert Baldick (ed.), *Pages from the Goncourt Journal* (Oxford: Oxford University Press, 1962), p. 206.

p. 266    'If I had died at sixty' ] Venturi, *Les Archives de l'impressionisme,* I, p. 92.

Epilogue

p. 268    'far from being understood' ] Ralph Shikes and Paula Harper, *Pissarro: His Life and Work* (London, Melbourne and New York: Quartet, 1980), p. 315.

p. 268    'as a painter I am beginning to see more clearly' ] Richard Kendall (ed.), *Cézanne by Himself: Drawings, Paintings, Writings* (London, New York, Sydney and Toronto: MacDonald Orbis, 1990), p. 244.

p. 268    'it took me forty years to discover that painting is not sculpture' ] John Rewald, *Cézanne: A Biography* (The Netherlands: Harry N. Abrams, 1986), p. 192.

p. 268    'you see, Cézanne never knew what he was doing' ] Ibid., p. 266.

p. 268    'the atmosphere of lamps or moonlight' ] Henri Loyrette, *Degas: Passion and Intellect* (London and New York: Thames & Hudson and Harry N. Abrams, 1993), p. 121.

p. 269    'outright marvels' ] Antoine Terrasse, *Degas* (London: Thames and Hudson, 1972) p. 67.

p. 269    'what a fate!' ] Richard Kendall (ed.), *Degas by Himself: Drawings, Prints, Paintings, Writings* (London: MacDonald Orbis, 1989; 1st published, 1987), p. 242.

p. 269    'I think I am beginning to understand something about it' ] Jean Renoir, *Renoir: My Father* (London: Collins, 1962; 1st published, 1958), p. 404.

p. 269    'It's quite beyond my powers at my age' ] Richard Kendall (ed.), *Monet by Himself: Paintings, Drawings, Pastels, Letters* (London, New York, Sydney and Toronto: MacDonald Orbis, 1990; 1st published 1989), p. 240.

p. 269    'No, I am not a great painter' ] Ibid., p. 245.

p. 270    'I can never forget everything my friends and I owe your dear father' ] Claude Monet, quoted in Lionello Venturi: *Les Archives de l'Impressionisme,* I (Paris and New York: Editions Durand-Ruel, 1939), p. 97.

# BIBLIOGRAPHY

Jad Adams: *Hideous Absinthe: A History of the Devil in a Bottle* (London: I.B. Tauris, 2004)

Kathleen Adler: *Camille Pissarro: A Biography* (London: Batsford, 1978)

Kathleen Adler: *Manet* (Oxford: Phaidon, 1986)

Kathleen Adler: *Unknown Impressionists* (London: Guild Publishing/ Phaidon, 1988)

Kathleen Adler and Tamar Garb: *Berthe Morisot* (Oxford: Phaidon, 1987)

Jean-Louis Ayme (Preface by): *Tous au bain!: Plaisirs aquatiques au XIX siècle* (ex. cat.) (Croissy-sur-Seine: Musée de la Grenouillère, 2002)

Robert Baldick (ed.): *Pages from the Goncourt Journal* (Oxford: Oxford University Press, 1962)

Georges Bataille: *Manet* (Geneva: Editions d'Art Albert Skira and New York: Rizzoli International Publications, 1983; 1st published, 1955)

Marie-Louise Bataille and Georges Wildenstein: *Berthe Morisot: Catalogue des peintures* (Paris: Editions d'Etudes et des Documents, 1961)

Charles Baudelaire: *Correspondance I & II, texte établi, présenté et annoté par Claude Pichois avec la collaboration de Jean Ziegler* (Paris: Gallimard, 1973; 1st published, 1966)

Germain Bazin: *Edouard Manet* (London: Cassell, 1988; 1st published Milan, 1972)

Alice Bellony-Rewald: *The Lost World of the Impressionists* (London: Weidenfeld & Nicolson, 1976)

Anne-Marie Bergeret-Gourbin (ed.): *Un Siècle de bains de mer dans l'estuaire de la Seine, 1830–1930* (Honfleur: Musée Eugène Boudin, 2003)

David Bomford et al.: *Art in the Making: Degas* (London: National Gallery and Yale University Press, 2004)

Dominique Bona: *Berthe Morisot: Le Secret de la femme en noir* (Paris: Grasset, 2000)

Pascal Bonafoux: *Au Fil de la Seine* (Paris: Editions de Chène, 1998)

Alan Bowness (Intro.; ex. cat.) *The Impressionists in London* (London: The Arts Council of Great Britain, 1973)

Fenton Bresler: *Napoleon: A Life* (London: HarperCollins, 1999)

Richard Brettel and Christopher Lloyd: *Catalogue of Drawings by Camille Pissarro in the Ashmolean Museum, Oxford* (Oxford: Oxford University Press, 1980)

Beth Archer Brombert: *Edouard Manet: Rebel in a Frock Coat* (Chicago: University of Chicago Press, 1996)

Frederick Brown: *Zola: A Life* (London: Macmillan, 1996; 1st published, New York: Farrar, Straus & Giroux, 1995)

Dominique Bussillett: *Lettres: Promenade epistolaire sur la côte Normande au XIX siècle* (Cabourg Calvados: Editions Cahiers du Temps, 2001)

Augustin de Butler: *Renoir: Ecrits, entretiens et lettres sur l'art* (Paris: Les Editions de l'Amateur, 2002)

Françoise Cachin: *Manet, 1832–1883* (New York: The Metropolitan Museum of New York & Harry N. Abrams, 1983)

Françoise Cachin, *Manet*, translated by Emily Read (London, Barrie & Jenkins, 1991)

Françoise Cachin: *Manet: Painter of Modern Life* (London: Thames & Hudson, 1995; 1st published, 1994)

Sarah Carr Gomm: *Manet* (London: Studio Editions, c. 1992)

Cassell's *History of the War between France and Germany, 1870–1871, Vol. II*, intro. by Edmund Ollier (London: Cassell, n.d.)

Mary Ann Caws (ed.): *Mallarmé in Prose* (New York: New Directions, 2001)

Adrien Chappuis (ed.): *Cézanne: Catalogue raisonné* (London: Thames & Hudson, 1973)

Jean Clay and the editors of *Réalitiés: Impressionism* (NJ: Chartwell Books and Librairie Hachette et Société des Etudes et de Publications Economiques, 1973; 1st published, 1971)

Raymond Cogniat: *Sisley* (Naefels: Bonfini Press, 1978)

Pierre Courthion and Pierre Cailler (eds.), *Portrait of Manet by Himself and his Contemporaries, I & II* (London, Cassell, 1958)

François Daulte: *Renoir* (London: Thames & Hudson, 1972)

Marianne Delafont: *Berthe Morisot, ou L'Audace raisonné*, Fondation Denis et Annie Rourt (Marianne Delafont, Caroliner-Genet-Bondeville) (Lausanne: Bibliothèque des Arts, c. 1987)

Loys Delteil: *Le Peintre-Graveur illustré: the graphic works of c19 & c20 artists: an illustrated catalog, Vol. XVI: Raffaelli* (New York: Collectors Editions, Ltd, Da Capo Press, 1969)

Bernard Denvir: *The Chronicle of Impressionism: An Intimate Diary of the Lives and World of the Great Artists* (London: Thames & Hudson, 2000; 1st published, 1993)

Bernard Denvir (ed.): *The Impressionists at First Hand* (London: Thames & Hudson, 1991; 1st published, 1987)

Theodore Duret: *Manet and the French Impressionists*, translated by J. E. Crawford Flitch (New York: Books for Libraries Press, 1971; 1st published 1910)

T.J. Edelstein (ed.): *Perspectives on Manet* (New York: Hudson Hills Press, 1990)

Stewart Edwards (ed.): *The Communards of Paris, 1871* (London: Thames & Hudson, 1973)

Peter H. Feist: *Renoir* (Cologne: Taschen, 2000)

François Fosca: *Renoir: L'Homme et son oeuvre* (Paris: Editions Aimery Somogy, 1985; 1st published, 1961)

Lewis Galantière (ed.): *The Goncourt Journals, 1851–1870* (London, Toronto, Melbourne and Sydney: Cassell, 1937)

Tamar Garb: *Women Impressionists* (Oxford: Phaidon, 1986)

William Gaunt: *The Impressionists* (London: Thames & Hudson, 1970)

William Gaunt: *Renoir* (Phaidon 1982; 1st published, 1962)

Lawrence Gowing (ex. cat.): *Cézanne: The Early Years, 1859–1872*, ed. Mary Anne Stevens (London: Royal Academy of Arts in association with Weidenfeld & Nicolson, 1988)

Bernard Growe: *Edgar Degas, 1834–1917* (Cologne: Taschen/Midpoint Press, 2001)

Marcel Guérin (ed.): *Degas: Letters*, translated by Marguerite Kay (Oxford: Bruno Cassirer, 1947)

Daniel Halévy: *My Friend Degas*, translated and ed. by Mina Curtiss (London: Rupert Hart-Davis, 1966)

Laurence Hanson: *Mountain of Victory: A Biography of Paul Cézanne* (London: Secker & Warburg, 1960)

Deborah Hayden: *Pox: Genius, Madness, and the Mysteries of Syphilis* (New York: Basic Books, 2004; 1st published, 2003)

Robert L. Herbert: *Impressionism: Art, Leisure, & Parisian Society* (New Haven and London: Yale University Press, 1988)

Robert L. Herbert: *Monet on the Normandy Coast* (New Haven & London: Yale University Press, 1994)

Anne Higonnet: *Berthe Morisot: A Biography* (London: Collins, 1990)

Patrice Higonnet: *Paris: Capital of the World* (Cambridge, Mass.: Harvard University Press, 2002)

Arthur Hoeber: *The Barbizon Painters: Being the Story of the Men of Thirty* (New York: Books for Libraries Press, 1969; first published, 1915)

Alistair Horne: *The Fall of Paris: The Siege and the Commune, 1870–71* (London: The Reprint Society, 1967)

John House: *Monet: Nature into Art* (New Haven and London: Yale University Press, 1986)

Michael Howard: *The Franco-Prussian War: The German Invasion of France, 1870–1871* (London: Rupert Hart-Davis, 1961)

Michael Howard: *Impressionism* (London: Carlton, 1997)

Michael Howard (ed.): *The Impressionists by Themselves: More than Twenty Artists, their Works, and their Words* (New York: Smithmark; London: Conran Octopus, 1991)

Claire Joyes: *Claude Monet: Life at Giverny* (London: Thames & Hudson, 1985)

Claire Joyes: *Monet's Cookery Notebooks* (London: Ebury Press, 1989)

Diane Kedler: *The Great Book of French Impressionism* (New York: Abbeville Press, 1980)

Richard Kendall (ed.): *Cézanne by Himself: Drawings, Paintings, Writings* (London, New York, Sydney and Toronto: MacDonald Orbis, 1990)

Richard Kendall (ed.): *Degas by Himself: Drawings, Prints, Paintings, Writings* (London: MacDonald Orbis, 1989; 1st published, 1987)

Richard Kendall (ed.): *Monet by Himself: Paintings, Drawings, Pastels, Letters* (London, New York, Sydney and Toronto: MacDonald Orbis 1990; 1st published, 1989)

Alan Krell: *Manet and the Painters of Contemporary Life* (London: Thames & Hudson, 1996)

Helen Langdon: *Impressionist Seasons* (Oxford: Phaidon, 1986)

Paul-André Lemoisne (ed.): *Degas et son oeuvre, 3* vols and a Supplement (New York and London: Garland, 1984)

Jacques Lethève: *Daily Life of French Artists in the Nineteenth Century* (London: Allen & Unwin, 1972)

Jean-Jacques Lévêque: *Gustave Caillebotte: L'Oublié de l'impressionisme, 1848–1894* (Paris: ACR Poche/Couleur, 1994)

Jack Lindsay: *Cézanne: His Life and Art* (London: Evelyn, Adams & Mackay, 1969)

Dominique Lobstein: *Monet* (Paris: Editions Jean-Paul Gisserot, 2002)

Nancy Locke: *Manet and the Family Romance* (Princeton and Oxford: Princeton University Press, 2001)

Henri Loyrette: *Degas: Passion and Intellect* (London and New York: Thames & Hudson and Harry N. Abrams, 1993; 1st published, Paris, 1988)

Patty Lurie: *The Impressionist Landscape* (Boston, Toronto and London: Little, Brown, 1990; 1st published, 1944)

Gerstle Mack: *Paul Cézanne* (London: Jonathan Cape, n.d.)

Roy McMullen: *Degas: His Life, Times, and Work* (London: Secker &

Warburg, 1985)

Melissa McQuillan: *Impressionist Portraits* (London: Thames & Hudson, 1886)

Firmin Maillard: *Les Derniers Bohèmes: Henri Murger et son temps* (Paris: Librairie Sartorius, 1874)

Julie Manet: *Journal, 1893–1899: sa jeunesse parmi les peintres impressionistes et hommes de lettres* (Paris: C. Klincksieck, 1979)

J. Patrice Marandel, François Daulte et al. (ex. cat.): *Frédéric Bazille and Early Impressionism* (The Art Institute of Chicago, 1978)

Nancy Mowll Mathews and Barbara Stern Shapiro: *Mary Cassatt: The Colour Prints* (New York: Harry N. Abrams, 1989)

Nancy Mowll Mathews (ed.): *Cassatt and her Circle: Selected Letters* (New York: Abbeville Press, 1984)

Nancy Mowll Mathews: *Mary Cassatt: A Life* (New Haven and London: Yale University Press, 1998; 1st published, 1994)

George Mauner (ex. cat.): *Manet: The Still-Life Paintings* (New York: Harry N. Abrams, in asssociation with the American Federation of Arts, 2000)

Guy de Maupassant: *Contes et nouvelles, 1875–1884* (Paris: Editions Robert Laffont, 1988)

W.S. Meadmore: *Lucien Pissarro: un coeur simple* (London: Constable, 1962)

Michel Melot: *The Impressionist Print*, translated by Caroline Beamish (New Haven & London: Yale University Press, 1996; 1st published, 1994)

John Milner: *The Studios of Paris: The Capital of Art in the Late Nineteenth Century* (New Haven and London: Yale University Press, 1988)

John Milner: *Art, War and Revolution, 1870–1871: Myth, Reportage and Reality* (New Haven and London: Yale University Press, 2000)

Charles S. Moffett et al. (eds.): *Impressionists in Winter: effet de neige (ex. cat.)* (London: Philip Wilson & Washington, DC: The Philips Collection, 1998)

Charles S. Moffett et al.: *The New Painting: Impressionism, 1874–1886* (ex. cat.) (San Francisco: The Fine Arts Museums of San Francisco, with the National Gallery of Art, Washington, 1986)

George Moore: *Reminiscences of the Impressionist Painters* (Dublin: The Tower Press Booklets no. 3, Maunsel, 1906)

Julian More: *Impressionist Paris: The Essential Guide to the City of Light* (London: Pavilion, 1998)

Gilles Neret: *Manet: The First of the Moderns* (Cologne: Taschen, 2003)

Henri Perruchot: *Manet*, trans. by Humphrey Hare (London: Perpetua,

1962; 1st published, Paris, 1959)

Julie Pissarro: *Quatorze lettres de Julie Pissarro*, with a Preface by Edda Maillet (Pontoise: L'Arbre & Les Amis de Camille Pissarro, 1984)

Dianne W. Pitman: *Bazille: Purity, Prose, and Painting in the 1860s* (Pennsylvania State Press, 1998)

Griselda Pollock: *Mary Cassatt: Painter of Modern Women* (London: Thames & Hudson, 1998)

Jean-Michel Puydebat: *Les Impressionists autour de Paris: tableau de banlieu avec peintres* (Auvers: SEM Château d'Auvers, 1993)

C.F. Ramuz: *Cézanne: Formes* (Lausanne: International Art Book, 1968)

Theodore Reff: *The Notebooks of Edgar Degas: A Catalogue of the Thirty-Eight Notebooks in the Bibliothèque Nationale and Other Collections, I, II, III* (Oxford: Clarendon Press, 1976)

Jean Renoir: *Renoir, My Father* (London: Collins, 1962; 1st published, 1958)

John Rewald: *Camille Pissarro: Letters to his Son Lucien* (New York: Pantheon, 1943)

John Rewald: *Cézanne: A Biography* (The Netherlands: Harry N. Abrams, 1986)

John Rewald: *The History of Impressionism* (London: Secker & Warburg, 1880; 1st published, 1973)

John Rewald: *The Ordeal of Paul Cézanne*, trans. by Margaret H. Liebman (London: Phoenix House, 1950)

John Richardson: *Edouard Manet: Paintings and Drawings* (London: Phaidon, 1958)

Denis Riout (ed.): *Les Ecrivains devant l'impressionisme* (Paris: Macula, 1989)

Georges Rivière: *Renoir et ses amis* (Paris: H. Floury, 1921)

Michel Robida: *Renoir: Enfants* (Lausanne: International Art Books, 1959)

Marc Rosen and Susan Pinsky: *Mary Cassatt: Prints and Drawings from the Artist's Studio* (New York: Princeton University Press, 2000)

Denis Rouart and Daniel Wildenstein (eds.): *Edouard Manet: Catalogue raisonné, Tome 1, Peintures* (Lausanne and Paris: La Bibliothèque des Arts, 1975)

Denis Rouart (ed.), newly introduced and edited by Kathleen Adler and Tamar Garb: *The Correspondence of Berthe Morisot, with her Family and Friends* (London: Camden Press, 1986)

Denis and Anne Rouart Foundation: *Berthe Morisot: Reasoned Audacity* (Paris: Musée Marmottan, 2002)

Karin Sagner-Duchting: *Renoir: Paris and the Belle Epoque* (Munich and New York: Prestel-Verlag, 1996)

Karin Sagner-Duchting: *Claude Monet: A Feast for the Eyes* (Cologne, Lisbon, London, New York, Paris and Tokyo: Taschen, 1998)

Margaret Shennan: *Berthe Morisot: The First Lady of Impressionism* (Stroud: Sutton Books, 2000; 1st published, 1996)

Ralph E. Shikes and Paula Harper: *Pissarro: His Life and Work* (London, Melbourne and New York: Quartet, 1980)

Richard Shone: *Sisley* (London: Phaidon, 1994; 1st published, 1979)

Richard Shone: *Sisley* (London: Phaidon, 1999; 1st published, 1992)

Enid Starkie: *Baudelaire* (London: Gollancz, n.d.)

Mary Ann Stevens (ed.): *Alfred Sisley* (New Haven and London: Yale University Press, 1992)

A. Tabarant: *Manet et ses oeuvres* (Paris: Gallimard, 5th edition, 1947)

Antoine Terrasse: *Degas*, in 'The Great Impressionists' series, directed by Daniel Wildenstein (London: Thames & Hudson, 1975; 1st published, Milan, 1972)

Belinda Thomson: *Impressionism: Origins, Practice, Reception* (London: Thames & Hudson, 2000)

Richard Thomson: *Degas: The Nudes* (London: Thames & Hudson, 1988)

Paul Hayes Tucker: *Monet at Argenteuil* (New Haven and London: Yale University Press, 1982)

Paul Hayes Tucker: *The Impressionists at Argenteuil* (ex. cat.) (New Haven and London: Yale University Press, 2000)

Paul Valéry: *Degas, danse, dessin* (Paris: Gallimard, 1938)

Paul Valéry: *Oeuvres, II* (Paris: Gallimard, 5th edition, 1960)

Lionello Venturi: *Les Archives de l'impressionisme, I & II* (Paris and New York: Editions Durand-Ruel, 1939)

Richard Verdi: *Cézanne* (London: Thames & Hudson, 1997; 1st published, 1992)

Ambroise Vollard: *En Ecoutant Cézanne, Degas, Renoir* (Paris: Bernard Grasset, 2003; 1st published, 1938)

Nicholas Wadley: 'Charm without Change: The Road to Impressionism' (London: Wallace Collection, July–August 2003), *Times Literary Supplement*, 4 July 2003, p. 20

C. P. Weekes: *Camille: A Study of Claude Monet* (London: Sidgwick & Jackson, 1962; 1st published, New York, 1960, as *Invincible Monet*)

Willet Weeks: *The Man Who Made Paris: The Illustrated Biography of Georges-Eugène Haussmann* (London: London House, 1999)

Frances Weitzenhoffer: *The Havemeyers: Impressionism Comes to America* (New York: Harry N. Abrams, 1986)

Barbara Ehrlich White: *Impressionists Side by Side: Their Friendships, Rivals and Artistic Exchanges* (New York: Knopf, 1996)

Daniel Wildenstein: *Claude Monet: Biographie et catalogue raisonné* (Lausanne and Paris: La Bibliothèque des Arts), Vol. I (1974); Vol. II (1979); Vol. III (1979); Vol. IV (1985)

Daniel Wildenstein: *Claude Monet: Catalogue raisonné, supplément aux peintures, dessins, pastels* (Lausanne: Wildenstein Institute), ibid. Vol. V (1991)

Daniel Wildenstein: *Monet, Or the Triumph of Impressionism* (Cologne: Taschen and The Wildenstein Institute, 1999)

Juliet Wilson-Bareau (ed.): *Manet by Himself* (London: Little, Brown, 2000; 1st published, 1991)

Emile Zola: *The Masterpiece*, translated by Thomas Walton, translation revised and introduced by Roger Pearson (Oxford: Oxford World's Classics, 1999; 1st published in the UK, 1950; 1st published, Paris, 1886)

## EXHIBITION CATALOGUES

(where not listed under author)

American Art Galleries: *Works in Oil and Pastel by the Impressionists of Paris*, MDCCCLXXXVI, American Art Galleries, New York: National Academy N620, A5, Box 1

The Arts Council of Great Britain: *Impressionists in London* (Hayward Gallery, London, 3 January–11 March, 1973)

National Academy of Design: *Special Exhibition: Works in Oil and Pastel by the Impressionists of Paris*, MDCCCLXXXVI, New York: National Arts Club Library

National Academy of Design: *Rave Reviews: American Art and its Critics, 1826–1925*, New York, 2000

# INDEX